INTERNATIONAL
ART GALLERIES

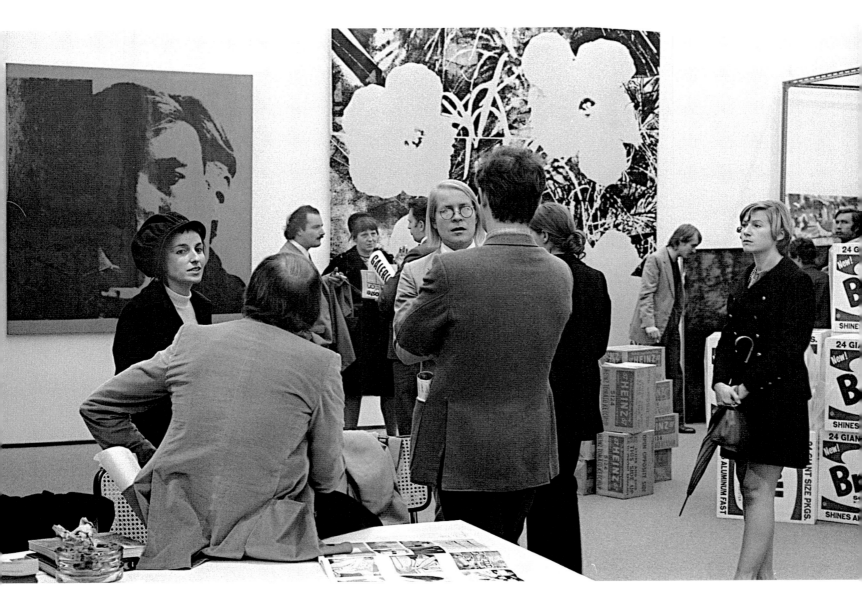

Above: Heiner Friedrich's booth
at the 'Kölner Kunstmarkt',
Cologne, 1970

Overleaf: *Mandala* at the
'KIMSOOJA' exhibition,
The Project, 2003

INTERNATIONAL ART GALLERIES
POST-WAR TO POST-MILLENNIUM

A NARRATIVE CHRONOLOGY
OF THE DEALERS, ARTISTS AND SPACES
THAT HAVE DEFINED MODERN ART

EDITED BY
UTA GROSENICK
+ RAIMAR STANGE

With 427 illustrations, 227 in colour

Thames & Hudson

CONTENTS

This book constitutes the first comprehensive international history of the modern gallery system. It contains more than seventy-five portraits of leading art galleries from around the world, which have not only been successfully selling works of art to passionate collectors since 1945, but through their work have left and continue to leave their mark on the style of contemporary art because they have been able to convince exhibiting institutions and art critics of the value of 'their' artists. This is what distinguishes every gallery portrayed in this book: in contrast to the mere art shop, they present in their rooms works by artists important to the age, and thus constantly supply the art business with decisive impulses. It is in galleries that curators and critics, as well as collectors, students and other art lovers, discover hitherto unknown artists because usually it is the galleries that provide the latter with their first public forum. New art movements are often formulated as such in galleries. Where, for example, would American Pop Art be without the Leo Castelli Gallery, or what would the international Fluxus movement have been without the commitment of René Block's gallery?

In this book we have deliberately restricted ourselves to the period since 1945. Art dealing has gone on since antiquity, when the ancient Romans bought sculptures from the Hellenes; in the Middle Ages, craftsmen formed guilds and marketed their works themselves, until in the 16th century, under the influence of Humanism, the idea of the artist as genius became the norm, a genius in whose works consumers were taking an increasing interest. The middleman between affluent art lovers and talented but impoverished artists was born. Since then, the middleman has played an ever more important role in the lives and careers of artists. It is even reported of Antoine Watteau that he died in the arms of his dealer Gersaint. While in the 19th century art galleries resembled, if anything, antique or curiosity shops, the profession of the art dealer was developing. The first dealer, by any modern definition, was the Frenchman Paul Durand-Ruel, born in 1831 to a man who kept an art supplies shop. He united such different professions as publicist, banker, dealer, consultant and collector in one person. These characteristics were further perfected by Daniel-Henry Kahnweiler, who opened his first gallery in 1907 and represented artists such as Picasso, Braque, Miró and Léger. He saw the moral justification of his activity in the task of freeing his artists as far as possible from all material worries.

Some French dealers had had branches in New York since the mid-19th century, but, even so, the United States seemed in the eyes of European dealers an, if anything, modest market. This situation changed, however, with pioneers such as Alfred Stieglitz, who opened his 291 Gallery on Fifth Avenue in 1908, exhibiting works by Toulouse-Lautrec, Rousseau, Cézanne, Matisse and Picasso. But it was not

until the arrival of Peggy Guggenheim, who opened her first gallery in London in 1938 and her second in New York in 1943, and went on to open new galleries after the Second World War, that an international art system developed in which galleries were able to occupy increasingly their current characteristic position in the art world.

We have arranged the individual portraits of the galleries chronologically, assigning them to the decades in which they enjoyed their greatest influence with the public. Each chapter is introduced with a brief historical sketch in order to summarize the social background of the decade in question. In the alterations that have occurred over the sixty years covered by the profiled galleries, there is a great deal to be gleaned, including a change of priorities in a gallery's programme, shifts in major art locations and new criteria for the presentation of an artist.

All the galleries in our book are concisely described, with text, pictures and a block of information, including date of foundation, proprietor, addresses and the artists represented. We regarded it as particularly important to present the galleries as living entities with their own particularities because each is unique in its own way and every gallery owner fundamentally different in his or her personality.

The galleries presented here – and this cannot be stressed enough – represent a selection that is ultimately subjective. Even so, our criteria for the selection of a gallery has been as follows: that it is or was influential in the aesthetic discourse of its age, that it discovered or launched new trends, and that it took risks. By contrast, its economic success is of no significance, although the strategies employed to this end do attract our interest. We have still not been able to include every gallery that fulfils these criteria, primarily due to the perennial problem of lack of space.

In order to give each gallery the most informed portrayal possible, this book has been compiled with the collaboration of writers renowned in the field, our correspondents so to speak: Kirsty Bell, Luca Cerizza, Stéphane Corréard (with Lili Laxenaire), Rachel Gugelberger, Barbara Hess, Jens Hoffmann, Sylvia Martin, Regina Schultz-Möller, Adam Szymczyk and Gilbert Vicario. We would like to thank them for their expertise and commitment, and we would also like to thank our two editors, Maria Platte and Nicola von Velsen. Without the generous support of the proprietors and staff of all the galleries, or the executors of their estates, in the matter of research and material procurement, this book would not have been possible: we would like to express our particular thanks to them. In addition, thanks go to the following individuals, whose advice has been especially helpful: Günther Herzog and Brigitte Jacobs at the Zentralarchiv des internationalen Kunsthandels (Central Archive of the International Art Trade) in Cologne, Alex Alberro, Walling Boers, Peter Friedl, Candida Höfer, Manfred Holtfrerich, Joachim Kreibohm, Patrick Meagher, Anton Vidokle, Jonathan Monk and Florian Waldvogel.

UTA GROSENICK AND RAIMAR STANGE, COLOGNE AND BERLIN, SPRING 2005

I. The Structural Change in Art

Today the gallery is so taken for granted as part of the everyday lives of artists and art collectors, art historians and passionate art lovers that we are quite likely to forget what a fundamental change in cultural life has in fact been brought about by the appearance of the modern art gallery since the end of the 19th century. Thus the art historian Max Raphael noted in his diary on 10 June 1941: 'If we view our present age in the context of history, it will be abundantly clear to what extent industry has grown and culture declined. Only the active bourgeoisie has continued to produce things of spiritual value, and to the extent that it has industrialized, art has disappeared from public life (together with religion) and has become a private affair (i.e. painting instead of architecture).'[1]

Raphael thus puts his finger on the decisive paradigm shift in the history of modern culture, and it has also been of essential importance for the appearance of the art gallery as an institution. Since the end of the 19th century, art has become increasingly detached from the institutional contexts of court and state, and is instead seen as a 'private pleasure' for the (affluent) middle classes, as part of a new economic order. This new art economics demands new forms of presenting, distributing and selling works of art – the private, commercially run gallery becomes indispensable. At the same time, public museums[2] and auction houses[3] have also taken on an undreamed-of importance for art.

What the bourgeois intellectual Max Raphael, best known for his pioneering 1913 book *Von Monet zu Picasso* (From Monet to Picasso), still regarded as a negative development in 1941 has become for us today something so self-evident that we no longer even question it. The genesis described by Raphael has set the tone: art is a business like any other; a painting represents a commodity whose aesthetic existence is bolstered, more or less successfully, by its value as a tradable investment.

The consequences wrought by the paradigm shift we have just described were, above all at the beginning of the 20th century, also aesthetic in nature. Among others, the Bremen literary scholar Peter Bürger convincingly outlined these in his *Theorie der Avantgarde* (Theory of the Avantgarde), published in 1974. One of his theses can be summarized as follows: it took the structural change from aristocratic to bourgeois society to lay the foundations for the social autonomy of art, which in turn made its aesthetic autonomy possible. Artists' liberation from previously laid-down representational tasks, from collective reception, and from clients who specified the content in advance is now reflected in an art 'raised out of the everyday plane'.[4] And this is precisely the function of the gallery: to give this 'bourgeois' art its ideal presentation and distribution potential and thus open up a (profitable) market to replace courtly structures.

1 Max Raphael, *Lebenserinnerungen*, Frankfurt am Main, 1989, p. 337.

2 In his book *Der Ursprung des Museums – Vom Sammeln,* Berlin, Krystof Promian wrote: '...museums are replacing churches as the places where all members of society can communicate in the celebration of the same cult. That's why there was an increase in the number of museums in the 19th and 20th centuries. The populace, especially the urban population, detached itself increasingly from traditional religion.' p. 69

3 Recommendable reading on the history of auction houses and galleries: Peter Watson, *Sotheby's, Christie's, Castelli & Co.*, Düsseldorf, Vienna, New York, Moscow, 1993

4 Peter Bürger, *Theorie der Avantgarde*, Frankfurt am Main, 1974, p. 72

Art venues: Thomas Huber,
Panorama, 1988

The modern gallery thus represents the interface between autonomous art and freelance artists on the one hand, and the capitalist market and its buyers – who mostly call themselves 'collectors' – on the other. In this respect, to a certain extent, it is the mediating instance between the studio and the drawing room. At the same time, the gallery also fills the gap left by the disappearance of prescribed representational tasks. For, since art now no longer comes across as a relatively fixed canon, a new discourse is necessary to decide what is 'good' art and what is not. This discourse began in the galleries – though, of course, not only there. It is in the gallery that 'young' art is seen and judged; if critics and curators judge the works to be good, they proceed to exhibitions at art associations or comparable institutions, and, if all goes well, they ultimately end up in the large collections of museums or wealthy private collectors.

II. The Gallery

The (turbulent) history of the art gallery is relatively young, having started at the beginning of the 20th century in cities such as Paris and Berlin, but it is only since the end of the Second World War that an increasingly worldwide commercial gallery scene has developed. For all that, it did not take long to find the ideal architectural form in which the work of the gallery could proceed in optimum fashion. The 'white cube' with its limpid and luminous structure – above all with its flat, preferably large walls, on which painting in particular can present itself undisturbed to the gaze of the art lover – has long since been the model for most exhibition rooms. Here (and this is the essential difference between the gallery and the shop) not only are works of art offered for sale, but changing exhibitions – most of them curated – are also staged.[5] For the 'white cube', which on the one hand takes account of art being 'raised above the plane of everyday life', as noted by Peter Bürger, also provides the sheltered space for the best mise-en-scène (from the one perspective) or perceptual opportunity (from the other) for this display of (autonomous) art. Thus the gallery serves as an insulating boundary and productive frame at the same time – a dialectic as problematic as it is tense, which the Irish art critic, artist and poet Brian O'Doherty was

probably the first to formulate in his legendary essay 'Inside the White Cube' in 1976. O'Doherty hits the nail on the head when he writes: 'The ideal gallery subtracts from the artwork all cues that interfere with the fact that it is "art".' The consequence of this concentrated isolation and framing is an enhanced 'presence' reminiscent of 'the sanctity of the church'. But he also stresses the constitutive quality of the gallery, by which 'the work is isolated from everything that would detract from its own evaluation of itself'.[6]

It is precisely in this 'survival arrangement, proto-museum, that prepares the condition of immortality'[7] that those two particular types of people are received, who approach art not only with interest, but ideally with enthusiasm or indeed with love, who not only write about it both knowledgeably and with commitment, but who above all would like to purchase the works exhibited in the gallery: the museum curator who hopes for immortality, and the collector who hopes for wealth.

III. Art

At least as long as the history of the gallery is the history of the artists' rebellion against any secularization of their work, secularization that is supposedly expressed in the reification and eventual marketing of aesthetics: if art can circulate only as a commodity in an art world that was being referred to as the 'art business' during the 1990s, then understandably there will be resistance. This began with the Dadaists and their explicitly anti-bourgeois and anti-capitalist art. As far back as the 1920s, the Dadaists had already started to attack the commodification of art with their collages of the cheapest materials possible. In their writings, for example, they demanded time and again that the ownership of art be prohibited. Hence the existence of the 'Dadaist revolutionary central council, German group, Hausmann, Huelsenbeck, Golyscheff', which campaigned both polemically and enthusiastically for the 'immediate establishment of a State House of Art and the abolition of the concept of ownership in new art'. The 'concept of ownership' was to be 'entirely eliminated in the supra-individual Dadaist movement, which liberates all people'.[8]

The gallery as frame, the frame as sculpture, the framed picture: Michel Majerus, *Controlling the Moonlight Maze*, neugerriemschneider, 2002

5 Another difference is that the art dealer normally deals in artworks that are in his possession, while the gallery owner works on a commission basis
6 All quotes: Brian O'Doherty, *In der weißen Zelle – Inside the White Cube*, Berlin, 1996, p. 9
7 Ibid., p. 90
8 Quoted from *Dada Berlin – Texte, Manifeste, Aktionen*, Stuttgart, 1977, p. 61

At the end of the Second World War, the art world was constantly getting worked up at the notion of the gallery as a location where art was presented as a commodity: this was the case with the Pop and Fluxus artists, for example, who were primarily concerned with the abolition of the distinctions between art and life, and hence with an opening of the borders between the gallery and the public space. One has only to think of Joseph Beuys, who in 1974, during his *I like America and America likes me* project, spent three days with a coyote in the René Block Gallery in New York in order to redefine the latter as a (mythical) habitat, in which nature, art and culture achieve a new trinity. The Conceptual Art of the 1960s and '70s, by contrast, worked against the commodification of art, dispensing entirely with actually producing the artwork in some cases. The American Conceptual artist Sol LeWitt observed: 'Ideas alone can be works of art.'[9] Robert Barry presented such an idea in December 1969 when he declared a closed gallery to be a work of art. His Amsterdam gallery, Art & Project, sent out invitation cards saying 'During the exhibition the gallery will be closed.'[10] The institution-critical art of the 1980s also turned right away from the gallery system at times, seeking the construction of an alternative order of 'non-capitalist' public arrangements.

And yet all these endeavours – Dadaism, Fluxus, Pop Art, Conceptual Art and the anti-institutionalism of the 1980s – ultimately ended up back in the despised galleries and museums, where they are put up for discussion, bought and preserved for posterity.

IV. The Collector

While the museum curator will primarily act on art-historical and institutional considerations when buying his or her works of art, the collector will pay attention only to his personal obsession, which on the one hand is not necessarily coupled with aesthetic expertise, but on the other is not accountable to anyone else. An attempt is

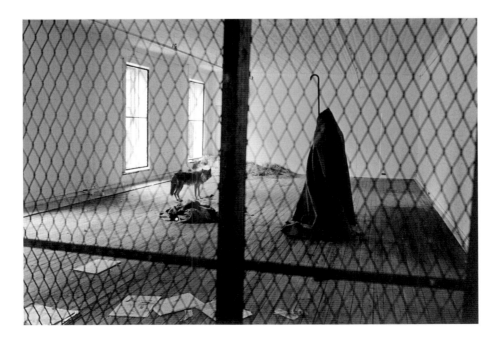

The gallery as living space: Joseph Beuys, *I like America and America likes me*, 1974

9 Quoted from *Katalog Westkunst*, Cologne, 1981, p. 281
10 See, for example, Brian O'Doherty, as in note 6, p. 115

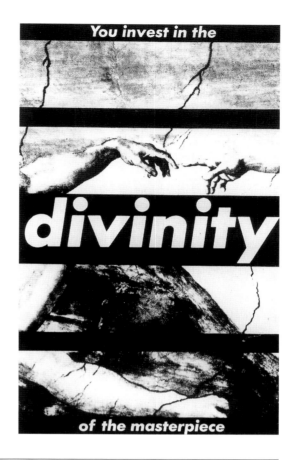

Honour where honour is due:
Barbara Kruger, *Untitled
(You invest in the divinity
of the masterpiece)*, 1982

often made to compensate for the lack of artistic knowledge by consulting with the gallery owner, but the individual obsession of the collector is nonetheless a fascinating characteristic. The image of the art buyer in a manic search for art may be a distortion, but it does contain at least an element of truth: collectors would not be true collectors if they were not also driven by an irrational love of art, for which they sometimes have to make considerable financial sacrifices. The reasons for this compulsive passion – already hinted at by the philosopher and culture critic Walter Benjamin[11] – are on the one hand a desire for order, and on the other the circumstance that art only becomes real for the collector when he or she has acquired it.[12] The collector has totally internalized the concept of possession: only as private property can he or she accept a work of art for what it is.

The US art publicist Peter Schjeldahl writes about a different cause for this mania in his 1988 essay 'Art and Money': the collectors 'are searching for evidence of values such as individuality and spirituality, precisely those qualities in other words which are trodden underfoot by the business and financial world. To pay a high price for this evidence...points to a purification rite, a metaphysical money-laundering'. The purchase of expensive works of art serves as a substitute for religious satisfaction, as compensation for the disappearance of religion, which was already noted by Max Raphael. And didn't Brian O'Doherty also talk of the 'sanctity of the church' in order to describe the atmosphere of the gallery? In the gallery, in other words, the initially profane act of striving for private property acquires an almost mythic aura. The purchase thus takes on a quality that can certainly also have political dimensions. Peter

11 In Walter Benjamin,
Das Passagenwerk, Frankfurt am
Main, 1982, p. 269. Walter Benjamin
writes: 'You have to know namely:
the world is present in every one
of the collector's objects,
and is ordered.'
12 In this sense Karl Marx claimed:
'Private property has made us so
stupid...that an object is only ours
when we have it.' In *Der historische
Materialismus*, Leipzig, 1932, p. 299

15

Schjeldahl sees a possible (anti-American) critique of civilization in the 'purification ritual' of the art purchase, for example: 'To invest one's possessions in a picture of the American flag[13] or to burn the American flag in Teheran are perhaps only two different ways of soothing wracked souls.'[14] Thus the white cube of the gallery is today not only part of a neo-liberal market, but can ideally also be the (mythic) critique of this system.

Writing about Galleries

(Critical) writing about galleries is a difficult undertaking. By contrast, the late 1920s were comparatively simple, when Walter Benjamin could still say of the critic: 'Enthusiasm for art is a sentiment foreign to the critic. In his hand, the artwork is the unsheathed sword in the struggle of minds.'[15] This form of art criticism is simple because it was uttered at a time when there was no really developed art market as such. The critic, full of idealism, could present himself, full of enthusiasm, as the combative 'strategist' in a purely intellectual cultural struggle because in those days there could be no talk of entanglements in the commercial business of art. But it is precisely this aspect that has changed increasingly since the end of the Second World War, and quite openly. The art critic today is always a bit of an agent, the public relations manager of the galleries: 'Any press is good press,' as they say, and so even the most malign attack is seen as publicity for the gallery at which it is aimed. It is no wonder then that many newspapers do not print their discussions of current gallery exhibitions on their review pages but in sections with telling titles such as 'Art and Market'.[16] Many have also set up quite separate sections with names such as 'The Art Market'.[17]

This new economic importance acquired by articles about galleries is also reflected in the fact that these articles are no longer left to critics alone. Rather, this journalistic field is ploughed in all sorts of different ways. For example, there are tourist-orientated gallery guides, which serve among other things to praise a town or city's quality of life due to the quantity and quality of the galleries to be found in it. Then there are catalogues of specialist art fairs such as 'Art Basel', with brief portraits of galleries and lists of the artists they represent. Time and again there are interviews with gallery owners, particularly in specialist magazines. This gives the owners an opportunity to talk about their programme, to describe how they deal with artists, and to present more or less profound considerations on current aesthetics – and, it goes without saying, not without self-serving remarks concerning their own work.[18] To be on the safe side, gallery owners have now even started taking articles about their workplace entirely into their own hands. The spectrum of these public-relations exercises ranges from the simple advertisement, sometimes designed by the artists – even reputable periodicals now fill two-thirds of their pages with such stuff[19] – to whole books about their own gallery, in which the historicization of their successful work can be promoted.[20] This gallery advertising in book form has already become a genre in its own right, which can be identified by

13 The American flag as motif is found, among others, in the work of Tom Wesselmann, Luc Tuymans, Jonathan Horrowitz, Cady Noland and Michel Majerus
14 Both quotes: Peter Schjeldahl, *Poesie der Teilhabe*, Dresden, 1997, p. 147
15 Walter Benjamin, *Einbahnstraße*, Frankfurt am Main, 1958, p. 52
16 In the *Berliner Tagesspiegel*
17 In the *Frankfurter Allgemeine Zeitung*

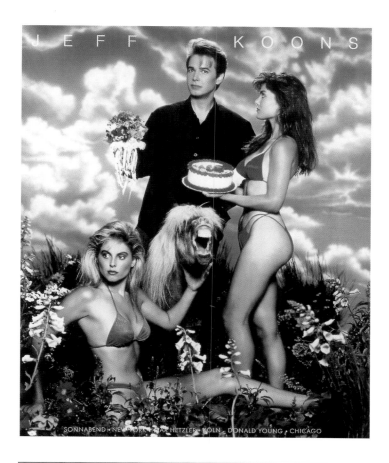

characteristic features that are constantly repeated. The most common are short theoretical articles alternated with interviews and statements by the respective artists and gallery owners, interspersed with photographs of the crowded gallery: guests on an opening night sipping champagne, the assistant concentrating on knowledgeable small talk with the exhibiting artist, tricky structural situations and other similar snapshots exuding an air of authenticity. After all, the pictures are intended to document the vitality of the business. In addition, there is usually a chronology of past exhibitions. Alongside these gallery depictions, in recent years the Internet has come to provide an inexpensive but international stage – no bad platform for the increasingly worldwide networking of the modern gallery business in the age of neo-liberal globalization.

RAIMAR STANGE

18 Read, for example, the interviews with Rudolf Zwirner, Rene Block, Konrad Fischer and Paul Maenz in *Kunstforum International*, Vol. 104, Cologne, 1989, p. 234

19 The absolute leader for a long time in the eyes of many has been the US publication *Artforum*

20 A short selection: *Eigen + Art – Ansichten über einen Raum I*, Leverkusen, 1991; *Hinter dem Museum – Wide White Space*, Düsseldorf, 1995; *Paul Andriesse, Art Gallery Exhibition*, Amsterdam, 1996; *Transmission*, Glasgow, 2001; *Bild Erzählung Öffentlichkeit – die Galerie Schöttle*, Vienna, 2001; Catronia Jeffries Gallery, Vancouver, 2001

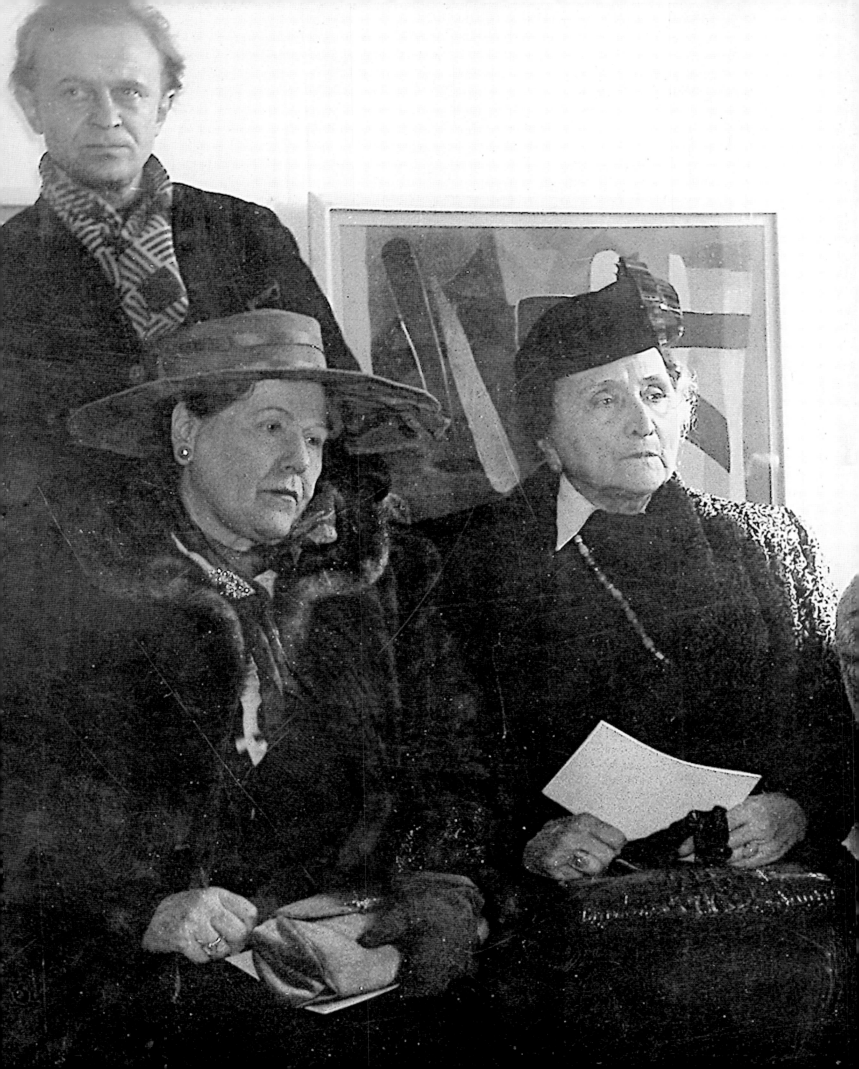

Angst and
Over-exuberance
The 1940s and 1950s

Mauritius Heinz, Baroness Hilla von Rebay and Ida Bienert at an exhibition opening in Galerie Stangl, 1950

The 1940s and 1950s were, more than any other period of the 20th century, characterized by wars, hegemonial expansion and territorial disputes. The Second World War, which began when Poland was invaded by Nazi Germany in 1939, ended with the surrender of Germany and Japan. The Pacific War was ultimately terminated when America dropped nuclear bombs on the Japanese cities of Hiroshima and Nagasaki. Between 1950 and 1953, the rival interests of the USA and the USSR led to a bloody war between North and South Korea and their respective allies. Africa saw numerous wars of liberation from colonial masters, for example in Algeria between 1954 and 1962. The most far-reaching geopolitical change, however, was wrought by the formation of a Western camp and an Eastern bloc, with the consequent division of the world into capitalist and socialist spheres of influence, which kept a close watch on their civilian populations through a far-reaching, subcutaneous network of agents, and exerted terror over them through a nuclear arms race.

In the United States, the agitation between East and West culminated at home in the witch-hunts of the McCarthy era (1950–54), during which left-leaning American intellectuals and artists in particular were accused of conspiratorial links with the Soviet Union. The mistrust that this revealed between politics and the arts was played out in what was, from an art-historical point of view, a remarkable context: for the first time, the world saw, in the form of Abstract Expressionism and its exponents Jackson Pollock, Willem de Kooning and others, an independent American avant-garde. Since the late 1930s émigrés such as Duchamp, Mondrian, Tanguy, Chagall and Max Ernst had been importing central modernist trends to America, and these served the younger generation of American artists as something immediate against which to react, and from which to demarcate themselves.

In Europe, artists such as Picasso, Miró and, in Germany, Baumeister worked in isolation in what came to be known as 'internal emigration'. Only after 1945 was modernism able to reclaim its throne. Picasso became the venerated master, and many artists looked to Paris, from which they hoped for a new orientation. And indeed major impulses did emanate from French artists such as Fautrier, Dubuffet (exponents of Art Brut) and Wols, a Franco-German. Their works appeared in the context of the philosophical musings of the Existentialists. The question of the relationship between the individual and his or her environment was successfully coupled in art with the visualization of an image of man appropriate to the age. Sartre's 'empty world', Merleau-Ponty's 'ambiguité', failure in the literary works of Camus and Beckett: all these became synonymous with an art characterized by a process-orientated and non-hierarchical structure with an emphasis on materials, an art today summarized under the heading 'Informel'. This artistic language made its great public debut in 1959 at the 'documenta 2' exhibition, a follow-up to the international art forum inaugurated in 1955. Informel was ubiquitous from Japan via Europe to the USA and Latin America. During the 1950s it was linked in the media with the concept of the 'free world' of the West, and used as a stick with which to beat communist-ruled countries, where Socialist Realism had become the only art form tolerated by

the state. Only towards the end of the decade did Pop artists, International Situationists and others provide not only new formal impulses, but also a new social-critical impetus.

Informel, which went hand in hand with musical trends such as jazz and atonal or serial music – composed by Pierre Boulez, Karlheinz Stockhausen and Luigi Nono, among others – embodies only one aspect of the 1950s. The other was represented by an easily digestible vocabulary of forms, characterized by smooth surfaces and streamline shapes: these gave a visual dynamic boost to people's everyday world in the form of objects ranging from kitchen appliances and kidney-shaped tables to automobiles. At a time of economic reconstruction and boom, they conveyed the corresponding feeling for life.

However, there was a lot that did not change, and in the tension-field of social developments, which were at the same time both nostalgic and progressive, a new, non-conformist youth culture made a triumphal appearance. It vehemently questioned the values of what in most cases was the conservative world of their parents, and its hallmarks – mostly exported from the USA via the rapidly expanding mass-media – were the petticoat, the hula-hoop and rock 'n' roll, James Dean, Marlon Brando and Marilyn Monroe.

Further horizons were opened up by radio and television, along with an increasing desire to travel – now once again possible as a result of the economic upswing. A broad public was now able to watch the international competitions interrupted by the Second World War. Thus, as early as 1948, the Olympic Games were once more held in London (though Germany was excluded), and in 1950 Brazil staged the World Cup for the first time since the war. When, in 1954, Germany actually won the World Cup, sport as an institution was able to restore a new feeling of self-worth to a whole nation.

A further international forum, finally, was the 1958 World Fair in Brussels, which was held under the motto 'A world view – A new humanism'. Numerous national pavilions produced a model landscape of the latest architectural possibilities in steel and curved concrete, while at the same time – 1956 to 1960 – the Brazilian architect Oscar Niemeyer was creating a whole (model) city in South America in the form of Brasilia. The central themes of Expo '58 in Brussels – 'nuclear technology' and 'space travel' – were reflected architecturally in the still extant 'Atomium'. A twenty-millionfold enlargement of a molecule as a pavilion, the so-called 'football with feelers', became the hallmark of a decade in which the structure of the molecule of life, DNA, was revealed (1953) and the Soviet Union launched the first artificial satellite, the Sputnik, into space (1957).

During the 1940s and 1950s the world became in many respects much larger. But the building of the Berlin Wall, which literally cemented the division between East and West, at the same time exposed the boundaries – in every sense – of this brave new world for all to see.

SYLVIA MARTIN

Art of This Century

YEAR OF FOUNDATION
1938
FOUNDER
Peggy Guggenheim
ADDRESS
1938–39 **Guggenheim Jeune, 30 Cork Street, London**
1942–47 **Art of This Century, 30 West 57th Street, New York**
CLOSED 1947

ARTISTS REPRESENTED
Hans Arp, Constantin Brancusi, Alexander Calder
Henri Laurens, Robert Motherwell, Antoine Pevsner
Jackson Pollock, Mark Rothko, Clyfford Still, Yves Tanguy

Peggy Guggenheim in Kay Sage's apartment on the Ile Saint-Louis in Paris, *c.* 1940

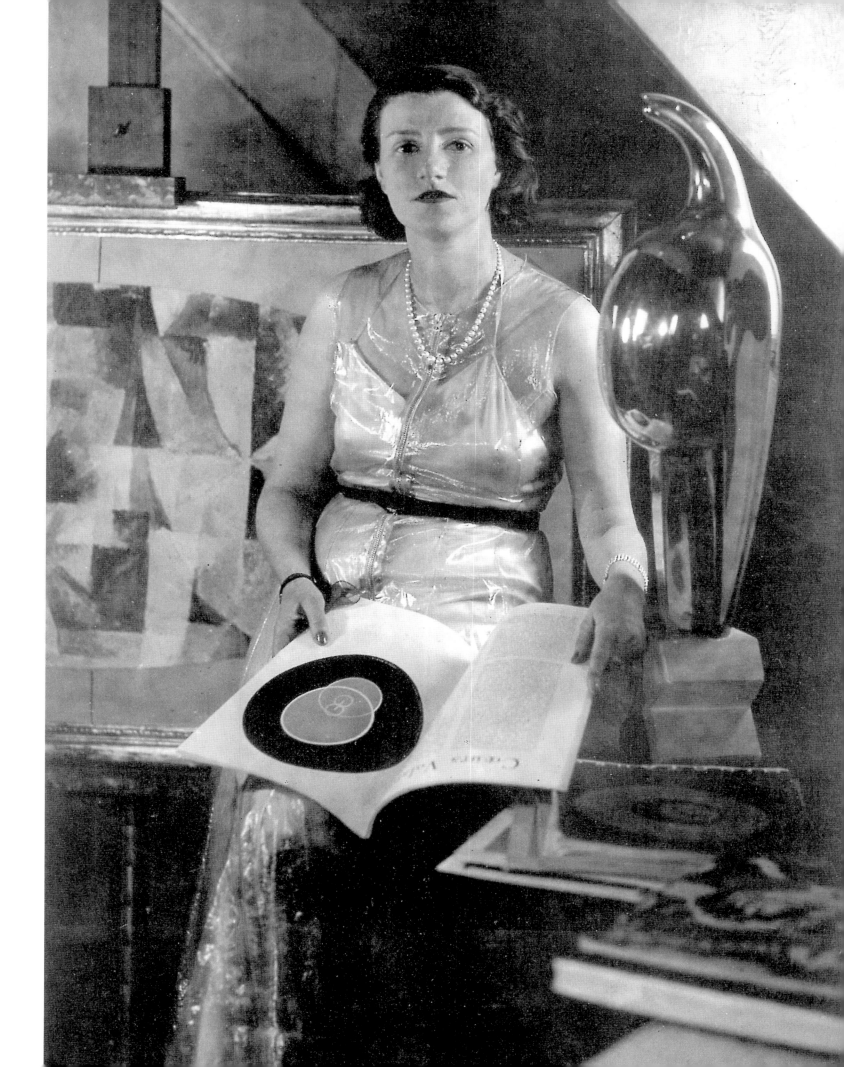

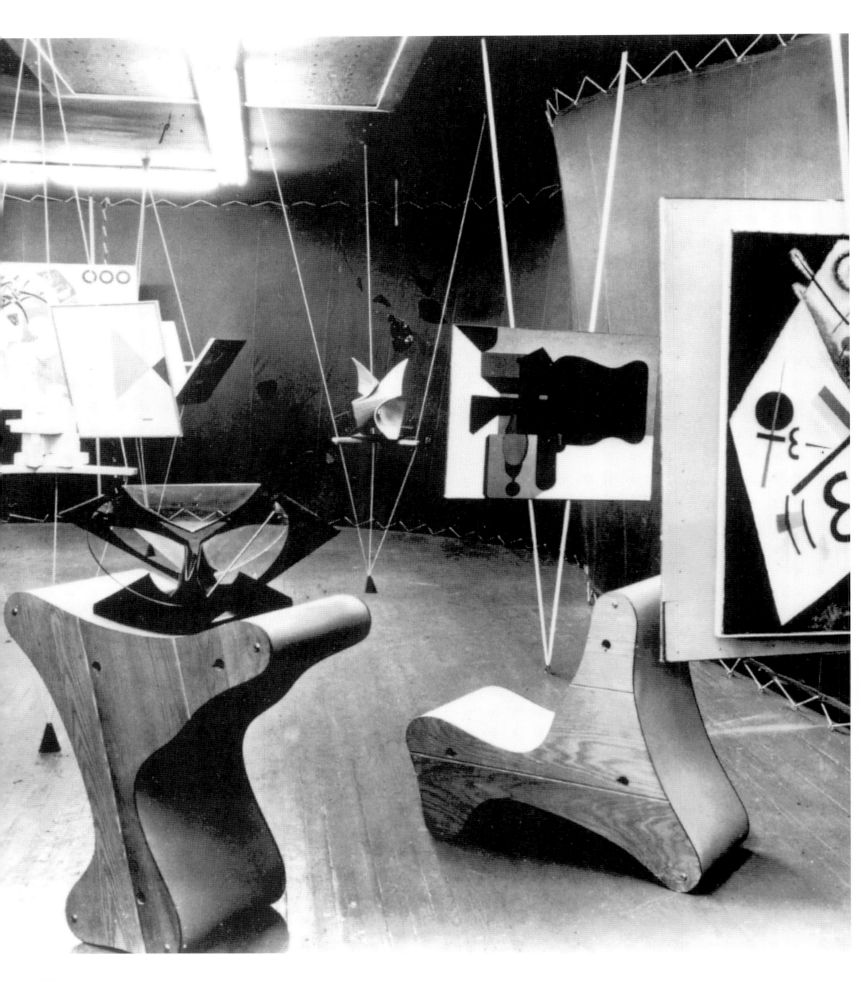

Peggy Guggenheim – a legend in her lifetime. 'I was bored and felt lonely, for I was living all alone in England in the country. I began to think about what I could do and, if possible, how I could make myself useful.' This is how Peggy Guggenheim, in her autobiography *Confessions of an Art Addict*, described the origin of her gallery Guggenheim Jeune, which she hoped to open in London at the beginning of 1938 with works by Constantin Brancusi, whom she adored. However, when she went to Paris to meet him, he wasn't there, and as a result she went to see Jean Cocteau, whose drawings became the subject of her first exhibition. Thanks to her old friend Marcel Duchamp, who introduced the artists for the gallery, Guggenheim Jeune quickly developed into a centre of Surrealist art. Thus Peggy Guggenheim not only arranged Wassily Kandinsky's first exhibition in Great Britain, but also acquainted the public with works by Hans Arp, Constantin Brancusi, Henry Moore, Antoine Pevsner, Yves Tanguy and Henri Laurens. Peggy Guggenheim had to import the sculptures of Alexander Calder as 're-usable raw materials' because His Majesty's Customs refused to accept them as art. Similarly, Hilla von Rebay, her uncle Solomon's art expert in New York, rejected Peggy's purchase proposals because he vehemently distanced himself from the 'trash' in the gallery. Peggy Guggenheim's strategy though was to buy one work from every exhibition for herself.

Although the gallery was making a loss, Peggy Guggenheim decided to found a museum of modern art in London. Her adviser in this matter was the art historian Herbert Read, the editor of the art periodical *The Burlington Magazine*. But with the outbreak of the Second World War, she had to bury her ambitious plans and also give up the gallery. With the list of exhibits for the new museum that Read had drawn up, she went to Paris and quite openly declared her intention of acquiring one picture per day. In order to be able to leave France as quickly as possible, many artists were glad of the opportunity to sell their works, albeit for a song. Between September 1939 and the German occupation of Paris in June 1940, Peggy Guggenheim acquired the portfolio that represented the foundation of the unique Peggy Guggenheim Collection, including works by Constantin Brancusi, Marc Chagall, Marcel Duchamp, Max Ernst, Alberto Giacometti, Paul Klee, Joan Miró and Pablo Picasso. Shortly before the Germans arrived, Peggy Guggenheim left Paris and returned to New York, where in October 1942 she opened the Art of This Century gallery.

The interior decoration of the rooms on 57th Street was the work of the Viennese architect Frederick Kiesler. The walls consisted of curved sections of rubber-tree wood, in front of which the unframed pictures were placed, mounted on baseball sticks, which could be set at any angle. Each work was illuminated by its own spotlight. At a time when only a handful of New York galleries were displaying modern art, Peggy Guggenheim exhibited her newly acquired collection of contemporary art. The legendary Surrealist exhibition also took place, at which Marcel Duchamp covered the exhibited works with a net consisting of twelve kilometres of string, and thus created the installation as an art form. Peggy Guggenheim targeted female artists for encouragement, and showed a particular predilection for young American

Interior view of the Art of This Century gallery in New York, the Abstracts Room, *c.* 1942

talent. Many of the artists known as the 'New York School', including Mark Rothko, Robert Motherwell and Clyfford Still, had their first solo exhibitions at her gallery. Her greatest achievement was the 'discovery' and promotion of Jackson Pollock, to whom she devoted herself entirely from 1943, and whom she made the focus of the gallery until it closed in 1947.

Before she returned to Europe in order to settle, with her collection, in the Palazzo Venier dei Leoni on the Grand Canal in Venice, she persuaded Betty Parsons to continue her work with Pollock and to arrange a solo exhibition for him. 'Betty Parsons was the spiritual heiress of my work…. Gladdened by the thought that she would be continuing to help the unknown artists, I handed my collection over to her for safe-keeping and flew with my two dogs to Europe.'

UTA GROSENICK

Galerie Beyeler

YEAR OF FOUNDATION
1947
FOUNDER
Ernst Beyeler
ADDRESS
9 Bäumleingasse, Basel

ARTISTS REPRESENTED
Hans Arp, Francis Bacon, Georg Baselitz
Paul Cézanne, Jean Dubuffet, Max Ernst, Sam Francis
Alberto Giacometti, Hans Hartung, Jasper Johns
Anselm Kiefer, Paul Klee, Fernand Léger, Henri Matisse
Piet Mondrian, Claude Monet, Barnett Newman
Pablo Picasso, Robert Rauschenberg, Mark Tobey
Maurice Utrillo, Vincent van Gogh, Andy Warhol

Jean Tinguely and Ernst Beyeler, 1987

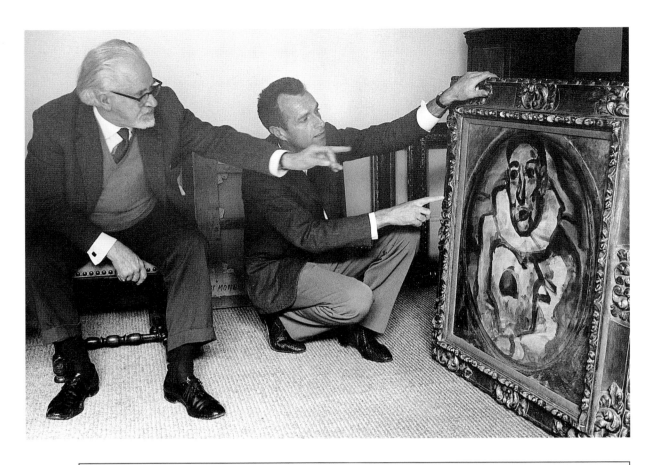

Mark Tobey and Ernst Beyeler
with a painting by
Georges Rouault, 1964

Coordinates of modernism. Art lovers will come across the name Ernst Beyeler in many places, not just in the Galerie Beyeler in Basel and the Fondation Beyeler in nearby Riehen, but also as a provider of works on loan to numerous exhibitions, which regularly subject the classical modern art of the 20th century to renewed questioning and present high-quality masterpieces to a broad public. Behind this name there stands a respected dealer, connoisseur and collector, who began his work in Basel in 1947.

After the decisive caesura represented by the Second World War, there was a need to revitalize modernism and, on this basis, to seek new paths in art. In this context, Beyeler focused his interest on classical modern art and specifically on French positions as formulated by artists such as Pablo Picasso, Robert Delaunay, Fernand Léger, the Fauves and others. He was equally fascinated by Paul Klee, Max Ernst, Alexei Jawlensky and Edvard Munch. It was a decision that grew out of his personal knowledge of classical modernism. He felt, he said, 'so comfortable and safe with these masterpieces'. In this field, which from the 1960s had been extended by new but established artists such as Mark Tobey or Jean Dubuffet, Beyeler developed an accurate eye for quality. Every work was outstanding in the succinctness of its imagery.

Beyeler presented these pictures and sculptures to the art lovers of Basel and to an increasingly international public in monographic and thematic exhibitions. He saw it as a creative part of his work to get artworks to enter into a dialogue with each other in the exhibition context. In 1947 he succeeded for the first time in doing this with

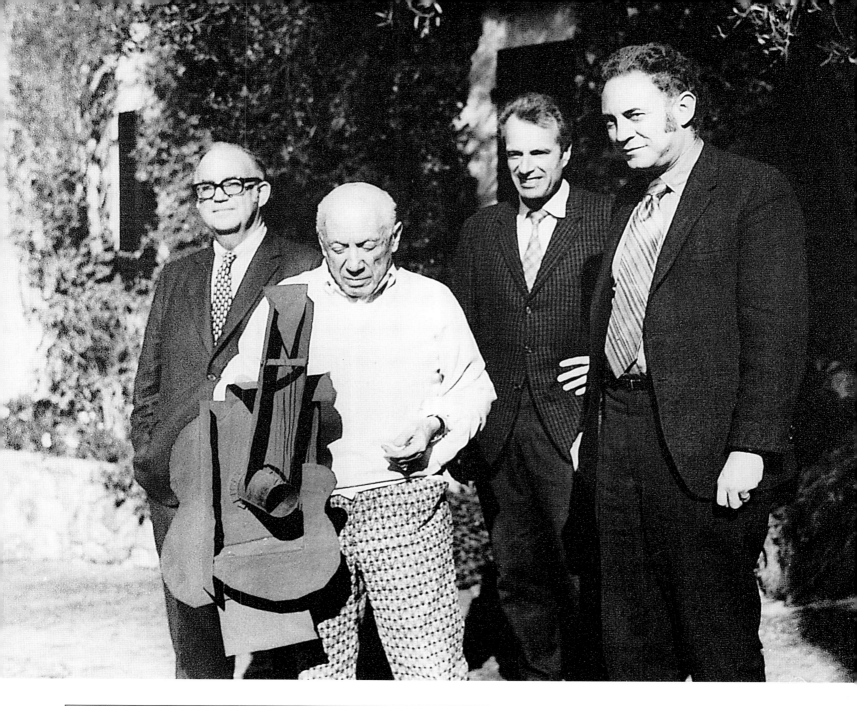

Japanese wood-block colour prints, which he arranged on the bookshelves of the former antiquarian bookshop at 9 Bäumleingasse.

His first exhibition of paintings, 'Pictures of the 20th Century', followed in 1951, and in 1953 Beyeler sold his first picture to a museum, Henri Matisse's landscape *La Berge*, which was purchased by the Kunstmuseum Basel. The series of summer exhibitions under the title 'Maîtres de l'art moderne', in which a whole variety of artists from the Impressionists to Picasso and Giacometti were represented, was provided with detailed accompanying publications, which proved a great help when he went international. The exhibition calendar of the Galerie Beyeler, which reads like a 'Who's Who' of classical modernism, owes its high profile not least to the network of collectors, curators and artists built up by Beyeler over the years. Since the 1960s, he has been able to sell large portfolios to museums – for example, an extensive group of works by Klee and various classical modern paintings to the new Kunstsammlung

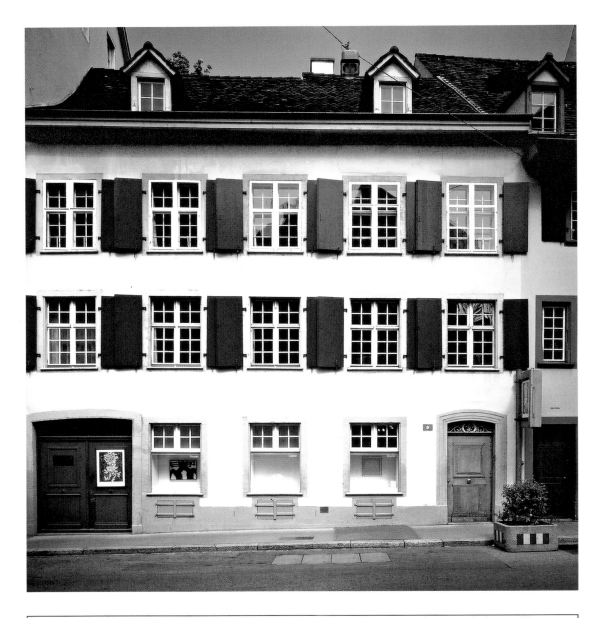

Façade of the gallery
at 9 Bäumleingasse

Nordrhein-Westfalen in Düsseldorf, where they form the heart of the collection. Ernst Beyeler acquired these and other works from the collection of the Pittsburgh industrialist G. David Thompson, who visited the Galerie Beyeler in Basel during one of the summer exhibitions in the late 1950s, an initial contact that was intensified in subsequent meetings. In order to make the American collection better known in Europe, Beyeler organized a touring exhibition in 1960, which visited Zurich, Düsseldorf, The Hague and Turin. The transactions that took place between Beyeler and Thompson made a major contribution to the gallery's international reputation. Beyeler also sold an extensive collection of some seventy works by Alberto Giacometti from the Thompson collection to museums in Switzerland, a country where the sculptor's oeuvre had hitherto been barely represented. Then, in the early 1970s, Beyeler organized the sale of a large stock of Klee's works from the Hulton collection in England.

But it was not just the collectors and museums that made the gallery's art business so lively. Ernst Beyeler was also a personal friend of many of the artists, which in view of their well-established positions was not something that could be taken for granted.

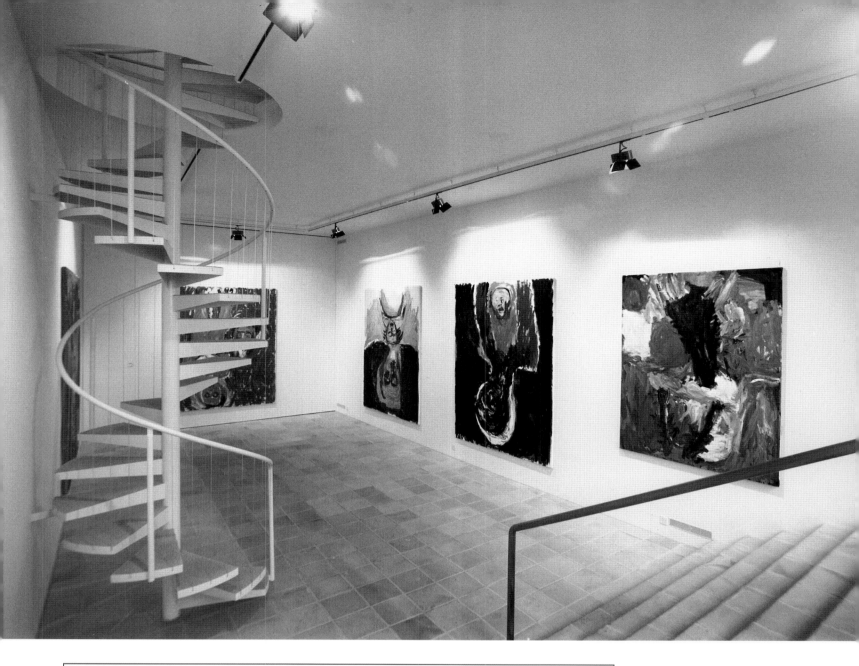

In 1957 he met Pablo Picasso, and after a number of conversations about art, Beyeler was finally able to select twenty-six pictures from Picasso's studio to exhibit and later sell. From the 1970s friendships with Roy Lichtenstein, Robert Rauschenberg and the New York gallery owner Leo Castelli also brought Pop Art into the gallery's programme. And in the 'wild' 1980s, during which interest in contemporary art grew enormously on a broad front, Beyeler extended his palette of pictures with the inclusion of works by Georg Baselitz and Anselm Kiefer.

The 'by-product' of Ernst Beyeler's experience as a gallery owner and dealer – spanning nearly sixty years – has been on show since 1997 in Riehen near Basel. In a museum designed by the star architect Renzo Piano, Beyeler has made his private collection, which he built up in parallel with his activities as an art dealer, and which reflects the latter at the highest level, accessible to the public. The gallery itself continues to occupy the original premises at 9 Bäumleingasse in Basel.

SYLVIA MARTIN

The large exhibition room in the Galerie Beyeler with works by Georg Baselitz, 1986

33

Galerie Iris Clert

YEAR OF FOUNDATION
1956

FOUNDER
Iris Clert

ADDRESS
3 Rue des Beaux-Arts, Paris

CLOSED 1985

ARTISTS REPRESENTED
Arman, René Brô, Gaston Chaissac
Lucio Fontana, Raymond Hains, Yves Klein
Ad Reinhardt, Jesús Rafael Soto
Jean Tinguely, Nicolás García Uriburu

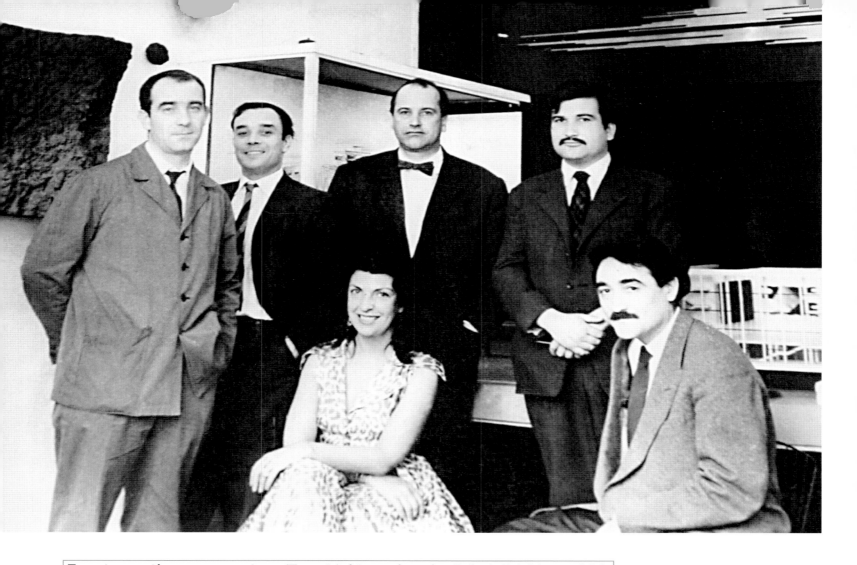

Twenty mystic square metres. True, it's bigger than the Galerie Légitime, which Robert Filliou kept under his flat cap, but even in the middle of Saint-Germain-des-Prés, twenty square metres is not much room in which to revolutionize modern art. After returning from her first visit to the United States, Iris Clert asked herself with humour and false naiveté: 'My car seems tiny to me, not to speak of my gallery. How could I achieve such great things in this tiny hole?' Even reduced to the cube that Yves Klein used for his exhibition 'Emptiness' on 28 April 1958, these twenty square metres showed the best space–achievement ratio in the whole history of art in the second half of the 20th century.

When her first gallery opened in 1956 at 3 Rue des Beaux-Arts in Paris, Greek-born Iris Clert thought: 'I'll plunge into art the way you dive into water without being able to swim.' Far from sinking, she used her good eye and a genuine advertising talent for over twenty years to run and promote one of the most curious and exalted galleries of all.

Her recipe for success was extremely simple: an unshakable belief in her destiny and in 'her artists', a faith that was abundantly nourished by her sharp-eyed regular customers. When she talked about the start of her relationship with Yves Klein, she confessed: 'My friendship with Yves grew more and more intense. My predilection for the esoteric and his mystical side complemented each other. In addition, with my sense of the paradoxical, I was more than happy.'

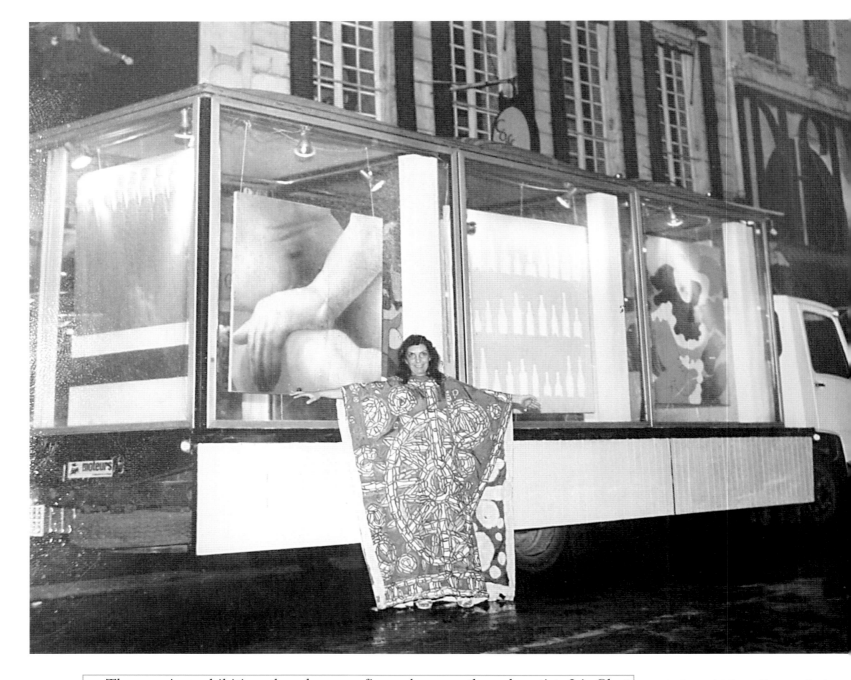

The opening exhibition, though, was a fiasco, because the only artists Iris Clert knew were two fellow Greeks, Takis and Tsingos. As she refused to choose between them, and wanted the best publicity possible for the event, she inaugurated the gallery with a one-woman show by the young Dutch painter Dora Tuynman, who had been recommended to her by an influential television journalist. The only echo was a brief notice in the arts magazine *Combat*, which welcomed the novelty. 'All beginnings are difficult; I had barely been open for two days when I was already being besieged by painters. Although collectors often have difficulty finding new galleries, one could be forgiven for believing that artists are like bats, fitted out with a radar that leads them directly to their prey: the art dealer.'

More than the artists or their works, it was above all the personality of the gallery owner that attracted attention. Thus, for example, the critic Pierre Descargues wrote:

'Mademoiselle Clert is pretty, which is why she can be forgiven for placing herself in the foreground, for doubtless we shall soon be seeing her on the cinema screen....' To which the young dealer answered: 'There is nothing better than a malign article; it makes the public curious, while an enthusiastic article is rarely read to the end.'

In November 1956 one of the 'bats' – an artist, in other words – opened the door to the tiny shop. Iris Clert recalled the subsequent exchange: '"I am Yves Klein," he said. "I have brought you a monochrome proposal." He was holding a small orange picture in his hand, which was entirely of one colour and as smooth as a piece of wall. "That's not a picture!" "Yes, it is a monochrome proposal. I'll leave it with you for a few days, then you can tell me what you think of it."'

Soon afterwards, the visit to the studio took place. 'I entered an immense room, in which he held his judo courses. On the walls I saw works, large monochrome panels in every colour. I thought they were there to depict judo belts. "What do you think of my pictures?" "I think they're good decorations for the judo hall." "But no, it is a metaphysical approach."'

The 'Floating Biennale', organized by Iris Clert on the 'Bella Laura', Venice, 1964

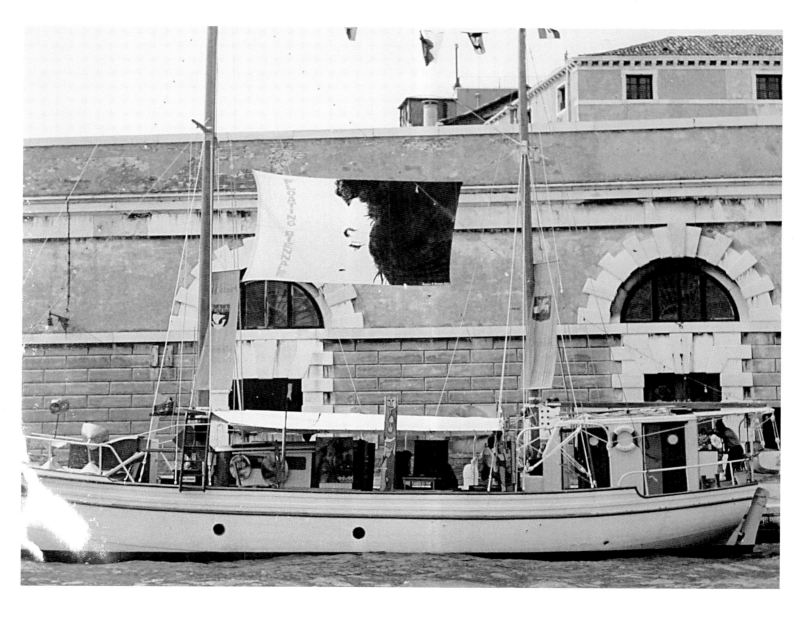

In May 1957 Iris Clert displayed the 'monochrome proposals' by Yves Klein in her gallery. 'To dare to exhibit nine pictures, all the same size, the same colour, and with the same texture, but at different prices, was really going too far in those days. The public was immediately divided: on the one hand the scornful sceptics, on the other the few admirers. Many of them congratulated me on my sense of humour and for arousing attention. And only a very few were able to see beyond the scandal,' she later recalled.

This was to be the first of a series of exhibitions that would go down in history: in 1958, as already mentioned, 'Emptiness', 'My Canvases. Concerto for 7 paintings' by Jean Tinguely and 'Pure Speed and Monochrome Stability' by Klein and Tinguely; in 1959 'Bas-reliefs in a Forest of Sponges' by Yves Klein (the great American collector and architect Philip Johnson bought one of the works) and the legendary 'Méta-Matics' by Tinguely. These were followed in 1960 by the exhibitions 'Atheist Mysticism' by Ad Reinhardt and 'Accumulations (the Full)' by Arman. And in 1961 visitors could see the 'Paintings and Totems' by Gaston Chaissac, followed by the 'Concetti Spaziali' of Lucio Fontana.

Iris Clert, who was active right up until the 1980s, was never again to collaborate with such a 'dream team', even if we take account of the fact that she was one of the first to exhibit works by Roy Adzak, Leon Golub and Uriburu.

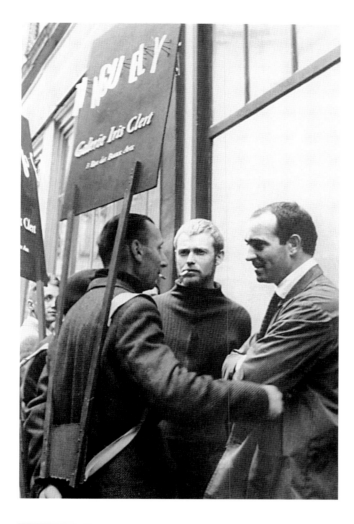

Jean Tinguely (right)
in front of his exhibition
'Méta-Matics', 1959

Iris Clert was a past-master of the art of continually finding her own ways of practising her trade, and in the process often developing a remarkable intuition. In 1962 she published the magazine *Iris-Time* to advertise her gallery. In order to avoid bankruptcy, in 1963 she organized the great 'Fourteen Days for Taxes (sale for the benefit of the Internal Revenue)', and in 1964 in Venice her 'Floating Biennale', an undemanding but spectacular fringe show. In 1966 Iris Clert presented the winter collection of Paco Rabanne and the 'Two French Weeks' in Dallas, Texas, after organizing an exhibition on the high seas aboard a ship of the United States Line.

In 1967 there came the 'great flea-ball (a market in experimental art)', and in 1968 she opened, together with Pierre Cardin, the Artomic night club. In 1971 she started the open-air 'cultural Stradart truck (a gallery on wheels)' project; this was a glazed truck which travelled to the public with exhibitions by, for example, parking outside museums on exhibition opening nights, for without a doubt, like Filliou she thought it legitimate 'for art to descend from its heights on to the streets'. Finally, Iris Clert sold her own signature, painted on canvas, with the ironic title 'The Financial Concept', in order, for the umpteenth time, to avoid bankruptcy.

STÉPHANE CORRÉARD (WITH LILI LAXENAIRE)

Galerie Der Spiegel

YEAR OF FOUNDATION
1945
FOUNDERS
Eva and Hein Stünke
ADDRESS
1945–48 **Gotenring/Ecke Thusneldastraße, Cologne-Deutz**
1948–82 **10 Richartzstraße, Cologne**
1983–95 **328 Bonner Straße, Cologne**
TODAY **10 Richartzstraße, Cologne**

ARTISTS REPRESENTED

Josef Albers, Karel Appel, Hans Arp
Mary Bauermeister, Johannes Brus, John Cage
Alexander Calder, Christo, Jean Dubuffet, Max Ernst
Joseph Fassbender, Karl Gerstner, Raimund Girke
HAP Grieshaber, Hans Haacke, Raymond Hains, Hans Hartung
Erich Hauser, Michael Heizer, Antonius Höckelmann
Henri Laurens, Fernand Léger, Lucebert, Markus Lüpertz
André Masson, Almir Mavignier, Georg Meistermann, Otto Müller
Ernst Wilhelm Nay, Pablo Picasso, Serge Poliakoff
Man Ray, Martial Raysse, Hans Salentin, Bernard Schultze
Michel Seuphor, Pierre Soulages, Dorothea Tanning, Jean Tinguely
Hann Trier, Heinz Trökes, Ursula, Victor Vasarély
Jacques Villeglé, Stefan Wewerka

Hein Stünke in front of the 'Kölner Kunstmarkt' poster, 1967

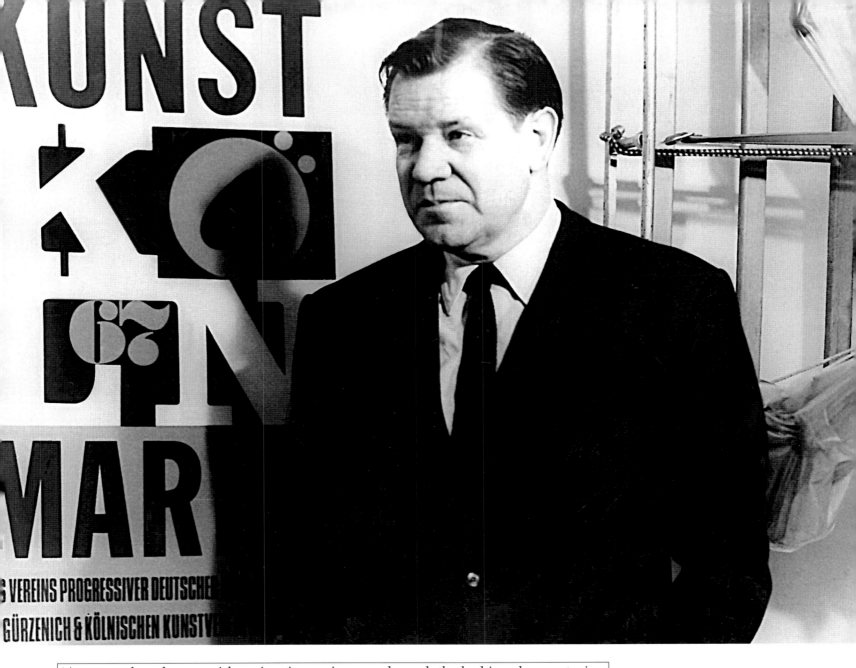

'Anyone who takes up with art is going, as it were, through the looking glass, entering a different country with different laws.' With this quotation from Jean Cocteau, Eva and Hein Stünke presented their concept and motivation for the establishment of a gallery for modern and contemporary art in a slim brochure entitled *Geh durch den Spiegel* ('Go Through the Looking Glass'). And they christened their gallery accordingly: 'Der Spiegel' means 'The Looking Glass'. As early as the winter of 1945 they opened their exhibition rooms on the (unfashionable) right bank of the Rhine in Cologne, thus implementing their ideas virtually immediately after the end of the war.

Eva Stünke, who had taken her doctorate in the history of art, brought the specialist knowledge and effervescent charm to the enterprise, while Hein Stünke, a bibliophile, knowledgeable aesthete, brought his love for craftsmanship and detail and his qualities as a *homo politicus*. The Stünkes were the first of a generation of gallery owners, who, unlike the great pre-war art dealers, were neither financially secured, nor socially prepared, for such a role by their family background. The first

years of this enterprise are sparsely documented, and give no inkling of the position that 'Der Spiegel' was to achieve in the decades to come. The capital base of the gallery was extremely thin; the first stock-in-trade still derived from a small collection of classical modern art, which Eva Stünke's father had put together. But what with commission business, and the task of looking after a number of collections in the Rhineland, a small operation was built up that could be kept alive with the support of word-of-mouth propaganda, the best advertising medium of those first post-war years. At times, in order to make ends meet, Eva Stünke worked as assistant to the

The gallery's first premises on the Gotenring in the Deutz district of Cologne

celebrated television current-affairs presenter Werner Höfer at the Cologne-based Westdeutscher Rundfunk broadcasting station. In 1948, the year that saw the introduction of the deutschmark to West Germany, the gallery crossed the Rhine and set up shop on Richartzstraße, near the cathedral and the central station, and it was here that the actual regular exhibition activity started. Alongside works by masters of the pre-war generation, such as Karl Hofer and Otto Müller, the paintings of the young Hann Trier were being shown as early as 1949. Der Spiegel maintained close contact with the so-called Alfter Circle, a group of artists supported by Count Salm-Reifferscheidt, centring on Joseph Fassbender, Hann Trier, Eugen Batz and Hubert Berke, whose regular meetings attracted a large number of art lovers.

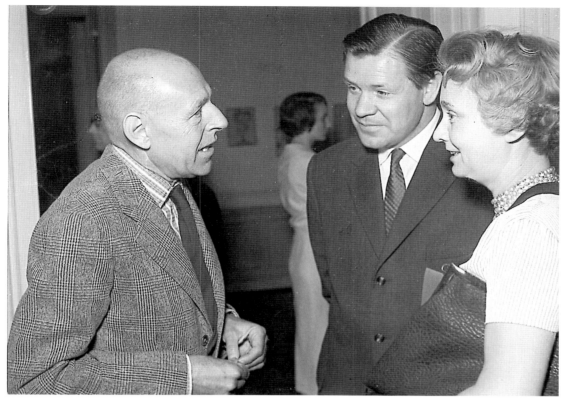

The mix between classical modern artists and the young, gradually emerging West German avant-garde continued to form the backbone of the Spiegel programme in the years to come. This programme encompassed works by Paul Klee and Ernst Ludwig Kirchner, as well as those by Joseph Fassbender and Edwin Scharff (all of whom exhibited in 1950). In addition, Eva Stünke's first trips to Paris brought new names to the Rhine: Gérard Schneider (1952), Henri Laurens (1953) and the first German exhibition of the works of Wols (1955). Any visitor to Cologne who was interested in contemporary art went to Der Spiegel, where you could see works by Hans Hartung, Henri Matisse, Georg Meistermann, Joan Miró, Ernst Wilhelm Nay, Pablo Picasso and Fritz Winter, while exhibitions of works by Serge Poliakoff, Pierre

Soulages and Vasarély resulted from a close cooperation, started in the 1950s, with the Galerie Denise René in Paris. The reputation acquired by the couple prompted Max Ernst to visit the Stünkes on his first visit to Cologne after the war, which in turn led to a friendship and, at times, a close working relationship. Max Ernst came to be identified with the gallery, and his oeuvre came to be one of its central concerns.

By the early 1950s Hein Stünke had already worked out a concept for the gallery's publishing business that provided for the production of high-quality editions, portfolios and catalogues, and was to reflect the gallery's profile. A far more pragmatic aspect of his thinking was the fact, always at the back of his mind, that the banks at that time would not make loans to galleries, but were only keen to offer credit to publishing houses and craft businesses. Thus, in 1951, a first book was published, a volume of text by Albrecht Fabri, and in 1954, on the occasion of an exhibition by the celebrated Marino Marini, the first volume in the series 'Geh durch den Spiegel' ('Go Through the Looking Glass' or, alternatively, 'Go through Der Spiegel'). These catalogues were accompanied by original graphic works, and editions were limited as a rule to about 100 copies. The affordable price of these volumes was designed to stimulate potential first-time buyers of artworks and extend the modest circle of collectors of contemporary art. In the 'Edition Portfolio', by contrast, as its name implies, portfolio works were produced to the highest printing standards possible, including works by Albers, Brecht, Geiger, Mavignier and Morellet, which, together with a series of expensively produced books conceived in close collaboration with the artists, were aimed at the class of established buyers. Finally, the 'Spiegelschriften' ('Spiegel Writings'), in a handy paperback format, contained art-theoretical or poetic texts and interviews with artists, and to this day their typographically consistent outward appearance represents a benchmark to which others may aspire.

The operations that latched on to the gallery's publishing activities expanded with a programme of their own, so that highly specialized sidelines emerged in frame manufacture, bookbinding and small furniture items, which together constituted a commercially significant component of the enterprise. Hein and Eva Stünke owed the reputation of their workshops to the proposal by Daniel Spoerri, conveyed through Karl Gerstner (exhibitions in 1963 and 1966), to include and realize the 'Edition MAT', a collection of serially produced artworks developed in 1959, in their programme. This ambitious undertaking was a success with the public, opening up a new young market. Commercially, however, it was a non-starter.

Through their involvement in the 'documenta' committee from 'documenta 2' onwards (Der Spiegel organized the graphics exhibition in the Orangery and was allocated a sales stand there), the Stünkes gained valuable information about the needs of art lovers and collectors. After the collapse of the market for the works of the École de Paris in the 1960s, which was followed by a general crisis in the art trade, Hein Stünke, together with his young colleague and former assistant Rudolf Zwirner, developed a concept for the first art fair, which was held in Cologne in 1967, and immediately found imitators throughout the world. Stünke realized that the decentralized art-

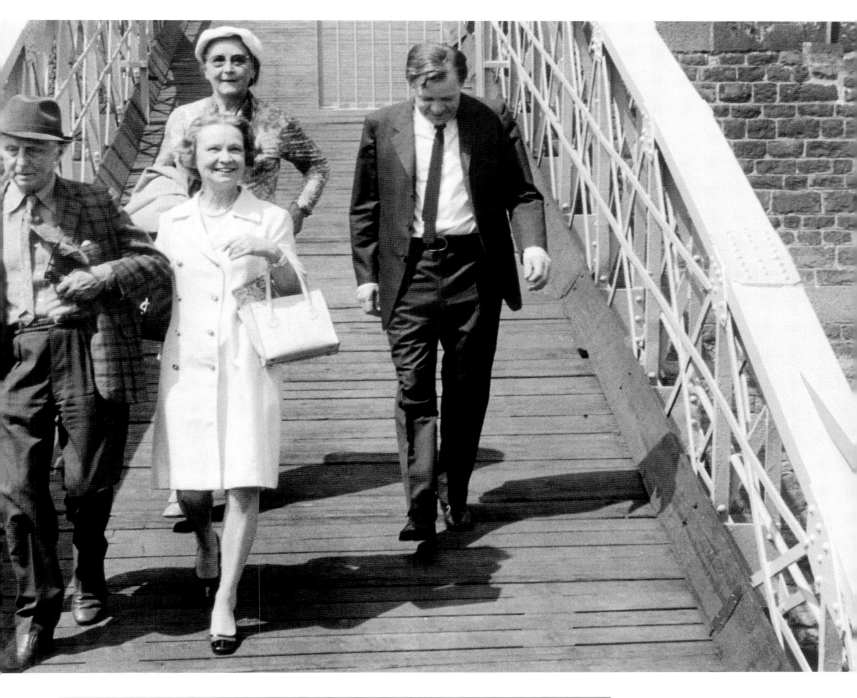

dealing situation in West Germany meant that the country's position as a dealing location could only be strengthened by an art fair and information event of this kind.

Der Spiegel never made contracts with 'its' artists. The Stünkes remained faithful to their original artists right into the 1970s and '80s, while at the same time bowing to economic necessity by including more up-to-date trends. In the 1980s the gallery moved to a new location in the south of Cologne. After the death of Eva Stünke in 1988 and Hein Stünke in 1994, Der Spiegel, now run by Hans Werner Hillmann, moved back to Richartzstraße. Der Spiegel still exhibits the works of 'its' artists from the early days, as well as more recent trends outside the mainstream.

REGINA SCHULTZ-MÖLLER

Eva and Hein Stünke escort Max Ernst on to a Rhine steamer to celebrate his 70th birthday, 1961

Galerie Parnass

YEAR OF FOUNDATION
1949

FOUNDER
Rudolf Jährling

ADDRESS
1949 **30 Aue, Wuppertal**
1949–61 **16/18 Alte Freiheit, Wuppertal**
1961–65 **67 Moltkestraße, Wuppertal**

CLOSED 1965

ARTISTS REPRESENTED
Pierre Alechinsky, Joseph Beuys, Erich Boedecker
Alexander Calder, Rolf Cavael, Al Copley, Corneille
Karl Friedrich Dahmen, Claire Falkenstein, Johannes Geccelli
Gerhard Hoehme, Friedensreich Hundertwasser, Norbert Kricke
Wifredo Lam, René Laubiès, Jean-Jacques Lebel, Konrad Lueg, E.R. Nele
Oyan Wen-Yuen, Nam June Paik, Adriano Parisot, Hans Platschek
Sigmar Polke, Gerhard Richter, Franz Roh, Bernard Schultze
Emil Schumacher, Jaroslav Serpan, Heinz Trökes, Wolf Vostell, Wols

Rudolf Jährling and Erich Boedecker

All I need is art. In the sixteen years of its existence between 1949 and 1965 in the city of Wuppertal, the Galerie Parnass, although operated as an amateur venture, set quality standards for professionals in what was then a post-war West German art scene still in its infancy, and small enough for everyone to understand. Rudolf Jährling – a trained architect and a widely travelled, passionate art lover – and his wife Annette made their office and private residence available for a series of changing exhibitions, readings, concerts and short theatrical pieces. The inaugural show within the red-brick walls of the gallery's first provisional home, which took place in January 1949, featuring figurative-symbolist small-format works by Ernst Kelle, was an improvised affair, like most other exhibitions in the immediate post-war period. But just a year later the new premises, designed by Jährling himself, were opened at 16/18 Alte Freiheit, which included, alongside the architectural office and exhibition rooms, a roof terrace and a small studio stage.

The inaugural exhibition of works by the New York-based *Life* magazine and UNO photographer Todd Webb, his first show in Germany, was a demonstration of the international reputation that Jährling had already acquired through his activities, and underpinned his gallery's claim 'to present selections of new design in order to make contemporary art better known': a consciously cross-genre concept. Numerous visitors from home and abroad rewarded Jährling's commitment with their presence. In contrast to other amateur enterprises of this kind, the commercial independence

of the Parnass (the gallery was to be self-supporting as far as possible, but not necessarily make a profit) led to no compromises on quality. Jährling chose his art and his artists without regard for financial considerations, and as a result the list of exhibitors and performers comes across as unprogrammatic and varied. Whether it was children's drawings from a Quaker school (1950) or the Wuppertal Neighbourhood Home (1961), architectural photos by Le Corbusier (first German exhibition in 1951), Alexander Calder's 'Mobilés' (first German exhibition in 1952, with a catalogue) or works by Wols (Alfred Otto Wolfgang Schulze, 1956), the selection documents the personal convictions of Rudolf Jährling; there is no sign of any strategic calculation.

Jährling's priorities in the 1950s – entirely in the spirit of the contemporary avant-garde – were abstract art, Tachism, the École de Paris and the German Informel. Here too, Jährling exhibited new and undiscovered works, and did not stick to the already salable, established 'goods' of the fellow gallery owners whose livelihoods depended on it. The independence of his selection is clearly reflected in the substantial number of German exhibitions devoted by Parnass to still unknown artists. Alongside such positions as the Calder exhibition, which attracted great interest, the graphic works of Jacques Hérold (1951), the paintings of the Russian artist André Lanskoy (1954, together with the Galerie Der Spiegel), early space-time sculptures by Norbert

Above, left: Friedensreich Hundertwasser reads his 'Mould Manifesto Against Rationalism in Architecture', 26 July 1958

Above, right: Erich Boedecker exhibition at the Galerie Parnass, 1964

Opposite: John Anthony Thwaites explains the artworks of Peter Brüning, 1958

Kricke (1954–55), the pictures of Jaroslav Serpan (1955–56) or the provocative and later famous 'Mould Manifesto Against Rationalism in Architecture', which the young Friedensreich Hundertwasser read out in the gallery in July 1958, there were exhibitions of such typical representatives of Informel as Bernard Schultze, Heinz Trökes, Hans Platschek, Emil Schumacher (all 1956), Peter Brüning (1958), Karl Friedrich Dahmen (1959) and Max Ackermann (1961), all at the start of their artistic careers. The same is true of the Düsseldorf Neue Realisten group – Konrad Lueg (the future proprietor of the Galerie Fischer), Sigmar Polke and Gerhard Richter. In order to attract Jährling's attention, they showed him their pictures, unsolicited, in his front garden. He rewarded this action two weeks later with an exhibition of their works in his premises (1964).

Sculptural works found a special place in the programme of Jährling the architect. The slate reliefs of Raoul Ubac were exhibited in 1951 for the first time in Germany, and again in 1959. The bronze and iron sculptures of the Los Angeles-born Shinkichi Tajiri were exhibited at Parnass in 1951 (another German first), 1957 and 1962, and Claire Falkenstein's amorphous formations were presented at a first solo exhibition in 1960. Following the complex and abstract sculptures of the English artist Robert Adams (1957) and the Dutchman Carl Visser (1959), Jährling exhibited the sculptures of the young, critical H. P. Alvermann (1964) and, by way of contrast, the seemingly naive, fairy-tale and fabulous concrete beings of the miner Erich Boedecker (1964). Openness toward the current tendencies of their time made the Jährlings respected partners of museum directors, collectors and, not least, the artists themselves. The exhibition openings were mostly accompanied by introductions by respected critics and art theoreticians such as Albert Schulze-Vellinghausen, John Anthony Thwaites, Will Grohmann, Eduard Trier and Jean-Pierre Wilhelm.

The Jährlings' particular openness toward everything new and relevant led to six exhibitions at the gallery's third and last location, centring on the Fluxus movement, which lent the Parnass a further historical relevance. In the turn-of-the-century villa, which the Jährlings moved to in 1961 and inaugurated with their 101st exhibition, George Maciunas gave his 1962 introductory lecture 'Neo Dada in New York', which can be seen as one of the first Fluxus manifestations in Europe. Benjamin Patterson celebrated his variations for the double-bass here. Nam June Paik's first solo exhibition was held at Parnass in 1963, and likewise Wolf Vostell created his happening *Neun-Nein-dé-coll/agen* there.

However, one of the most important impulses was provided, ironically, by the gallery's swansong, the legendary '24 Stunden' (24 Hours) with Joseph Beuys, Bazon Brock, Charlotte Moorman, Nam June Paik, Eckart Rahn, Tomas Schmit and Wolf Vostell. In addition, the six happenings – among over 150 gallery events – provide impressive testimony to the courage and sense of future trends that were characteristic of Rolf and Annette Jährling and of Parnass.

REGINA SCHULTZ-MÖLLER

Solo exhibition by Nam June Paik,
1963 (bottom left: his first robot)

51

Hanover Gallery

YEAR OF FOUNDATION
1948
FOUNDER
Erika Brausen
ADDRESS
32a St George Street, London
CLOSED 1972

ARTISTS REPRESENTED
Eva Aeppli, Hans Arp, Francis Bacon, Max Bill, Camille Bombois
Fernando Botero, Victor Brauner, Reg Butler, César, Sonia Delaunay
Jean Dubuffet, Max Ernst, Jean Fautrier, Alberto Giacometti
Marino Marini, F. C. McWilliam, Henry Moore, Louise Nevelson
Eduardo Paolozzi, Serge Poliakoff, Man Ray, Henri Rousseau
Niki de Saint Phalle, Kurt Schwitters, Jean Tinguely
Mark Tobey, William Turnbull, Victor Vasarély

Erika Brausen in the gallery's exhibition room

A French connection and the birth of Pop. Düsseldorf-born Erika Brausen had spent the Second World War years in England, where she worked as an assistant in London's Redfern Gallery before founding the Hanover Gallery in 1948, near Hanover Square in London's West End. During the 1920s and '30s she had moved around Europe, living in Hanover for a time and getting to know Kurt Schwitters through the collector Baron Garvens von Garvensburg, then in Paris, where she met artists Piet Mondrian and Georges Vantongerloo, and finally in Spain before leaving for England in 1936. The post-war climate in London was grim, not only economically but also culturally, as the British were deeply suspicious of the 'modern' forms of art from the Continent. Even the art schools were sceptical, with tutors at the Slade School of Art – where young sculptors William Turnbull and Eduardo Paolozzi were studying at the time – advising the students not to visit the Picasso and Matisse show at the Victoria and Albert Museum in London.

Despite this, a fertile dialogue between London and Paris was beginning which became essential in establishing London's place as a centre for innovation in the

new art. Erika Brausen's Hanover Gallery was instrumental in building this bridge between the two cities, showing many French painters as yet unknown in England, such as Rousseau and Bombois. Collectors were hard to find, however, particularly for Brausen's choice of unknown and untested young artists, and often a show would close with not a single work having been sold. She was determined in her support of these artists, however, and continued undeterred, introducing European sculptors Alberto Giacometti, Marino Marini, Hans Arp and Germaine Richier, while also championing young British sculptors Reg Butler, Turnbull and Paolozzi. Paolozzi and Turnbull were founding members of the 'Independent Group', which met at the recently opened Institute for Contemporary Arts and is generally credited with coining the term 'Pop Art' and initiating the Pop Art movement in Britain. Richard Hamilton, another key Independent Group member, approached Brausen in the mid-1950s, seeing the Hanover as 'the most prestigious gallery in London' at the time, and was offered a show in 1955. The resulting show of paintings 'sank like a stone' according to Hamilton, and it was nine years before his second show there. For this second exhibition, 'Paintings 1955–64', he showed his new collage-based paintings, including the famous satirical work *Hugh Gaitskell as a Famous Monster of Filmland*. This was sold to the Arts Council of Great Britain and precipitated a press debacle, with the *Daily Express* denouncing it as a waste of taxpayers' money and reintroducing Hamilton as the original proto Pop artist.

The Hanover's most notorious artist, however, was Francis Bacon, who had his first solo show there in 1949. His painting *Three Studies for Figures at the Base of a*

Crucifixion had created a sensation when it was included in a group show at the Lefevre Gallery in 1945, but the public was still unprepared for the Hanover Gallery's exhibition of six studies of heads, distorted and screaming in pain. This was the first full-blown demonstration of Bacon's famous definition of painting as 'the pattern of one's nervous system being projected onto the canvas'. Brausen represented Bacon exclusively throughout the 1950s, supporting him and promoting his work as well as mounting nine exhibitions culminating in the 1957 exhibition of nine paintings inspired by Van Gogh's *The Painter on the Road to Tarascon*, which he painted in one frenzied burst in the months preceding the show. Bacon's greatest critical champion was David Sylvester, who was in his early twenties when the Hanover Gallery opened. He became very involved with the gallery, writing essays and introductions for many of their exhibition catalogues, including Reg Butler's 1949 show, Paolozzi and Turnbull's joint show in 1950 and Germaine Richier's show in 1955.

By the end of the 1950s Bacon had gone on to receive considerable critical success, having represented Britain together with Lucian Freud and Ben Nicholson at the 1954 Venice Biennial, but his earnings were still modest. In 1958, with reputed gambling debts of £5,000, he left the Hanover Gallery and signed a contract with the Marlborough Gallery. Brausen was not in a position to compete with Marlborough, which was a much larger operation and could offer Bacon considerable advances while guaranteeing higher prices for his work. Other artists followed suit, leaving for other galleries over the years, and Brausen decided to diversify, opening an annex gallery together with Gimpel in Zurich in the early 1960s. While not such an important centre for artistic innovation, Zurich had a fast-developing art market, something that London still lacked. The Hanover Gimpel Gallery mounted exhibitions of work by many Hanover Gallery artists, including Louise Nevelson and Tinguely as well as Alan Davie, Ben Nicholson, Meret Oppenheim and Victor Vasarély. Though Brausen closed the Hanover Gallery in London in 1972, the Zurich branch continued for several years.

KIRSTY BELL

Sidney Janis Gallery

YEAR OF FOUNDATION
1948
FOUNDER
Sidney Janis
ADDRESS
1948–67 **15 East 57th Street, New York**
1968–99 **110 West 57th Street, New York**
(After Sidney Janis retired in 1986,
the gallery was run by his sons, Carroll and Conrad Janis,
and later by his grandson, David Janis)
CLOSED 1999

ARTISTS REPRESENTED
Josef Albers, Arman, Alexander Calder, Arthur B. Carles
Mercedes Carles, Jim Dine, Marcel Duchamp, Richard Estes
Alberto Giacometti, Arshile Gorky, Hans Hofmann, Franz Kline
Lee Krasner, René Magritte, Kasimir Malewitsch, Piet Mondrian
Claes Oldenburg, Pablo Picasso, C. S. Price, Bridget Riley
James Rosenquist, Mark Rothko, George Segal, Saul Steinberg
Maurice de Vlaminck, Andy Warhol, Tom Wesselmann, Robert J. Wolff

The gallerist as his own best critic. The Sidney Janis Gallery opened in New York in 1948 with a cameo retrospective of the work of Fernand Léger. According to William Rubin, who was a curator at New York's Museum of Modern Art between 1940 and 1990, Janis's exhibition was worthy in quality and historical emphasis of the types of exhibition he was accustomed to seeing in museums. Janis, who had begun acquiring works of art in 1926 with a small Whistler etching, had developed a remarkable collection of works by the 1930s that included, among others, the works of Giorgio de Chirico, Salvador Dalí, Paul Klee and Pablo Picasso.

Beginning in 1934, Janis was on the purchasing advisory committee of the Museum of Modern Art, until he opened his own gallery in 1948. In 1935 the 'Sidney Janis Collection of Modern Paintings' exhibition opened at the Arts Club of Chicago and included nineteen works: six Picassos, three Klees, two Légers and one painting each by de Chirico, Matisse, Gris, Dalí, Mondrian, Gorky, Rousseau and Kane, along with a catalogue that included a foreword by Harriet Janis, Sidney Janis's wife. The collection was subsequently loaned anonymously to a summer exhibition at the Museum of Modern Art entitled 'The Museum Collection and a Private Collection on Loan', and to 'Sidney Janis Collection: Twentieth Century Painters', exhibited at the University Gallery, University of Minnesota, Minneapolis.

Janis's reputation as a serious collector and art historian was firmly established in the 1930s, and by 1939 he sold his shirt-manufacturing company in order to devote

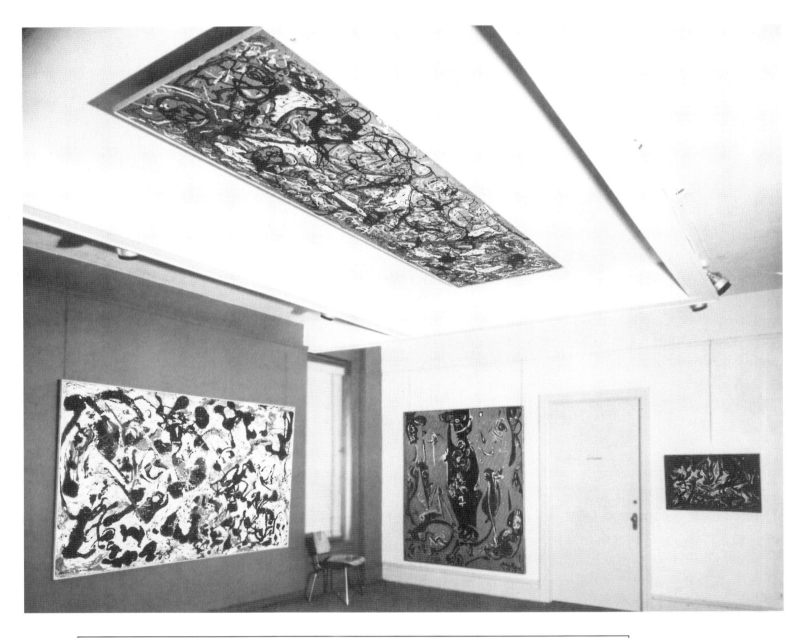

himself to writing and lecturing on art. By the 1940s Janis had begun to develop his interest in American primitive painters and organized an exhibition on the subject for the San Francisco Museum of Art in 1941 entitled 'They Taught Themselves'. At around the same time, Sidney Janis's interest in European artists in exile in the United States, which included Fernand Léger, Piet Mondrian, Max Ernst and Roberto Matta, led him to publish an article entitled 'School of Paris Comes to the U.S.' for the journal *Decision* in 1941.

Among other topics in the article, Janis expounded on Léger's impressions of American life, and on how Léger had been able to exemplify its character and spirit within his own work through the articulation of line, colour, light and shade. In another section of the article, Janis notes that Mondrian makes comments similar to Léger's about working in the United States, and about the increased level at which he has begun to produce work. Probably the most interesting statement that Janis makes in this article alludes to his obsession with acquiring works of art. 'New York is

supplanting Paris as the art centre of the world. This naturally means that the whole of America will play its part. Appreciation is gaining momentum on a nationwide scale, but distribution...is still a problem of large proportions. An extensive and imaginative merchandising plan aimed to encourage a vast American public to participate by purchasing the works of their time, will be a step in the right direction.'

Between 1948 and 1967 the Sidney Janis Gallery presented over seventy-four exhibitions. Until the 1950s this included large retrospectives of established modern masters, and group exhibitions of contemporary artists working in styles such as Cubism, Expressionism, Surrealism and various forms of abstraction. At the beginning of the 1950s Sidney Janis showed a clear commitment to the New York Abstract Expressionists through the presentation of works by Jackson Pollock, Willem de Kooning, Lee Krasner and Barbara Hepworth. In the exhibition '9 American Painters Today' in 1954, he exhibited works by Davis, de Kooning, Gorky, Hofmann, Kline, Pollock, Rothko, Still and Tobey. For Jackson Pollock's second solo exhibition in the gallery, Janis suggested to Pollock that he rename his pictures, instead of giving them numbers. Janis recalls: 'I thought it would confuse the art historians. Pollock considered it carefully, thereby thinking not only about the historians, critics and viewers, but also that it wasn't even original. About six weeks before the exhibition a driver from the moving company Home Sweet Home delivered the works to the gallery, and together with his wife Lee Krasner, Pollock arrived from the Springs, where they lived at that time. Almost the first thing he said

'New Tonk' exhibition by
Tom Wesselmann, 1968

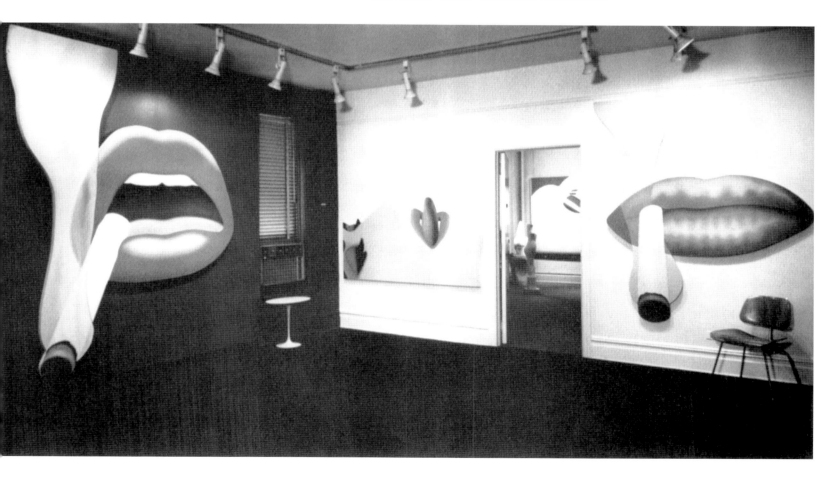

59

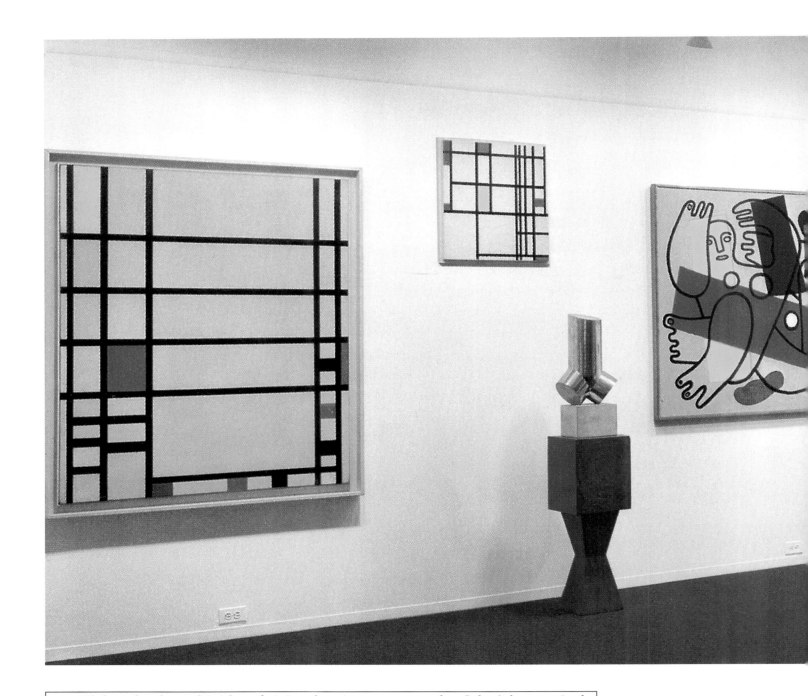

was: "I thought about this idea of giving the pictures names, but I don't have a single title." Lee shook her head in despair, but was called to the telephone just then. The pictures were scattered throughout the exhibition room, and he began to study them. Suddenly he pointed to a picture and said: "That picture is Sleeping Effort"; he pointed to another and gave it another poetic title. I wrote down the titles as quickly as I could, and in about fifteen minutes he had come up with at least fifteen beautiful, poetic titles. When Lee came back I listed off the titles, and she could hardly believe it and cried: "Fabulous!"'

In the 1960s Sidney Janis kept up with the artistic activities of the Pop generation. The first Pop Art group show in the Sidney Janis Gallery, 'New Realists' (1962), showed works by seventeen European artists and twelve Americans. The exhibition included Jim Dine's *Five Feet of Colorful Tools* (1962), James Rosenquist's *Marilyn*

Monroe I (1962), Claes Oldenburg's *Pastry Case II* (1962), as well as works by George Segal and Andy Warhol. *Pastry Case*, says Janis, looked 'so scrumptious, that my mouth always started to water. Not just the grandchildren, but even some neighbours were very interested in this piece: smaller visitors wanted to be held up, so they could see these chocolate cookies and ice-cream sundaes close up, and that was a lot of fun for us.' In 1967, after almost twenty years in the business, Sidney Janis announced that he wanted to donate 103 works from his private collection to the New York Museum of Modern Art. The Sidney and Harriet Janis Collection also contained recent purchases of contemporary art, including works by Marisol, George Segal and Andy Warhol.

GILBERT VICARIO

Galerie Aimé Maeght

YEAR OF FOUNDATION
1945

FOUNDER
Aimé Maeght

ADDRESS
1945–81 **13 Rue de Téhéran, Paris**
SINCE 1957 **42 Rue du Bac, Paris**

ARTISTS REPRESENTED
**Francis Bacon, Mahieddine Baya, Jean Bazaine
Georges Braque, Alexander Calder, Marc Chagall
Eduardo Chillida, Hélène Delprat, Arnold Fiedler
Gérard Gasiorowski, Alberto Giacometti, Aki Kuroda
Dominique Labauvie, Fernand Léger, Richard Lindner
Joan Miró, Max Neumann, Marco Del Re
Antoni Tàpies, Raoul Ubac, Bram van Velde**

Marguerite and Aimé Maeght on the Maeght Foundation's inaugural evening, 28 July 1964

In the name of the father. 'With him, the adventure expanded, and the art dealer, with and through the artist, seized the power to share fame on equal terms with him,' wrote Jean-Gabriel Mitterrand about Aimé Maeght. 'The adventure expanded…'. These words hit the nail on the head in characterizing the careers of a worker and lithographer from northern France and the daughter of a merchant from the Côte d'Azur.

The 'classic' start of the gallery was followed by a turbulent period after the outbreak of the Second World War. The unoccupied zone of the Côte d'Azur became a major intellectual and financial centre. Aimé Maeght was a friend of Jean Moulin, one of the leaders of the French Resistance, and because of his Nordic descent was able to move around the country freely. He took advantage of this circumstance to pursue an incredible task: the rescue of the most fantastic collections, for many affluent art lovers had left their Parisian apartments in a hurry in order to find shelter in their sumptuous villas on the Riviera.

With their keys in his pocket, Aimé Maeght made frequent trips between Cannes and Paris, and on each of these trips his luggage contained masterpieces hidden beneath gouache still lifes, which had only to be wiped off with a damp

Adrien and Aimé Maeght with Louis-Gabriel Clayeux, 1956

sponge once the pictures were in safety. At the same time, as he was thus winning the gratitude of the most important large collectors, Maeght formed a friendship with the painters Pierre Bonnard and Henri Matisse, both of whom had also settled on the coast. By the time France was liberated, the art market had been bled dry, the artists had fled, and many gallery owners had either been expropriated or had simply given up.

Encouraged by the artists, Marguerite and Aimé Maeght opened their first gallery under their own name on Rue de Téhéran in Paris with an exhibition of works by Henri Matisse. The many collectors indebted to Maeght guaranteed his increasing commercial success. With the 'Le Surréalisme' exhibition, organized two years later in 1947 by André Breton and Marcel Duchamp, the gallery achieved phenomenal celebrity. The survey exhibition of the following year, 'Masters of Abstract Art', rounded off the programme of a gallery that was open to all the various styles of 20th-century art: Joan Miró and Raoul Ubac were Surrealists,

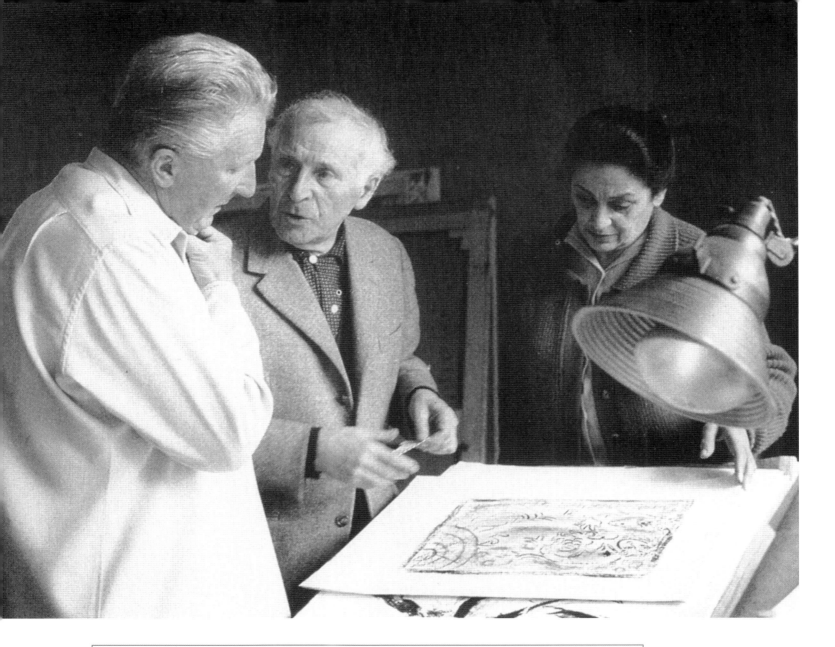

Georges Braque was a Cubist, Pierre Bonnard a Post-Impressionist and Henri Matisse a Fauvist, and Alexander Calder, Marc Chagall, Bram van Velde, Jean Bazaine and, from 1951, Alberto Giacometti and Wassily Kandinsky were also represented. In addition, Aimé Maeght always appreciated prints, and together with his son Adrien, who took this branch over from him in 1947, produced more than 12,000 editions. The magazine *L'Art Vivant*, which they produced between 1968 and 1975, had a monthly readership of almost 120,000.

The sudden death of his son Bernard in 1953 interrupted Aimé Maeght's great elan. In 1974 he recalled this period: 'For the first time in my life, I let myself go. But again it was painters who showed me the way forward. Georges Braque got me to do something that would help me to overcome my grief and to find a place for modern art where we live, between thyme and rosemary…. Fernand Léger said: "If you do that, I'll bring you my daubs. I'll even paint the rocks."' To a musical accompaniment provided by Ella Fitzgerald and Yves Montand, the Fondation Maeght was ceremonially opened on 28 July 1964 in Saint-Paul de Vence, and Arts Minister André Malraux declared in his speech: 'Never before has the

Aimé Maeght with Marc and Vava Chagall preparing André Malraux's *Et sur la terre* edition at the printing press in Saint-Paul

attempt been made to create, instinctively and through love, the universe in which modern art not only has its place, but can also find a world which was once called the supernatural.'

Aimé's son, Adrien Maeght, went his own way after 1957 by opening a gallery on Rue du Bac in Paris. Therefore, until Aimé's death in 1981, there were two Maeght galleries in Paris, different in structure, but with a similar sensibility towards art. With the support of Daniel Lelong, Aimé extended his empire by opening exhibition rooms in Zurich (1970), Barcelona (1974), New York (1978) and in 1979 at 14 Rue de Téhéran, where he exhibited the works of younger artists. During this period, Francis Bacon, Eduardo Chillida and Antoni Tàpies were included in the gallery's programme.

Performance at the 'Le Surréalisme' exhibition organized by Marcel Duchamp and André Breton at the Galerie Aimé Maeght in Paris, 1947

Meanwhile, Adrien spent much of his time on the editions. In 1977, after the death of his mother, he took over her famous contract system, and thus engaged René Klasen, Bernard Télémaque and Hervé Voss. The contracts were only ever oral, but were nevertheless binding for gallery and artists alike, providing all of the latter with a series of advantages: use of the secretarial services, payment of bills at the La Coupole restaurant on Montparnasse, inclusion of the artist's entire production in the gallery's programme, free studio space and, in addition, a fixed monthly salary. Accounts were drawn up at the end of the year, and settlement was made according to sales during the year, any difference being transformed into the gallery's stock.

This practice explains the enormous number of works of art held by Marguerite and Aimé Maeght, enough to fill eight Airbus planes. On the other hand, the Adrien Maeght gallery, now run by his children, is still tied to artists who admittedly leave most art lovers and museum curators cold.

STÉPHANE CORRÉARD (WITH LILI LAXENAIRE)

Marlborough Fine Art

YEAR OF FOUNDATION
1946

FOUNDERS
Frank Lloyd and Harry Fischer

ADDRESS
1946–60 **17/18 Old Bond Street, London**
1961–72 **39 Old Bond Street, London**
SINCE 1973 **6 Albemarle Street, London**

ARTISTS REPRESENTED
Frank Auerbach, Francis Bacon, Christopher Bramham
Bill Brandt, Jules Brassaï, Christopher Le Brun, Lovis Corinth, Otto Dix
Lyonel Feininger, Lucian Freud, Karl Gerstner, Francis Giacobetti
Erich Heckel, Barbara Hepworth, Ronald B. Kitaj, Oskar Kokoschka
Raymond Mason, Henry Moore, Ben Nicholson, Therese Oulton
Victor Pasmore, Paula Rego, Graham Sutherland

The façade of Marlborough Fine Art in London

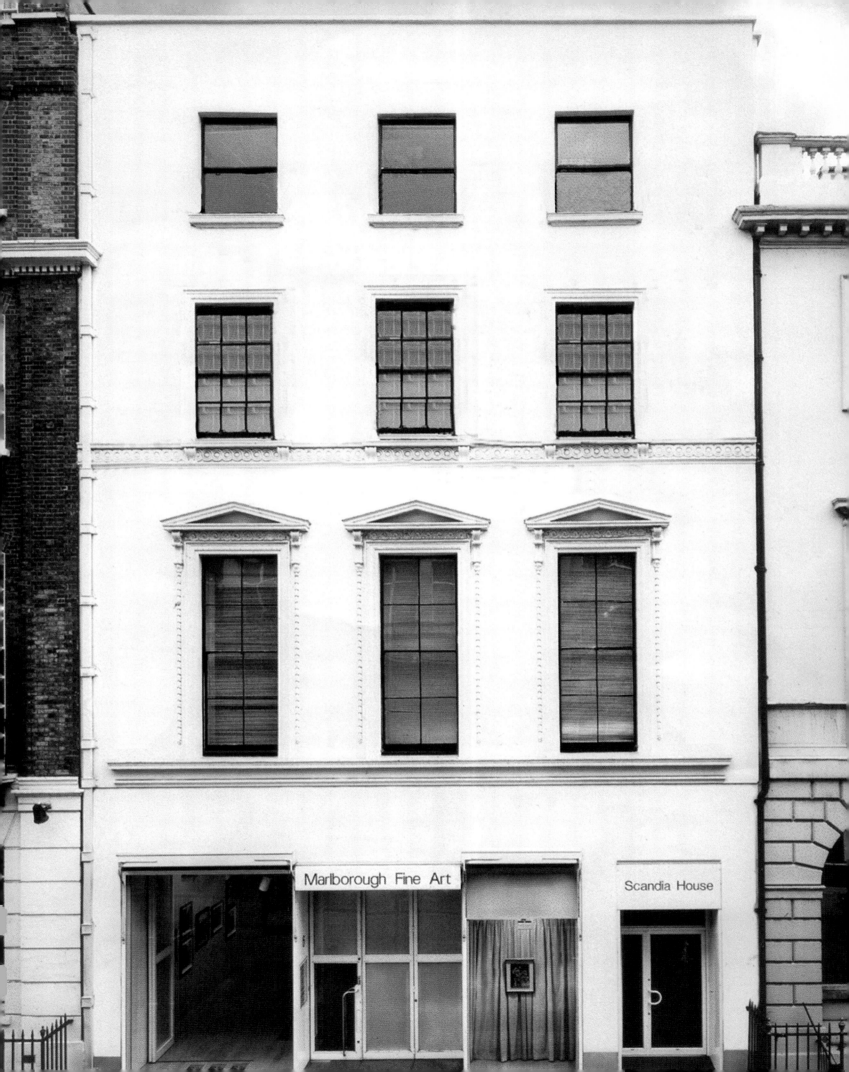

Left and overleaf: A group
exhibition to mark the
reopening of the gallery
in Albemarle Street in 1991,
with works by Avigdor Arikha,
Frank Auerbach, Francis Bacon,
Christopher Bramham, Steven
Campbell, Lynn Chadwick,
Stephen Conroy, Christopher Couch,
John Davies, Dieter Hacker,
Barbara Hepworth, Bill Jacklin,
Andrzej Jackowski, Ken Kiff,
R. B. Kitaj, Oskar Kokoschka,
Raymond Mason, Henry Moore,
Therese Oulton, Victor Pasmore,
Celia Paul and Paula Rego

Viennese antique dealer Frank Lloyd had fled to Britain from France in 1940 to escape the Nazis, and founded Marlborough Fine Art in 1946 together with fellow Viennese émigré Harry Fischer. The international art market was slowly beginning to revive in the post-war years, and Marlborough began by dealing in the lucrative areas of Impressionism and Post-Impressionism. By the mid-1950s the art market was beginning to boom, and now that the previously volatile territory of the French Cubists and German Expressionists had become more widely accepted, as well as profitable, Marlborough moved into these areas too. It organized large-scale loan exhibitions of paintings by Courbet, Monet and Pissarro, drawings by Guys and Van Gogh and retrospectives of Léger, Gris and Picasso, as well as historical surveys such as 'Art In Revolt (Germany 1905–1925)'.

By this point, not only the art market but also the artistic community had undergone a transformation. Sculptor Henry Moore had won the International Prize for Sculpture at the 1948 Venice Biennial, while Nicholson represented Britain there in 1954 together with new-generation painters Francis Bacon and Lucian Freud. Many younger artists, among whom Bacon and Freud were perhaps the most successful, who had been nurtured to success by smaller independent galleries, had been taken over by Marlborough by the late 1950s. Bacon signed a ten-year contract with them in 1958, which went on to last his whole lifetime. The agreement gave Marlborough the sole and exclusive rights to sell and authorize the sale of Bacon's work and set up a pattern of advancing money to the artist to be repayable by way of paintings. In *Private View*, the legendary book documenting the British art scene in the 1960s, John Russell wrote that, 'there was a moment in the late 1950s when Marlborough seemed to have in mind a monopoly, with every living artist of consequence on the payroll'. They staged the first major exhibition of Jackson Pollock in 1961, and in 1963 signed a contract with Kurt Schwitters and held an enormous show of his work.

Marlborough Fine Art was firmly established as London's primary art-dealing powerhouse by the time they moved to new premises across the road in 1961 and reopened the old gallery as the 'New London Gallery' specifically to show work by younger artists. A dynamic new art scene was beginning to emerge, and Marlborough New London Gallery found itself right at its centre, with shows by first-generation Pop artist Joe Tilson and young Royal College of Art graduate R. B. Kitaj, whose first solo show, 'Pictures with Commentaries / Pictures without Commentaries', was held there in 1963. The influential 1961 exhibition 'New London Situation', featuring the large-scale Abstract Expressionist-inspired paintings of John Hoyland, Bernard Cohen and Robyn Denny and radical painted sculptures of a young Anthony Caro, was followed by the 'New New York Scene' show, which added to the vital dialogue between London and the United States, inspiring the burgeoning Pop Art generation. In 1962 Frank Lloyd moved to New York himself and opened a second gallery there, enriching the trans-continental exchange by bringing artists such as Mark Rothko and Jack Smith to London. The New York branch went on to represent many of the most important modern American masters, including Rothko, Philip Guston and Robert Motherwell, while acquiring the estates of Pollock, Franz Kline and Ad Reinhardt. Over the next two decades the Marlborough empire continued to expand, with branches opening in Rome, Zurich, Toronto and Montreal, until it achieved an unparalleled level of world prominence and accumulated wealth.

Lloyd himself had a reputation for being a shrewd but charming businessman. 'I don't collect pictures,' he once said, 'I collect money.' But his success was sullied in the 1970s with a notorious court case involving the Rothko estate, which lasted eleven years and ended in a criminal trial revealing shocking abuses of power and greed. This was followed in the 1990s by a similar scandal with the estate of Francis Bacon, which accused the gallery of exploiting the artist's financial naivety. But despite losing the Pace and Bacon estates as well as the Motherwell, Gottlieb and David Smith estates in the wake of the scandals, Marlborough continued to find new areas of profit. The London and New York businesses had for several years been in the hands of Lloyd's son Gilbert and nephew Pierre Levai when he died aged eighty-six in his home in the Bahamas.

KIRSTY BELL

Betty Parsons Gallery

YEAR OF FOUNDATION
1946

FOUNDER
Betty Parsons

ADDRESS
1946–63 **15 East 57th Street, New York**
1963–77 **24 West 57th Street, New York**

CLOSED 1977

ARTISTS REPRESENTED
**Forrest Bess, Hans Hofmann, Ellsworth Kelly
Lee Krasner, Richard Lindner, Barnett Newman
Jackson Pollock, Ad Reinhardt, Mark Rothko
Leon Polk Smith, Clyfford Still, Richard Tuttle**

Barnett Newman and Betty Parsons with Newman's *The Wild*, 1951

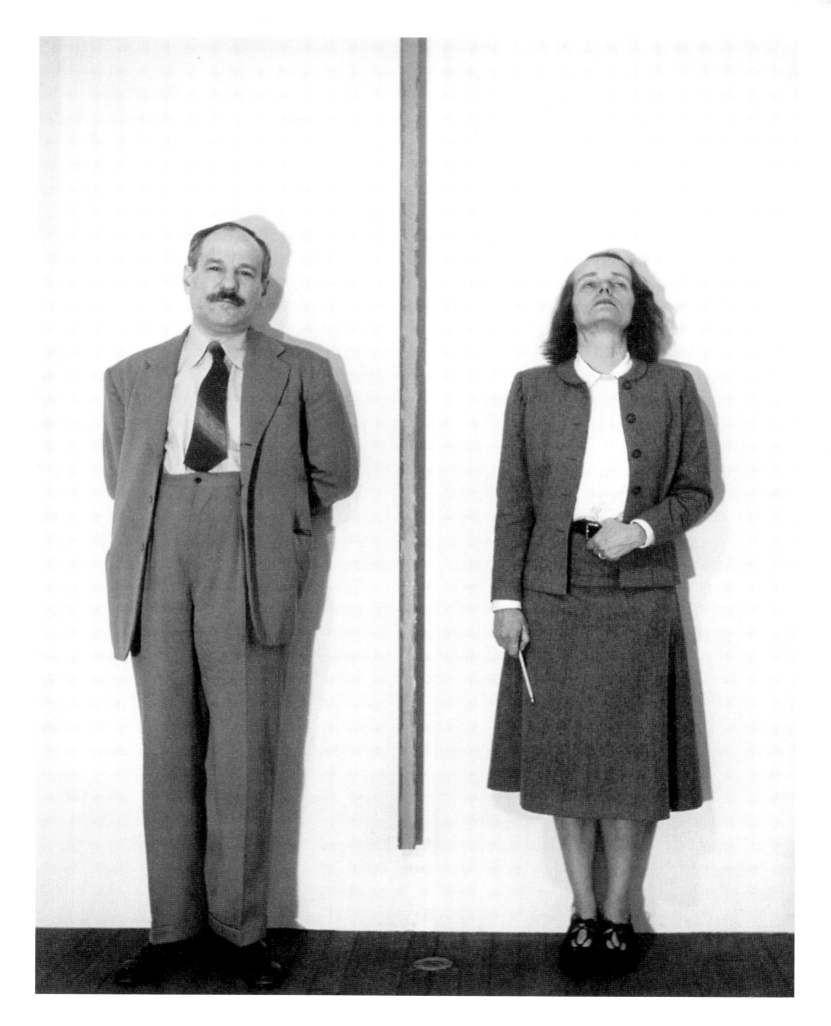

The flagship of modernism. Shortly after the Second World War, when the art dealer Mortimer Brandt, in whose gallery she managed a department, decided to return to his native England, Betty Parsons opened a gallery in New York under her own name. She took over the rooms, and with the words, 'A gallery is not a place to rest, but to look at art. People don't come to my gallery to make themselves comfortable,' she cleared out all the furniture, had the walls painted white and strong lighting installed. Her first exhibition was 'Northwest Coast Indian Art', her second a solo Ad Reinhardt show.

When Peggy Guggenheim closed her gallery Art of This Century in 1947, Betty Parsons formally 'inherited' her artists. Barnett Newman said: 'We want to be in your gallery.' She added Hans Hofmann, Jackson Pollock, Mark Rothko, Clyfford Still and Barnett Newman to the artists she had already represented at Mortimer Brandt's gallery. Their abstract, often wall-sized pictures needed 'room to breathe', and they wanted to exhibit them in an environment that recalled the studios in which they had been painted. Thus the Betty Parsons Gallery soon became the favourite venue of abstract painters.

In March 1947 Betty Parsons exhibited works by Mark Rothko – those works in which the artist placed just one or two fields of subdued, or sometimes glowing colour

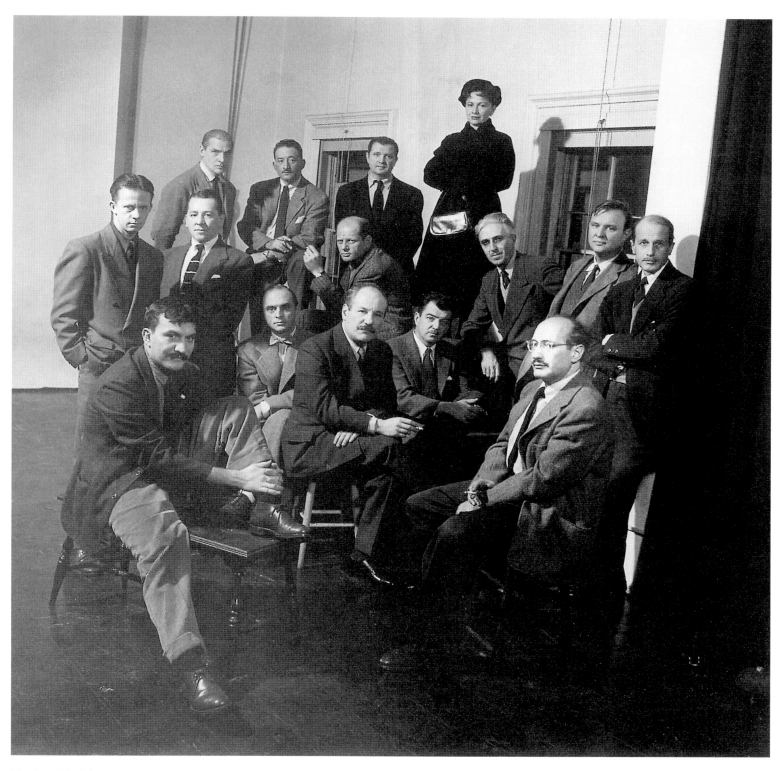

The Irascible (Die Jähzornigen), 1951
Seated, from left to right: Theodoros Stamos, Jimmy Ernst, Jackson Pollock, Barnett Newman, James Brooks and Mark Rothko
Standing, from left to right: Richard Pousette-Dart, William Baziotes, Willem de Kooning, Adolph Gottlieb, Ad Reinhardt, Hedda Sterne, Clyfford Still, Robert Motherwell and Bradley Walker Tomlin. Brooks was the only artist in the group not to exhibit at the Betty Parsons Gallery

on the canvas, making the colour look like it was floating against an almost invisible colour background. The prices were between US\$200 and US\$1,500 per picture, but hardly any were sold. Betty Parsons was beside herself with rage: 'All the critics hate my exhibitions, my gallery and my artists.'

In the first few years of her gallery, Betty Parsons – in her opinion – struggled to introduce her artists to an ignorant and hostile public. Often enough, holes were torn in the paintings, or the word 'shit' scrawled across the surface. There is one anecdote about a Time-LIFE manager, who, in order to make fun of his wife, bought her a Jackson Pollock for US\$250. Ironically, the couple made a fortune by selling the picture a few years later. And yet the gallery soon got the reputation of being the place where the latest and, in some cases, the best American art could be seen.

The opening of Jackson Pollock's exhibition at the Betty Parsons Gallery on 21 November 1949. From left to right: Barnett Newman, Jackson Pollock, Jimmy Ernst and Charles Egan. On the walls: left, 'Number 33', 1949; right, 'Number 3', 1945

From 1949 there was growing dissatisfaction among 'the giants', as Betty Parsons called Barnett Newman, Jackson Pollock, Ad Reinhardt, Mark Rothko and Clyfford Still. They said she should be selling more, brokering more museum exhibitions, and making them rich and famous at last. At the start of the 1950s it seemed that this dream might be coming true. 'The giants' were exhibited at the Museum of Modern Art, opinion-forming magazines such as *Time*, *LIFE* and *Vogue* ran regular reports on the gallery, and the economic upswing led to increased turnover. In 1951 the five artists suggested to Parsons over dinner that she represent only them, and exclude all the other artists from the gallery, in order, as Newman put it, 'to make her the most important dealer in the world'. But Betty Parsons, who always took her artists' ideas seriously, replied: 'This is not my way.'

As a result, one after the other they made agreements with other galleries – for example, Jackson Pollock, who transferred to the young art dealer Sidney Janis in 1951, to whom Betty Parsons had let rooms on her floor shortly before. Betty Parsons

increasingly devoted her time to her own painting. In 1959, following an unexpected bequest, she had the architect and sculptor Tony Smith build her a studio on Long Island, and discovered an amazing range of unknown talents, which she exhibited in her gallery. In an art scene characterized by increasing competition, a dealer had to exploit an artist, stage public interest in his work, create a demand for it, control production, and get prices to rise. Betty Parsons continued her work without reference to any of this; she celebrated the new and praised the innovative, without thinking about past mistakes or future strategies. Thus, in 1965, she allowed the young artist Richard Tuttle, who was working as an assistant in the gallery, to exhibit his works in the rooms during the summer months.

In the late 1960s and '70s it looked as though Betty Parsons only wanted to present young unknown artists as her discoveries, and allow them to move on to other galleries as soon as they had established themselves. After twenty years, having made her name as a dealer, she now wanted recognition as an artist, and as early as 1968 the Whitechapel Art Gallery in London gave her a solo exhibition.

Whether as artist or gallery owner, her motto was always what Barnett Newman had once said to her: 'In order to appreciate the work, the most important thing is to fight.'

UTA GROSENICK

Betty Parsons in the office of her first gallery on East 57th Street, *c.* **1953–54**

Galerie Denise René

YEAR OF FOUNDATION
1944
FOUNDER
Denise Bleibtreu
ADDRESS
1944–76 **Galerie Denise René, 124 Rue de La Boétie, Paris**
SINCE 1966 **Galerie Denise René Rive Gauche, 196 Boulevard Saint-Germain, Paris**
1967–69 **Galerie Denise René – Hans Mayer, Krefeld**
1969–75 **Galerie Denise René – Hans Mayer, Kunstmarkt für Grafik und Objekte**
1 Mühlenstraße, 123 Ostwall, Düsseldorf
then in the Kö-Center, Simon-Passage, Düsseldorf
SINCE 1971 **Galerie Denise René – Hans Mayer, 2 Grabbeplatz, Düsseldorf, today Galerie Hans Mayer**
1971–78 **Galerie Denise René, 6 West 57th Street, New York**
1977–80 **Galerie Denise René Beaubourg, 113 Rue Saint-Martin, Paris**
SINCE 1991 **Galerie Denise René, 22 Rue Charlot, Paris**

ARTISTS REPRESENTED
Yaakov Agam, Hans Arp, Max Bill, Pol Bury, Alexander Calder
Sonia Delaunay, Jean Dewasne, Robert Indiana
Robert Jacobsen, Wassily Kandinsky, Piet Mondrian
François Morellet, Jean Tinguely, Victor Vasarély

Denise René in front of a 'photographism' by Victor Vasarély in the 'Formes et couleurs murales' exhibition, 1951

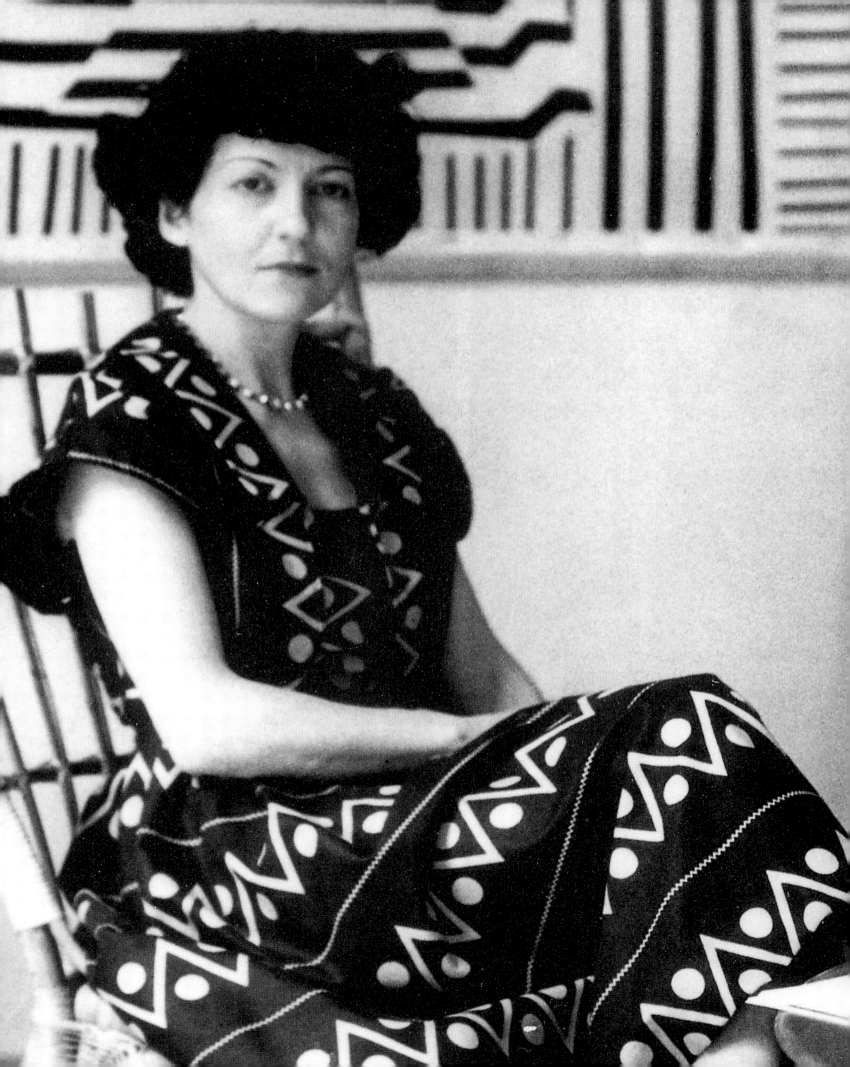

The living legend of a century of abstract art. There is, strictly speaking, no such person as Denise René. Georges Bleibtreu invented this name for a fashion studio opened by his daughters Denise and Renée-Lucienne in a flat on Rue de La Boétie, near the Champs-Elysées, in 1939. At this time, Denise often visited the intellectuals who congregated in the Café de Flore, and fell in love with Hungarian graphic artist Victor Vasarély at first sight. Thus events at the start of the Second World War took an unexpected turn. Vasarély, who was working as a commercial artist, received no commissions during the German occupation, and the fashion sector was hardly doing any better, so he suggested to Denise that they turn the shop into an interior-design studio.

During the war, many people worked here illegally, and the studio became a Resistance rendez-vous. It goes without saying that the Galerie Denise René took over these premises after the liberation. The actual opening took place in November 1944 with an exhibition of 'drawings and compositions' by Vasarély. Denise René (for this was how Denise Bleibtreu was known to everyone, even though her sister continued to work by her side) recalls it thus: 'Everyone was impressed, the collectors Roger Dutilleul, Wilhelm Uhde and the publisher Jean Aubier and even André Breton wondered whether the Surrealists hadn't found a new painter here, because of the numerous *trompe-l'œil* effects in Vasarély's graphic inventions.' This 'Surrealist tendency' continued to be very much present in the gallery's early days. It

Opening of the
'Esquisse d'un Salon'
exhibition, 21 May 1963

was the venue in June 1945 for Max Ernst's first post-war exhibition, and the following year similarly for Francis Picabia. But it is abstract art and, even more, geometric art that is quite obviously the hallmark of the Galerie Denise René, and in fact the gallery contributed largely to the appearance of this movement, for as Denise René says, 'Quite frankly there was no abstract art in France. It developed in November 1946 after the exhibition by Auguste Herbin, an artist who worked in great isolation,

and around me.' The gallery itself was also an isolated phenomenon for a long time. In the *Lettres Françaises* the critic Jean Bouret described it as a 'laboratory for the incapable painters of our age'.

After the 'Abstract Painting' exhibition of February 1946, which made a decisive contribution to this movement, the gallery exhibited – alongside the 'geometric' artists Jean Dewasne and Jean Deyrolle, with whom Denise René signed exclusive contracts – the 'lyric' artists Hans Hartung and Gérard Schneider, as well as Serge Poliakoff. Given this support in Paris, which according to many critics was due to strong personalities such as Léo Degand and Charles Estienne, abstract painting and its circle tended to become more radical. The various tendencies could no longer co-exist as equals, and Denise René of course made her selection. While Vasarély's experiments were proceeding by leaps and bounds, she explained that by nature she was more drawn to geometric art: 'I was receptive to the rational, the purity of forms, the controlled thinking, not left to chance, which it embodied: discipline in sensitivity.'

The joint presentation of the works of Hans Arp and Sophie Taeuber-Arp in June 1950 contributed to lending the business a new dimension, to the extent that it took place before the exhibitions of the Danish artists Richard Mortensen and Robert Jacobsen, who were of great importance for the development of the gallery beyond French borders.

At the end of 1951 Denise René organized – for museums in Copenhagen, Helsinki, Stockholm and Oslo – the ambitious 'Clear Forms' touring exhibition, in which the gallery's artists were represented alongside Alexander Calder, Fernand Léger and Le Corbusier. These exhibitions abroad became one of the gallery's hallmarks, and contributed a great deal both to its own reputation and to that of the artists involved, while attracting numerous foreign collectors at the same time. Denise René always regretted 'never having had more than ten French collectors at once'.

Her 1955 exhibition 'Le Mouvement', with the artists Agam, Bury, Calder, Duchamp, Jacobsen, Soto, Tinguely and Vasarély, marked the start of the 'kinetic art' movement, and was the starting point for excursions beyond the picture. It also triggered sudden new problem areas, which were reflected in the 1960s in her collaboration with the architects André Bloc and the sculptor Nicolas Schöffer, as well as in the radical experiments of the GRAV group for art in the public space.

In 1957 Denise René had the courage to take on an exhibition of works by Piet Mondrian from the Stedelijk Museum in Amsterdam, which had been rejected by all the museums in France; this finally made her name. From now on, the story of the gallery was tied up with the phenomenal success of Vasarély, which opened the way to every possible boldness on the part of Denise René. In 1966 she opened the Galerie Denise René Rive Gauche on the Boulevard Saint-Germain, which

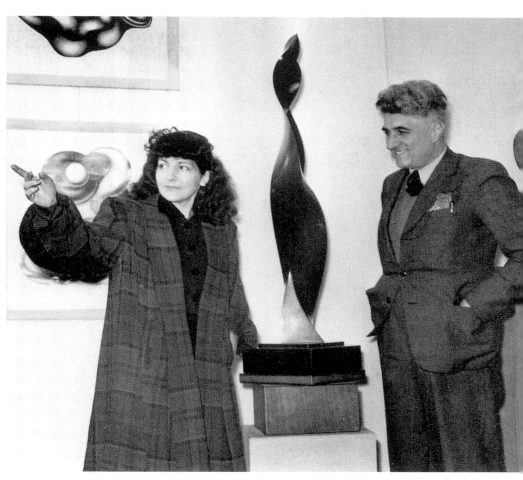

was used for the publication and presentation of multiples – and hence she contributed to the popularization of Op Art. To the sounds of an unforgettable concert by The Who, the following year she opened a gallery in Krefeld in Germany with Hans Mayer.

Now at the peak of her fame, in 1971 she finally opened her fabulous gallery in the heart of Manhattan with an exhibition of works by Yaakov Agam. 'Ten years too late,' in the opinion of many. 'As soon as I could,' she replied. The world of art had changed by this time. Vasarély was regarded as a braggart, the Pop wave had swept all before it, and Denise René had been deflected by Minimal Art, which was why she could no longer fulfil her obligations toward the Constructivism she loved so much. Finally the oil crisis turned the world upside down. In 1978 the New York gallery closed, and Hans Mayer made himself increasingly independent. Thrown back once more on her activities in Paris, Denise René could now enjoy the unique position she had achieved in such a brilliant manner. In 1997 she allowed herself the luxury of exhibiting the 'Walt Disney Paintings' of Bertrand Lavier. The École de Paris is detectable once more in the cartoons, designed by a master with French wit – once again the gallery owner, who has now definitively attained the status of a legend, has thumbed her nose at the public.

STÉPHANE CORRÉARD (WITH LILI LAXENAIRE)

Above, left: Auguste Herbin,
Orange, 1953

Above, right: Denise René and
Étienne Béothy at the opening of the
'Herbin – Béothy' exhibition, 1946

Galerie Stangl

YEAR OF FOUNDATION
1948
FOUNDER
Otto Stangl
ADDRESS
1948–61 **7 Martiusstraße, Munich**
1962–75 **11 Brienner Straße, Munich**
CLOSED 1975

ARTISTS REPRESENTED

Otmar Alt, Horst Antes, Willi Baumeister, Max Bill
Julius Bissier, Alexander Calder, Antonio Calderara, Rolf Cavael
Alan Davie, Adolf Erbslöh, Max Ernst, Lyonel Feininger
Rupprecht Geiger, Werner Gilles, Raimund Girke, Julio González
HAP Grieshaber, Günter Haese, Fritz Harnest, Hans Hartung
Bernhard Heiliger, Ernst Hermanns, Alexei Jawlensky
Wassily Kandinsky, Ernst Ludwig Kirchner, Paul Klee, Alf Lechner
Fernand Léger, Richard Paul Lohse, Henri Matisse
Brigitte Meier-Denninghoff, Joan Miró, Henry Moore
Edvard Munch, Gabriele Münter, Max Pfeiffer Watenphul
Pablo Picasso, Serge Poliakoff, Niki de Saint Phalle
Oskar Schlemmer, Michael Schoenholtz, Rudolf Schoofs
Werner Schreib, K. R. H. Sonderborg, Pierre Soulages, Hann Trier
Heinz Trökes, Victor Vasarély, Gerd Winner, Fritz Winter, Wols

Etta Stangl, 1953

Abstract by all the rules of art. Contemporary art in Munich – that meant the gallery run by Etta and Otto Stangl. In 1948 the couple opened their first premises on Martiusstraße in the Schwabing district and, although neither had any experience in the art trade, the business stood from the outset on the solid foundations of a magnificent collection of classical modern works. Etta Stangl's father, the piano builder Rudolf Ibach from Wuppertal, had left his daughter significant portions of his collection, compiled in the first two decades of the 20th century, of works by the Expressionists (including die Brücke and Der Blaue Reiter), Neue Sachlichkeit and the Bauhaus masters. Paul Klee in particular was represented with some fifty works, forming a focus of its own. It was to the fame of this collection that the two young art dealers owed their outstanding contacts to museum directors all over the world.

Ludwig Grote, the then head of the Germanisches Nationalmuseum in Nuremberg and the guiding spirit behind the first major post-war exhibitions ('Der Blaue Reiter', 1949, and 'The Bauhaus Painters', 1950), became their trusted adviser. On the foundation of the outstanding Ibach collection, and of Munich as a location, a link with classical modernism was evident even from the name: the Moderne-Galerie Otto Stangl was an allusion to the Moderne-Galerie Heinrich Thannhauser, which first presented the works of the Blaue Reiter group to the public in 1911. With works by Alexei Jawlensky, the couple presented their first exhibition to the public in February 1948. It was followed that same year by exhibitions of works by Paul Klee and Wassily Kandinsky, in each case accompanied by a catalogue.

Again in that first year, Maria Marc, the widow of Franz Marc, using Klaus Lankheit as a mediator, transferred the administration of Marc's artistic estate to Otto Stangl. The importance of this task could only improve the reputation of the gallery, which staged an exhibition of Franz Marc's works in 1949. In the years to come, the Stangls were able to sell important works by Marc to such West German museums as the Bayerische Staatsgemäldesammlung, the Kunsthalle in Karlsruhe, the Staatsgalerie in Stuttgart, the Niedersächsische Landesgalerie Hannover and the Karl Ernst Osthaus-Museum in Hagen. In close cooperation with Klaus Lankheit and with the support of the Bayerische Staatsgemäldesammlung, Otto Stangl's enduring commitment finally led to the opening of a Franz Marc Museum in 1986, located in the small Bavarian town of Kochel am See, where Marc was buried.

The purchasing policy of the Munich museums pre-1933 had almost entirely ignored the local avant-garde. The Stangls were therefore able to cash in on the need to catch up, and their exhibitions attracted substantial interest. But it was not just the Munich museums that wanted to put this right: all the collections of modern art in West Germany were trying to re-build their stocks following the great Nazi sell-off. As the Stangls' exhibition policy included the integration of the Ibach collection, their carefully conceived shows came up to museum standards, and museum directors from home and abroad were constant visitors. The dealing side in the immediate post-war years, however, was – astonishingly – largely focused on contemporary art, for the core works of the Ibach collection were not for sale.

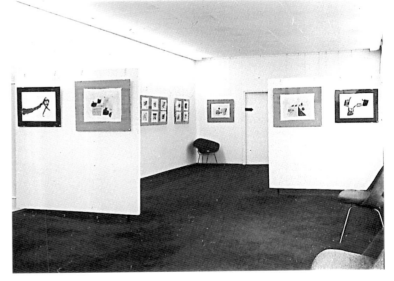

From top to bottom: exhibitions
by Serge Poliakoff (1957),
Heinz Trökes (1968) and
Julius Bissier (1962)

Opening of the Alf Lechner
exhibition at the Galerie
Stangl, 1971

Stangl's commitment to an artist and his works was the result of deep personal conviction. The gallery prolonged the abstract works of German Informel and the École de Paris, which were regarded as progressive – and in its activities reflected the need for identity, internationalism and a new beginning, which in turn highlighted the spirit and the dilemma of the modern movement in Germany post-1945. Even before the opening of their exhibition rooms, the private quarters of Etta and Otto Stangl provided a venue for the artists of the 'Gruppe der Gegenstandslosen' (Group of the Non-representational), founded in 1949 and later renamed ZEN 49, centring on Rolf Cavael, Rupprecht Geiger, Gerhard Fietz, Willy Hempel, Fritz Winter, Brigitte Matschinsky-Denninghoff, Theodor Werner and Willi Baumeister. In its founding manifesto the group referred explicitly to the art of Der Blaue Reiter; as far as the Galerie Stangl's programme was concerned, this led to a rational merger of contemporary art with the works of classical modernism, whose post-Nazi rehabilitation was one of their concerns.

Via ZEN 49, the Stangls made contact with other artists close to the group, including Hann Trier and, in particular, Julius Bissier, whose works were the subject of

Opening of the Fritz Winter
exhibition, 1950
From left to right: Mauritius Heinz,
Baroness Hilla von Rebay,
Ida Bienert and Maria Marc

four exhibitions. In their conviction that modernism could be found in abstract art, the Stangls concentrated on harmonious, compositional pictorial concepts. The more aggressive versions of Action and all-over painting, the art of Emil Schumacher and Karl Otto Götz and even the late works of their friend Rolf Cavael, whom the Stangls exhibited in 1949 and 1954 and who changed his allegiance to van de Loo in 1955, were not to the couple's taste.

The Stangls and their circle of artists were supported not only morally, but also financially and in kind (in the form of care packages), by Hilla von Rebay, the head of the Museum of Non-Objective Painting, renamed the Solomon R. Guggenheim Museum three years after its founder's death in 1949. Baroness Rebay, his increasingly controversial adviser, bought from the Stangls and advertised their programme, before retiring from the museum in 1952.

Among the results of the Stangls' frequent journeys were the early exhibitions of the Swiss Concrete artists (1949), a Feininger exhibition (1950), and exhibitions with Gérard Schneider and Pierre Soulages (1952).

In 1975 the gallery premises on Brienner Straße were closed, but trade was continued from the Stangls' private address. Thanks to its extraordinary quality, the collection built up inconspicuously by Etta and Otto Stangl during their active lives as art dealers aroused considerable attention when it was put on show posthumously by the Bayerische Staatsgemäldegalerie in 1993. Etta and Otto Stangl died in 1990 within a few weeks of each other; their dream of a museum of post-1945 abstract art, a document of their personal conviction and passion as an extension to the Franz Marc Museum in Kochel, remained unfulfilled, however.

REGINA SCHULTZ-MÖLLER

Otto Stangl with a sculpture
of his father, Hans Stangl, 1962

'I have a dream'
The 1960s

Visitor to the Galerie Rolf Ricke, 1965

Martin Luther King's great dream, and that of the civil rights movement he led, was of equal rights for the population of black Americans. Characterized by many dreams, visions and fantasies of a better, different world, the era of the 1960s saw the completion of post-Second World War reconstruction and a consolidation of prosperity. Just as many dreams, however, also failed during this period.

The Cold War continued between East and West, and in 1962–63 the dispute between the USA and the USSR during the Cuban Missile Crisis threatened to end in a nuclear conflict, which was only just avoided. As president, John F. Kennedy portrayed the US as a responsible nation, and pursued social reforms in his domestic policy. In 1963 Kennedy was shot in Dallas. King was murdered in 1968. Together with Castro Ruz, guerrilla leader Ernesto Guevara Serna, known as 'Che', championed the Cuban revolution and promoted that country's revolutionary restructuring. Without benefit of a trial, Che was shot in Bolivia in 1967. Even though these men's goals and socio-political contexts could not have been more diverse, they all stand for new beginnings and the will to make changes.

The student movement formed in Europe aimed at changing social structures by way of university reforms. The situation escalated in many places in 1968, with violent clashes between students and police. Similarly rebelling against conservative, middle-class structures of affluence and the folly of the Vietnam War, the so-called Hippie movement began in the USA. It reached its high point with the Woodstock festival in 1969, and lived on in 'Flower Power'.

The search for a more humane world was reflected in the psychedelic music of The Doors, Jimi Hendrix, The Grateful Dead, Jefferson Airplane and others. In 1966 Frank Zappa released his first LP, *Freak out!*, and in England The Beatles embodied an anti-middle-class attitude. The animated film *Yellow Submarine* reflected the colourful, psychedelic style that characterized the main design currents of the time. French Nouvelle Vague directors such as Godard, Truffaut and Chabrol simultaneously experimented with discontinuous narrative styles, thereby turning against the Hollywood film machine.

Artists produced extremely varied, experimental and critical work. While Pop artists still remained primarily within the picture frame – though Andy Warhol's factory system was already overstepping the traditional realm of panel painting – extremely diverse approaches were being developed, marking the 'abandonment of the image': process-orientated approaches in Action Art with Happenings, Fluxus and performances; the minimalists' reductive, constructive tendencies; ephemeral Land Art and Eat Art styles; retakes on the objet trouvé by Nouveaux Réalistes and the artists of Arte Povera; and experiments with new media, particularly in the television and video work of Nam June Paik. Artistic approaches were manifold, the boundaries between genres became blurred, and a deliberate connection with society and life was almost always sought. Art was analysed in terms of everyday reality and contextualized correspondingly. Structuralism, founded in France, brought about a conceptual reorientation from Existentialism's subjective level

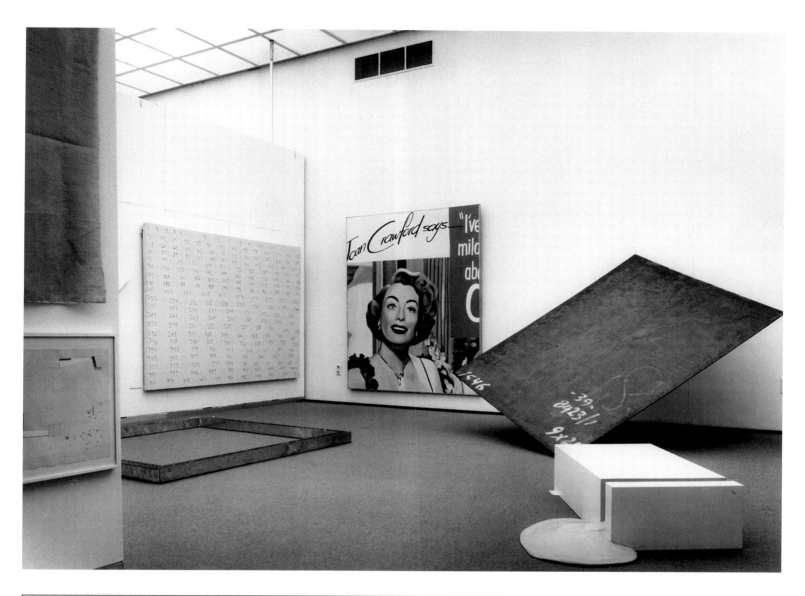

(1950s) to a contextual and functional level, and formed the philosophical counterpart to these events.

This was accompanied by strong population increases worldwide during the 1960s, both in industrial nations and in developing countries. Migration and rural exodus changed demographic structures and demanded new solutions, particularly in the field of municipal planning. Architects and architectural groups from the 'Metabolism' movement initiated in Japan (Kurokawa, Archigram and Fuller, among others), who were introduced to a broad public at Expo '67 in Montreal, formulated new functional visions consisting of mobile, in general seemingly organic cells ('Plug in City' by Archigram).

While the possibilities seemed unlimited through exciting scientific and technical achievements from NASA's Apollo programme – with Neil Armstrong becoming the first man on the moon in 1967 – to the decoding of DNA information, many of the ideas and visions born in the 1960s were laid low by increasing commercialization.

SYLVIA MARTIN

Rolf Ricke's stand at the 'Kölner Kunstmarkt' in 1969, with works by Keith Sonnier, Klaus Rinke, Harriet Korman, James Rosenquist, Richard Serra and Gary Kuehn (Photo: Schmitz-Fabri)

Galleria L'Attico

YEAR OF FOUNDATION
1966

FOUNDER
Fabio Sargentini
(who took over the gallery founded by
his father, Bruno Sargentini, in 1957)

ADDRESS
1966–68 **20 Piazza di Spagna, Rome**
1969–76 **22 Via Cesare Beccaria, Rome**
1972–78 AND SINCE 1983 **41 Via del Paradiso, Rome**

ARTISTS REPRESENTED
Vito Acconci, Joseph Beuys, Trisha Brown, Pizzi Cannella
Francesco Clemente, Gino De Dominicis, Marcel Duchamp
Jean Fautrier, Simone Forti, Gilbert & George
Philip Glass, Joan Jonas, Jannis Kounellis, Sol LeWitt
René Magritte, Eliseo Mattiacci, Mario Merz, Marisa Merz
Hidetoshi Nagasawa, Nunzio, Luigi Ontani, Nam June Paik
Charlemagne Palestine, Giulio Paolini, Pino Pascali
Steve Paxton, Michelangelo Pistoletto, Sergio Ragalzi
Steve Reich, Terry Riley, Klaus Rinke, Robert Smithson
Jean Tinguely, Marco Tirelli, Robert Whitman, La Monte Young

The 'crew' of the Galleria L'Attico on the Tiber, 1977

Fabio Sargentini's theatre. The Galleria L'Attico's history reflects a paradigmatic change of generations. The gallery that Bruno Sargentini opened on Piazza di Spagna in 1957 already bore the name L'Attico, and was dedicated particularly to Italian and international Informel painting.

Bruno's son Fabio Sargentini assisted his father even in the early years, until they parted company completely in 1966, after which the son remained in the rooms on Piazza di Spagna.

Eliseo Mattiacci, Pino Pascali and Mario Merz in front of Pascali's *Bridge*, 1968

A decisive reorientation can be seen at this point, which went hand in hand with the revolutionary developments of Land Art, Anti-Form and Conceptual Art. The limitations of two-dimensional pictorial space became ever more apparent, while nature and material, already evoked abstractly by a variety of the Informel, overstepped the bounds of representation and forced their way directly into real space. With his dedication and dynamism, Sargentini also surpassed a second gallery in Rome that was receptive to the new developments, La Tartaruga, and seduced artists away from it, including Pino Pascali and Jannis Kounellis, whose potential he recognized immediately. These two artists primarily marked the gallery programme in its early years. Pascali, who died very young in 1972, opened the gallery with a two-part exhibition, showing key works such as *Il Mare* and *Code di Balena*. Kounellis showed shortly thereafter. Here, the Mediterranean with its mythology seems to confront

Robert Smithson, *Asphalt Run
Down*, Rome, 1969

America's Pop Art, which had celebrated its triumph only a few years earlier at the Venice Biennial.

Also of fundamental importance was the group exhibition 'Fuoco Immagine Acqua Terra' in June 1967, in which some elements of the phenomenon that Germano Celant was to name Arte Povera appeared. Pascali's *Puddles* and *Cubes of Earth* used natural elements very directly, Kounellis exhibited the famous *Margherita con fuoco*, and Gilardi showed one of his *Nature Carpets* made of foam. A further Kounellis exhibition followed, in which he displayed cacti, a parrot, an aquarium and a pile of cotton wool.

In 1968 Sargentini dedicated separate exhibitions to the walk-in room installations of Gianni Colombo, Eliseo Mattiacci and Luca Patella, which invite the viewer's direct participation. A tendency towards theatre and performance became ever clearer, and a series of concrete actions scrutinized the gallery, both as a physical and symbolic space, in terms of its self-image as an institution. As early as 1968 Sargentini turned his gallery into a training room open to the public for several days, made it available for a two-day programme of electronic music, and presented Simon Forti as the first performance artist in the gallery. Finally, Mattiacci carried out a project completely outside the gallery rooms.

In January 1969 Sargentini opened an exhibition venue that was unusually innovative for its time, a subterranean parking garage in the Via Beccaria: it was even closer to real life, and 'underground' in the truest sense of the word. The exhibition

Jannis Kounellis's horses,
14 January 1969

room began its programme with Kounellis's twelve live horses, followed by a solo exhibition by Mario Merz in which the first igloos and bundles of brushwood were shown, as well as the car in which the artist had travelled from Turin, and lastly an action by Mattiacci involving a steam roller. Gino de Dominicis's first solo exhibition took place in the same year, and the following year he showed his famous tableau vivant *Zodiaco*.

The gallery became increasingly active and open to all possible types of artistic practice, particularly in the fields of performance, theatre and music. Sargentini's international art connections, particularly to the American art scene, became increasingly closer.

Before the end of 1969, Sargentini showed one of Sol LeWitt's wall drawings in the latter's first solo exhibition in Italy. In a rapid series of events the gallery presented the Italian public with representatives of the musical avant-garde and of performance art. In the 1960s and early 1970s L'Attico presented Trisha Brown, Steve Paxton, Yvone Rainer, Steve Reich, Philip Glass, La Monte Young, Charlemagne Palestine, Nam June Paik and many others. Sargentini financed these transitory projects from the sale of paintings by the masters of Surrealism and the Informel movement.

He opened another showroom in the Via del Paradiso, in a historic building with frescos on the ceiling – the perfect counterpart to the subterranean parking garage in the Via Beccaria. Towards the end of the same year, actions and performances by Gilbert & George and, in his first solo exhibition, by Vito Acconci, could also be seen. At the same time the gallery regularly continued the excursions beyond its conventional rooms: in his first Italian exhibition, Robert Smithson carried out the famous Land Art action *Asphalt Run Down* (1969), in which a truckload of boiling asphalt was dumped in a tip. In 1970 Marisa Merz used a small aeroplane for a work in the gallery, and Joan Jonas used a boat for an action on the Tiber.

But Sargentini went even further in investigating the possibilities of a gallery. He organized actions around the clock, and opened the gallery only at night for one whole week. Then, in 1976, the possibilities for the showroom in Via Beccaria seemed finally to have been exhausted. In a spectacular action Sargentini flooded the gallery with 50,000 litres of water before giving it up.

Logical further developments included a floating gallery on the Tiber and a travelling gallery in Madras, India, together with Francesco Clemente and Luigi Ontani. Sargentini himself, who increasingly felt the need to step out on to the performative stage, finally brought the gallery's history to a close. It did not reopen until 1983, with a programme focused on painters such as Pizzi Cannella and sculptors like Nunzio.

The path taken by Fabio Sargentini, with unbelievable consistence and energy, and more as an artist and director than an art dealer, had been too independent and exemplary for him to consider a continuation or comeback.

LUCA CERIZZA

Galerie René Block

YEAR OF FOUNDATION
1964
FOUNDER
René Block
ADDRESS
1964–66 **18 Frobenstraße, Berlin**
1966–79 **11 Schaperstraße, Berlin**
1974–77 **409 West Broadway, New York**
CLOSED 1979

ARTISTS REPRESENTED
Joseph Beuys, Claus Böhmler, George Brecht, K. P. Brehmer
Bazon Brock, Robert Filliou, Dan Graham, Richard Hamilton, Dick Higgins
K. H. Hödicke, Rebecca Horn, Allan Kaprow, On Kawara, Alison Knowles
Charlotte Moorman, Nam June Paik, Sigmar Polke, Gerhard Richter
Dieter Roth, Gerhard Rühm, Tomas Schmit, Wolf Vostell

René Block in front of his gallery with Joseph Beuys's 'sled', 1970

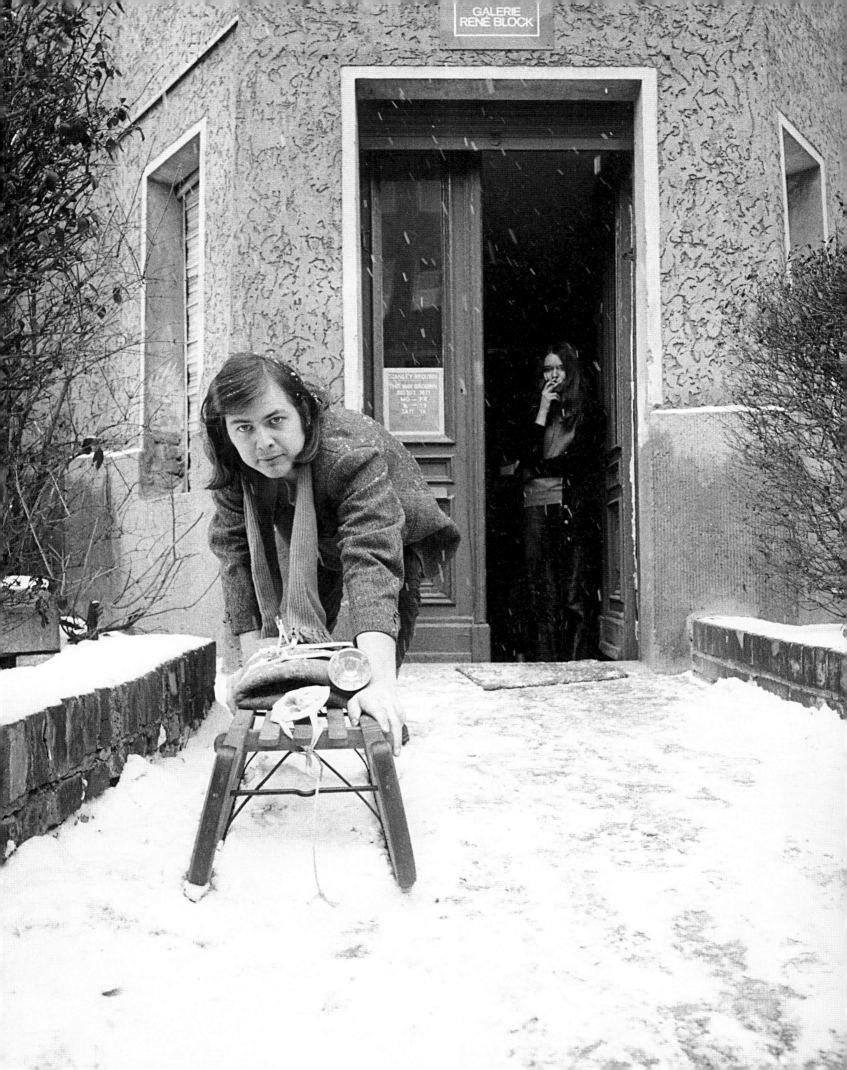

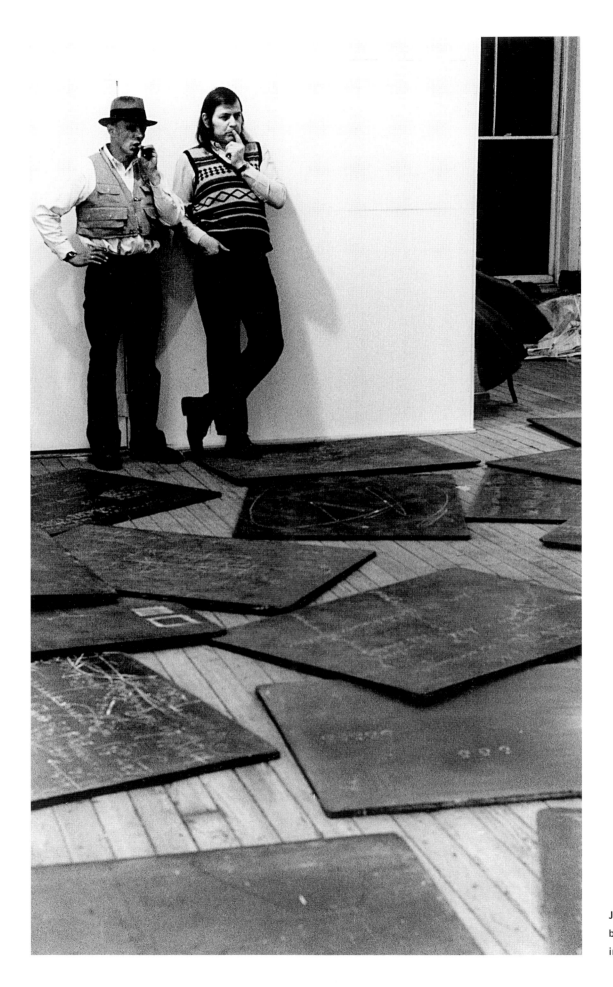

Joseph Beuys and René Block
building the exhibition 'Richtkräfte'
in New York, 1975

Fluxus instead of luxury (Fluxus statt Luxus). 'People like René Block cannot fail,' Joseph Beuys is reputed to have once said.[1] The recipient of this praise, at least since founding his gallery in Berlin in 1964, has tirelessly and very successfully championed two artistic currents that created a furore, particularly in the 1960s: the activities of Joseph Beuys and the international Fluxus movement. The opening exhibition in the autumn of 1964, with the pointed title 'Neodada, Pop, Décollage, Kapitalistischer Realismus', introduced the Fluxus artist Wolf Vostell, but also, among others, Gerhard Richter, K. P. Brehmer and Sigmar Polke, who were then just promoting their Capitalist Realism style of painting. René Block dedicated exhibitions to this artistic direction again and again. In December of the same year, Joseph Beuys presented his legendary performance *Der Chef* (The Chief) in the gallery. In this performance Beuys rolled himself up in a large roll of felt for eight hours. During this time he used a microphone to transmit strange, quasi-animalistic grunting noises to the public. Subsequently, in October 1966, he presented the action *EURASIA*, in which the artist guided a hare, fastened to a bulky wooden framework and with its paws extended by *c.* 180 cm sticks, through the exhibition room. Finally, in May 1972, Beuys presented the garbage collected

'Hommage à Lidice', 1967.
The works in this exhibition
were a gift from the artists
to the Czech village of Lidice.
Works by, among others:
Sigmar Polke, Bernd Koberling,
Joseph Beuys, K. P. Brehmer,
Dieter Roth, C. O. Paeffgen,
Gerhard Rühm, Stefan Wewerka,
Gotthard Graubner and
Günther Uecker

from his *Ausfegen* (Sweeping Up) action at Galerie René Block. Joseph Beuys had swept up Karl Marx Square in the Berlin neighbourhood of Neukölln after the May Day workers' holiday, thereby appealing for an ideology-free, and thus 'cleanly swept' consciousness among the proletariat and left-wing students.

The Fluxus movement as a whole, however, was the artistic current that more or less consistently determined the programme in the Galerie René Block until its closure in 1979. From December 1966, all important Fluxus artists, from George Brecht to Dieter Roth, from Robert Filliou to Alison Knowles, exhibited often in the rooms in Schaperstraße. In the summer of 1965 Charlotte Moorman and Nam June Paik gave their first 'Berlin Concert'. Important group shows also took place there, such as the 'Hommage à Berlin' (1965) with Bazon Brock, Stanley Brouwn and K. H. Hödicke. This was followed two years later by the exhibition 'Hommage à Lidice' with Joseph Beuys, Gerhard Richter, Sigmar Polke and Blinky Palermo, among others. Music festivals and the European premiere of Erik Satie's *Vexations* were also included in Block's dedicated programme. Among his other activities in the 1970s, Block introduced the Fluxus publishing house 'Something Else Press', held a film evening with Marcel Broodthaers, and presented 'Flux objects from the cellar of George Maciunas', the movement's artistic organizer. Then it was Joseph Beuys who, in 1979, gave the final exhibition in the Berlin gallery. Its laconic title was 'Ja jetzt brechen wir den Scheiss hier ab' (Yes, now we're quitting all the shit here).

Above, left: *music while you work* by Arthur Køpcke, performed by Arthur Køpcke, Emmett Williams, Al Hansen, Charlotte Moorman, Tomas Schmit, Robert Filliou, Marianne Filliou and Carolee Schneemann at the Festum Fluxorum, Berlin, 1970

Above, centre: 'Sweet Wall' action by Allan Kaprow, 1970

Above, right: Nam June Paik, *Der Denker*, 1976–78

Profitably selling the Fluxus artists' ephemeral works, which were generally made from cheap, fragile materials, was still a great problem at that time – even though Wieland Schmid asserted: 'René Block was…the born art dealer for Fluxus'.[2] Nonetheless, in 1974, Block opened his New York gallery in a Manhattan loft. Even with the gallery's opening show he made art history once again: Joseph Beuys staged his performance *I like America and America likes me*, in which the artist, wrapped in a piece of felt, remained penned up for three days in the gallery room with a coyote, and entered into a dialogue with the animal (see the illustration on p. 14). During the next three years in New York, Block showed artists such as Nam June Paik and Arthur Køpcke, Reiner Ruthenbeck and Rebecca Horn.

Even after his gallery's closure, René Block continued his engagement for Fluxus – in the DAAD Gallery in Berlin between 1982 and 1992, for example, and in numerous exhibition projects such as the 1985 'Biennale des Friedens' in Hamburg, and 'The Readymade Boomerang' in 1990 during the 8th Biennial of Sydney. Today, René Block is head of the Museum Fridericianum in Kassel, where he repeatedly offers Fluxus artists a fascinating forum, but has also built up a reputation with exhibitions on the theme of 'periphery'. 'Fluxus in Germany', which Block put together in 1995 for the 4th Istanbul Biennial, still travels to international institutions.

RAIMAR STANGE

1 Wieland Schmied, in *Mit dem Kopf durch die Wand*, exhib. cat., Wuppertal, 1996, p. 153
2 Ibid., p. 151

Leo Castelli Gallery

YEAR OF FOUNDATION
1957

FOUNDER
Leo Castelli

ADDRESS
1957–76 **4 East 77th Street, New York**
(on the third floor, founded by Castelli and Ileana Sonnabend)
1969–88 **Castelli Graphics, 4 East 77th Street, New York**
1971–99 **420 West Broadway, New York**
1980–88 **142 Greene Street, New York**
1988–98 **578 Broadway, New York**
SINCE 1999 **59 East 79th Street, New York, run by Barbara Bertozzi**

ARTISTS REPRESENTED

Richard Artschwager, Lewis Baltz, Miquel Barceló, Robert Barry, Jean-Charles Blais
Lee Bontecou, James Brown, Daniel Buren, John Chamberlain, Alan Charlton, Sandro Chia
Christo, Joseph Cornell, Hanne Darboven, Jan Dibbets, William Eggleston, Dan Flavin
Gérard Garouste, Alberto Giacometti, Richard Hamilton, Keith Haring, Douglas Huebler
Jasper Johns, Donald Judd, Ellsworth Kelly, Frederick Kiesler, Yves Klein, Joseph Kosuth
Roy Lichtenstein, Mario Merz, Robert Morris, Bruce Nauman, Kenneth Noland
Claes Oldenburg, Robert Rauschenberg, James Rosenquist, Ed Ruscha
Robert Ryman, David Salle, Julian Schnabel, Richard Serra, Keith Sonnier
Doug Starn, Mike Starn, Frank Stella, Robert Therrien, James Turrell
Cy Twombly, Meyer Vaisman, Claude Viallat, Andy Warhol, Lawrence Weiner

Leo Castelli in his gallery in SoHo, 1980s

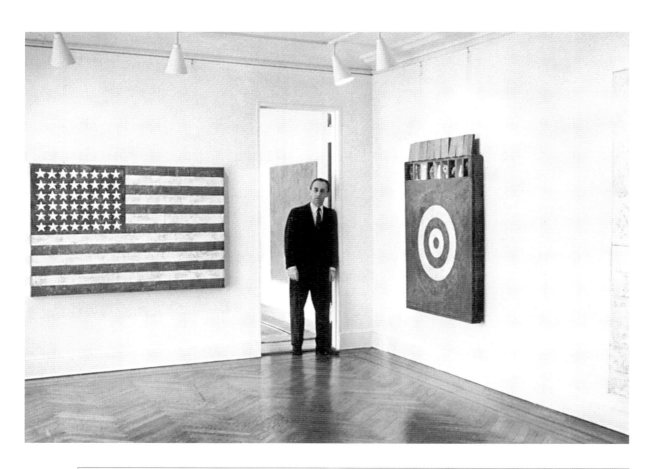

Leo Castelli at the Jasper Johns
exhibition, 1958

A place where art history was made. Willem de Kooning once said, 'Give Leo Castelli two beer cans and he could sell them.' Upon hearing that remark, Jasper Johns made a sculpture of two cans of Ballantine Ale. Castelli sold the piece to Pop Art collector Robert Scull for US$960. In 1973 Scull sold it at auction for US$90,000.[1] For much of his legendary career, Leo Castelli had the Midas touch – and so much more. One of the most important dealers of all time, he was so powerful that, due to his promotion of Pop Art and Minimalism in the late 1950s, he has been held responsible for the demise of the first group of American artists to achieve international influence – the second generation of Abstract Expressionists.

Leo Castelli did not discover many new artists. His interest was in detecting new movements. Nor did he lure artists away from other galleries. Artists were drawn to him. Representing top artists, generating astronomical sales and effectively building an empire, Castelli created a blueprint for generations of dealers to follow. But Castelli's powerful reign was characterized more by his role as a true art aficionado and benefactor than as a market-driven capitalist. A true champion of artists, he was an early advocate of giving them stipends against sales, and gave them increased exposure by encouraging mutually supportive collaborations and networks between dealers, a move that also minimized competition. To the delight of his artists, art always came first. To the chagrin of his staff, business came second. His earnings went towards the realization of difficult and large projects, and into the development of his gallery, which he treated like a museum. And he treated his artists like friends, holding their opinions in high regard. Critics did not dictate Castelli's aesthetic

choices; rather, he wanted to hear what artists had to say about other artists. This mutual respect engendered fiercely supportive and long-term relationships. Indeed, very few artists left him.

Castelli was born 4 September 1907, in the Austro-Hungarian port city of Trieste.[2] He followed in his father's footsteps in banking, studied law and went into insurance, all with a widely documented lack of enthusiasm. In 1962 he married Ileana Schapira,[3] the daughter of a wealthy industrialist, who gave Castelli an opportunity to work at an Italian bank in Paris. It was there, in 1939, amidst the milieu of the Surrealists, that he opened his first gallery with furniture designer René Drouin. They were able to organize one exhibition before the outbreak of the First World War. If the seed of art appreciation was planted in Paris, it grew in New York when, in 1941, the Castellis joined the inevitable exodus of European intellectuals. It was in New York that Castelli cultivated his aesthetic sophistication, with the help of his friend, the Chilean artist Roberto Matta, his art-savvy wife Ileana, and the collection of New York's Museum of Modern Art. While working for his father-in-law's knitwear business, he began dealing in Kandinsky works on the side, eventually becoming the representative for the Kandinsky estate. Castelli's connection to Europe gave him a certain edge.

In 1949 Castelli became the main organizer of 'The Club', a popular beacon for intellectual activity. In a rented downtown space, artists such as Willem de Kooning, Ad Reinhardt, Franz Kline, Grace Hartigan, Larry Rivers, Lee Krasner and Jackson Pollock, and critics such as Harold Rosenberg, gathered for lectures and symposia

Bruce Nauman,
solo exhibition, 1968

on art. Two years later, Castelli exhibited the work of Jasper Johns and Robert Rauschenberg in the seminal 'Ninth Street Show', which included some seventy artists and drew critical attention to the accomplishments of the downtown art world, attracting major museum collectors to the gritty streets of SoHo and generating a new buzz.

The New York art scene was rapidly escalating in the late 1950s, with around a hundred galleries concentrated in two neighbourhoods: downtown, on 10th Street in the East Village, and uptown, in the 57th Street area. In February 1957 the Castellis

opened their first gallery in their East 77th Street townhouse with an exhibition of the work of American and European artists, including de Kooning, Pollock, Jean Dubuffet, Alberto Giacometti and David Smith. But it wasn't until the final show of the season, which included works by Johns and Rauschenberg, that Castelli broke new ground. Two events around this time had a profound impact on him: seeing Rauschenberg's work in 1954 at the Egan Gallery, and Johns's work three years later at the Jewish Museum. Transitional figures in the shift from Abstract Expressionism to Pop Art, these two artists were the first that Castelli signed. Johns's first solo exhibition with Castelli in 1958 landed 'Target with Four Faces' on the cover of *ARTNews*, and the death knell of Abstract Expressionism was officially rung. The following year, the Castellis divorced, but remained friends and collaborators (Ileana's Paris gallery would play a large role in introducing Castelli's artists to Europe).

The 1960s were marked by many 'firsts' for Castelli. In 1960 Frank Stella's first solo show unveiled his aluminium stripe paintings. During New York's 1962 Pop Art explosion – the year Ileana opened her own gallery in Paris – Castelli mounted Roy

Above, left: Robert Rauschenberg exhibition, 1961

Above, centre: Roy Lichtenstein's first exhibition at the Leo Castelli Gallery, 1962

Lichtenstein's first solo exhibition, in which the artist showed his signature comic-strip paintings. Warhol joined the gallery in 1964 with an exhibition of his flower paintings. In 1965 – the year that Castelli showed James Rosenquist's 84-foot-long *F-111* – Richard Bellamy closed his Green Gallery and placed many of his artists with Castelli, including Donald Judd, Dan Flavin and Robert Morris. Continuing Bellamy's early advocacy of Minimal Art, Castelli nurtured the next generation of Minimalism, exhibiting work by Judd, Morris and Flavin, and giving Bruce Nauman his first solo exhibition in 1968. He opened a warehouse space on 108th Street the

following year, inviting artists such as Richard Serra, Keith Sonnier and Eva Hesse to create site-specific works, and introducing the work of Arte Povera artist Giovanni Anselmo. The industrial space became a prototype for site-specific and process-orientated art in New York.

In the early 1970s Ellsworth Kelly, Claes Oldenburg and Edward Ruscha joined Castelli. It was also during this time that he championed the work of several Conceptual artists, including the European artists Jan Dibbets and Hanne Darboven, and the Americans Joseph Kosuth, Lawrence Weiner, Douglas Huebler and Robert Barry.

In 1971, a year after his ex-wife opened Sonnabend Gallery in SoHo, Castelli opened a gallery in the same location – 420 West Broadway. By this time, many of Castelli's artists had major museum exhibitions.

In 1974 the Jared Sable Gallery (originally founded in 1972) reopened as Sable-Castelli, a joint effort to form a commercial venue for contemporary art in Canada, marking the debut of Andy Warhol, James Rosenquist, Eric Fischl, Elizabeth Murray, Robert Smithson, Sol LeWitt and Susan Rothenberg, among others.

Above, right: First exhibition at the Leo Castelli Gallery in New York in East 77th Street, with works by Marsden Hartley, Willem de Kooning, David Smith, Jackson Pollock, Francis Picabia and Robert Delaunay, 1957

By 1977 the art market was well on its way to becoming an international industry, with power shifting from critics and curators to collectors and dealers. Financially, it was a challenging time for Castelli. Difficult to understand, Minimal and Conceptual Art were poor sellers. The proliferation of galleries brought fiercer competition. Several new galleries founded by ex-Castelli employees vied for his artists. But he persevered, often going to great lengths for his artists. To accommodate large works by artists such as Serra and Rosenquist, Castelli opened his second SoHo gallery in 1980 at 142 Greene Street. In October of that year, he mounted the group exhibition 'Architecture II' at 420 West Broadway. This was the first time a major gallery had commissioned architects to design residential buildings on speculation, a common exhibition premise for New York galleries today. Continuing his interest in collaboration, Castelli partnered with fellow gallerist Mary Boone in 1982 to present works by Julian Schnabel and David Salle. Though Schnabel was the first new artist he had signed since 1971, Castelli made his biggest sales in the booming 1980s.

In 1992 Castelli joined forces with dealer Larry Gagosian and started a special project space for large and heavy works, located on Thompson Street in SoHo, opening with the work of Walter de Maria, and followed by an exhibition of Roy Lichtenstein's bronze sculptures. Three years later Castelli married Italian art critic Barbara Bertozzi. In 1999 the once vibrant building at 420 West Broadway closed and has since been transformed into luxury condominiums. In SoHo an era had passed, while another was coming to fruition in Chelsea. Castelli and Bertozzi moved to East 79th Street, inaugurating the space with an exhibition of monotypes by Johns. Castelli died in 1999 at the age of ninety-one.

In the history of contemporary art, no dealer has loomed as large as Leo Castelli. Advancing new forms and business models, breaking down barriers between dealers and, most importantly, fostering long-term relationships with artists, Castelli helped to shape the course of American art. In 1976 he became the first recipient of the Manhattan Cultural Awards prize in the field of art for 'having discovered and encouraged an entire generation of artists',[4] a feat unlikely to be repeated, given the sheer quantity of dealers today, many of whom walk on a path created by Castelli. One only has to visit the Chelsea galleries to witness his impact: from the galleries to the dealers to the artists, Castelli has left an indelible mark on the art world. In his tenth anniversary catalogue – only one decade into his forty-year career – Annette Michelson wrote, 'The history of the Castelli Gallery will, ultimately, be that of the artists.' Without doubt, Castelli proved her claim to be completely true.

RACHEL GUGELBERGER

1 Tomkins, Calvin, *New Yorker* magazine, 26 May 1980
2 www.usajewish.com/scripts/usaj/paper/Article.asp?ArticleID=564
3 Tomkins, Calvin, *New Yorker* magazine, 26 May 1980
4 Tomkins, Calvin, *New Yorker* magazine, 26 May 1980

Donald Judd, *Untitled,* **1962**

Ferus Gallery

YEAR OF FOUNDATION
1957

FOUNDERS
Walter Hopps and Edward Kienholz
1959–66 Irving Blum was director

ADDRESS
1957–59 **736A North La Cienega Boulevard, Los Angeles**
1959–66 **723 North La Cienega Boulevard, Los Angeles**

CLOSED 1966

ARTISTS REPRESENTED
Larry Bell, Billy Al Bengston, Joseph Cornell
Richard Diebenkorn, Robert Irwin, Jasper Johns
Donald Judd, Ellsworth Kelly, Ed Kienholz
Roy Lichtenstein, Ed Ruscha, Frank Stella, Andy Warhol

Photo of Irving Blum for an advert for the Ferus Gallery in *Artforum*, September 1963

Warhol's nursery. Although the Ferus Gallery on La Cienega Boulevard, Los Angeles, lasted less than ten years, it has attained a legendary status through its association with the rise of Pop Art and as home to Andy Warhol's first solo exhibition. The gallery was founded in 1957 by Californian assemblage artist Edward Kienholz and young museum curator Walter Hopps to show the work of their artist contemporaries in North and South California. Within a year, the gallery already represented around seventy artists, and Kienholz was anxious to get out of the gallery and back into his studio. At this time, young entrepreneur Irving Blum had been hanging around New York's 57th Street galleries and the Cedar Bar getting to know the Abstract Expressionist scene, and was starting to feel the urge to move west: 'I've always had a longing for the horizontality of the West and for the weather…just on a hunch I thought I would go to L.A. and explore the idea of opening a gallery.' Ferus was, according to Blum, 'by far the most interesting – and most chaotic – gallery in Los Angeles'. Kienholz agreed to sell him his share of the gallery for US$500, and Blum became the new director. Together with Hopps, he whittled down the list of artists to about a dozen from the West Coast and aimed to have about the equivalent number from New York. They moved across the street to another premises on La Cienega and hung a sign with 'FERUS' emblazoned in big letters above the gallery's square display window.

The gallery's exhibitions encompassed all directions of West Coast art, from Abstract Expressionists such as Richard Diebenkorn and John Altoon, Assemblagists like Kienholz and Bruce Conner to minimalist Robert Irwin and Proto-Pop artist Billy Al Bengston. The Ferus programme was mixed and fast-paced, with solo shows such as Billy Al Bengston's valentine paintings, inspired by Jasper Johns's targets; Kienholz's 'Roxy's'; Jasper Johns's small sculptures shown together with borrowed Kurt Schwitters collages; and a group show of New York Abstract Expressionists, including Barnett Newman, Mark Rothko and Willem de Kooning. The turning point came in 1961, however, when Blum was introduced to Andy Warhol on a trip to New York. 'This was before Andy had his veneer,' said Blum. 'Early on he was really accessible and charming and terribly terribly sweet.' When Blum visited again some months later, Warhol showed him six or seven paintings of Campbell's soup cans. Warhol agreed enthusiastically to show them in Los Angeles, and in 1962 Ferus exhibited thirty-two soup can paintings, arranged on a shelf, which ran at eye level around the entire gallery. The show was met with general bafflement and ridicule and, when only a couple of paintings sold, Blum made the shrewd decision to cancel these sales and keep the whole group together, which he bought from Warhol for himself for a total of US$1,000 ('the best $1,000 I've ever spent'). The group was recently acquired by the Museum of Modern Art in New York for a sum reputed to be around US$15m.

With its laid-back attitude and unapologetic culture of automobiles, freeways, billboards and Hollywood stars, Los Angeles was as close an environment to 'pure Pop' as one could get. In 1962 Walter Hopps, who was by now curator at the Pasadena

Exterior view of the Ferus Gallery, Los Angeles, beginning of the 1960s

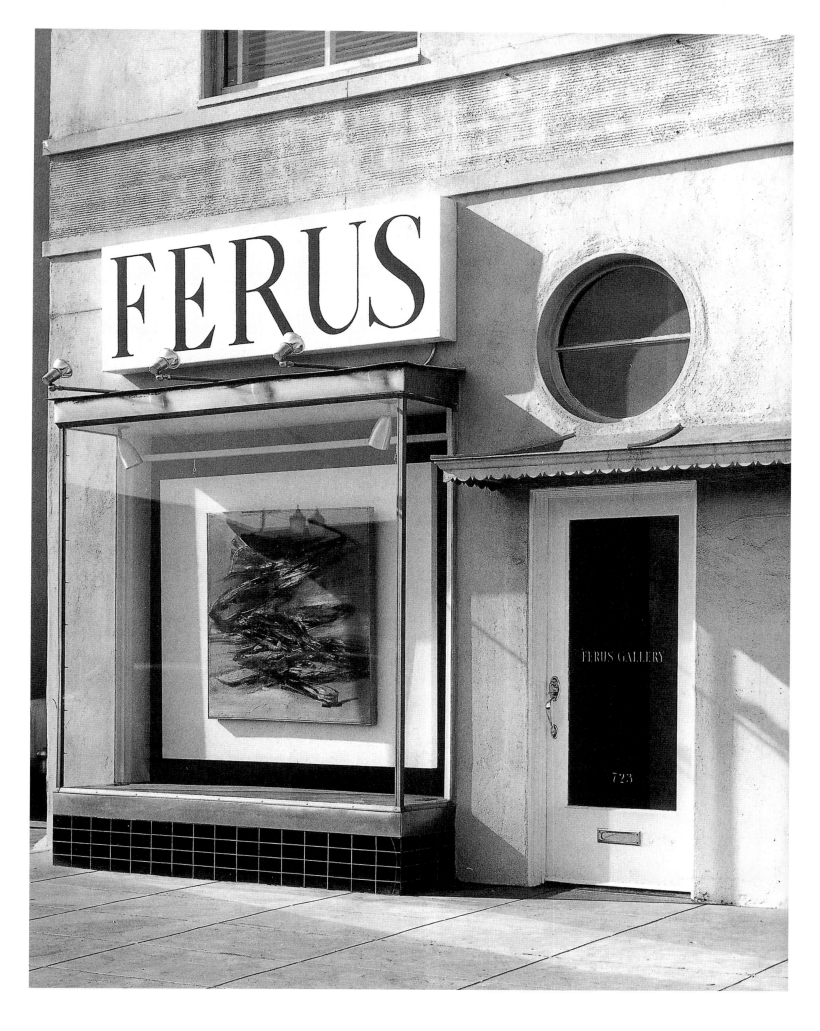

Nico, Irving Blum, Andy Warhol,
Ed Ruscha and Ken Price in
Los Angeles, 1966

Art Museum and no longer involved with Ferus, curated 'New Painting of Common Objects', the first museum exhibition of what would become known as 'Pop' Art. The show featured New York artists Lichtenstein, Warhol and Jim Dine with West Coast artists Edward Ruscha, Joe Goode and Wayne Thiebaud. Edward Ruscha's first solo show at Ferus was in 1963 with his large flat paintings of billboard logos and gas stations, which celebrated the man-made landscape of LA: 'I could almost have lived anywhere to produce art – but the inspiration came right from this city.' That year, Warhol drove across the country for his second Ferus show. He had already sent the work ahead: a roll of canvas printed with single, double and triple silk-screened images of Elvis Presley, which he left to Blum to cut and stretch into individual works. They were shown together with silk-screen paintings of Liz Taylor. These repeated iconic images, together with Warhol's declaration that a silk-screened image was a painting, signalled the height of Pop Art.

There was now a lively and intensely social art community in LA, as several new galleries had opened on La Cienega Boulevard, and a tight coterie of artists would hang out at Barney's Beanery, the West Coast's answer to the Cedar Bar. Ferus was the home gallery for most of these artists, but also played an important role in introducing them to the work of their East Coast contemporaries, among them minimalists Donald Judd, Carl Andre and Frank Stella. Over the next few years, as the flare of Pop waned, Ferus turned more towards the geometries of Ellsworth Kelly, Stella

and Bengston's new Chevron paintings. But, for Blum, the height of the gallery had been during the Pop years: '...at that point the West Coast artists and those I was showing from back East seemed to have reached a kind of parity.... But that soon began to shift. The East Coast artists began to dominate...and it soured the situation.' He closed Ferus in 1966.

KIRSTY BELL

Poster for a Roy Lichtenstein
exhibition at the Ferus Gallery, 1964

123

Robert Fraser Gallery

YEAR OF FOUNDATION

1962

FOUNDER

Robert Fraser

ADDRESS

69 Duke Street, London

CLOSED 1969

ARTISTS REPRESENTED

**Clive Barker, Hans Bellmer, Peter Blake, Derek Boshier
Patrick Caulfield, Harold Cohen, Bruce Conner, Jim Dine
Jean Dubuffet, Richard Hamilton, Jann Howarth
Alain Jacquet, Horst Egon Kalinowsky, Konrad Klapheck
Richard Lindner, Roberto Matta, Henri Michaux
Claes Oldenburg, Eduardo Paolozzi, Robert Rauschenberg
Bridget Riley, Harold Stevenson, Cy Twombly, Andy Warhol**

Robert Fraser in his gallery, mid-1960s

Art, drugs and rock 'n' roll. Robert Fraser is best known as the person hand-cuffed to Mick Jagger in Richard Hamilton's famous painting *Swingeing London*, taken from tabloid newspaper photographs of the two in a police van after being convicted of drug possession. Apart from being what Keith Richards described as a 'gentleman junkie' and gay London dandy with a circle of fashionable and glamorous friends, Fraser was also owner of London's hippest gallery, open from 1962 to 1969. The gallery in Duke Street became a centre point for the swinging London scene and all that was new in art, fashion and music, earning Fraser the nickname 'Groovy Bob'.

Fraser, the son of a successful city banker, was educated at Eton and had a brief and undistinguished career as an officer in the Kings African Rifles before deciding to move to New York in the late 1950s to find out more about the art world. In the four years he spent there, he became friends with artists Ellsworth Kelly and Jim Dine and was neighbours with Robert Indiana and Agnes Martin. Inspired by the New York scene and growing interest in American art, he decided to return to London and establish his own gallery there as a 'way of being able to show the top American painters'. He had the Duke Street shop redesigned by visionary British architect Cedric Price, who turned it into a bright white space, quite unlike the other gloomy Cork Street galleries, most of which dealt in 'modern', largely Impressionist work. Fraser began immediately with a sophisticated programme of avant-garde contemporary work, opening with black-and-white drawings and gouaches by Jean Dubuffet, with exhibitions by Richard Lindner, Henri Michaux and Matta in the following months. Having been in New York at the start of the 1960s, he had missed the beginnings of London's own Pop Art movement but caught up quickly, going on to show Peter Blake, Patrick Caulfield, Clive Barker, Derek Boshier and Bridget Riley as well as founding Pop artists Eduardo Paolozzi and Richard Hamilton. He had a sharp eye and an intuitive understanding of art as well as impeccable style that meant his exhibitions were consistently elegant and innovative. By 1965 the gallery had become the focal point for the extraordinary cultural renaissance and social revolution that was transforming London from the 'Big Smoke' into 'Swinging London'. His exhibition openings attracted a glamorous crowd made up not only of radical young artists but also rock stars like The Beatles and The Rolling Stones, along with groupies Marianne Faithfull and Anita Pallenberg, and actors Terence Stamp and Julie Christie. Even Marlon Brando made an appearance one night. The scene continued at his Mayfair apartment, with endless parties where marijuana and later LSD were in plentiful supply and films by young filmmakers like Kenneth Anger were screened. It became 'a veritable mecca for the movers and groovers of the sixties' scene'.

Fraser was the first to show the American Pop artists Jim Dine, Claes Oldenburg and Andy Warhol, also arranging an impromptu screening of *Chelsea Girls* at his apartment. His 1966 group show 'L.A. Now' introduced Ed Ruscha, Dennis Hopper, Larry Bell and Bruce Conner to London. It was Fraser who convinced The Beatles to

Richard Hamilton, *Swingeing London*, 1967. Robert Fraser is on the left, with Mick Jagger on the right

commission Peter Blake to design the cover for their Sergeant Pepper album and suggested Hamilton, who came up with the bare white cover for what came to be known as *The White Album.* He lived a decadent life with a penchant for good suits, expensive shirts and champagne lunches, not to mention the array of recreational drugs that were starting to appear. While most of the artists he worked with appreciated his clear and intuitive approach to their work, he was notorious for not paying them. He was a terrible businessman, constantly being baled out of sticky financial situations by his family, and, although he would drive around in a chauffeur-driven white Rolls Royce, he would invariably pay his artists with cheques that were unsigned or bounced, or indeed not at all. With his wealthy aristocratic background, there was a huge gulf between him and the artists he worked with: he simply did not understand that they could be dependent on his payments for their livelihood. As Patrick Caulfield put it, 'It's difficult to swing if you haven't got any money.'

Fraser's notoriety attracted its fair share of scandal from the still straight-laced British establishment. In 1966 a group of twenty-one drawings and watercolours by Jim Dine were seized by Scotland Yard, and the gallery was prosecuted for obscenity under the archaic 'Vagrancy Act'. A year later, Fraser was at Keith Richards's house when it was raided, and he was arrested along with The Rolling Stones for possession of drugs. There was a huge scandal in the tabloid press, and all were found guilty. The case went to appeal. While Keith Richards and Mick Jagger had their sentences overturned, Fraser's appeal was rejected and he was sentenced to six months in London's Dickensian Wormwood Scrubs prison. Having been caught with the much more serious drug heroin (as opposed to the amphetamines and hallucinogenics found on the Stones), coupled with his aristocratic and Etonian background, he was made an example of. The gallery closed and went into receivership, although Richard Hamilton organized a couple of exhibitions while Fraser was in jail. Once he came out, he continued with shows by Caulfield, a Happening by John Lennon and Yoko Ono, and a three-hour afternoon exhibition by young artists Gilbert & George, but his heart was no longer in it. He had lost interest and finally closed the gallery in 1969. 'I've closed,' he said, 'because I didn't want to become a middle-aged art dealer and I felt I had had enough.'

He spent much of the 1970s in India and returned to London to open a new gallery in the early 1980s, but this was short-lived. He became very sick, one of the first in London to be diagnosed with AIDS, and died in 1986.

KIRSTY BELL

'The American Scene' exhibition, with works by Jim Dine, Roy Lichtenstein, Claes Oldenburg, Andy Warhol and others, 1967

Galerie Heiner Friedrich

YEAR OF FOUNDATION
1963

FOUNDERS
Six Friedrich, Heiner Friedrich and Franz Dahlem

ADDRESS
1963–90 **15 Maximilianstraße, Munich**
1990–97 **15 Cuvilliésstraße, Munich**
1997–98 **2 Konradstraße, Munich**
SINCE 1998 **18 Steinheilstraße, Munich**
1970–75 **50 Bismarckstraße, Cologne**

CLOSED 1975

ARTISTS REPRESENTED
Carl Andre, Siegfried Anzinger, Georg Baselitz, Walter Dahn, Hanne Darboven
Georg Jiri Dokoupil, Gilbert & George, Stephan Huber, Donald Judd, Anselm Kiefer
Imi Knoebel, Raimund Kummer, Sol LeWitt, Thomas Locher, Walter de Maria
Blinky Palermo, A. R. Penck, Arnulf Rainer, Robert Rauschenberg, Thomas Rentmeister
Gerhard Richter, Ed Ruscha, Reiner Ruthenbeck, Robert Ryman, Fred Sandback
Andreas Schulze, Richard Serra, Cy Twombly, Franz Erhard Walther

Heiner Friedrich conversing with a visitor to his stand at the 'Kölner Kunstmarkt', 1970

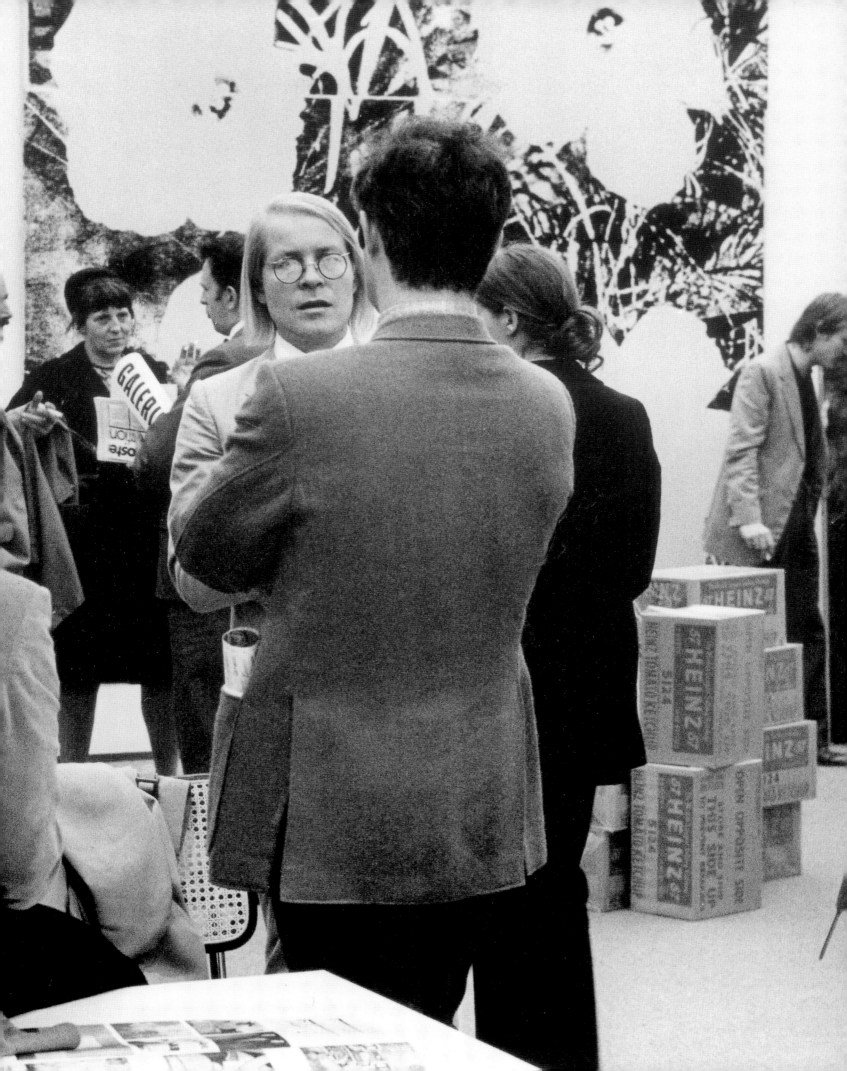

German-American friendship. In 1963 Franz Dahlem and the couple Six and Heiner Friedrich founded the Galerie Friedrich & Dahlem in Munich. All three were relatively inexperienced in the art business, and thus their first exhibitions are hardly worth mentioning: 'We screwed up a lot,' Six Friedrich later said with extreme frankness.[1] In 1964, however, the three were already showing pictures by Gerhard Richter and Cy Twombly, followed a year later by paintings by Georg Baselitz and graphics by Robert Rauschenberg. Six and Heiner Friedrich parted from Franz Dahlem at that time.

In the following years the gallery, now called Galerie Heiner Friedrich, quickly became a ground-breaking pioneer in the field of American art. In 1968 important exhibitions by Walter de Maria, Carl Andre, Robert Ryman, Sol LeWitt, Fred Sandback and Dan Flavin took place here. Walter de Maria's project was the most legendary: he filled the Munich gallery a metre deep with dark earth. This *Earthroom* is still considered one of the classics of so-called Land Art. Minimal Art – then just gaining slow acceptance – also became important in the gallery's agenda. Thus at the time Heiner Friedrich consistently backed apparently unsaleable art. The gallery also did considerable service to contemporary German art in these years, showing the work of the twenty-three-year-old Peter Heisterkamp in 1966, who called himself Blinky Palermo, and Franz Erhard Walther's *Leihobjekte* in 1967.

The 'Demonstrative 1967' exhibition, with Konrad Lueg, Sigmar Polke, Blinky Palermo and Gerhard Richter in the Studio DuMont, organized by Heiner Friedrich as an alternative event to the 'Kölner Kunstmarkt', Cologne, 1967

133

134

Blinky Palermo in the Galerie
Friedrich & Dahlem during an
exhibition of his paintings and
drawings, 1966

Six Friedrich and Fred Sandback,
mid-1970s

At the end of the 1960s the Friedrichs divorced. Heiner Friedrich opened a branch in Cologne in 1970. In 1971 he moved to the USA, where he married the millionaire heiress Phillipa de Menil, and with her he founded the Dia Art Foundation in New York City in 1974. There he continued to promote American art intently.

Six Friedrich remained in Munich and initially operated the gallery together with Fred Jahn and Sabine Knust. Under the name 'Editionen der Galerie Heiner Friedrich', the gallery turned limited company-produced editions of object multiples. Beginning in 1980, however, Six Friedrich dedicated herself to actual gallery work again, showing works by Siegfried Anzinger in her first new 'real' exhibition. In the same year there followed presentations by A. R. Penck, Arnulf Rainer and an installation by Fred Sandback. At the beginning of 1982 Six Friedrich and Sabine Knust parted company; Fred Jahn had already become independent by then. Sabine Knust became involved with the Maximilian Verlag, while Six Friedrich took sole charge of the actual gallery. In the early summer of that year she surprised everybody with Andreas Schulze's first solo exhibition. Important, primarily young artists whom she had 'discovered' followed, such as Stephan Huber and Walter Dahn.

In 1998 Six Friedrich founded the GalerieSixFriedrichLisaUngar with Lisa Ungar. Many prominent names such as Siegfried Anzinger, Andreas Schulze and Stephan Huber remained in their programme. Even after forty years of gallery work, Friedrich still believes that, 'Through new artists, continually new horizons open up.'[2]

RAIMAR STANGE

1 In *Kunstforum International*,
 Vol. 104, November/December
 1989, p. 247
2 Ibid., p. 249

Gerhard Richter and
Heiner Friedrich at the
Richter exhibition, 1966

Green Gallery

YEAR OF FOUNDATION
1960
FOUNDER
Richard Bellamy
ADDRESS
1960–65 **15 West 57th Street, New York**
CLOSED 1965

ARTISTS REPRESENTED

Milet Andreyevich, Jo Baer, Darby Bannard, Robert Beauchamp
Lee Bontecou, Sally Hazelet Drummond, Jean Follet, Miles Forst
Yayoi Kusama, Tadaaki Kuwayama, Roy Lichtenstein, Robert Morris
Kenneth Noland, Claes Oldenburg, Pat Passlof, Larry Poons
James Rosenquist, Lucas Samaras, George Segal, Richard Smith
Myron Stout, Mark Di Suvero, Robert Whitman, Phillip Wofford

Richard Bellamy and James Rosenquist at the opening of the latter's exhibition, 1964

Instinct for new art. Among the first to treat commercial space as an arena for artistic experimentation and innovation, art dealer Richard Bellamy opened in 1960 what is considered by many to have been the prototype for the alternative art space: the Green Gallery. With a focus more on art than on the art market, the gallery survived for only five years, but in that short time Bellamy broke through the dominance of Abstract Expressionism, launching the careers of several artists who would go on to become leading figures of Pop Art, including Claes Oldenburg, James Rosenquist and Tom Wesselmann. He was also an early advocate of Minimal Art, showing the work of Mark di Suvero, Dan Flavin, Donald Judd and Robert Morris.

Though he was a champion of the new, Bellamy was keenly disinterested in trends. In 1969, speaking about Pop Art, he said: 'I didn't see it as a new phenomenon, or see the artists as some "brand new" breed. I saw them in a studio context, and my art experience of their work was continuous and not different to any other. The aesthetic sensation was not the "brand new" product people were talking about. It's the sensibility of any new work you have to touch on.'[1]

It was this even-handed approach to art that allied him so closely with artists. George Segal described his first dealer as follows: '...a delicate poet, the sensitive fellow, who was responsive to the nuances and delicacies of new art movements. A strange fellow, with an uncanny instinct for what was new and marvellous in

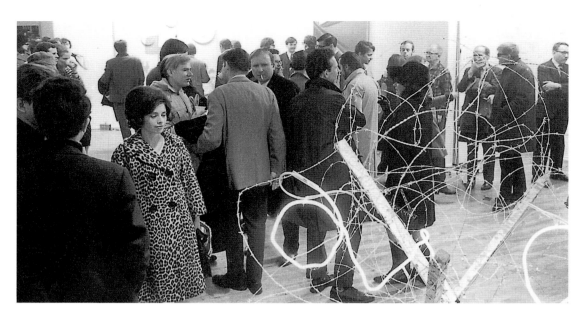

modern art. As such, I was drawn to him, like a shot. Here was an art dealer who could share the mental life of the artist whom he was representing. He had an incredible instinct for new art.'[2] That instinct was confirmed in 1962 when the Sidney Janis Gallery presented 'The New Realists', a seminal exhibition that included the works of such artists as Oldenburg, Rosenquist, Segal and Wesselmann. This celebrated exhibition is still widely recognized today as the moment that sounded the 'boom' of Pop Art. Yet these artists had already exhibited earlier that same year at the Green Gallery: Rosenquist in February, Segal in May, Oldenburg in September and Wesselmann in November.

Born in Cincinnati in 1927, Richard Bellamy moved to Provincetown, Massachusetts, in 1949, where he quickly gravitated towards the artists at the Hans Hofmann School. In 1952 several of Hofmann's acolytes – including Wolf Kahn, Allan Kaprow, Jan Muller, Segal and Richard Stankiewicz – opened one of the first New York art collectives, the legendary Hansa Gallery, named after their former teacher. Established as a provisional exhibition space until the group found an uptown dealer, the Hansa Gallery became an alternative to the impenetrable 57th Street gallery scene, and in 1995 Bellamy became the director. Bellamy said that the young members of the Hansa 'felt that it was...an idealistic kind of bastion'.[3]

In the face of financial difficulty, Hansa closed in 1959. The following year, with the backing of taxi-fleet owner Robert Scull – Pop Art's first leading collector – Bellamy opened the Green Gallery on West 57th Street. Thus began a five-year journey that wrote Bellamy – and many of today's most successful artists – into the history books. Driven by Bellamy's keen eye and sense of the new, the Green Gallery accumulated a series of 'firsts': the first solo shows for sculptor Mark di Suvero (1960), Robert Morris (1963) and James Rosenquist (1963), the first exhibition of Flavin's fluorescent light sculptures (1964), the first exhibition of Donald Judd's cadmium red painted wood sculptures (1963), the first exhibition of Richard Smith's colour field paintings (1961) and the first exhibition of Oldenburg's soft

sculptures (1962). Oldenburg's soft sculpture debut – a hamburger, an ice cream cone and a piece of cake – followed his famous 1961 presentation of 'The Store', a massive installation co-organized by the Green Gallery, in which he presented art and objects for sale in an avant-garde fusion of art and consumerism.

But although Bellamy's exhibitions were often big victories (the works in Rosenquist's first show almost sold out before the opening), Bellamy was never fully comfortable being an art dealer. 'I was probably trying to disassociate myself from the nasty business end of art,' he said, 'and trying to assert my disinterested idealistic preoccupation with it.'[4] Continuing in the cooperative tradition of Hansa, Bellamy saw his gallery as more than just a place for collectors to view art for sale – it was a place for experimenting with new forms and new media. Even his exhibition announcement cards – with their exploration of layouts and graphics, and their inclusion of poetry or art criticism – became arenas for artistic expression. However, a decline in sales and increasing competition ultimately forced the Green Gallery to close in 1965, but Bellamy's reputation as a first-rate art connoisseur remained intact, as did his loyalty to his artists – he personally placed most of them in the care of fellow dealers Leo Castelli and Sidney Janis.

Robert Morris, solo exhibition, 1964

View of a group exhibition, with works by Robert Morris, Larry Poons, Kenneth Noland, Tadaaki Kuwayama, Donald Judd, Frank Stella, Darby Bannard and Ellsworth Kelly, 1963

In the early 1960s, with increasing international attention focused on American art, the New York market gained momentum, while collecting art became something of a status symbol.[5] As the market grew, however, so did competition among dealers. From the beginning, Bellamy shared costs with his artists. Then, when the gallery began to make a modest profit in 1963, he began paying them monthly stipends and higher commissions. However, some of his artists switched dealers for even more lucrative opportunities (in 1964 Rosenquist left for Castelli, and Segal for Janis). Still, select purchases from the Green Gallery – made by collectors such as Howard Lipman, Richard Baker and Philip Johnson – landed Bellamy's artists in major museum collections, including the Museum of Modern Art and the Whitney Museum of American Art. Much to the chagrin of many artists and critics, Scull made the largest profits. At an infamous 1973 Sotheby's auction, he sold fifty works for a sum of US$2.2m; among them were a Larry Poons painting (bought for US$1,000, sold for US$25,000) and a Lucas Samaras piece (bought for US$450, sold for US$20,000) – both purchased from the Green Gallery. When the gallery closed in 1965, Barbara Rose published 'ABC Art' in *Art in America*. The history of Minimal Art was born.[6]

Bellamy continued to be a force in New York's contemporary art scene, organizing exhibitions of such major artists as Richard Artschwager, Richard Serra and Keith Sonnier. In 1971 he became a founding board member of PS 1 Contemporary Art Center in Long Island City, and in 1980 he founded one of the first art spaces in Tribeca – the Oil & Steel Gallery. When Bellamy died in 1998, the *New York Times* art critic Roberta Smith wrote that the he was 'known for his brilliant eye, his skill at installing exhibitions, his love of tennis, his "towering modesty" (as his shyness was sometimes called) and his devotion to new art and its creators'. That same year, PS 1 founder Alana Heiss invited Bellamy's son Miles to organize an exhibition that

Dan Flavin, solo exhibition, 1965

epitomized his father's sensibility. The guest speakers at the memorial held in conjunction with the exhibition included di Suvero, Rosenquist, Segal, Serra, Rose, Agnes Gund, Ivan Karp and Christophe de Menil.

RACHEL GUGELBERGER

1 Suzi Gablik, interview with Richard Bellamy, *Studio International*, 1969
2 Amber Edwards, interview with George Segal for *George Segal: American Still Life*, PBS, 1998–99
3 Richard Baker, interview with Richard Bellamy, Smithsonian Archives of American Art, http://artarchives.si.edu/oralhist/bellam63.htm, 1963
4 Ibid.
5 William G. Morrison, 'Economics and Economic Perceptions of the Art Market', http://collection.nlc-bnc.ca/100/202/300/artbus/1996/artbus.b06/banktwentyone.html.
6 Barbara Rose. 'ABC Art', *Minimal Art: A Critical Anthology*, edited by Gregory Battcock, University of California Press, Los Angeles, 1968

Galerie Yvon Lambert

YEAR OF FOUNDATION
1961

FOUNDER
Yvon Lambert

ADDRESS
1961–65 **Place du Grand Jardin, Vence**
1965–67 **29 Rue de Seine, Paris**
1967–77 **15 Rue de l'Echaudé, Paris**
1977–89 **5 Rue du Grenier Saint-Lazare, Paris**
SINCE 1986 **108 Rue Vieille du Temple, Paris**
SINCE 2003 **564 West 25th Street, New York**

ARTISTS REPRESENTED
Francis Alÿs, Alice Anderson, Carl Andre, Robert Barry, Pierre Bismuth
Christian Boltanski, Slater Bradley, Spencer Finch, Nan Goldin
Douglas Gordon, Jenny Holzer, Jonathan Horowitz, Koo Jeong-A
On Kawara, Anselm Kiefer, Joey Kötting, Bertrand Lavier
Claude Lévêque, Jonathan Monk, David Shrigley
Ross Sinclair, Vibeke Tandberg, Niele Toroni, Salla Tykkä

Yvon Lambert in the entrance to his gallery in Rue Vieille du Temple, Paris, 1990s

The patron. In the summer of 2000 the entire Paris art and fashion world flocked to Avignon for the opening of the 'Lambert Collection'. Displayed beneath the gilded stucco of the Hôtel de Caumont, a little 18th-century architectural jewel, were several hundred works collected by the Paris gallerist Yvon Lambert during his career, which spanned nearly forty years. This event demonstrated incomparable appreciation for a dealer who was always active in France – a country that may have invented the art trade but behaves with shameful diffidence towards it nevertheless.

After the 1986 opening of his new showroom, located on Rue Vieille du Temple and with an overwhelming glass roof spanning most of its 800 square metres of space, followed by his appointment as chairman of the Comité d'Organisation de la Foire d'Art Contemporain de Paris (FIAC) in 1996, the event in Avignon proved the third step on the victor's rostrum for Yvon Lambert. This elegant, refined and calmly smiling man, a genuine patron of the French art scene, can now look back with pleasure on his achievements since opening a tiny gallery in 1961 in his home

Bertrand Lavier, *Vitrines*, **2000**

town of Vence, where he proudly exhibited the works of regional painters and dreamt of Kahnweiler.

The gallery quickly took on its full dimension thanks to its Paris branch, initially opened in 1965 in a small room on Rue de Seine and later moving to Rue de l'Echaudé. In the first exhibitions with works on paper accompanied by small leaflets, art and literature were combined in a very French tradition: Jules Pascin and Paul Morand, Jean Hélion and Francis Ponge. Saint-Germain-des-Prés was in a complete uproar at the time. Between the remnants of an abstract, handed-down painting style, collectively labelled School of Paris (École de Paris), emerged dealers who presented a radically new type of art: on Rue des Beaux-Arts Iris Clert was showing Nouveau Réalisme and its periphery, while on Boulevard Saint-Germain Denise René was representing Geometrical Art. The epiphany for Yvon Lambert, however, came on Rue Mazarine: 'The most significant gallery for me was the Sonnabend Gallery. It showed Pop Art in its entirety. That hit like a bomb. There I saw the first works by Robert Rauschenberg, Jasper Johns, Andy Warhol, Jim Dine and Claes Oldenburg: These works were full of humour.'

In the same period, due to his visit to the now legendary exhibition 'When Attitudes Become Form', organized by Harald Szeemann in Berne, he ultimately became convinced of the urgency of showing American art in Europe. Yvon Lambert, in fact, recognized that after Pop Art 'Conceptual Art and Land Art are two outstanding artistic currents', and accordingly exhibitions featuring Robert Barry, Hamish Fulton, On Kawara, David Lamelas, Sol LeWitt, Richard Long, Robert Ryman and Lawrence Weiner took place on Rue de l'Echaudé. In 1968 Jean-Michel Sanejouand executed two 'organizations of space' for him there. At the same time, a showroom was opened a stone's throw away on Rue Bonaparte

by Daniel Templon, a former sports instructor, who exhibited works by Victor Burgin, Donald Judd and Joseph Kosuth: the School of Paris was finally dead and buried. Perhaps Gordon Matta-Clark was ironically searching for their remains when, in 1976, he cut a square hole 40 centimetres across and 4 metres deep in the gallery floor.

Despite the lack of enthusiasm on the part of French collectors, Yvon Lambert weathered his first ten years in Paris thanks to his unfailing business sense and his affiliations in the European art scene. Commenting about this period, he said: 'There were no art fairs at that time, but an unofficial network developed with Lisson in London and Konrad Fischer in Düsseldorf. I found myself in a very lonely position. For example, the people taking care of planning for the Centre Georges Pompidou

Douglas Gordon, *Pretty much every video and film work from about 1992 until now. To be seen on monitors, some with sound, others run silently and all simultaneously*, 2003

were absolutely unreceptive to the gallery's position and suggestions. But I could count on support from Belgian, Swiss, Italian and also some German collectors. Ileana Sonnabend bought my whole Ryman exhibition from me on the evening of the vernissage, and I was mad with joy. The next morning she called to tell me that her husband was in disagreement, and cancelled the purchase. So much the better for me; I sold the pictures some time later at a much higher price.'

As the Centre Pompidou did not come to him, Yvon Lambert went to it, moving his gallery in 1977, the year the Centre was opened, into a strange square room on Rue du Grenier Saint-Lazare. With its momentum at the beginning of the 1980s, the gallery integrated various directions of new European painting into its programme, including Miquel Barceló, Anselm Kiefer, Julian Schnabel and Helmut Middendorf, as well as the best-known French artists, including Jean-Charles Blais, Robert Combas, Philippe Favier and Loïc Le Groumellec. What a shock! The

less passionate deplored the lack of taste, the less compromising cried 'betrayal'. About this stormy period, Yvon Lambert only remarks, 'I had a lot of fun', and points out that painting always held an important place in his programme, as proven by the presence of Brice Marden and Cy Twombly, who had been with him since the 1970s.

Yvon Lambert, who is a tactician after all, used the 1980s to fill his bank accounts and his address book: since that time the interior design community headed by Andrée Putman, as well as the fashion community, particularly Azzedine Alaïa and Jean-Charles de Castelbajac, have bought everything from him.

In view of painting's general decline in Europe, it has slowly been disappearing from gallery walls since the beginning of the 1990s, and Yvon Lambert has cleverly

Carlos Amorales, *The Bad Sleep Well*, New York, 2003

used a little side room directly facing the street to 'test' his emerging artists. Thus artists such as Douglas Gordon, Jonathan Monk, David Shrigley, Nan Goldin and Andres Serrano are still being added to the gallery's list of 'international young art'.

Despite forty years of effort Yvon Lambert is not in a position, any more than his colleagues, to help any artist from the French scene achieve a lasting break-through at international level. Perhaps we should turn to the news that has Paris excited in the light of this regret: Yvon Lambert is opening a gallery in the heart of Chelsea in New York, the stronghold of the American art market, to showcase the qualities of artists who have not been shown there yet, such as Carlos Amorales, Koo Jeong-A, Bertrand Lavier and Claude Lévêque. This affair will be well worth following up.

STÉPHANE CORRÉARD (WITH LILI LAXENAIRE)

Galerie van de Loo

YEAR OF FOUNDATION
1957

FOUNDER
Otto van de Loo

ADDRESS
1957–63 **25 Maximilianstraße, Munich**
1963–66 **22 Maximilianstraße, Munich**
1966–75 **60 Villa Stuck, Prinzregentenstraße, Munich**
1975–94 **27 Maximilianstraße, Munich**
1994–97 **16 Wurzerstraße, Munich**
SINCE 1998 **29 Maximilianstraße, Munich**
(run by Marie-José van de Loo)

ARTISTS REPRESENTED
Pierre Alechinsky, Karel Appel, Julia Bornefeld
Constant Gunter Damisch, Martin Disler, Pinot Gallizio
Klaus Hack, Beate Haupt, Franz Hitzler, Asger Jorn
Günther Kempf, Gustav Kluge, Alfred Kremer, Henri Michaux
Heike Pillemann, Hans Platschek, Heimrad Prem, Arnulf Rainer
Mischa Reska, Helmut Rieger, Eun Nim Ro, Antonio Saura
K. R. H. Sonderborg, Urs Stadelmann, Helmut Sturm
Yolanda Tabaneram, Richard Vogl, Maurice Wyckaert, H. P. Zimmer

Otto van de Loo, 1971

The spectacle of painting. Munich, 11 September 1957. Otto van de Loo opened the gallery bearing his own name in the attic of 25 Maximilianstraße, with an exhibition of work by K. R. H. Sonderborg. Four more exhibitions followed in the good three months remaining till the end of the year, with work by the artists Rolf Cavael, Gustav Deppe, Hans Platschek and Al Copley. The enormous speed with which new exhibitions replaced the old is synonymous with Otto van de Loo's hunger for contemporary, period-critical visual languages. 'The visual statements made by contemporary artists fascinated me, making me uneasy and inspiring my existence,' the gallery owner reminisced in 1982.

It all began immediately after the end of the Second World War in the Märkische Museum in the gallerist's hometown of Witten, where he helped with preparations for contemporary art exhibitions. On the advice of Karl Otto Götz and even before opening his gallery in Munich, in 1957 van de Loo travelled to Paris, which was still regarded as the crucible and hotbed of the latest artistic approaches. From here Otto van de Loo took the artists Asger Jorn, Antoni Tàpies, Antonio Saura and Pierre Alechinsky back to Munich with him, where the artistic climate had until then been characterized by the activities of the group ZEN 49 and, in terms of dealers, by the gallerists Günther Franke and Otto Stangl, who primarily represented the classical modern.

The gallery's programme quickly became apparent and is inseparably connected with the personality of Otto van de Loo. This was due on the one hand to van de Loo's aspiration to concentrate on contemporary positions within the widening range of available art – an attitude that secured him the only invitation to a German gallerist in 1963 to attend the 1st 'Salon international de Galeries pilotes' in Lausanne, a forerunner of the 'Kölner Kunstmarkt', which opened four years later with van de Loo's cooperation. Primarily, though, it was due to the type of art he selected: characterized by an angular, uncomfortable, and almost violent surface, with content expressing an existential impetus. Concretely this meant that at the end of the 1950s his gallery showed Informel painting, which was dominant in Europe at the time but hardly ever seen in Munich, with artists such as Sonderborg, Emil Schumacher, Fred Thieler, Emil Cimiotti, Hans Platschek, O. H. Hajek, Henri Michaux and Wols, but also Constant, Roberto Matta, Maurice Wyckaert, Gunter Brus and Arnulf Rainer, with a gestural style that enters into direct symbiosis with the figure. Van de Loo accompanied these artists' development in regular exhibitions. For the first time in Germany he presented Asger Jorn, a co-founder of the artists' group COBRA, created in 1948, and likewise presented Antoni Tàpies and Antonio Saura, whose work until then had only been exhibited in neighbouring countries. Due to his socially orientated understanding of art, Asger Jorn, who was also a close friend of van de Loo, became the mentor of the group Spur, whose members Lothar Fischer, Heimrad Prem, Helmut Sturm and H. P. Zimmer initially came together at the Munich art academy in 1957. The Danish artist also initiated contact with the Situationists in Paris, who in 1959 took the group Spur as their German section during the third S. I. conference in Munich. Initial differences

Interior view of the Galerie van de
Loo in Prinzregentenstraße, Munich

quickly became apparent when, in his opening speech, Constant called on the artists to give up their profession. The Situationists, including the movement's mastermind Guy Debord, who was also in Munich, radically advocated an anti-art attitude, which the Spur artists did not share. The refusal of the Spur group to practise inflexible iconoclasm finally led to their exclusion from the S. I.

This brought even Otto van de Loo, who was also in contact with the Situationists through Asger Jorn, into inner conflict at this moment, and not only in his function as a dealer. He saw the picture, an artistic medium towards which his entire inter-

est and engagement had been directed, declared obsolete. For him, however, the picture was not dead.

As an affiliation of 'painting advocates', the gallery now became – besides the already proven positions – an exhibition platform for the group Spur. The kick-off for this was the presentation of Spur as a group in October/November 1959. Further group exhibitions followed, as well as individual presentations by its members. As Spur and Wir – a parallel association of artists formed in 1959 in Munich with Hans Matthäus Bachmayer, Reinhold Heller, Florian Köhler, Heino Naujoks and Helmut Rieger – united in 1965 into the group Geflecht, their first public appearance took place in September 1966 in the Galerie van de Loo in the exhibition 'Antiobjekte 1965/66 Geflecht'. The group's gallerist also made a studio available in Herzogstraße, where many of the collectively developed objects were created.

Otto van de Loo also continued to 'inspire' the situational art context, and in the 1960s this increasingly had to include performative art. Thus, by opening the Forum gallery at 5 Seitzstraße in 1968, van de Loo created a platform for actions, Happenings and film screenings. For two years, artists such as Hermann Nitsch, Wolf Vostell and others expressed themselves in this location against a background of student unrest, until Helmut Sturm and artist colleagues of his opened the Kinderforum van de Loo there in 1970, which still promotes children's creativity today at 69 Schellingstraße.

Opening of the exhibition 'Raum Telemetrie' by Wolf Vostell, 1969. Visitors with sound- and light-sensitive cups

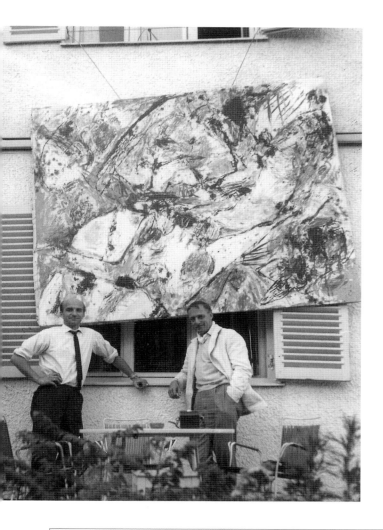

Besides the exhibition activities, numerous publications bear witness to van de Loo's intensive preoccupation with the works of the gallery's artists. Van de Loo's two-year interlude with another gallery in Essen (1959) must also be mentioned.

The gallerist has entrusted large bodies of work from his own collection, which he has compiled over the years, to a succession of public institutions. In 1992 he donated a cross section of works from his gallery programme to the Neue Nationalgalerie in Berlin, in 1994 his entire collection of prints by Asger Jorn to the Kupferstich-Kabinett der Staatlichen Kunstsammlungen in Dresden, and in 1997 a compendium of almost 200 paintings to the Kunsthalle in Emden, to name just a few.

After forty years Otto van de Loo brought his activities as an art dealer to a close. Since 1998 his daughter Marie-José has been the sole director of the gallery at 29 Maximilianstraße, and with her arrival the programme has also been modified. She consistently focuses some of her activities on bodies of work by some of the early artists such as Alechinsky, Constant, Jorn, Platschek, Saura, Sonderborg and the group Spur, as well as by Franz Hitzler, Gustav Kluge and Gunter Damisch, whom the gallery has represented since the 1980s. In addition, Marie-José van de Loo is now treading new paths with young artists.

SYLVIA MARTIN

Above, left: Otto van de Loo and Asger Jorn in front of the painting *Ausverkauf einer Seele* in Eisenacher Straße, 1959

Above, right: Marie-José and Otto van de Loo, 1998

PaceWildenstein

YEAR OF FOUNDATION
1960

FOUNDER
Arnold Glimcher

ADDRESS

1960–65 **Pace Gallery, 125 Newbury Street, Boston**
1963–68 **Pace Gallery, 9 West 57th Street, New York**
SINCE 1968 **Pace Gallery, 32 East 57th Street, New York**
SINCE 1971 **Pace Editions, 32 East 57th Street, New York**
1990–2000 **Pace Gallery/PaceWildenstein, 142 Greene Street, New York**
SINCE 1996 **PaceWildenstein, 9540 Wilshire Blvd, Los Angeles**
SINCE 2000 **PaceWildenstein, 534–548 West 25th Street, New York**

ARTISTS REPRESENTED

Georg Baselitz, Alexander Calder, John Chamberlain, Chuck Close
Jim Dine, Jean Dubuffet, Dan Flavin, Adolph Gottlieb
Barbara Hepworth, Robert Irwin, Alfred Jensen, Donald Judd
Alex Katz, Sol LeWitt, Robert Mangold, Agnes Martin, Henry Moore
Elizabeth Murray, Louise Nevelson, Isamu Noguchi, Claes Oldenburg
Pablo Picasso, Robert Rauschenberg, Ad Reinhardt
Bridget Riley, Mark Rothko, Robert Ryman, Lucas Samaras
Julian Schnabel, Joel Shapiro, Kiki Smith, Saul Steinberg
Antoni Tàpies, James Turrell, Coosje van Bruggen, Robert Whitman

Arnold Glimcher speaking with Jean Dubuffet, 1972

Lucas Samaras, Helen and George Segal, Judith Heidler, Fred Mueller and Arne Glimcher at the opening of the 'Lucas Samaras, Selected Works 1960–1966' exhibition, 1966

The unwilling gallerist. Arnold Glimcher began his career as an artist attending Boston's Massachusetts College of Art and continued in Boston University's MFA programme. It was there that he met Brice Marden, whom Glimcher would later represent. Ultimately, Arne Glimcher was not satisfied with his own artistic progress. As he later told critic Barbara Rose, 'I asked myself if the painting I was working on was as good as a Picasso. Then like a Saul Steinberg cartoon, a huge "No" resounded in the studio space.' Arne started selling and collecting art while still a student in Boston, and made a modest profit selling Käthe Kollwitz prints. When Glimcher was twenty-one his father passed away, prompting him to consider opening a gallery as a way to make money. The original Pace Gallery opened at 125 Newbury Street in Boston's fashionable Back Bay neighbourhood in 1960, financed by a US$2,400 loan from Glimcher's older brother Herb. At the time Arne was a senior at the Massachusetts College of Art, and his wife Mildred was a junior art history major at Wellesley College.

The Pace Gallery opened in a modest shopfront, which, in the beginning, was often tended by Glimcher's mother while Arne and Milly attended school. Many of the initial exhibitions comprised works by local artists and professors that Arne met at the Massachusetts College of Art. The inaugural exhibition at Pace Gallery was a group show featuring paintings by Albert Alcalay, David Berger, Jason Berger,

Lawrence Kupferman and Robert S. Newman, as well as sculpture by Mirko. In the autumn of that same year, Glimcher organized 'Four Sculptors: Arp, César, Mallary, Mirko'. The Italian sculptor Mirko was the director of the Carpenter Center at Harvard at the time, and the gallery that represented him, the World House Gallery in New York, had previously been uncooperative in allowing Glimcher to mount a one-man show in Boston. In the end, it was Glimcher's tenacity and the help of mutual acquaintances that enabled him to convince Mirko to loan a few pieces of sculpture to the exhibition.

Glimcher's friendship with the collector Allan Stone, on the other hand, enabled him to borrow César's and Robert Mallary's sculpture for the show. The Arp works in the exhibition were borrowed from the Hanover Gallery and Denise René.

Julian Schnabel exhibition, 1984

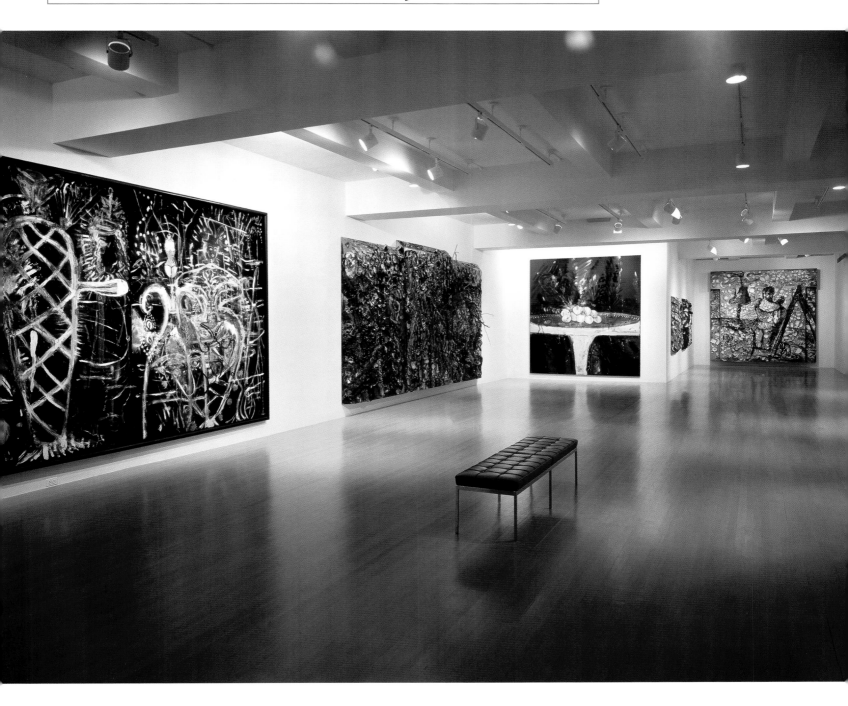

61

New works by Chuck Close, 2003

In the spring of 1961, the Pace Gallery organized a Louise Nevelson exhibition entitled 'Recent Sculpture'. As Glimcher notes, it was the help of legendary dealer Martha Jackson that allowed him to mount an exhibition of the work of such an influential figure. 'Through Ms Jackson's generosity and confidence, I was able to present an exhibition of Nevelson in my new Boston gallery. Nevelson's sculptures are large, but they broke down into units that I could load into a U-Haul truck myself and drive to Boston.... I invited Ms Nevelson to Boston for the opening, offering accommodations at the Ritz Hotel and a round trip plane ticket for which I had no way of paying. It was only the success of the exhibition that saved me. Already legendary for her eccentric costumes, I remember Nevelson arriving at the gallery on a warm May afternoon wearing enough layers of clothing to fill a closet, crowned by a huge fox hat. It was the beginning of a relationship that lasted twenty-nine years until Louise Nevelson's death in 1988.'

Now, after more than forty years in business, the Pace Gallery and PaceWildenstein (founded in 1993) have developed into one of the largest gallery empires worldwide. The Pace galleries' 'domain' currently includes PaceWildenstein, which recently moved into the Chelsea gallery district, the Pace/MacGill Gallery on 57th Street,

which specializes in photography, Pace Prints, Pace Master Prints, Pace Primitive and Pace Editions, Inc.

A good example of Arnold Glimcher's dedication to the presentation and promotion of art can be seen in his relationship with the painter Chuck Close. Barbara Rose writes: 'Glimcher's relationship to Close is among the most important of his life. His consistent support in difficult times after the laming stroke the artist suffered gave Close his self-confidence back, and this helped him to ambitiously keep on inventing and producing, despite extreme physical stress, and to redefine portrait painting.' Glimcher himself emphasizes: 'I never wanted to become a gallerist. Today you can go to an art school to become a gallerist. I am interested in the art, not in the business.'

GILBERT VICARIO

Overleaf: Installation *Of her Nature* by Kiki Smith, 1999

Louise Nevelson, 'Sculpture of the '50s and the '60s', 2002

63

Galerie Rolf Ricke

YEAR OF FOUNDATION
1963

FOUNDER
Rolf Ricke

ADDRESS
1963 **Friedrich-Ebert-Straße, Kassel**
1964-68 **44–46 Kölnische Straße, Kassel**
1968-74 **22 Lindenstraße, Cologne**
1975-76 **20–26 Rinkenpfuhl, Cologne**
1976-81 **23 Friesenplatz, Cologne**
SINCE 1982 **10 Volksgartenstraße, Cologne**

CLOSED 2004

ARTISTS REPRESENTED
Richard Artschwager, Atelier van Lieshout, Jo Baer, Larry Bell
Mel Bochner, Michael Buthe, Ingrid Calame, Barry Flanagan
Pia Fries, Michael Heizer, Eva Hesse, Franka Hörnschemeyer
Jasper Johns, Donald Judd, Barry Le Va, Fabián Marcaccio
Joseph Marioni, Oliver Mosset, Horst Münch, Bruce Nauman
Steven Parrino, David Rabinowitch, Mel Ramos, David Reed
Klaus Rinke, Ulrich Rückriem, Ed Ruscha, Fred Sandback
Karin Sander, Adrian Schiess, Richard Serra, Robert Smithson
Keith Sonnier, Jessica Stockholder, Alan Uglow, Günter Umberg, John Wesley

Rolf Ricke (lying in front) during construction of his stand for the 'Kölner Kunstmarkt', 1968

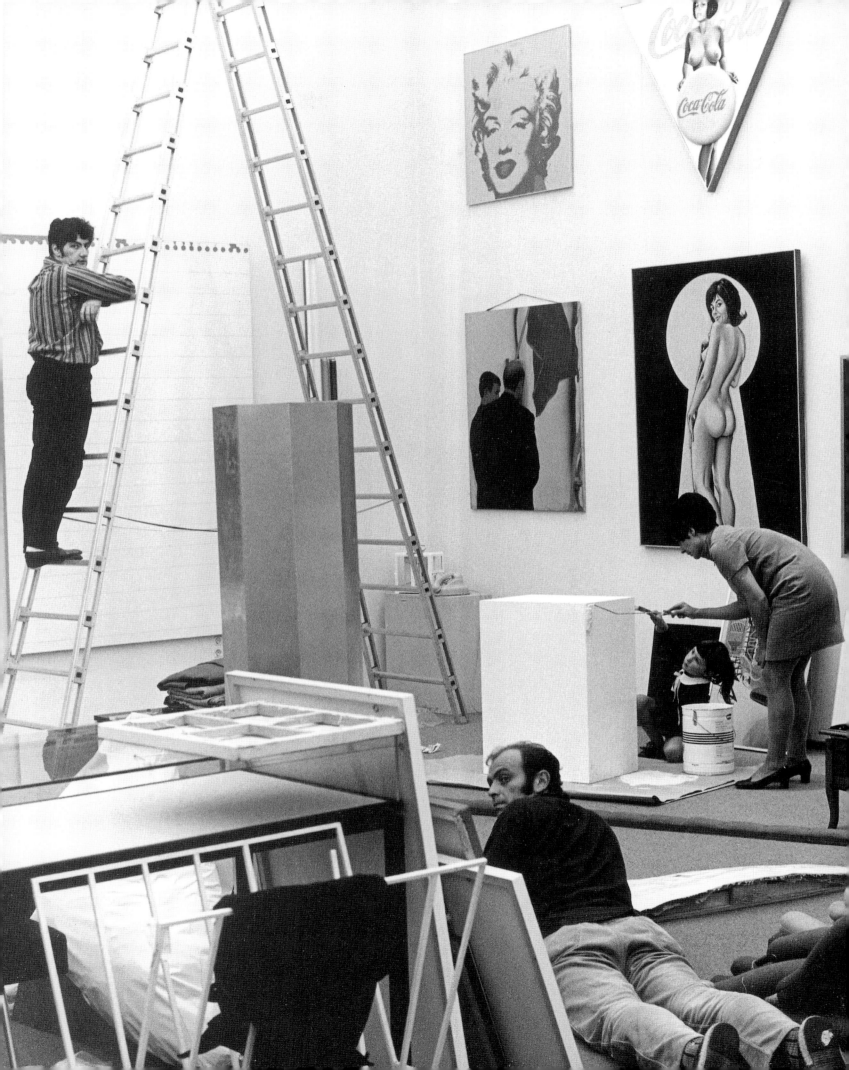

The art of presentation. In July 1955 – at the peak of the Cold War – the first 'documenta' opened in Kassel, which at that time still lay directly on the border with the GDR. The town, a former location of the armament industry, was still marked by the destruction from the Second World War. For Rolf Ricke, born in Kassel and then in his early twenties, this great exhibition was his first encounter with the art of the 20th century – as it was for most West Germans of his generation. His repeated visits to the two 'documenta' exhibitions in 1955 and 1959, and the presentation of the art exhibited there, made a deep impression on Rolf Ricke: in reminiscing he confirms, 'Arnold Bode's presentation of the art was just as important for me as the art itself. Since then, presentation has played a very essential role in my experience with art.' Anyone viewing the photos that Ricke compiled of his installed exhibitions for more than four decades – whether these were in his gallery rooms, at art-fair stands, or in public institutions – will see this statement confirmed. They show the gallery owner's consistent personal style in the arrangement of art – a manner of dealing with artworks that seeks formal correspondence and establishes coherencies across decades and styles.

Paradoxically, the desire to own art himself was what initiated Ricke's gallery work. Inspired by the work available at 'documenta 2', he began to collect graphics, predominantly from the School of Paris (École de Paris), and he financed the acquisitions by arranging the sale of pieces to other interested parties for a commission. In

September 1963, motivated more by his interest in contemporary art than by local demand, Rolf Ricke moved these activities into the rooms adjoining a bookshop in Kassel: 'There was nobody in Kassel showing art,' he remembers. 'I never asked myself, on the other hand, whether there would be any audience at all for it.' On the occasion of the third 'documenta' in 1964, Ricke risked turning his part-time job as a gallerist into a profession. He quit his job with the record company CBS and opened a larger gallery in the cellar of a local fire-insurance company, the Hessische Brandschutzversicherung. These rooms, with their whitewashed brick walls, recalled the spatial aesthetics of the Museum Fridericianum. However, Ricke's project did not take a decisive turn until 1965: after 'documenta' was over, the demand for art dried up in Kassel. Moreover, Ricke wanted to stop obtaining his exhibits from other dealers, and start cooperating directly with the artists.

In January 1965, on behalf of the collector Hans-Joachim Etzold, he travelled for the first time to New York, which was then the undisputed centre of the art world. At an exhibition at Museum Haus Lang in Krefeld, Etzold had noticed large-format prints by American representatives of Pop Art, such as Jim Dine, Jasper Johns, Robert Rauschenberg and James Rosenquist. Ricke was to purchase these from the ULAE (Universal Limited Art Edition) publishing house. Shortly thereafter, the gallerist returned not only with the desired works, but also with an exclusive

contract concluded with art publisher Tatyana Grossman to be ULAE's European representative. To his surprise he had effortlessly gained access to the New York art scene, without even having had to produce any special references. From the perspective of New York, on the other hand, Ricke belonged to a new generation of art dealers who were to help American art succeed in Europe. In the Leo Castelli, Green and Bianchini galleries, not only did Ricke see Pop Art, which had already started to establish itself in Europe, but also works of Minimal Art, which was still as good as unknown in Germany. To Ricke, the new trends in American Art made European abstract art seem outmoded: 'America', wrote Ricke in 1989, 'showed me a path into the future, which I immediately accepted.' Accordingly, the first European presentations of American artists such as Bill Bollinger, Richard Serra, Keith Sonnier and Lee Lozano formed a main emphasis of his gallery programme in the following years.

Another innovation of the late 1960s was Ricke's method of production: sculptures requiring a lot of work, such as those of Gary Kuehn or Barry Le Va, were no longer flown in but produced on location. Ricke describes the atmosphere of radical change in 1967–68 in this way: 'The traditional path from studio to gallery was interrupted and its previous form questioned; a new partnership began between artist and gallerist, the latter becoming included in the process of art creation. The gallery…then became a studio, and still is today, and the gallerist became even more a patron because he gave the artist a chance to carry out his ideas for the generally unsaleable pieces, which were sometimes also based on the gallery's floor plan.'

In 1967, with the founding of the 'Kölner Kunstmarkt', the first art fair for contemporary art, Cologne became the most important location for the West German art trade. As a consequence, Ricke closed his rooms in Kassel after 'documenta 4' in 1968, and opened a gallery in Cologne in March of that same year. Since then Ricke has taken market fluctuations and radical changes in artistic directions into account again and again, either by moving into new rooms, or by partially altering his gallery's profile. Thus in the mid-1970s he cooperated with the Projection gallery owned by Ursula Wevers, who had specialized in new artistic media such as film, video and audio recordings. When representational painting began to win back a central place in the art market at the end of the 1970s, Ricke fostered painters like Holger Bunk and Horst Münch, but since the late 1980s he has also continuously integrated younger American artists, including Jessica Stockholder and Fabián Marcaccio, into his programme. The fact that the focus of his interest since the 1960s has been on art's materiality and its creation process is proven by Ricke's own extensive collection, which reflects the gallery's history and was presented publicly for the first time at the Neues Museum Nürnberg in the summer of 2002. In autumn 2004 Rolf Ricke announced his retirement, and gave up his gallery at the end of that year. His former employees, Anke Schmidt and Iris Maczollek, continue to run it in the same location, albeit slightly smaller, under the name Galerie Schmidt Maczollek.

BARBARA HESS

'Der weite Blick', group exhibition
with work by Hanspeter Hofmann,
Peter Zimmermann, Claudio Moser
and Richard Artschwager, 2003

HARD CORE

Galerie Alfred Schmela

YEAR OF FOUNDATION
1957
FOUNDER
Alfred Schmela
ADDRESS
1957–66 **16–18 Hunsrückenstraße, Düsseldorf**
1967–71 **3 Luegplatz (in the apartment of the Schmela family), Düsseldorf**
SINCE 1971 **3 Mutter-Ey-Straße, Düsseldorf**
**(From 1980 the gallery was run by Monika and Ulrike Schmela,
and since 2002 by Ulrike Schmela)**

ARTISTS REPRESENTED
Eva Aeppli, Arman, Joseph Beuys, Christo, Robert Filliou, Lucio Fontana
Sam Francis, Gotthard Graubner, Hans Haacke, Konrad Klapheck
Yves Klein, Morris Louis, Konrad Lueg, Gordon Matta-Clark
Robert Morris, Kenneth Noland, Sigmar Polke, Martial Raysse
Gerhard Richter, George Segal, Antoni Tàpies
Jean Tinguely, Richard Tuttle, Günther Uecker

Alfred Schmela in front of the entrance to his gallery in Hunsrückenstraße in the old town of Düsseldorf, 1957

'**The best salesman in the world**' (Peter Ludwig).[1] Alfred Schmela, born in 1918, opened his gallery in 1957 in the midst of Düsseldorf's old town, in a shopfront obtained for him by the chairman of the culture committee. Schmela had wanted to be a painter himself since his early youth, but at his father's urging he was completing his civil engineering studies when he was drafted in 1940. In 1947 he returned from wartime captivity and began to study painting at a private school in Düsseldorf, and in Paris with André Lhote. Although he was able to make ends meet as a painter, after his marriage and the birth of his first daughter he discovered his sales talent and hatched a plan to become a gallerist. A decade and a half later he told the *Südwestdeutsche Allgemeine* newspaper: '…the idea that art is a product has never governed me in my work. …Dealing with art requires passion and enthusiasm. Another decisive incentive for running the gallery is the permanent contact with artists, thus concretely the constant discussion of artistic problems. The art which I represent has always been new, young and progressive.'[2]

Shortly before the gallery was to open, Schmela saw two paintings in Paris that he liked and found out that they were the work of Antoni Tàpies. Thus he immediately

Galerie Alfred Schmela on Luegplatz in Düsseldorf-Oberkassel. Back row, from left to right: Margret Mack, Rotraut Klein, Günther Uecker, Monika Schmela, Alfred Schmela, Ilse Uecker, Marianne Brüning, Peter Brüning, Karl Otto Götz, Jochen Hiltmann, Gotthard Graubner and Gitta Graubner. Front row, from left to right: Gerhard Richter, Konrad Lueg, Konrad Klapheck, Joseph Beuys, Rissa, Erwin Heerich, Hildegard Heerich and Norbert Tadeusz

wrote to Barcelona, but the painter put him off until a later date. During a nightly pub crawl he met the Düsseldorf artist Norbert Kricke, who had just purchased a blue picture by Yves Klein. Seeing it led Schmela to travel to Paris quickly, and on 30 May 1957 the gallery was opened with Yves's *Le Monochrome*. The press were horrified, and visitors also could not believe that pictures that had 'only just been underpainted' were to be sold. In 1958, while sitting on a selection jury, Alfred Schmela was confronted with a bronze sculpture that impressed him greatly. In response to his query, Ewald Mataré declared: 'That was my best pupil, but unfortunately he is crazy. His name is Joseph Beuys.'[3] A few months later the man with the hat entered the gallery. Schmela was convinced that he had met the greatest living German artist, and told everybody about his discovery. However, Schmela was unable to convince Beuys to exhibit, since he didn't yet feel the time was ripe. Seven years later, on 26 November 1965, 'Irgendein Strang…' was opened. Beuys simultaneously carried out the action *Wie man dem toten Hasen die Bilder erklärt (How to explain pictures to a dead hare)*: with a golden honeyed head, and an iron and felt foot, he walked from object to object with the dead hare in his arms.

Schmela is one of those connoisseurs who refuse to explain art they regard as important. When he mumbled 'good artist' in his inimitable Rhenish dialect, then

Exhibition by Lucio Fontana in the Schmela family apartment on Luegplatz, 1968

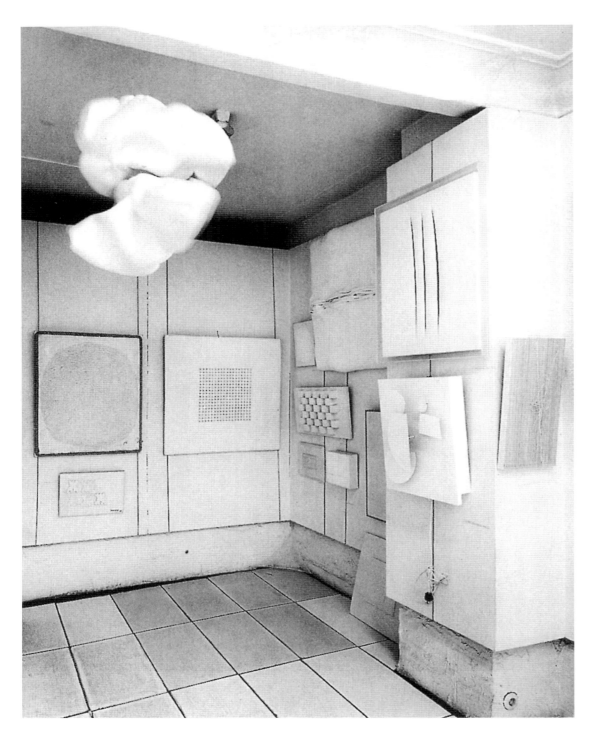

View of the exhibition 'Weiss –
Weiss', with works by Giuseppe
Capogrossi, Lucio Fontana,
Gotthard Graubner, Oskar Holweck,
Yves Klein, Piero Manzoni,
Almir Mavignier, Christian Megert,
Blinky Palermo, Otto Piene,
Uli Pohl, Jesús Rafael Soto, Jan
Schoonhoven, Ferdinand Spindel,
Antoni Tàpies, Jean Tinguely,
Günther Uecker, Jef Verheyen
and Gerd de Vries, 1965

that had weight, and a 'that picture is good' from him sufficed to move many a collector to purchase. Not only does his fascination for Beuys and his support for the artist group ZERO prove his infallible eye, but it is also very much proven by enumerating the artists whose works he was the first to exhibit in Germany: Yves Klein (1957), Antoni Tàpies (1957), Sam Francis (1958), Jean Tinguely (1959), Lucio Fontana (1960), Arman (1960), Arnulf Rainer (1962), Kenneth Noland (1962), Morris Louis (1962), Christo (1963), Gerhard Richter (1964), Robert Morris (1964), Hans Haacke (1965), Jörg Immendorff (1965), Robert Indiana (1966), Richard Tuttle (1968), Robert Filliou (1969), Co-Op Himmelb(l)au (1970) and Gordon Matta-Clark (1977).

At the end of 1966 Schmela had to move out of the rooms in Hunsrückenstraße because the city terminated his lease there. After almost signing a lease for a space in the Kö-Center on the elegant promenade Königsallee, Schmela was able to obtain the services of Dutch architect Aldo van Eyck to develop a city property in Mutter-Ey-Straße, where his new gallery was also to come into being. Thus 'the terror of the old town'[4] was not lost to that part of the city. Until construction was completed and the gallery reopened with Beuys's *Barraque d'Ull Odde*, 1971, the gallery was moved without further ado into the apartment on Oberkasseler Luegplatz.

Interior view of the gallery in Mutter-Ey-Straße, 2004.
Architect: Aldo van Eyck

In 1974 the city of Düsseldorf leased him the Palais Lantz, located in Lohausen and complete with its own park, with the stipulation that Schmela was to set up sculptures there. Schmela moved the gallery office, archive and storage room there, took out a bank loan, and began enthusiastically planning the sculpture garden: large bronzes by Joan Miró, mobile sculptures by George Rickey, steel sculptures by Erwin Heerich, a stone piece by Eduardo Chillida, a sculpture by Bernhard Luginbühl and one by Richard Serra. It was Schmela's idea that the sculptures should also be for sale, so that a change could take place in the park more often. Thereby he avoided declaring the works as his private property, however, and tried to represent them as belonging to the public. This was because he still preferred people to abuse the sculptures – on the supposition that they were financed with their own taxes – than for him to be seen as the owner of the works, and thus as a capitalist. After Schmela's death in 1980, his wife Monika and daughter Ulrike continued to operate the gallery in Mutter-Ey-Straße. Ulrike has been in charge of exhibitions there since April 2002.

UTA GROSENICK

1 Monika Schmela on Alfred Schmela, in *Kunstforum*, No. 104, November/December, 1989
2 *Südwestdeutsche Allgemeine Zeitung*, 23 January 1969
3 *Alfred Schmela – Galerist – Wegbereiter der Avantgarde*, pub. by Karl Ruhrberg, Cologne, 1996
4 Barbara Hess, '30 Jahre Ausstellungen bei Konrad Fischer 1967–1997', in *Sediment, Mitteilungen zur Geschichte des Kunsthandels*, Book 2, Bonn, 1997

Seth Siegelaub Contemporary Art
Seth Siegelaub Projects

YEAR OF FOUNDATION
1964

FOUNDER
Seth Siegelaub

ADDRESS
1964–66 **6 West 56th Street, New York**
1967–71 **Project work**

CLOSED 1971

ARTISTS REPRESENTED
Carl Andre, Robert Barry, Pierre Clerk, Jan Dibbets
Michael Eastman, E. F. Hebner, Douglas Huebler
Joseph Kosuth, Sol LeWitt, Herbert Livesey, Martin Maloney
Robert Morris, Lawrence Weiner, Edward Whiteman

'Künstler-Verkaufs- und Rechtsabtretungsvertrag' (page 1 of the German version) and
The Artist's Reserved Rights Transfer and Sale Agreement (pages 1 to 3 of the original English version),
New York, 1971. This project was initiated and signed by Seth Siegelaub, and drafted by lawyer Robert Projansky,
to protect artists' moral and economic rights by defining and protecting them through legally prescribed means

KÜNSTLER-VERKAUFS- UND RECHTS-ABTRETUNGS-VERTRAG

Der beiliegende dreiseitige Vertrag wurde von Bob Projansky, einem New Yorker Rechtsanwalt, aufgesetzt, nachdem ich mit über 500 Künstlern, Händlern, Anwälten, Sammlern, Museumsleuten, Kritikern und anderen Leuten gesprochen und korrespondiert hatte, die mit den Tagesgeschäften der internationalen Kunstwelt zu tun haben.

Der Vertrag will einige allgemein bekannte Ungerechtigkeiten in der Kunstwelt beseitigen, insbesondere den fehlenden Einfluß des Künstlers auf die Verwendung seines Werkes und seine Nichtbeteiligung an Wertsteigerungen, nachdem er sein Werk aus den Händen gegeben hat.

Der Vertragstext trägt den derzeitigen Praktiken und wirtschaftlichen Realitäten der Kunstwelt Rechnung, insbesondere in ihren privaten, geldlichen und informativen Aspekten, und berücksichtigt gleichermaßen die Interessen und Motive aller Beteiligten.

Vielleicht wird dies der Standardtext für den Verkauf und die Übertragung aller zeitgenössischen Kunstwerke; daher wurde der Vertrag so fair, einfach und praktisch wie möglich abgefaßt. Er läßt sich entweder in der vorliegenden Form oder mit geringfügigen Änderungen entsprechend Ihrer besonderen Situation verwenden.

Falls die nachstehenden Informationen nicht alle Ihre Fragen beantworten, so wenden Sie sich bitte an Ihren Rechtsanwalt.

WAS DER VERTRAG BEWIRKT

Der Vertrag will dem Künstler geben
- 15 % des Mehrwerts jedes Kunstwerks bei jedem Übergang in andere Hände;
- einen Überblick darüber, wer jeweils der Eigentümer ist;
- das Recht auf Unterrichtung, wenn das Werk ausgestellt werden soll, so daß der Künstler Rat und Anweisungen zur vorgesehenen Ausstellung seines Werkes geben (siehe Artikel 7 (b)) oder die Ausstellung untersagen kann;

1

AGREEMENT OF ORIGINAL TRANSFER OF WORK OF ART

Fill in date, names and addresses of parties

This agreement made this_____day of_____, 19_____, by and between
_____(hereinafter the "Artist"), residing at
_____and
_____(hereinafter the "Collector"), residing
at_____;

WITNESSETH:
WHEREAS the Artist has created that certain work of art;

Fill in data identifying the Work

Title:_____Identification #:_____
Date:_____Material:_____
Dimensions:_____Description:_____

(hereinafter "the Work"); and
WHEREAS Artist is willing to sell the Work to Collector and Collector is willing to purchase the Work from Artist, subject to mutual obligations, covenants, and conditions herein; and
WHEREAS Collector and Artist recognize that the value of the Work, unlike that of an ordinary chattel, is and will be affected by each and every other work of art the Artist has created and will hereafter create; and
WHEREAS the parties expect the value of the Work to increase hereafter; and
WHEREAS Collector and Artist recognize that it is fitting and proper that Artist participate in any appreciated value which may thus be created in the Work; and
WHEREAS the parties wish the integrity and clarity of the Artist's ideas and statements in the Work to be maintained and subject in part to the will or advice of the creator of the Work,
NOW, THEREFORE, in consideration of the foregoing premises and the mutual covenants hereinafter set forth and other valuable considerations the parties hereto agree as follows:

Fill in price or value; strike out one not applicable

PURCHASE AND SALE. ARTICLE ONE: The Artist hereby sells to Collector and Collector hereby purchases the Work from Artist, subject to all the covenants herein set forth (for the price of_____ receipt of which is hereby acknowledged) (at the agreed valuation for the purposes of this agreement of _____).

FUTURE TRANSFERS: ARTICLE TWO: Collector covenants that in the event Collector shall hereafter sell, give, grant, barter, exchange, assign, transfer, convey or alienate the Work in any manner whatsoever or if the Work shall pass by inheritance or bequest or by operation of law, or if the Work shall be destroyed and insurance proceeds paid therefor, Collector or Collector's personal representative shall:

Fill in name, address of artist's agent, if any; strike out one not applicable

(a) file a current TRANSFER AGREEMENT AND RECORD in the form and containing the information set forth and called for in the specimen hereunto annexed and made a part hereof, completed and dated, and subscribed by Collector or Collector's personal representative and collector's transferee, with the (Artist at the address set forth above) (Artist's agent for the purpose: _____ at:_____) within thirty days of such transfer, distribution, or payment of insurance proceeds, and shall

Fill in name, address of artist's agent, if any; strike out one not applicable

(b) pay a sum equal to fifteen percent (15%) of the Appreciated Value (as hereinafter defined), if any, occasioned by such transfer or distribution or payment of insurance proceeds to (Artist at the address set forth above) (Artist's agent for the purpose:_____at:_____) within thirty days of such transfer, distribution, or payment of insurance proceeds.

PRICE/VALUE. ARTICLE THREE: The "price or value" to be entered on a TRANSFER AGREEMENT AND RECORD shall be:
(a) the actual selling price if the Work is sold for money; or
(b) the money value of the consideration if the Work is bartered or exchanged for a valuable consideration; or
(c) the fair market value of the Work if it is transferred in any other manner.

APPRECIATED VALUE. ARTICLE FOUR: "Appreciated Value" of the Work for the purposes of this Agreement, shall be the increase, if any, in the value or price of the Work set forth in a current duly executed and filed TRANSFER AGREEMENT AND RECORD over the price or value set forth in the last prior duly executed and filed TRANSFER AGREEMENT AND RECORD, over the price or value set forth in ARTICLE ONE herein
(a) In the event a current duly executed TRANSFER AGREEMENT AND RECORD is not timely filed as required by ARTICLE TWO herein, Appreciated Value shall nonetheless be computed as if such current TRANSFER AGREEMENT AND RECORD had been duly executed and filed, with a price or value set forth therein equal to the actual market value of the Work at the time of the current transfer or at the time of the discovery of such transfer.

1

TRANSFEREES TO RATIFY AGREEEMENT. ARTICLE FIVE: Collector hereby covenants that he will not hereafter sell, give, grant, barter, exchange, assign, transfer, convey or alienate the Work in any manner whatsoever or permit the Work to pass by inheritance or bequest or by operation of law to any person without procuring such transferee's ratification and affirmation of all the terms of this Agreement and transferee's agreement to be bound hereby and to perform and fulfill all of the Collector's covenants set forth herein, said ratification, affirmation and agreement to be evidenced by such transferee's subscription of a current duly completed and filed TRANSFER AGREEMENT AND RECORD.

Strike out one not applicable

PROVENANCE. ARTICLE SIX: Artist hereby covenants that (Artist) (Artist's agent for the purpose as set forth in ARTICLE TWO) will maintain a file and record of each and every transfer of the Work for which a TRANSFER AGREEMENT AND RECORD has been duly filed pursuant to ARTICLE TWO herein and will at the request of the Collector or Collector's successors in interest, as that interest shall appear, furnish in writing a provenance and history of the Work based upon said records and upon Collectors' notices of proposed public exhibitions and will certify in writing said provenance and history and the authenticity of the Work to Collector and his successors in interest, and, at Collector's reasonable request, to critics and scholars. Said records shall be the sole property of the Artist.

EXHIBITION. ARTICLE SEVEN: Artist and Collector mutually covenant that
(a) Collector shall give Artist written notice of Collector's intention to cause or permit the Work to be exhibited to the public, advising Artist of all details of such proposed exhibition which shall have been made known to Collector by the exhibitor. Said notice shall be given for each such exhibition prior to any communication to the exhibitor or the public of Collector's intention to cause or permit the Work to be exhibited to the public. Artist shall forthwith communicate to Collector and the exhibitor any and all advice or requests that he may have regarding the proposed exhibition of the Work. Collector shall not cause or permit the Work to be exhibited to the public except upon compliance with the terms of this article.

Strike out (b) if not required

(b) Collector shall not cause or permit any public exhibition of the Work except with the consent of the Artist to each such exhibition.
(c) Artist's failure timely to respond to Collector's timely notice shall be deemed a waiver of Artist's rights under this article, in respect to such exhibition and shall operate as a consent to such exhibition and to all details thereof of which Artist shall have been given timely notice.

ARTIST'S POSSESSION. ARTICLE EIGHT: Artist and Collector mutually covenant that Artist shall have the right, upon written notice and demand to Collector made not later than 120 days prior to the proposed shipping date therefor, to possession of the Work for a period not to exceed sixty (60) days solely for the purpose of exhibition of the Work to the public at and by a public or non-profit institution, at no expense whatsoever to Collector. Collector shall have the right to satisfactory proof of sufficient insurance and pre-paid transportation or satisfactory proof of financial responsibility therefor. Artist shall have the right to such possession of the Work for one period not to exceed sixty (60) days every five (5) years

NON-DESTRUCTION. ARTICLE NINE: Collector covenants that Collector will not intentionally destroy, damage, alter, modify or change the Work in any way whatsoever.

REPAIRS. ARTICLE TEN: Collector covenants that in the event of any damage to the Work, Collector shall consult with Artist prior to the commencement of any repairs or restoration and if practicable Artist shall be given the opportunity to make any required repairs or restoration.

Strike out one not applicable

RENTS. ARTICLE ELEVEN: In the event that Collector shall become entitled to any monies as rent or other compensation for the use of the Work at public exhibition, the Collector shall pay a sum equal to one-half of said monies to (Artist) (Artist's agent as set forth in ARTICLE TWO herein) within thirty (30) days of the date when Collector shall become entitled to such monies.

REPRODUCTION. ARTICLE TWELVE: Artist hereby reserves all rights whatsoever to copy or reproduce the Work. Artist shall not unreasonably refuse permission to reproduce the Work in catalogues and the like incidental to public exhibition of the Work.

NON-ASSIGNABILITY. ARTICLE THIRTEEN: No rights created in the Artist and for the Artist's benefit by the terms of this Agreement shall be assignable by Artist during the Artist's lifetime, except that nothing herein contained shall be construed as a limitation on Artist's rights under any copyright laws to which the Work may be subject.

NOTICE. ARTICLE FOURTEEN: Artist and Collector mutually covenant that there shall be permanently affixed to the Work a NOTICE of the existence of this Agreement and that ownership, transfer, exhibition and reproduction of the Work are subject to the covenants herein, said NOTICE to be in the form of the specimen hereunto annexed and made a part of this Agreement.

Strike out (a) if not applicable

(a) Because the Work is of such nature that its existence or essence is represented by documentation or because documentation is deemed by Artist to be part of the Work, the permanent affixing of said NOTICE to the documentation shall satisfy the requirements of this article.

TRANSFEREES BOUND. ARTICLE FIFTEEN: In the event the Work shall hereafter be transferred or otherwise alienated from Collector or Collector's estate in any manner whatsoever, any transferee taking the Work with notice of this Agreement shall in every respect be bound and liable to perform and fulfill each and every covenant herein as if such transferee had duly made and subscribed a properly executed TRANSFER AGREEMENT AND RECORD in accordance with ARTICLE TWO and ARTICLE FIVE herein at the time the Work was transferred to him or her.

2

EXPIRATION. ARTICLE SIXTEEN: This Agreement and the covenants herein shall be binding upon the parties, their heirs, legatees, executors, administrators, assigns, transferees and all other successors in interest and the Collector's covenants do attach and run with the Work and shall be binding to and until twenty-one (21) years after the deaths of Artist and Artist's surviving spouse, if any, except that the covenants set forth in ARTICLE SEVEN, ARTICLE EIGHT and ARTICLE TEN herein shall be binding only during the life of the Artist.

WAIVERS NOT CONTINUING. ARTICLE SEVENTEEN: Any waiver by either party of any provision of this Agreement, or of any right hereunder, shall not be deemed a continuing waiver and shall not prevent or estop such party from thereafter enforcing such provision or right, and the failure of either party to insist in any one or more instances upon the strict performance of any of the terms or provisions of this Agreement by the other party shall not be construed as a waiver or relinquishment for the future of any such terms or provisions, but the same shall continue in full force and effect.

AMENDMENT IN WRITING. ARTICLE EIGHTEEN: This Agreement shall not be subject to amendment, modification, or termination, except in writing signed by both parties.

ATTORNEYS' FEES. ARTICLE NINETEEN: In the event that either party shall hereafter bring any action upon any default in performance or observance of any covenant herein, the party aggrieved may recover reasonable attorneys' fees in addition to whatever remedies may be available to him or her.

IN WITNESS WHEREOF, the parties have set their hands and seals to this Agreement as of the day and year first above written.

Fill in NOTICE in full (Do not remove from original)

SPECIMEN - SPECIMEN - SPECIMEN

NOTICE

Ownership, Transfer, Exhibition and Reproduction of this Work of Art are subject to covenants set forth in a certain Agreement made the _____ day of _____, 19_____, by and between_____
and_____
the original of which is on file with_____
at_____

_____(Artist)

_____(Collector)

SPECIMEN - SPECIMEN - SPECIMEN

Fill in ONLY:

TRANSFER AGREEMENT AND RECORD

To:
Know ye that_____
residing at_____
has this day transferred all his right, title and interest in that certain Work of art known as:

data identifying the Work

Title:_____Identification #:_____
Date:_____Material:_____
Dimensions:_____Description:_____
to_____residing at_____,

names of parties ("between ____ and ____")

transferee, at the agreed price or value of_____. Transferee, hereby expressly ratifies and affirms all the terms of that certain Agreement made by and between_____and_____

date

on the _____ day of_____, 19_____, and agrees to be bound thereby and to perform and fulfill all of Collector's covenants set forth in said agreement.
Done this _____ day of_____, 19_____,
at_____

(Do not remove from original)

3

View of the installation
*Haverhill – Windham – New York
Marker – Piece* by Seth Siegelaub,
New York, 1968

With reason! Seth Siegelaub Contemporary Art was a gallery located at 6 West 56th Street in New York. It existed for only eighteen months, from the autumn of 1964 to the spring of 1966. The artists represented during that period included Pierre Clerk, Edward Whiteman, Michael Eastman, Martin Maloney, E. F. Hebner, Herbert Livesey and Lawrence Weiner.

After the gallery closed in 1966, Siegelaub became a private dealer, working closely on projects with the artists Carl Andre, Robert Barry, Douglas Huebler, Joseph Kosuth and Lawrence Weiner, in which he tried to adapt the exhibition environment to the new possibilities opened up by the new forms of art, especially what is now known as Conceptual Art. This gradually led to his becoming the first 'autonomous curator', and between February 1968 and July 1971 he independently organized, throughout the USA, Canada and Europe, twenty-one highly diverse projects, including exhibitions, books and catalogues in new and original formats. The following list provides a short overview of the individual projects:

[1] Carl Andre, Robert Barry and Lawrence Weiner. Bradford Junior College, Bradford, Massachusetts, February 1968, four-part printed mailing announcement.

[2] Carl Andre, Hay – Robert Barry, Mesh – Lawrence Weiner, String. Windham College, Putney, Vermont, 1968. This exhibition is considered the first site-specific outdoor exhibition.

[3] Benefit exhibition organized by Siegelaub, 4–7 October 1968, for the congressional electoral campaign of Ed Koch, then a progressive politician from Greenwich Village in New York.

[4] Douglas Huebler: Douglas Huebler, 2–30 November 1968. Seth Siegelaub, New York, 1968. This was the first exhibition in which the catalogue was the exhibition.

[5] Lawrence Weiner: Statements. The Louis Kellner Foundation; Seth Siegelaub, New York, 1968. 64 pages, 10 x 18 cm, paperback, edition of 1,000. This was the first exhibition in which a book was the exhibition.

[6] Carl Andre, Robert Barry, Douglas Huebler, Joseph Kosuth, Sol LeWitt, Robert Morris, Lawrence Weiner. Also known as the 'Xeroxbook'. Siegelaub / Wendler, New York, 1968.

[7] 5–31 January 1969. Seth Siegelaub, New York, January 1969. McLendon Building at 44 East 52nd Street. A ground-breaking group exhibition of so-called Conceptual Art, with work by Robert Barry, Douglas Huebler, Joseph Kosuth and Lawrence Weiner.

[8] March 1969. Seth Siegelaub, New York, March 1969.

[9] Joseph Kosuth, Robert Morris. Bradford Junior College / Seth Siegelaub, March 1969.

[10] Robert Barry: Robert Barry / Inert Gas Series / Helium, Neon, Argon, Krypton, Xenon / From A Measured Volume To Indefinite Expansion / April 1969 / Seth Siegelaub, 6000 Sunset Boulevard, Hollywood, California.

Billboard with work by Daniel Buren, *Papier avec des rayures verticales roses et blanches, chacune 8,7 cm*, **Paris, 1969**

[11] Jan Dibbets. May 1969.

[12] Simon Fraser Exhibition, 19 May to 19 June 1969. Vancouver / Burnaby, Canada. June 1969.

[13] July, August, September 1969.

[14] Prospekt '69, Düsseldorf, September 1969.

[15] Carl Andre. Seven Books of Poetry. 7 Volumes. Dwan Gallery & Seth Siegelaub, New York, October 1969.

[16] Jan Dibbets. Roodborst territorium / Sculptuur 1969. Robin Redbreast's Territory / Sculpture 1969. Domaine d'un rouge-gorge / Sculpture 1969. Rotkehlchenterritorium / Skulptur 1969. Seth Siegelaub & Verlag Gebr. König, New York and Cologne, January 1970.

[17] Michel Claura, ed. 18 PARIS IV.70. Seth Siegelaub, New York, April 1970.

[18] Studio International (London), Volume 180, No. 924, July–August 1970.

[19] The Halifax Conference, Halifax, The Nova Scotia College of Art & Design, Nova Scotia (Canada), October 1970.

[20] The Artist's Reserved Rights Transfer and Sale Agreement, with Lawyer

Artists represented in the exhibition 'January 5–31, 1969'. From left to right: Robert Barry, Douglas Huebler, Joseph Kosuth and Lawrence Weiner

Robert Projansky, New York, February 1971. A project initiated by Seth Siegelaub with lawyer Robert Projansky. The preparation and publication of a sales contract for artwork setting forth and protecting artists' moral and economic rights, including their 15% participation in any profits made on the resale of their work. By 1972 the contract had been re-worked, adapted, translated and published in a similar format in at least five other languages (French, German, Italian, Spanish and Dutch) and has been reprinted and published in various adaptations since then.

[21] United States Servicemen's Fund Art Collection. The USSF, New York, July 1971.

In 1972 Seth Siegelaub left the art world to pursue other projects in France. For example, he has researched politically left-wing communication and culture, published his results, and founded the International Mass Media Research Center (IMMRC). In the 1980s he became involved in research on the social history of hand-woven textiles, and later edited and published the *Bibliographica Textilia Historiae* (1997), the first general bibliography on the history of textiles. He has also dealt in rare books on the subject. Currently he is doing research for a project about the physics of time and causality. Siegelaub has lived in Europe since early 1972, and presently lives in Amsterdam.

UTA GROSENICK

View of the installation *25* at Seth Siegelaub Contemporary Art, New York, 1966. From left to right: Franz Kline's *Winged Victory*, 1958; John Chamberlain's *Emperor Hudson*, 1958; Barnett Newman's *Outcry*, 1958

Ileana Sonnabend Gallery

YEAR OF FOUNDATION
1962
FOUNDER
Ileana Sonnabend
ADDRESS
1962–65 **Galerie Ileana Sonnabend, 37 Quai des Grands-Augustins, Paris**
1966–80 **Galerie Ileana Sonnabend, 12 Rue Mazarine, Paris**
1974–75 **Galerie Sonnabend, 14 Rue Etienne Dumont, Genf**
1970–71 **Sonnabend Gallery, 924 Madison Avenue, New York**
1971–99 **Sonnabend Gallery, 420 West Broadway, New York**
SINCE 2000 **Sonnabend Gallery, West 22nd Street, New York**

ARTISTS REPRESENTED
Giovanni Anselmo, Arman, John Baldessari, Bernd and Hilla Becher
Ashley Bickerton, Mel Bochner, Christian Boltanski, Elger Esser, Dan Flavin
Gilbert & George, Candida Höfer, Jasper Johns, Clay Ketter, Jeff Koons
Roy Lichtenstein, Mario Merz, Robert Morris, Rona Pondick, Robert Rauschenberg
James Rosenquist, Haim Steinbach, Hiroshi Sugimoto, Andy Warhol, Matthew Weinstein

Ileana Sonnabend in Paris, 1960s

Agit Pop and calculated provocation. Ileana Sonnabend began collecting in the 1950s together with her husband at that time, Leo Castelli. Sonnabend, born in Rumania as the daughter of a wealthy industrialist, and Castelli, an Italian banker, had fled Europe for New York in 1941 with their four-year-old daughter Nina. During the 1940s Castelli remained in Europe during almost the entire war, while Sonnabend immersed herself in the exciting New York art scene. 'At that time New York was an amalgamation of exiled Europeans. Max Ernst and Yves Tanguy came to exhibition openings.'

In the 1950s the up-and-coming Leo Castelli Gallery began promoting the works of Jasper Johns and Robert Rauschenberg, in which Sonnabend also played a part. After her amicable divorce at the end of the 1950s, she married Michael Sonnabend in 1960, a filmmaker and art lover whom she had known for years. The couple moved to Paris and opened the Ileana Sonnabend Gallery in order to be able to broaden their commitment to contemporary international artists. As the art critic Annette Michelson reported, the opening of the gallery in Paris was just as bewildering as it was disappointing: nobody came, and this remained a mystery until someone explained to the Sonnabends that they had timed their opening to coincide with the holidays. Despite this initial slip-up, the Paris gallery became an important meeting place for the presentation of an increasingly international group of young artists.

In 1970 the Sonnabends decided to open a gallery on Madison Avenue in their home city of New York, and in the following year in SoHo, at 420 West Broadway.

Pop Art exhibition, 1963

Ileana reported: ''67 and '68 were very difficult years in Paris, because everyone was politically active, nobody was interested in art, and young people didn't go to galleries. The collectors were very afraid of spending money, and even more afraid of the tax collectors who were after them…. We lived right beside the Place Saint-Michel, and the apartment was constantly full of tear gas. It was very uncomfortable. And that was the point at which I decided that it was perhaps time to return home, but I didn't really want to leave.'

During the 1970s the Sonnabends began to exchange exhibitions between their galleries in Paris and New York, enabling them to present contemporary work almost simultaneously to spectators on both sides of the Atlantic. Artists such as Robert Rauschenberg and Dan Flavin were presented to European audiences, while the work of Gilbert & George, Mario Merz, and Bernd and Hilla Becher was brought to the attention of North American audiences. The Sonnabends closed their Paris gallery in the 1980s in order to concentrate their activities in New York, which at the time was seen as the centre of the burgeoning Neo-Expressionist movement. Their

187

gallery was instrumental in presenting the work of the German artists Anselm Kiefer, George Baselitz, A. R. Penck, Jörg Immendorff and Albert Oehlen in the USA.

Over the decades, the Sonnabends earned a reputation for consistently showing works other dealers might dismiss as too difficult for the times or simply impossible to sell. Their galleries showcased Pop Art; Minimal and Conceptual Art; video, dance and performance art; Italian Arte Povera works made of found materials; photographs and photo-based art; and works by such Postmodern artists as Jeff Koons and Ashley Bickerton.

Now in her mid-80s, Ileana Sonnabend continues to be drawn to artwork she finds surprising, incomprehensible, or even upsetting. She is known for her passionate support of her artists, no matter how unconventional their visions might seem. 'I'm particularly interested in works that are by now "classical" and still keep their provocation,' she told the *New York Times* earlier this year. Art writer Michel Bourel has said that Ileana considers herself 'more art lover than agent', and Robert Rauschenberg once said, 'I've never finished a painting without wondering what Ileana would think of it.' 'You do what you need to do,' she told Acconci about a performance that involved two weeks of sporadic public masturbation. During the run of what was probably the most flagrantly hard-core show to grace a private gallery, Koons's *Made in Heaven*, Ileana chose to put *Butt Red (Close Up)*, 1991, a silk screen of Koons and Cicciolina engaged in anal sex, on display in her office.

GILBERT VICARIO

Left: View of Bernd and Hilla Becher exhibition, 1990

Opposite: Jeff Koons, *Made in Heaven*, 1991

Galleria Gian Enzo Sperone

YEAR OF FOUNDATION
1964

FOUNDER
Gian Enzo Sperone

ADDRESS

1964–69 **15 Via Cesare Battisti, Turin**

1969–81 **27 Corso San Maurizio, Turin**

1966–67 **24 Via Bigli, Milan**

1972–74 **49 Piazza SS. Apostoli, Rome (Sperone & Fischer)**

1974–75 **21a Via Quattro Fontane, Rome (Sperone & Fischer)**

1975–84 **21a Via Quattro Fontane, Rome (Gian Enzo Sperone)**

SINCE 1984 **15 Via di Pallacorda, Rome (Gian Enzo Sperone)**

1972–75 **142 Greene Street, New York (Gian Enzo Sperone)**

1975–82 **142 Greene Street, New York (Sperone Westwater Fischer)**

1982–2002 **142 Greene Street, New York (Sperone Westwater)**

1989–97 **121 Greene Street, New York**

SINCE 2002 **415 West 13th Street, New York (Sperone Westwater)**

ARTISTS REPRESENTED

Carl Andre, Giovanni Anselmo, Alighiero Boetti, Sandro Chia, Francesco Clemente, Hanne Darboven
Peter Halley, Douglas Huebler, Joseph Kosuth, Wolfgang Laib, Jonathan Lasker, Sol LeWitt, Roy Lichtenstein
Richard Long, Brice Marden, Mario Merz, Aldo Mondino, Frank Moore, Bruce Nauman, Luigi Ontani
Mimmo Paladino, Giulio Paolini, Michelangelo Pistoletto, Robert Rauschenberg, Gerhard Richter, Susan Rothenberg
Robert Ryman, Julian Schnabel, Richard Tuttle, Cy Twombly, Not Vital, Andy Warhol, Gilberto Zorio

Michelangelo Pistoletto, Gian Enzo Sperone and Maria Pioppi with *Quadro di fili elettrici*, 1967

An Italian in America. In 1963 Michelangelo Pistoletto showed his mirror pictures in a solo exhibition at the Galleria Galatea in Turin. The gallery owner, however, didn't like the exhibition at all. In complete desperation the artist drove to Paris and asked the American Pop artists living there for a meeting at the Sonnabend Gallery. Ileana Sonnabend, however, liked the catalogue for his Turin exhibition so much that she travelled there and bought up the complete show. A few weeks later Pistoletto returned to Paris, accompanied by his friend Gian Enzo Sperone, whom he had met while the latter was working in the Turin gallery.

This early episode already contains the operating principles and views that would guide Gian Enzo Sperone: a close relationship to young, promising Italian artists, and good connections in the international art world. Thanks to his contacts, initially to Ileana Sonnabend and then to Leo Castelli, Sperone managed to make American Pop Art known, even before it had made its breakthrough, at the 64th Venice Biennial in Italy. As early as 1963 Sperone, then still running the Galleria Il Punto, exhibited work by Roy Lichtenstein.

Thus began his rapid ascent. In the following year, when Sperone was only twenty-five, he opened his own gallery in a Turin shopfront, where he continued to present American art (showing Italian premieres by Rosenquist, Warhol and Wesselmann in respective solo exhibitions), artists of New Realism (Nouveau Réalisme), and Italian artists with whom he maintained close contact (Pistoletto, Mondino and Sottsass). Once again thanks to Pistoletto, who greatly promoted the gallery, artists such as Piero Gilardi and Pino Pascali joined in. In 1966 the latter exhibited his unusual cannons, which had previously been declined by the Galleria La Tartaruga in Rome. The exhibition remained practically unsaleable, but it already

View of Giovanni Anselmo
exhibition, 1968

Jannis Kounellis, *Untitled*, 1971

showed Sperone's interest in events in the capital city. In the same year the important group exhibition 'Arte abitabile' with Pistoletto, Gilardi and Piacentino took place, and represented a decisive step towards art, which ventured out into the showroom itself, and which was created in an atmosphere of exchange between artists.

The gallery was headquartered in Milan for only a year, but during that year Dan Flavin's first solo exhibition in Italy took place, and even if it seemed to attract little attention, Lucio Fontana and the collector Giuseppe Panza di Biumo, who purchased the entire exhibition, were among the few who saw it.

From 1967 the number of Italians among the artists represented increased. Marisa Merz and Gilberto Zorio were given their first solo exhibitions, and the year closed with an important show by Pistoletto, who displayed his *Oggetti in meno* in an exhibition ambiance of constant change. Meanwhile, the gallery had also become a place where critics such as Tommaso Trini and Germano Celant exchanged views, and attracted emerging artists from the new generation in Italy, who were to make a name for themselves under the classification Arte Povera. However, it was also a point of origin for exemplary outbursts in everyday life and life on the street, such as

in the important group exhibition 'Con temp l'azione', which was curated by Daniele Palazzoli, together with the galleries Stein and Il Punto. Palazzoli emphasized the necessity for art that was more immediately connected with life and open to participation: 'The action to be carried out, becomes interaction.... The things no longer stand for themselves, they stand for that which they produce, for the relationships they create.' One can glimpse the manifesto of an epoch in this.

Appearing in the decidedly full programme of 1968–69 were artists such as Merz, Anselmo (with some of his major works), Kounellis, Calzolari, Penone and Boetti with his famous self-portrait *Io che prendo il sole a Torino*. Also included were some of the most important representatives from the new styles of Anti-Form, Land Art, Minimal Art, and Conceptual and Process Art, which had begun to gain acceptance in Europe and the USA, including Robert Morris, Carl Andre, Lawrence Weiner, Bruce Nauman, Joseph Kosuth, Douglas Huebler, Hamish Fulton, Richard Long, On Kawara, Daniel Buren, and Art & Language. In 1969, at the peak of student unrest, the gallery increasingly became an open, informal room in the university neighbourhood in order to suit the requirements and exhibition practices of the new generation of artists.

Above, left: Cannons by Pino Pascali, 1966

Above, right: George, Gilbert, Gian Enzo Sperone and Konrad Fischer, early 1970s

The late 1960s and early 1970s saw the establishment of the Galleria Gian Enzo Sperone as an international centre of the avant-garde. This role was secured in 1972 through a collaboration with the Düsseldorf gallerist Konrad Fischer, who intensely promoted the spread of Minimal Art. Sperone opened a branch together with Fischer in Rome, and opened another branch in New York in the same year, but this time alone. In 1975 Fischer also became involved there, together with Angela Westwater, who worked for *Artforum* at the time. Fischer left the gallery in 1982. Solo exhibitions were not initially planned for the programme of the New York branch. Instead, exhi-

bition constellations were created to run over a longer period, in which the presence of the latest generation of Italian artists could be felt in America: artists who had been exposed to the international scene thanks, among other things, to exhibitions such as the 1968 Venice Biennial, 'Prospect 68', 'Prospect 69', 'Op Losse Schroeven' and 'When Attitudes Become Form'.

Sperone now stood at the centre of a tightly related network for the international exchange of artists and ideas, with hubs located in Rome, New York and, until 1981, in Turin. Sperone also very clearly pursued the further development of international art. Painting became increasingly noticeable from the mid-1970s, above all the styles of Neo-Expressionism and Quotation Art. This included artists who would later count among the group of the Trans-avantgarde, as well as American and German painters such as Schnabel, Baechler and Richter.

Even today, the effects of the galleries Sperone and Sperone Westwater continue in the exchange of presentations by recognized contemporary artists, and the presentation of young Italian and international artists.

LUCA CERIZZA

Above, left: Francesco Clemente exhibition, 1983

Above, right: Double igloo by Mario Merz, 1979

Galerie Michael Werner

YEAR OF FOUNDATION

1964

FOUNDER

Michael Werner

ADDRESS

1964–69 **80 Pfalzburger Straße, Berlin**

1969–73 **14–18 St Apernstraße, Cologne**

1973–79 **50 Friesenstraße, Cologne**

SINCE 1979 **24–28 Gertrudenstraße, Cologne**

1990–2000 **21 East 67th Street, New York**

SINCE 2000 **4 East 77th Street, New York**

ARTISTS REPRESENTED

**Hans Arp, Georg Baselitz, Max Beckmann, Joseph Beuys
Marcel Broodthaers, James Lee Byars, Gaston Chaissac
Jörg Immendorff, Anselm Kiefer, Per Kirkeby, Eugène Leroy
Markus Lüpertz, A. R. Penck, Sigmar Polke
David Salle, Kurt Schwitters**

Michael Werner with the painting *Oberon* by Georg Baselitz in the 1st Orthodoxen Salon, Berlin, 1964

The art dealer. 'I suspect I am one of the last old-fashioned dealers for contemporary art, because right from the beginning I didn't want to put art forward for discussion, but to possess it.'[1] Thus gallerist Michael Werner, nevertheless one of the most successful in his field worldwide, somewhat coyly describes his own self-image. Michael Werner, who abandoned his secondary education before graduating, learned his profession from the bottom up by working for five years as an assistant in the Berlin gallery of Rudolf Springer, beginning in 1958. During that time he became acquainted with the two artists Eugen Schönebeck and Georg Baselitz. Georg Baselitz then set up the contact with A. R. Penck and Markus Lüpertz, who were still living in the GDR. To this day these three painters, together with Jörg Immendorff whom the gallerist met in Cologne at the end of the decade, form the basis of the Galerie Michael Werner.

Initially, however, Werner lost his job with Rudolf Springer and in 1963 he founded a gallery on Berlin's Kurfürstendamm together with Benjamin Katz, who had just inherited a considerable amount of money, and who later became a well-known photographer. The opening exhibition with Georg Baselitz promptly provoked a scandal: Baselitz's painting *Die große Nacht im Eimer* (The Big Night Down the Drain) from 1962–63 showed a masturbating boy with an oversized penis: at that

Michael Werner with
Detlev Gretenkort, Per Kirkeby,
A. R. Penck, Markus Lüpertz, Georg
Baselitz and Jörg Immendorff,
Copenhagen, 1985

time still a case for the public prosecutor's office. The cooperation with Benjamin Katz did not last long, however, and only a year later Werner opened his own space in Pfalzburger Straße, the Orthodoxen Salon, and naturally with another picture by Georg Baselitz. For financial reasons this enterprise also ended quickly, and Werner continued his exhibition activities in his Berlin apartment.

At the end of 1968 Michael Werner moved from Berlin to Cologne, at that time the stronghold of contemporary art in divided Germany. There he took over the Galerie Hake, after which his true career as a gallerist began. From now on he not only risked everything to establish the four above-mentioned 'Painter Princes' nationally, but particularly also internationally – 'raus aus dem deutschen Mief'[2] (out of this bad German air) as the self-confident motto ran – but he also showed comparatively Conceptual art. In the following years Marcel Broodthaers, James Lee Byars and Anselm Kiefer had their first solo exhibitions in Germany at Michael Werner's. The exhibitions were accompanied by catalogues again and again. At 'documenta 6', curated by Rudi Fuchs from Holland, many of the gallery artists were prominently represented, including Georg Baselitz, Markus Lüpertz and A. R. Penck. Now, at the end of the 1970s, the success that the dedicated painting fan Michael Werner had hoped for began, and still endures today. Asked about his ideas on viewing paintings, he once answered: 'It is a matter of absorbing energy, of irritation. In the best case it provokes a stimulating excitement, an agitation in the brain.'[3]

A further important career step took place in March 1990, when he opened the Michael Werner Gallery in New York. Ten years earlier Michael Werner had run a

Galerie Michael Werner's stand at the 'Kölner Kunstmarkt', 1973

View of James Lee Byars's
installation *The Angel*, 1989,
Michael Werner Gallery,
New York, 1996

gallery there together with Mary Boone, whom he married in 1985. Now he began working under his own auspices in Manhattan as well – with a very specific objective. Werner explains: 'I have only in the last few years begun to show classical modern works, and mainly in my New York gallery which I opened in 1990 to provide information about the development of German painting.'[4] The gallerist, who never tires of reproving the quality of art museums, most collections, and art criticism, has unceremoniously taken on the task of aesthetic education himself, and makes formal connections between Hans Arp and A. R. Penck, between Kurt Schwitters and Georg Baselitz, and between Wilhelm Lehmbruck and Jörg Immendorff.[5] On the one hand the attempt to locate contemporary art within its history is successful, but on the other to ennoble one's 'own' artists self-confidently through modern art history is naturally an extremely skilful gambit by a gallerist. Collectors like that. Even if the gallery itself is already a part of recent (German) art history, it is still working intensively, both in Cologne and in New York, for the success of its artists.

RAIMAR STANGE

1 Quoted from: 'Wir leben in einem komischen Land,...', interview with Heinz-Norbert Jocks, *Kunstforum*, No. 135, 1996, p. 482
2 Quoted from: *manager magazin*, No. 4, Hamburg, 1987, p. 316
3 Heinz-Norbert Jocks, op. cit.
4 Ibid., p. 481
5 Ibid., p. 482

GALERIE MICHAEL WERNER

200

Immendorff mal Penck, Penck mal Immendorff
(Immendorff as Penck, Penck as Immendorff), 1977

Wide White Space

YEAR OF FOUNDATION
1966
FOUNDERS
Anny De Decker and Bernd Lohaus
ADDRESS
1966–68 **1 Plaatsnijdersstraat, Antwerp**
1968–74 **2 Schildersstraat, Antwerp**
1974–77 **81–83 Molenstraat, Antwerp**
CLOSED 1977

ARTISTS REPRESENTED

Carl Andre, Karel Appel, Georg Baselitz, Lothar Baumgarten, Joseph Beuys
Marcel Broodthaers, Daniel Buren, James Lee Byars, Henning Christiansen, Christo
Walter de Maria, Robert Filliou, Dan Flavin, Lucio Fontana, Piero Gilardi
Gotthard Graubner, Hugo Heyrman, Mauricio Kagel, Yves Klein, Addi Køpcke
David Lamelas, Sol LeWitt, Richard Long, Heinz Mack, Piero Manzoni
Alvir Mavignier, Bruce Nauman, Blinky Palermo, Panamarenko, A. R. Penck
Otto Piene, Sigmar Polke, Martial Raysse, Gerhard Richter, Dieter Roth
Reiner Ruthenbeck, Jesús Rafael Soto, Daniel Spoerri, Hisachika Takahashi
Antoni Tàpies, Jean Tinguely, Niele Toroni, Günther Uecker, Per Olof Ultvedt
Ger van Elk, Victor Vasarély, Bernar Venet, Andy Warhol, Lawrence Weiner

Carl Andre, *Clastic*, 1968

The gallery as adventure. In the mid-1960s a group of artists who organized Happenings in the streets of Antwerp formed around the Belgian artists Wout Vercammen, Hugo Heyrman and Panamarenko. They were joined by the Düsseldorf sculptor Bernd Lohaus, who had recently met the Flemish art historian Anny De Decker in Madrid. Since the events were regularly stopped by the police, Anny De Decker spontaneously rented an empty and inexpensive ground floor space, in which the artists could carry out their Happenings undisturbed. The room was painted white, and despite being rather small was called 'Wide White Space', whereby 'Wide' referred to the breadth of the intellectual space. The first exhibition by Panamarenko, Bernd Lohaus and Hugo Heyrman opened on 18 March 1966 with the *Milkyway* Happening.

Although the two founders admittedly had no idea about this kind of work – 'neither Anny nor I had ever worked in a gallery, and didn't know how they ran' (Bernd Lohaus) – they wanted to continue what they had started. They already dedicated their third exhibition to Marcel Broodthaers, who was then still completely unknown, and who immediately became a key figure for the gallery.

The Düsseldorf gallerist Alfred Schmela came to Antwerp for the first time during this exhibition, and found it unbelievable that the *Casserole and Closed Mussels* stood directly on the floor. It was something completely new to show an object without a pedestal or Plexiglas hood. Wide White Space became an important meeting place in general for the Rhenish collectors and gallerists who met artists or bought work there: work that they could later show in their own rooms.

A charismatic person of great importance for the gallery was Joseph Beuys. His work also deviated from the classic mode of gallery operations in which presented works are manufactured by the artist in the studio, transported to the gallery, and hung there on the walls. With the film documentation of his *Eurasienstab* action, which was shown daily in Wide White Space, the gallery became a 'social space' where people with similar interests could meet.

To comprehend fully the history of Wide White Space's development, it is essential that one understands the cultural situation in Belgium during the 1960s, where the development of avant-garde trends in art was in no way supported by public institutions, but exclusively by private individuals. Unlike in neighbouring

Interior and exterior views of the gallery in Schildersstraat in Antwerp with *A Work in Situ* by Daniel Buren, 1974

Panamarenko, *Donderwolk*, 1971

Anny De Decker, Marcel Broodthaers, Bernd Lohaus, Otto Hahn and Daniel Buren in the Musée d'Art Moderne de la Ville de Paris, Département des Aigles, Section XIXe Siècle, 1969

countries, there it was the galleries and collectors who substantially promoted and advanced artistic production.

It must have seemed like pure irony to the artists that the gallery lay behind the venerable old Antwerp museum, and that Wide White Space's invitations contained the remark 'behind the museum' for easier orientation by their visitors, since the museum granted no space to them or to contemporary art. Thus Wide White Space was these artists' only possible exhibition space, and for ten years the most remarkable works of art were shown behind the inflexible museum's back.

Wide White Space's fame increased abruptly in the spring of 1967 when Bulgarian artist Christo, who then lived in New York and already enjoyed a certain reputation in the press and among collectors, exhibited there.

To make their artists accessible to an international audience as well, Anny De Decker and Bernd Lohaus rented two conference rooms in the Hotel Hessenland (today the Mercure) during 'documenta 4' in Kassel in 1968, and set up an Accrochage there. Some months later the gallery was invited to the first 'Prospect' in the Düsseldorf Kunsthalle. This exhibition, organized by Konrad Fischer, Hans Strelow and Karl Ruhrberg, was in a sense a counter-reaction to the more classical 'Kölner Kunstmarkt', established a year earlier. Besides works from other artists of the gallery, some pieces by Beuys were shown. The most spectacular of these was a grand piano covered completely in felt, like the one Beuys had already used in an action at the Düsseldorf Art Academy in 1966. When Werner Schmalenbach, who had been head of North Rhine-Westphalia's art collection since 1962 and who commanded one of the highest purchase budgets in Germany, saw the piano, he cried out:

'My poor, poor children.' In 1969 Anny De Decker and Bernd Lohaus travelled to New York, where they discovered James Lee Byars and Lawrence Weiner for their gallery. During their absence they presented 'Young American Artists' in the Wide White Space: Carl Andre, Richard Artschwager, Bill Bollinger, Dan Flavin, Walter de Maria, Bruce Nauman and Sol LeWitt.

While three of the Wide White Space artists (Carl Andre, Joseph Beuys and Christo) were represented at 'documenta 4', almost all of them appeared at 'documenta 5' organized by Harald Szeemann in 1972. Even if a commendation for the gallery's work lay in this circumstance, its end could be read there as well. The two gallerists' plan had been to show artists who exhibited nowhere else, but not to have to defend themselves against other galleries, who would try to woo away the now well-known artists. In 1973 the exhibition programme was reduced gradually, and the gallery was closed in May 1975. Another exhibition by Richard Long followed, and a final one in 1977 by Lawrence Weiner.

Wide White Space and its founders' interests in many artistic directions, as long as this was pursued to an extreme, stood as an example for many galleries founded in the same era. These, however, were much more prepared to back art that was already well established on the market, while Anny De Decker and Bernd Lohaus were focused more on their relationship to art itself, and on personal friendships with artists. Anny De Decker therefore noted later: 'We always viewed the gallery as an adventure, and not at all as commerce or a business venture.'

UTA GROSENICK

Galerie Rudolf Zwirner

YEAR OF FOUNDATION
1959

FOUNDER
Rudolf Zwirner

ADDRESS
1959–62 **Am Folkwang Museum, Essen**
1962–64 **Kolumbakirchhof, Cologne**
1964–71 **16 Albertusstraße, Cologne**
1972–92 **18 Albertusstraße, Cologne**

CLOSED 1992

ARTISTS REPRESENTED
Georg Baselitz, René Daniels, Felix Droese, Max Ernst
Lucio Fontana, Asger Jorn, Konrad Klapheck, Astrid Klein, Gustav Kluge
Imi Knoebel, Henri Laurens, René Magritte, Olaf Metzel, C. O. Päffgen
A. R. Penck, Sigmar Polke, Gerhard Richter
Daniel Spoerri, Jean Tinguely

The Galerie Rudolf Zwirner at 18 Albertusstraße, Cologne

An art dealer in the classical sense. In 1955 the first 'documenta' took place in Kassel, and upon visiting it the then twenty-two-year-old Rudolf Zwirner was certain that in his future he wanted 'to arrange modern art and explain it to the public'.[1] He quit his law studies and began to help out at the Galerie Der Spiegel in Cologne, owned by Hein Stünke, whom his parents knew well. A short time later he completed an apprenticeship in Berlin at the Rosen auction house, and was then invited by Heinz Berggruen to work as a trainee in his art dealership in Paris. It was in Paris in 1958 that he received news of his appointment as Secretary General of the second Kassel 'documenta'.

While the first 'documenta' had still been largely confined to European trends in contemporary art, and the second one in 1959 attempted to represent German Informel as the prevalent stylistic direction, nobody there could ignore the influence of American art any more, and the large-format works by Clyfford Still, Barnett Newman and Robert Rauschenberg were the real sensation.

Zwirner quickly remarked that visitors to 'documenta' wanted not only to admire the new art, but also to own it. Through the relationships he had developed while

Rudolf Zwirner at the
'Kunst für Köln' action,
early 1960s

preparing the exhibition, it was easy for him to obtain drawings. He also purchased some works by Matisse and Picasso, and with this starting inventory he opened his own gallery in Essen in December 1959. Zwirner's programme, however, was not initially orientated towards the Informel or Abstract Expressionism, but towards the École de Paris (School of Paris), with artists such as Yves Klein, Georges Mathieu, Jesús Rafael Soto, Cy Twombly, Karel Appel and Takis. But these exhibitions were unpopular in Essen, where the audience's taste favoured the Expressionists and Chagall. Thus two years later he moved the gallery to Cologne, where there were already some well-known galleries, such as Aenne Abels's, or that of the Stünkes, and some avant-garde artists as well. Combined with the museums and public broadcasting by the Westdeutscher Rundfunk, it was a cultural breeding ground.

In his rooms at Kolumbakirchhof, Zwirner showed Jean Tinguely's machines and Daniel Spoerri's performance art. He travelled to the United States for the first time in 1963, where he bought works by Lichtenstein, Segal, Warhol and Jim Dine. He wrote about this later: 'I was fascinated by the return to representation in all its variations, from Nouveau Réalisme, and British and American Pop Art, through to

Dinner in the gallery on
the opening of the new rooms
at 18 Albertusstraße, 1972

German artists like Konrad Klapheck, Gerhard Richter, Dieter Roth and Sigmar Polke.'[2] Anything representational, however, was still frowned upon in Germany; Pop Art shocked people, and an exhibition organized by Zwirner in 1965 with works by René Magritte received no particular response.

Young art could only be sold with difficulty, and out of this crisis Hein Stünke and Rudolf Zwirner founded the 'Kölner Kunstmarkt' in 1967, to provide art with an adequate forum and broader popularity. Only Cologne gallerists who dealt with contemporary art were invited to show at the Kunstverein (art society) and the conference halls in Gürzenich. Galleries from other cities or countries were not to take part: after all, one didn't want to invite the competition home just yet. The concept worked, and the first 'Kölner Kunstmarkt' was a financial success and became a fixed institution in Cologne, where the art business improved in the years that followed.

In 1971 Zwirner purchased the neighbouring property with the ruins of the former Kreissparkasse bank at 16 Albertusstraße, where he had begun presenting his artists, and built a new gallery based on his own notions there. In these rooms, which opened in 1972, Classic Modern and avant-garde art were united under one roof. In 1986 Rudolf Zwirner remarked that his gallery was not specialized like those of some other colleagues, who had concentrated on Hard Edge, Conceptual Art or

GALERIE RUDOLF ZWIRNER

Zero; nor did he have contracts with any individual artists as was otherwise usual in his line of business – because his interest was in providing information about art, and not in promoting single artists on the market.[3]

In 1992 Zwirner gave up his activities as a gallerist, but remained active as an exhibition curator. In 1993 he created the Zentralarchiv des internationalen Kunsthandels (Central Archive of the International Art Trade), which is dedicated to archiving and reprocessing the large quantities of correspondence and photos left by galleries that no longer exist. In 2000 Zwirner was granted an honorary professorship at the Hochschule für Bildende Kunst in Brunswick, the city in which he grew up, and since then he has passed his diverse art-business experience on to his students.

UTA GROSENICK

1 Rudolf Zwirner, in *Kunstforum*, No. 104, November/December, 1989
2 Rudolf Zwirner, 'Deutsche Nachkriegskunst im Kontext des internationalen Kunstgeschehens – Erinnerungen eines Kunsthändlers', in *Deutschlandbilder – Kunst aus einem geteilten Land*, Cologne, 1997
3 Christiane Vielhaber, 'Rudolf Zwirner – Galerist zwischen Köln, Rom und New York', in *KunstKöln*, Cologne, 1986

Interior view of the gallery at 18 Albertusstraße

The Pleasures and Limits of Growth
The 1970s

Leo Castelli at an exhibition opening at the Metro Pictures Gallery, 1981

The 1970s have been the subject of rose-tinted hype in recent years. The colourful, often globular, and always futuristic designs of Luigi Colani, Joe Colombo and Verner Panton are celebrating a cheerful comeback; the fashion of this decade, which managed to combine frumpiness and a contrived jazziness at the same time, is all the rage in every second-hand and retro shop; while the pop music of the era has likewise seen a revival in the early 21st century. Disco music à la *Saturday Night Fever*, which took movie theatres by storm in 1977, and 'Glam Rock' à la T. Rex, Sweet and David Bowie can once again be heard *ad nauseam* in clubs and on the radio.

But for those who actually lived through them, the 1970s were a contradictory decade, with much they would prefer not to see revived. The 1972 Olympic Games in Munich got off to a good start, but are now chiefly remembered for the attack by Palestinian radicals on Israeli athletes, while the following year witnessed the military coup in Chile, and all this time, until 1975, the Vietnam War was raging. The student revolts of the 1960s, with their promising vision of Utopia, had been put down throughout the Western world, which was now entering a period of reaction. However, it was a reaction that sought to safeguard its position by implementing far-reaching reforms, first broached in the 1960s, in educational, environmental and social policy. The global economic situation was likewise far from rosy. For the first time since the Second World War, it was clear that there were limits to growth. Rampant inflation became an issue, and the oil crisis of 1973–74 made it clear that the resources of planet Earth were not infinite. Then towards the end of the decade, terrorists, especially in Germany and Italy, threw down the gauntlet to the state, which reacted in a less than confident fashion. The German government, for example, sought to weed out 'extremists' from the public services and pushed privacy invasion to the limit in its search for terrorists, demonstrating a still underdeveloped sense of democracy. In reaction to this came the Punk movement, with its legendary bands such as the Sex Pistols, The Clash and the New York Dolls, which spread from the US via Britain to the cities and suburbs of the developed world, and beyond. Finally, in 1980, Republican former Hollywood actor Ronald Reagan was elected president of the United States. Not a bad metaphor of the age: the culture industry and conservatism went into the 1980s hand in hand.

The history of art in the 1970s is as contradictory as the other aspects of the decade, which opened with the triumphal march of Minimal and Conceptual Art, which had appeared in the mid- and late 1960s respectively. In the wake of these two currents, Land Art, the quickly spreading video art and performance art, and not least the ever more confident feminist art were also making their aesthetic mark. The legendary 'documenta 5', the 'mother of all succeeding documentas', curated by Harald Szeemann in 1972, was entirely dominated by these, in most cases, highly intellectual artistic tendencies. At the same time, Pop Art, represented by Andy Warhol and Roy Lichtenstein, continued to make a splash. From about 1978, however, a reverse trend became evident, and the art business started to be taken over by a comparatively superficial aesthetic. The painting of the Italian Trans-avantgarde or

the German 'Neue Wilde' was now sating an alleged 'hunger for pictures', which Minimal and Conceptual Art were both unable and unwilling to satisfy. Painters such as Mimmo Paladino or Francesco Clemente, Jörg Immendorff, Georg Baselitz or Markus Lüpertz suddenly came to be seen as typical exponents of a Postmodern art. The traditional canvas returned to replace a broader view of art: in parallel with the social developments, in other words, art too witnessed a conservative backlash.

The success story of the galleries in the 1970s begins, however, not surprisingly, in New York, where, in 1971, Leo Castelli, Ileana Sonnabend, André Emmerich and John Weber moved to SoHo, or, to be more precise, to 420 West Broadway. Paula Cooper's gallery had been there since 1968, and now many others followed, so that the neighbourhood 'south of Houston Street' quickly became the centre of contemporary art in the Western world. But in Europe too, contemporary art established itself at the start of the decade, for example in the new German art stronghold of Cologne, increasingly as a factor in a style-conscious life. Pop Art of course played a leading role, but it too was unable to help the art market overcome the problems that arose in the mid-1970s, problems whose origins lay not least in the above-mentioned oil crisis, and the economic recession that followed. Many galleries therefore welcomed the painting boom ushered in by the Trans-avantgarde and the 'Neue Wilde': these movements enlivened the market if nothing else.

RAIMAR STANGE

Thomas Ammann Fine Art

YEAR OF FOUNDATION
1977

FOUNDERS
Thomas and Doris Ammann

ADDRESS
SINCE 1977 **97 Restelbergstraße, Zurich**

ARTISTS REPRESENTED
Francis Bacon, Balthus, Joseph Beuys, Alexander Calder, Marc Chagall
Paul Klee, Willem de Kooning, Roy Lichtenstein, Brice Marden
Henri Matisse, Joan Miró, Pablo Picasso, Robert Ryman
Philip Taaffe, Cy Twombly, Andy Warhol, Tom Wesselmann

Thomas Ammann, 1950–93

Opposite: The gallery's library with a sculpture by Alexander Calder during the 'Thirty Three Women' exhibition, 2003

Left: Doris Ammann

Friendship as the secret of success. Brother and sister Thomas and Doris Ammann founded the Thomas Ammann Fine Art gallery in Zurich in 1977. Thomas Ammann had learnt about the art business at the Bruno Bischofberger gallery, starting from scratch. At first, the pair were financially supported by Alexander Schmidheiny, the wealthy son of an industrialist, and a childhood friend of Thomas Ammann, but the gallery was soon successful enough to stand on its own feet. The recipe for success sounds simple: a pronounced talent for salesmanship, a sound sense of artistic quality, and close friendships with artists and collectors. Together, these three factors made Thomas Ammann one of the most respected gallery owners in Switzerland in the 1980s, and not only there.

To start with, Thomas Ammann Fine Art's programme concentrated primarily on two artistic movements: Impressionism and classical Modernism. Lucrative artists such as Balthus, Paul Klee, Pablo Picasso and Joan Miró are still on the gallery's list even today. Soon, though, Thomas Ammann broadened his spectrum and included more modern American artists such as Cy Twombly, Roy Lichtenstein and Andy Warhol.

'Years ago, people hardly ever talked about art at dinner parties, but today every housewife in New Jersey is an art dealer,' was how Thomas Ammann once described the art boom of the 1980s. The 'balanced programme' philosophy of Thomas Ammann

Exterior view of the back of the
gallery during an exhibition
of work by Robert Ryman, 2002

Fine Art catered for precisely this clientele, and others besides: in other words, positions sanctioned by history on the one hand, balanced by discreetly progressive art on the other.

In 1993 Thomas Ammann died in his early forties, and since then his sister Doris has run the business with equal success. The gallery is now regularly represented with a large stand at 'Art Basel', and, moreover, she is the sole agent for Willem de Kooning in Europe. And together with the director of the gallery, Georg Frei, she is modernizing the gallery's programme, albeit tentatively. Martin Kippenberger and Francesco Clemente, for example, have taken part in group exhibitions at Thomas Ammann Fine Art in the 21st century. Finally, in the autumn of 2003, the gallery, in collaboration with the Andy Warhol Foundation for the Visual Arts, New York, published the second volume of Andy Warhol's catalogue raisonné – a project on which Thomas Ammann had been working since the 1970s.

RAIMAR STANGE

THOMAS AMMANN FINE ART

Stand at 'Art Basel', 2002,
with works by Tom Wesselmann

Art & Project

YEAR OF FOUNDATION
1968

FOUNDERS
Geert van Beijeren and Adriaan van Ravesteijn

ADDRESS
1968–71 **8 Richard Wagnerstraat, Amsterdam**
1971–73 **18 Van Breetstraat, Amsterdam**
1973–78 **38 Willlemsparkweg, Amsterdam**
1978–90 **Prinsengraachtweg, Amsterdam**
SINCE 1990 **42 Nieuwesluizerweg, Slootdorp**

ARTISTS REPRESENTED
John Baldessari, Robert Barry, Stanley Brouwn, Daniel Buren, Sandro Chia
Francesco Clemente, Tony Cragg, Enzo Cucchi, Hanne Darboven, Jan Dibbets, Gilbert & George
Imi Knoebel, Joseph Kosuth, Sol LeWitt, Richard Long, David Tremlett, Lawrence Weiner

Project-based. Art & Project, founded in 1968, was probably the most important avant-garde gallery in the Netherlands. The two proprietors, Geert van Beijeren and Adriaan van Ravesteijn, were not concerned at the start of their gallery careers with presenting and selling works of art. Instead, they were interested in having project-based art ideas 'circulated'. At first, Geert van Beijeren and Adriaan van Ravesteijn wanted to realize this concept in connection with architecture, but it quickly became apparent that the Conceptual Art of the 1960s offered the better opportunity of putting art up for a discussion that was not primarily concerned with the aesthetic production of works. The 'dematerialization of the art object' (Lucy R. Lippard), which at the time was being successfully promoted by Conceptual artists, had succeeded in leading art to new social and political fields: it was precisely this element that fascinated the Art & Project gallery in Amsterdam.

Only a year after its establishment, the gallery was already collaborating with artists such as Lawrence Weiner, Stanley Brouwn and Robert Barry. They used the bulletins sent out by Art & Project not only as invitations or information sheets, but as a form of art in themselves. Later they were joined by artists such as John Baldessari and Joseph Kosuth, and slowly an international network within the Conceptual Art scene was built up. Collaborations with other galleries such as Konrad Fischer, Paul Maenz and Yvon Lambert also broadened the spectrum of the gallery's work. In 1969 Robert Barry made art history by writing in the Art & Project Bulletin 17: 'during the exhibition the gallery will be closed' – a criticism of the gallery as a medium, unsurpassed in its logical consistency even today. A year later, Art & Project exhibited art by Hanne Darboven, Imi Knoebel and Sol LeWitt, and in May Gilbert & George exhibited themselves here as 'Living Sculpture'. The next year, the artists working with the gallery included John Baldessari and Daniel Buren.

The Art & Project programme is continually changing, and in different directions, not least because some of the artists represented became so expensive that the gallery could no longer afford to exhibit them. In the 1980s, finally, colourful paintings by Sandro Chia, Francesco Clemente and Enzo Cucchi were presented in the gallery. A greater contrast with the initially favoured but anti-sensuous Conceptual Art can hardly be imagined. Then in 1990 Art & Project moved to Slootdorp in the Dutch provinces and gradually disappeared from the international art limelight.

RAIMAR STANGE

Overleaf: Bulletin on the Robert Barry exhibition, 1969

art & project

adriaan van ravesteijn
geert van beijeren bergen en henegouwen

amsterdam 9
richard wagnerstraat 8
(020) 720425

bulletin 17

drukwerk/
printed matter

aan/to

<u>17.12 - 31.12.1969</u>
exhibition:

robert barry

tuesday 2-5 p.m.
wednesday 2-5 p.m.
thursday 2-5 p.m.
friday 2-5 p.m.
saturday 2-5 p.m.

during the exhibition the gallery will be closed.

Paula Cooper Gallery

YEAR OF FOUNDATION
1968

FOUNDER
Paula Cooper

ADDRESS
1968–73 **96 Prince Street, New York**
1973–96 **155 Wooster Street, New York**
SINCE 1996 **534 West 21st Street, New York**
SINCE 1999 ALSO **521 West 21st Street, New York**

ARTISTS REPRESENTED
Carl Andre, Jo Baer, Jennifer Bartlett, Jonathan Borofsky
Celeste Boursier-Mougenot, Sophie Calle, Mark Di Suvero
Dan Flavin, Wayne Gonzales, Robert Grosvenor
Michael Hurson, Donald Judd, Yayoi Kusama
Julian Lethbridge, Sherrie Levine, Sol LeWitt
Christian Marclay, Claes Oldenburg & Coosje van Brugge
Adrian Piper, Jan Schoonhoven, Andres Serrano
Rudolf Stingel, John Tremblay, Kelley Walker
Meg Webster, Robert Wilson, Jackie Winsor

Political correctness from the outset. The Paula Cooper Gallery opened in the autumn of 1968 with an exhibition supporting the Student Mobilization Committee to End the War in Vietnam, displaying works by, among others, Carl Andre, Dan Flavin, Donald Judd, Robert Mangold and Robert Ryman, as well as the very first wall painting by Sol LeWitt. Conceptual and Minimal Art have remained the focus of the gallery's agenda since its inception. Alongside the exhibitions of visual art, the gallery also stages regular concerts, dance-performances, poetry readings and charity events.

Paula Cooper was the first gallery owner to venture away from the commercially developed uptown to the relatively unfashionable downtown. She is regarded as the pioneer of SoHo, which in the 1960s was dominated by small workshops and wholesalers in run-down lofts, but by the 1970s and '80s had become Manhattan's gallery and boutique neighbourhood. Her first gallery was located on the upper floor of a building on Prince Street, in a loft fitted out by the artists themselves. Five years later, she exchanged it for roomy shop premises with a display window on Wooster Street.

Exhibition to support the Student Mobilization to End the War in Vietnam, with works by Will Insley and Jo Baer on display in the picture, 1968

'I didn't want to be a gallery like the other galleries,' said Paula Cooper, explaining her decision to set up shop in SoHo. 'I wanted a large room where there would be no solo exhibitions, but a constant succession of works of art. Most of the artists needed money urgently, and I would simply sell their works. If an item was sold, I would put up another. It would be a continually changing flexible group exhibition…. There were therefore a number of reasons why I wanted to go Downtown, but mainly because that was where the artists lived.'[1]

Some of these artists, including Carl Andre, Jennifer Bartlett, Lynda Benglis, Jonathan Borofsky, Donald Judd, Elizabeth Murray and Sol LeWitt, are now world famous. 'I regard the artists as my clients,'[2] she says, a claim supported by the post-sale financial arrangements: 60 per cent for the artist, 40 per cent for the gallery, whereas fifty-fifty is the norm for other galleries.

View of Robert Gober's installation with *Wedding Gown*, *Cat Litter* and *Hanging Man/Sleeping Man*, 1989

In 1989 Cooper helped the then unknown Robert Gober achieve a breakthrough with his legendary 'Gender and Identity' exhibition. The two were introduced by the painter Elizabeth Murray, whose canvases he stretched. The walls of the gallery were completely covered with Gober's wallpaper with its repeated motifs of a sleeping white man and a black man strung up on a tree. Leaning against the walls were plaster casts of bags of cat litter, while standing in nervous expectation in the middle of the otherwise empty room was a wedding dress, hand-sewn by the artist himself. The darkened side room was papered with scrawled drawings of male and female genitalia, while the wall was perforated with bathtub plugholes; brightly illuminated on a plinth in the middle of the room was a bag of greasy doughnuts.

At the time, Gober praised Cooper in glowing terms: 'I know dealers who tell their artists what they're supposed to wear. The best thing about Paula is that she leaves me in peace. She shields me – not in an infantile, but in a protective fashion – from the obligations. She only rarely brings collectors to my studio and encourages me to go my own way. That's very unusual for an art dealer.'[3] Ten years later, at the pinnacle of his success, Gober left the gallery, having decided to sell all his works himself.

Overleaf: Jonathan Borofsky exhibition, 1980

When in the mid-1990s the first galleries began to move away from SoHo to Chelsea, Paula Cooper was among them. 'I've been in SoHo since 1968 and in these premises since 1973, and quite honestly, I've had a bit too much,' she said. 'I like changing rooms and building rooms. I'm bored by this room, and I don't like the neighbourhood any more.'[4]

The new premises were in a 19th-century building on 21st Street, whose conversion into one of New York's most attractive galleries won an award for designer Richard Gluckman. Here, since the autumn of 1996, regular five-weekly exhibitions have taken place, the most spectacular of which include a retrospective of the French artist Sophie Calle with works dating from between 1981 and 2001, a compilation of very early drawings (1959–63) by Claes Oldenburg, and an exhibition of large-scale sculptures by Mark di Suvero. In 1999 the gallery fitted out a second room on the opposite side of the street. Originally conceived as a private showroom, it is now also open to the public. Here, though, the exhibitions are on for longer, so that visitors have the opportunity to return for a second look.

'I would like people to slow down,'[5] says Paula Cooper, but slowing down seems to be the last thing on her mind. In 2000 she established her own recording label called 'Dog w/a Bone', which to date has released recordings featuring music by Morton Feldman, Petr Kotik and the S. E. M. Ensemble, and Marcel Duchamp's complete musical works. Since 2002 the Paula Cooper empire has also included 192 Books, a bookshop on 10th Avenue, New York, which features key works of literature and history, art and criticism, and the social and natural sciences, as well as travel and children's books. It also provides space for occasional exhibitions.

UTA GROSENICK

Above, left: Exterior view of the Paula Cooper Gallery on 21st Street, re-built by Richard Gluckman

Above, right: Sherrie Levine/ Joost van Oss exhibition, 1999

PAULA COOPER GALLERY

236

1 In Michele Amateau, 'Interview:
 Paula Cooper', *Ocular*, June 1977
2 In Valerie Block, 'The Art of the
 Dealer: A Completely Equal
 Relationship', *The New York
 Observer*, 18 April 1988
3 Ibid.
4 In Amei Wallach, 'Overrun,
 SoHo's Art World Shifts Ground',
 New York Times, 12 May 1996
5 In Steven Vincent, 'Paula Cooper
 Opens Second Space', *Art & Auction*,
 15 April 1999

Galerie Konrad Fischer

YEAR OF FOUNDATION
1967

FOUNDER
Konrad Fischer

ADDRESS

1967–70 **12 Neubrückstraße, Düsseldorf**

1970–74 **25 Andreasstraße, Düsseldorf**

SINCE 1974 **7 Platanenstraße, Düsseldorf**

1975–82 **142 Green Street, New York (Sperone, Westwater, Fischer)**

1983–92 **5 Mutter-Ey-Straße, Düsseldorf**

ARTISTS REPRESENTED

Carl Andre, Giovanni Anselmo, Richard Artschwager
Lothar Baumgarten, Bernd and Hilla Becher
Joseph Beuys, Alighiero Boetti, Daniel Buren
Alan Charlton, Hanne Darboven, Jan Dibbets
Dan Flavin, Hamish Fulton, Isa Genzken
Gilbert & George, On Kawara, Harald Klingelhöller
Jannis Kounellis, Wolfgang Laib, Sol LeWitt
Richard Long, Robert Mangold, Brice Marden
Mario Merz, Reinhard Mucha, Bruce Nauman
Blinky Palermo, Giuseppe Penone, Sigmar Polke
Gerhard Richter, Ulrich Rückriem, Reiner Ruthenbeck
Robert Ryman, Gregor Schneider, Thomas Schütte
Robert Smithson, Lawrence Weiner

Isa Genzken, Konrad Fischer, Gerhard Richter and Bernd Becher in the gallery on Platanenstraße

The artist who became a gallery owner. Konrad Fischer studied painting at the Düsseldorf Art Academy and tried to make a career as an artist under his mother's maiden name, calling himself Konrad Lueg. In 1962, with his former fellow students Gerhard Richter and Sigmar Polke, he went off in search of a gallery. As they could not find one to start with, they rented a shop where they could exhibit their works, and a year later, they arranged an exhibition in a Düsseldorf furniture store, Berges – an exhibition entitled 'Demonstration on behalf of Capitalist Realism'. In 1964 the three artists had their first gallery exhibition at the Galerie Parnass in nearby Wuppertal. A short time later, Konrad Lueg signed a contract with the Galerie Schmela in Düsseldorf. He also helped the proprietor, Alfred Schmela, to hang exhibitions and accompanied him on business trips. Then Schmela suggested that he open a branch of the Galerie Schmela to exhibit the work of young artists. Konrad Fischer was horrified, not believing himself up to the job, but when Schmela called a few days later to withdraw the offer, 'I found I was already an art dealer, and said: "Then I'll do it myself."'[1] At 12 Neubrückstraße in Düsseldorf, right next to the legendary artists' bar 'Cream Cheese', Konrad Fischer found a gateway, which seemed to him a suitable place for a gallery. 'I already had an idea of what I wanted to do…Carl Andre, Sol LeWitt, all of Minimal Art – that's what I wanted to exhibit.'[2]

Exterior view of the Galerie Konrad Fischer at 12 Neubrückstraße in Düsseldorf, late 1960s

Galeria Foksal
Foksal Gallery Foundation

Galeria Foksal

YEAR OF FOUNDATION
1966

FOUNDER
Wiesław Borowsky

ADDRESS
SINCE 1966 **1/4 Ul. Foksal, Warsaw**

ARTISTS REPRESENTED

Mirosław Balka, Krzysztof M. Bednarski, Christian Boltanski, Alan Charlton, Marek Chlanda, Tomasz Ciecierski
Michael Craig-Martin, Peter Downsbrough, Stanisław Drózdz, Zbigniew Gostomski, Zuzanna Janin, Koji Kamoji
Anselm Kiefer, Robert Maciejuk, Annette Messager, Deimantas Narkevicius, Marzena Nowak, Roman Opałka
Jadwiga Sawicka, Mikołaj Smoczyński, Maria Stangret-Kantor, Leon Tarasewicz
Tomasz Tatarczyk, Lawrence Weiner, Krzysztof Wodiczko, Włodzimierz Jan Zakrzewski

Foksal Gallery Foundation

YEAR OF FOUNDATION
1997

FOUNDERS
Joanna Mytkowska, Andrzej Przywara and Adam Szymczyk

ADDRESS
1997–2001 **1/4 Ul. Foksal, Warsaw**
SINCE 2001 **1A Gorskiego, Warsaw**

ARTISTS REPRESENTED

Paweł Althamer, Cezary Bodzianowski, Katarzyna Józefowicz, Edward Krasiński, Piotr Uklański, Artur Zmijewski

Adam Szymczyk, Andrzej Przywara and Joanna Mytkowska, 2001

The multiple ambiguity of the white cube. On 1 April 1966 the Galeria Foksal opened in Warsaw. The invitation to the inaugural exhibition – a postcard with abstract compositions of intersecting white and black circles – was designed by Edward Krasiński, one of the artists in the circle in which the idea to set up the gallery had originated.

On a later photomontage, *We See You*, what we see are the faces of the other members of the group: the critics and art historians Wiesław Borowsky, Anna Ptaszkowska and Mariusz Tchorek, and the artists Zbigniew Gostomski, Tadeusz Kantor, Maria Stangret and Henryk Stażewski. After the departure of Ptaszkowska and Tchorek from the gallery in the early 1970s, as a result of internal conflicts within the group, the art historian Andrzej Turowski came to play an important role in the development of a profile for the Galeria Foksal. He was a constant companion, reflecting on the role of an institution that was continually subjecting itself to critical examination.

While Poland was a 'People's Republic', the opening of a gallery for contemporary art was, like any other private initiative, impossible without the agreement of the powers that be. The founders of the gallery were allocated premises in the former library of Marxist classics in a wing of the 19th-century Zamoyski Palace on Ulica Foksal, a side street of Nowy Swiat, the main street in the historic centre of the city, which had been reconstructed after the Second World War. Administratively and financially, the Galeria Foksal was affiliated to the Craft Workshops, a state-run enterprise, which was concerned with the artistic settings for days of national celebration, and which for years carried out various work, free of charge, for the gallery's exhibitions, including Krzysztof Wodiczko's *Vehicle*.

Exterior view of the Foksal Gallery Foundation

The art critics who ran the gallery played the avant-garde cards of experiment and Modernism carefully, and their exhibition agenda did not as a rule overstep the mark of what was politically acceptable. The absence of overt political commitment on the part of artists and exhibition organizers was virtually the rule in post-war Poland, and the few 'contraventions' were marginalized by the authorities. Similarly, dissident intellectuals sought agreement with the literary, cinema and theatrical communities, and identified with a conservative vision of the arts, without overly interesting themselves in traditionally 'left-wing' contemporary art.

The Galeria Foksal circle in the 1960s and '70s produced not only exhibitions, but also theoretical articles ('Introduction to the General Theory of Place', 1967), manifestos ('What Don't We Like About Galeria Foksal?', 1968) and institutional projects ('Living Archive', 1971). The Galeria Foksal worked like the experimental galleries of Western Europe: works were commissioned in order to update constantly the dossiers of the individual artists, exhibitions were documented, and within the bounds of the possibilities then existing, efforts were made to take part in the international information network. The Galeria Foksal worked for twenty-three years in a communist state, making clever use of the latter's lethargy. The gallery never wanted to be a commercial venture, indeed it could not be, and this also underlines its individuality vis-à-vis its West European counterparts; it pursued its own 'strategy' and outlined its position in articles and public appearances. The gallery called into question the invariability of the rules of the game between the artist, the artwork and the public, as well as the context of this game: the exhibition in a white room.

The Galeria Foksal was an exhibition room measuring seven metres by five, an ideal white cube. But even the very first environment exhibitions to take place there ('Pokaz Synkretyczny / A Syncretistic Performance' by Wlodzimierz Borowski, 1966;

Paweł Althamer, *Bródno 2000*, Warsaw, 2000

the 'Linear Sculptures' exhibition by Edward Krasiński, 1968) evoke a mood of the unspoken, a pleasurable multiple ambiguity. The artists were intuitively overstepping the boundaries imposed by the architecture and transferring the perception of the exhibition from the physical to the mental space, as in the famous 'Between', 1977, by Stanisław Drózdz, where the beholder finds herself literally inside the word. During the 1970s, Conceptual and Post-minimal artists executed site-specific projects at the Galeria Foksal. The gallery became one of the international showcases, and Giovanni Anselmo, Robert Barry, Christian Boltanski, Victor Burgin, Tom Marioni and Lawrence Weiner were among those to appear. The room was played upon in hundreds of ways and subjected to hundreds of 'solutions'. In the course of time, the gallery became a legendary institution, an eastern outpost of contemporary art. During the 1980s, now run autonomously by Wiesław Borowsky, it basically ignored Neo-Expressionist tendencies and continued to work largely with Conceptual artists, but in the process moved closer to metaphorical art and added Anselm Kiefer to its list. Continually redefining itself, the gallery inaugurated a process of 'becoming history', which is still ongoing today. The idea of a 'Living Archive', a de-materialization of artistic production and its location, returned: the Galeria Foksal *is* an archive.

In the mid-1990s three young art historians, Andrzej Przywara, Joanna Mytkowska and Adam Szymczyk, started a collaboration with the head of the gallery, Wiesław Borowsky, and exerted a considerable influence on the gallery's agenda. By cooperating with artists of different generations, they sought critically to re-interpret the canon of the Galeria Foksal, in which they found certain secondary currents and unspoken aspects. They searched for a contemporary applica-

tion for the artistic and gallery strategies, which they had modified, of the upheavals of the 1960s and '70s. From the tradition of the Galeria Foksal, what we get is self-irony and a game with the objet d'art, such as we find in the works of Edward Krasiński; in the book *Tadeusz Kantor: From the Archive of the Galeria Foksal* they seek to present this artist, previously identified with the theatre, as one of the leading personalities of the theoretical and personal disputes in Polish art in 1970; they direct our interest to the art of Stanisław Drózdz, which developed from concrete poetry to three-dimensional textual spaces. They often implemented an intuitive sampling of avant-garde strategies: for the 'Better know / better not know' exhibition of visual art of the 1960s, the Galeria Foksal, invited to take part, was transported by a professional firm to the Galeria Zacheta, and Douglas Gordon, Mirosław Balka and Paweł Althamer supplemented the presentation with specially commissioned works, which call into question the unambiguity of historical representations.

In the new political and economic reality of the post-1989 Republic of Poland, and in view of the obvious collapse of state and municipal arts policy, the curators of the Galeria Foksal, together with Wiesław Borowsky, set up the Foksal Gallery Foundation in 1997. The four years during which the municipal gallery and the

Anselm Kiefer, *The Angel of History*, view of the installation at the Galeria Foksal

private Foundation co-existed in a single room proved to be a dramatic time, but rich in interesting projects. During this period, the Foundation staged exhibitions of such artists as Tom Friedman, Job Koelewijn, Anna Niesterowicz, Wilhelm Sasnal, Gregor Schneider, Gerda Steiner and Artur Zmijewski, and also an exhibition lasting several months and continually changing, with the title 'Creeping Revolution' (1999–2000), in which at various points Jaroslaw Flicinski, Edward Krasiński, Jim Lambie, Peter Pommerer, Andrzej Szewczyk and Richard Wright were involved:

within the framework of this exhibition projects were also staged outside in the city by Paweł Althamer and Piotr Uklański.

After the 'Bureaucracy' exhibition involving Chad McCail and Steven Pippin in 2001, the Foksal Gallery Foundation went its own way, opening office and exhibition premises on the third floor of a 1960s building in Warsaw; its inaugural exhibition, 'A Walk at the End of the World' (with artists including Francis Alÿs, Cezary Bodzianowski and Franziska Furter), which was based on a Polish episode in the biography of the Swiss author Robert Walser, opened on 8 December 2001. The new room, glazed on two sides, with a view of the Palac Kultury i Sztuki (Palace of Art and Culture), has seen exhibitions not only by artists such as Balka, Bodzianowski, Niesterowicz, Sasnal and Uklański, with whom the Foundation had already worked, but also by new female artists, including Berta Fischer, Goshka Macuga and Monika Sosnowska. The Foundation was also responsible for the project Nova Popularna – a semi-legal bar in rented premises, designed and operated by Paulina Olowska and Lucy McKenzie. The Foundation has staged numerous projects outside Warsaw, including the international 'Hidden in a Daylight' exhibition in Cieszyn (2003).

When taking part in international art fairs, the Foksal Gallery Foundation carries out no commercial business in the Polish market, and reinvests all the revenue from sales in the execution of diverse projects in Poland and in the support of local artists.

ADAM SZYMCZYK

Galerie Metropol

YEAR OF FOUNDATION
1978
FOUNDERS
Christian Meyer and Georg Kargl
ADDRESS
1978–81 **2 Liliengasse, Vienna**
1982–95 **12 Dorotheergasse, Vienna**
CLOSED 1995

ARTISTS REPRESENTED
Hanne Darboven, Andrea Fraser, Renée Green
Elke Krystufek, Thomas Locher, Walter Obholzer
Raymond Pettibon, Charles Ray
Rudolf Stingel, Sue Williams

Thomas Locher, Tanja Grunert, Christian Meyer and Franz Graf, 1992

Two's company. The Galerie Metropol was founded by Christian Meyer and Georg Kargl on Dorotheergasse in Vienna in 1978; at first the two dealt in antiques, in particular Viennese Art Nouveau. Then in 1988 they organized the 'Dorotheergasse Free Zone' project, which marked the start of their energetic commitment to contemporary art. For this unusual undertaking, works by artists such as Valie Export, Peter Kogler and Gerwald Rockenschaub, which invaded the public space to a greater or lesser degree, were financed by the owners of businesses on Dorotheergasse: this element of looking after artists combined with the production of art(works) was subsequently to be a hallmark of the ordinary gallery business of the Galerie Metropol, which began in March 1990 with an exhibition by Franz Graf. Presentations of work by Ad Reinhardt, Richard Artschwager, Hanne Darboven and Thomas Locher followed in quick succession. It was a clever agenda, which was based on Conceptual Art at first, a trend that 'was basically never accepted in Austria, because here, painting is dominant', as Christian declared at the time. The gallery continued this aesthetic education programme in the spring of 1991 with its major thematic exhibition 'The Picture After the Last Picture'. The exhibition was curated by Kasper König and Peter Weibel, and sought to call into question 'the idea of the picture at the level of contemporary seeing and thinking', as the curators wrote in the catalogue. To this end, works for example by Gerhard Richter and On Kawara, Robert Ryman and Rosemarie Trockel, and Jenny Holzer and Sherrie Levine were shown.

A year later, for the 'documenta IX' exhibition in Kassel, the Galerie Metropol produced the sculpture *Oh Charlie, Charlie, Charlie* by Charles Ray, who had already exhibited at the gallery at the end of 1991. In 1993 Christian Meyer and Georg Kargl supervised Austria's contribution to the 45th Venice Biennial. Peter Weibel in turn invited Gerwald Rockenschaub, Andrea Fraser and Christian Philipp Müller to take part – three artists, in other words, who were very much part of the Galerie Metropol

Christian Meyer and **Georg Kargl**, early 1990s

Passers-by in front of the installation by Thomas Locher, 1992

'stable'. This close cooperation between curator, artists, gallery and Biennial was somewhat controversial at the time, as it was believed by some to represent a baleful alliance between the commercial market and institutional art. The same year, the gallery owners, in collaboration with Ulf Wuggenig, organized the symposium 'The Aesthetic Field' at the Viennese Academy of Applied Arts (Hochschule für angewandte Kunst). Artists such as Jeff Koons, John Miller and Raymond Pettibon gave 'Lectures on Forms of Practice in Art'. In 1993–94 the gallery sought to cooperate

Elke Krystufek in her
installation, 1992

Renée Green at her exhibition, 199

with the academy once more to stage an exhibition series entitled 'curated by' to mark the institution's 125th anniversary. The curators were to be Markus Brüderlin and Dan Cameron. However, 'curated by' did not come to fruition. 'The exhibition series "curated by", likewise proposed by ourselves, seemed to the authorities to be too critical of the institution, and was therefore discontinued,' Meyer explained.

Subsequently the gallery exhibited artists such as Renée Green, Peter Fend and Mark Dion, who had been suggested by Colin de Land, the head of the New York gallery American Fine Arts. Generally, the gallery's agenda now no longer focused solely on Conceptual Art, but also took account of movements which, as Christian Meyer put it, thematized a 'flight inwards, extreme psychologization, for cultural statements'. This agenda is represented by names such as the young Elke Krystufek and Sue Williams, as well as the 'old master' Bruce Nauman.

In 1995 Meyer and Kargl ended their seventeen-year collaboration with an exhibition of works by Karen Kilimnik, and the Galerie Metropol closed down. The break-up had been brought about by different ideas about what a gallery should be doing. Today Meyer and Kargl each run their own galleries in Vienna.

RAIMAR STANGE

Exterior view of the gallery, with an exhibition of the works of Christian Philipp Müller (the artist is in the foreground), 1993

Galerie nächst St. Stephan

YEAR OF FOUNDATION
1954
FOUNDER
Monsignore Otto Mauer
1973–77 **Oswald Oberhuber**
SINCE 1978 **Rosemarie Schwarzwälder**
ADDRESS
1 Grünangergasse, Vienna

ARTISTS REPRESENTED
Carl Andre, Siegfried Anzinger, Herbert Brandl, Ernst Caramelle
Helmut Federle, Imi Knoebel, Sherrie Levine, Robert Mangold
Brice Marden, Ingo Meller, Gerhard Merz, Gerhard Richter
Gerwald Rockenschaub, Robert Ryman, Karin Sander, Adrian Schiess
Günter Umberg, James Welling, Erwin Wurm, Heimo Zobernig

Rosemarie Schwarzwälder, 2004

Clarity of purpose. The name 'Galerie nächst St. Stephan' means 'gallery next to St Stephan' – St Stephan's Cathedral in Vienna. And, as the name suggests, it was originally a church-run business. But before its founding father, Monsignor Otto Mauer, died in 1973, he set up an independent association to operate the gallery, and thus fortunately prevented it from falling into the hands of the church. From 1973 to 1977 it was run by Oswald Oberhuber, who was also Rector of the Hochschule für angewandte Kunst (Academy of Applied Art) in Vienna. Finally, in 1978, the management of the business was taken over by Rosemarie Schwarzwälder, who had previously worked as an art journalist (among other things). It was only now that the Galerie nächst St. Stephan started to build up a Europe-wide reputation.

Rosemarie Schwarzwälder was characterized by a very conscious attitude towards her own work. 'Gallery work is not primarily art dealing,' she wrote, and went on in definite terms. 'I have ideas in my head, not goods you can shift around. This approach needs a clear programme.'[1]

Rainer Ganahl, 'War-TV.com' and 'My Private War Archive, Afghanistan, Fall 2001', two posters in the gallery's display window

Opening of the Donald Judd
exhibition, 11 March 1988

This clear programme of Schwarzwälder's was at first characterized by a well-thought-out development, which extended from the sensitive presentation of (interdisciplinary) performances, via the critical treatment of the flood of pictures painted by the 'Neue Wilde' and the Trans-avantgarde in the early 1980s, to an ongoing and concentrated confrontation with Conceptual Art from around the mid-1980s. In all this, she sees herself as the intermediary between artists and public: 'I am the next, after the artist and the work. I observe. I make associations. I create networks. I publish.'[2] As an 'information gallery'[3] the Galerie nächst St. Stephan makes its point both precisely and concisely, but as an information gallery that seems to have inexorably and increasingly become a sales and advisory gallery for collectors.

In 1984 Rosemarie Schwarzwälder staked out the cardinal points for her future gallery activity with the group exhibition 'Signs, Floods, Signals – neo-constructive and parallel', which was a pioneering event, and not just for her. With works by Helmut Federle, Gerwald Rockenschaub, Imi Knoebel, Heimo Zobernig, John M Armleder and Brigitte Kowanz, she succeeded for the first time not only in reacting to an artistic trend, but in actively helping to create an art movement herself. The art world was hit by the 'Neo Geo' movement. An aesthetic between Abstraction and Concept, between work and project, was here successfully presented, and it has kept its relevance to the present day. It was then that Gerwald Rockenschaub and Heimo Zobernig, for example, discovered the gallery, which they were later to promote on an ongoing basis, and where they continue to be displayed for much of the time. This – doubtless calculated – endurance is also evidenced by the 'Early 80s and now' exhibition, staged in the gallery at the end of 2001 and start of 2002, which, with works by, among others, Helmut Federle and Imi Knoebel, revealed the roots of her favourite art in exemplary fashion. Further artists at that time were Gerhard Merz, Günter Umberg and Stephen Bambury.

Typical of the Galerie nächst St. Stephan is the curating of thematic group exhibitions. The ongoing production of artist catalogues has also been an aid in exploring the possibilities of Rosemarie Schwarzwälder's own aesthetic ideas. It was not until 1987 that the gallery was privatized, thus securing for Schwarzwälder greater freedom of action and making it easier for her to maintain a consistent profile. In the same year she exhibited a corporate collection for the first time – for the 'Erste österreichische Spar-Casse', a savings bank. Instead of merely counting on the enthusiasm of private collectors, the Galerie nächst St. Stephan exploited the financial clout of business. Schwarzwälder asked: 'Should the gallery owner increasingly rely on corporate cooperation? Should the gallery owner only be an adviser and forget about exhibiting? Or should he or she give up the gallery altogether and get into new forms of mediation?'[4] To date, she has answered these questions with an exhibition activity that relies less on the 'implemented quality of individual items' than on the showing of 'a stronger connection'[5] in art.

<div style="text-align: right">RAIMAR STANGE</div>

1 In Rosemarie Schwarzwälder, *Klares Programm*, Regensburg 1995, p. 9
2 Ibid., p. 12
3 Ibid., p. 17
4 Ibid., p. 57
5 Ibid., p. 59

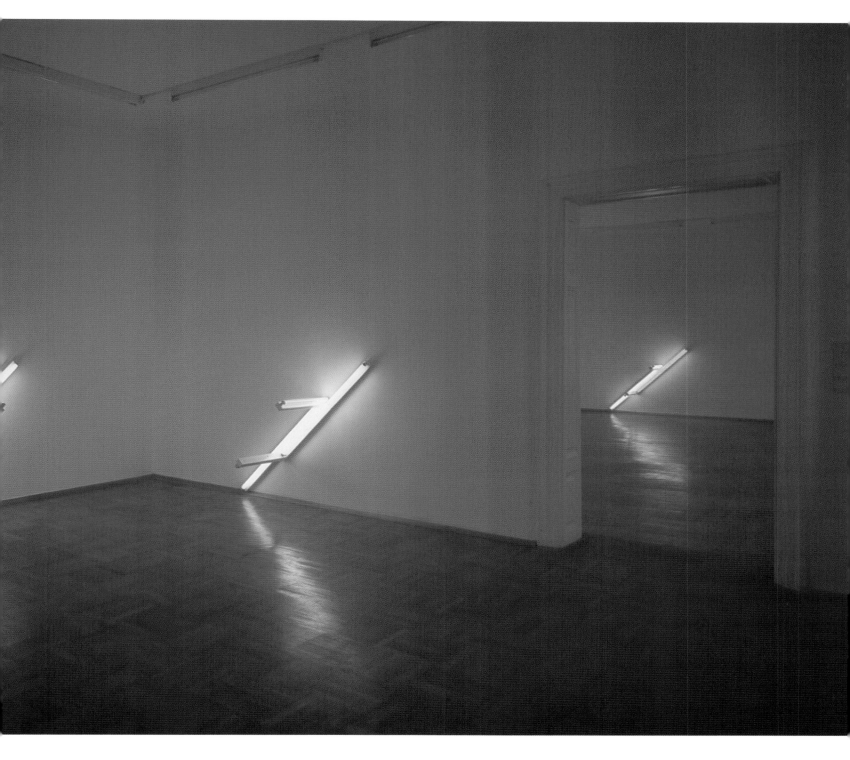

View of the Dan Flavin exhibition,
'Untitled (to my friend DeWain
Valentine)', 1991

Marian Goodman Gallery

YEAR OF FOUNDATION
1977

FOUNDER
Marian Goodman

ADDRESS
1977–81 **38 East 57th Street, New York**
SINCE 1981 **24 West 57th Street, New York**
SINCE 1999 **79 Rue du Temple, Paris**

ARTISTS REPRESENTED
Eija-Liisa Ahtila, Chantal Akerman, Giovanni Anselmo
John Baldessari, Lothar Baumgarten, Dara Birnbaum
Christian Boltanski, Marcel Broodthaers, Daniel Buren
Maurizio Cattelan, James Coleman, Thierry de Cordier
Tony Cragg, Richard Deacon, Tacita Dean, Rineke Dijkstra
David Goldblatt, Dan Graham, Pierre Huyghe, Cristina Iglesias
William Kentridge, Sol LeWitt, Steve McQueen, Marisa Merz
Annette Messager, Juan Muñoz, Maria Nordman, Gabriel Orozco
Giulio Paolini, Giuseppe Penone, Gerhard Richter, Anri Sala
Thomas Schütte, Thomas Struth, Niele Toroni, Jeff Wall
Lawrence Weiner, Francesca Woodman

Theory and practice. Marian Goodman's 8,000-square-foot New York gallery is about as trendy as a university library – and that's a good thing. No flashy, fleeting, up-to-the-minute exhibitions there. It is a place to contemplate the revered work of such intellectual leviathans as Lothar Baumgarten, James Coleman, Gerhard Richter and Lawrence Weiner. With three distinct gallery spaces that give viewers the sense of being at a small centre for contemporary art rather than at a commercial gallery – and offerings of such brainy artist editions as Mel Bochner's *Misunderstandings: A Theory of Photography* – Marian Goodman Gallery is not just a place to see art, but to learn. The artists here focus less on themselves than on the concerns of the world.

In fact, several of her artists are like tenured professors. She has worked with Tony Cragg for twenty-two years, Gerhard Richter for nineteen years, Thomas Schütte, Jeff Wall and Thomas Struth for fifteen years and Lawrence Weiner for eighteen years. This commitment to artistic development – and a healthy disinterest in the art world's customarily modish veneer – has earned Goodman a reputation of being one of the most respected dealers of the last two decades.

Unsurprisingly, her roster reads like a contemporary art class syllabus: Giovanni Anselmo, John Baldessari, Christian Boltanski, Marcel Broodthaers, Maurizio Cattelan, Tacita Dean, William Kentridge, Juan Muñoz and Gabriel Orozco, among others. Also unsurprising is her continued record of achievement: in 2003 almost two dozen of her artists exhibited in museums.

The granddaughter of a Hungarian painter who gave up art to raise a family, Goodman was surrounded by art as a child. Her father, a collector of Milton Avery paintings, even mounted art shows in their home. She studied art history at Columbia University, and being the only woman in her programme, realized the limited curatorial prospects for women.

In 1965 she founded Multiples, Inc., which published editions of works in a variety of media – prints, books, records – by various American artists, including Richard Artschwager, Sol LeWitt, John Baldessari, Dan Graham, Roy Lichtenstein, Claes Oldenburg, Robert Smithson and Andy Warhol. Multiples, Inc. reflected an idealistic, populist vision: expand the exposure of artists and reach the wider audience by creating art editions at affordable prices.

Currently, the gallery offers several editions, including Graham's *Two Parallel Essays: Two Related Projects for Slide Projector & Photographs in Motion*, Douglas Huebler's *Location Piece #2, New York City – Seattle Washington*, Allan Kaprow's *Pose: March 22, 1969*, Joseph Kosuth's *Notebook on Water*, LeWitt's *Schematic Drawing for Muybridge II, 1964*, Richard Long's *Rain Dance* and Robert Morris's *Continuous Project Altered Daily*.[1]

A defining year was 1968. During a visit to 'documenta' (the renowned quinquennial art exhibition in Kassel, Germany), Goodman was particularly impressed by *Eurasienstab* (Eurasian Staff), a twenty-minute, black-and-white film by Beuys.[2] However, when she tried to show it in the United States, there was no interest.

Maurizio Cattelan,
Frank and Jamie, 2002

269

Around the same time, she met Marcel Broodthaers, and was shocked to learn that he had not yet exhibited in America.

Indeed, few New York dealers – with the exception of European gallerists such as Leo Castelli, Ileana Sonnabend and John Weber – included European artists in their programming. Though Americans had not fully developed a taste for contemporary European art, Goodman noticed something very telling: some European artists were more concerned with the art process than with formal issues – a central premise to much American art of that period.

The time was ripe for the birth of a crossover market, and in 1970 Multiples, Inc. began to produce and show early editions of European artists, including Beuys, Broodthaers, Richter and Blinky Palermo. Multiples, Inc. continued to issue art editions until 1975, and Goodman opened her gallery two years later. The inaugural exhibition introduced the work of Belgian Conceptual artist Broodthaers to the American public, showcasing films, objects, drawings and paintings.

While Goodman's cadre of artists includes some very important Americans, she is best known for introducing European artists to the American public early on, as well as Mexican, Canadian and South African artists. In fact, she currently represents over twenty European artists – quite possibly more than any gallery in Europe. And though her penchant for Conceptual and Minimal Art has kept her vision in tight focus, she has managed to cast a wide net. From the enigmatic work

View of Lothar Baumgarten's installation *How to See Venice*, 1983–84

of German masters Kiefer and Richter to the unique photographic practices of Struth, Wall and Rineke Dijkstra, her artists represent a wide variety of thought and practice.

Goodman's unflagging commitment to the international art scene was further reinforced in 1999 when she opened a gallery in Paris, at 79 Rue du Temple. It's a perfect location for a passionate intellectual such as Marian Goodman: in the 17th century, it was the site of the Académie Montmor, a meeting place for scientists and philosophers.[3]

RACHEL GUGELBERGER

1 http://www.mariangoodman.com
2 http://www.walkerart.org/
 uia-bin/uia_doc.cgi/query/
 14?uf=uia_LAAdhL
3 Westfall, Richard S., Department
 of History and Philosophy of Science,
 Indiana University, *Catalog of the
 Scientific Community*

View of Juan Muñoz exhibition, 1999

Galerie Max Hetzler

YEAR OF FOUNDATION
1974
FOUNDER
Max Hetzler
ADDRESS
1974–76 **15 Wiesbadener Straße, Stuttgart**
1976–79 **62a Silberburgstraße, Stuttgart**
1978–79 **12 Gutenbergstraße, Stuttgart**
1979–82 **2 Schwabstraße, Stuttgart**
1983–88 **21 Kamekestraße, Cologne**
1988–93 **21 Venloer Straße, Cologne**
1989–92 **Exhibition space, 1–3 Alsdorfer Straße, Cologne**
1989–93 **Luhring Augustine Hetzler, 1330 4th Street, Santa Monica, USA**
1994–97 **94 Schillerstraße, Berlin**
SINCE 1995 **90/91 Zimmerstraße, Berlin**
SINCE 2001 **15–18 Holzmarktstraße, Berlin**

ARTISTS REPRESENTED
Darren Almond, Herbert Brandl, Candice Breitz, Glenn Brown
Jean-Marc Bustamante, Werner Büttner, Rineke Dijkstra, Günther Förg
Ellen Gallagher, Liam Gillick, Robert Gober, Georg Herold, Axel Hütte
Martin Kippenberger, Jeff Koons, Won Ju Lim, Sarah Morris, Reinhard Mucha
Albert Oehlen, Yves Oppenheim, Richard Phillips, Thomas Struth
Philip Taaffe, Kara Walker, Terry Winters, Christopher Wool

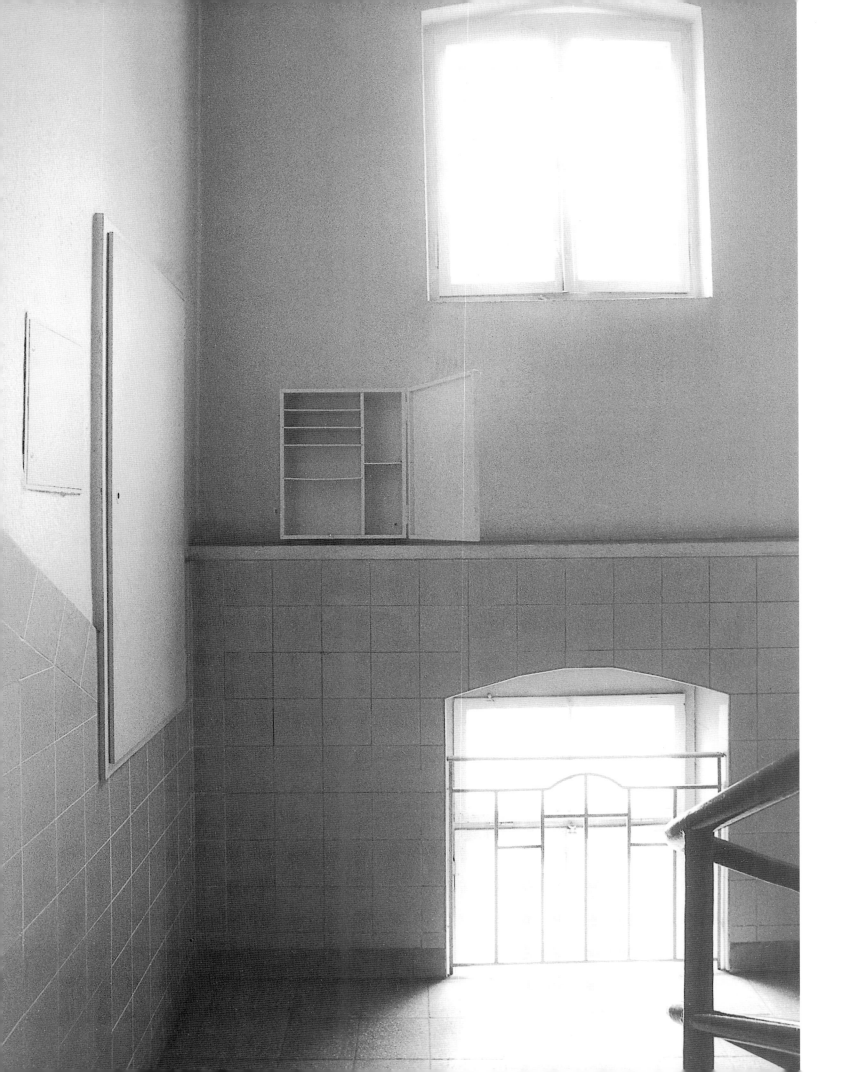

The I.-N.-P. gallery. 'In no other gallery is success so closely linked to one group of artists as Hetzler's name to Kippenberger, the Oehlen brothers, Günther Förg and Georg Herold, who built up their national and international success with him and through him.' The accurate summation of a German gallery guide.

But let's start at the beginning. In 1974 Max Hetzler, after an apprenticeship in the art trade, was one of the co-founders of the Stuttgart gallery Hetzler + Keller. At first they exhibited primarily artists from the Stuttgart region; the opening exhibition was devoted to Erwin Heerich, who was followed by Karl Gerstner and Franz Bernhard. Artists from Rinke's or Rückriem's classes at the local art academy like-wise frequently exhibited there. From December 1979 Max Hetzler ran the gallery alone, a phase that was kick-started by a duo exhibition by Klaus Rinke and Rebecca Horn. In the autumn of 1981 Martin Kippenberger had his debut in the gallery, with the group centring on 'Kippi': Werner Büttner had his first exhibition in the Galerie Max Hetzler immediately after, Markus Oehlen followed in March 1982, and his

brother Albert in September of the same year. These four artists continued to exhibit regularly 'at Hetzler's'. In February 1983, for example, the 'Fab Four' held a joint exhibition there. In May 1984 (the gallery had by now been in Cologne for a year) Martin Kippenberger exhibited his legendary I.N.P. pictures. The letters stand for 'Ist-Nicht-Peinlich', or 'it's not embarrassing'. The exhibition, like many others, was accompanied by a catalogue, while the invitation card was designed by the 'East German' painter A. R. Penck.

Max Hetzler skilfully exploited the art boom of those years. Since 1982 the gallery had regularly visited the big art fairs in Basel, New York and Miami. Self-assured, Max Hetzler declared: 'To take part in a fair without being financially secure in advance is pointless. Fairs are primarily publicity and secondarily international presence and business.' At the end of the decade he even expanded into the USA, where between 1989 and 1992, together with the Luhring Augustine Gallery in New York, he ran the Luhring Augustine Hetzler Gallery in Santa Monica. There, the artists exhibited included Americans such as Jon Kessler, Cady Noland and Christopher Williams, but it goes without saying that Martin Kippenberger and Albert Oehlen were represented too. 'The "excursion" to California was a strategic partnership with the New York Luhring Augustine Gallery,' Max Hetzler said, 'and

has been crucial for the careers of the Galerie Hetzler artists like Förg, Oehlen, and Kippenberger. With the presence of these artists we have found new collectors, and museum exhibitions have resulted.' When the art market collapsed at the start of the 1990s, Hetzler was forced to close this branch.

In the spring of 1994 the gallery moved again, this time to Berlin, which everyone at that time thought would replace Cologne as the most important location for contemporary art. In Berlin the gallery took up where it had left off in Cologne, but also exhibited young artists such as Darren Almond and Rineke Dijkstra. At the start of 2003 the Galerie Max Hetzler became the first gallery in the German capital to open a second branch there. In the east of the city, in the arch of the overhead railway on Holzmarktstraße, the emphasis was on video art. The gallery started with the video *Miami* by Sarah Morris, and in September 2003 it was the turn of the young Candice Breitz. The Galerie Hetzler remains a lively venue for contemporary art more than twenty years after its foundation.

RAIMAR STANGE

Overleaf: 'Hospital' exhibition, with works by Darren Almond, Liam Gillick, Richard Hamilton, Jeff Koons, Sarah Morris, Jorge Pardo, Richard Phillips, and Jane and Louise Wilson, Zimmerstraße, Berlin, 1997–98

Darren Almond and Sarah Morris, 'at speed', overhead railway arch, Holzmarktstraße, Berlin, 2002

Lisson Gallery

YEAR OF FOUNDATION
1967
FOUNDER
Nicholas Logsdail
ADDRESS
1967–73 **68 Bell Street, London**
1968–73 **57 Lisson Street, London**
1973–80 **66–68 Bell Street, London**
1980–82 **56 Whitfield Street, London**
1982–87 **66–68 Bell Street, London**
SINCE 1987 **67 Lisson Street & 52–54 Bell Street, London**
SINCE 2002 **Lisson New Space, 29 Bell Street, London**

ARTISTS REPRESENTED
**Francis Alÿs, Carl Andre, Art & Language, John Baldessari
Pierre Bismuth, Christine Borland, Roddy Buchanan
James Casebere, Tony Cragg, Richard Deacon, Ceal Floyer
Douglas Gordon, Dan Graham, Rodney Graham, Donald Judd
Anish Kapoor, On Kawara, John Latham, Sol LeWitt
Robert Mangold, John McCracken, Jonathan Monk
Julian Opie, Tony Oursler, Santiago Sierra, Jan Vercruysse
Richard Wentworth, Jane & Louise Wilson**

Exterior view of the gallery, with Julian Opie's installation *Sculptures Films Paintings*, 2001

The trendsetter. If any gallery in Britain can call itself a 'trendsetter', then it's the Lisson Gallery. It was here that in the 1960s and '70s Conceptual artists such as Dan Graham and Art & Language, On Kawara and Yoko Ono had their first exhibitions in London, as did the American minimalists Carl Andre, Donald Judd and Sol LeWitt. Then in the 1980s the Lisson Gallery was an important centre for the 'New British Sculpture' of Tony Cragg, Richard Deacon, Richard Wentworth and Anish Kapoor, whose first major exhibitions were staged there. In the 1990s Nicholas Logsdail, who opened the gallery in London's Marylebone district in 1967 while he was still a student at the Slade School of Art, remained true to his committed role as a pioneer: video and installation artists Tony Oursler, Douglas Gordon and Jane & Louise Wilson were exhibited there early in their careers.

Today the gallery also represents younger artists of the 'fourth generation', so to speak, such as Pierre Bismuth, Ceal Floyer and Jonathan Monk. The thrilling and pioneering work of the Lisson Gallery can also be expressed in numbers: more than 350 exhibitions and, not least, fifteen nominations of the gallery's artists for the renowned Turner Prize. The figures speak for themselves. But it is also interesting that there are some art movements for which Nicholas Logsdail has not been able to work up any enthusiasm. The Pop Art of the 1960s and the Neo-Expressionist painting of the 1980s, for example, left him cold – another factor that has lent a clear profile to his gallery agenda, whose cardinal points can be summed up as playful intellect, limpid beauty, austerity of form and conceptual anti-narcissism.

'Think I have changed the landscape,' was Nicholas Logsdail's self-assured verdict on himself.[1] He and his staff succeeded in this not least because the Lisson Gallery exhibitions have usually been staged at great expense, and at the same time with great attention to detail, much sensuous vigour, and sophisticated precision. This was the case with Jane & Louise Wilson's video installation *Normapaths* in 1995: with a great sense of expectation, video sequences were projected on walls floor-to-ceiling, showing the two artists first in black leather à la Emma Peel, then in comparatively staid, not to mention prudish, brown, in various action scenes. The two power girls demolished film sets with evident pleasure, and it was almost incidental that this video installation, with its intelligent re-coding, appropriated the action film, actually a male domain, for a feminism that was as playful as it was media-conscious, and as aggressive as it was tongue-in-cheek.

Since 1992 the gallery has been housed in a building on Bell Street designed by the architect Tony Fretton, making it the city's only commercial gallery to have premises specially designed for art exhibitions. With its classically lucid, indeed purist formal language, the building provides an ideal match for the art presented there by Nicholas Logsdail. Ten years later, the gallery took over a further room on the same street, so that it can now flexibly exploit an exhibition space of more than 5,000 square metres. Time and again, the artists treat these outstanding rooms with respect for their individuality, seeking dialogue with them. The young British artist Ceal Floyer, for example, included the work *Warning Birds* in her 2002 exhibition.

Ordinary commercial bird silhouettes are stuck to the gallery's broad display window 'as in real life' – albeit so many of them as to produce the impression that it is not so much the birds that need to be warned against the glass, which could break their necks, but rather the people that need to be warned against a grisly avian invasion. A tribute maybe to Alfred Hitchcock, the past master of the detective and horror movie, and his classic film *The Birds*.

RAIMAR STANGE

Christine Borland, *Ecbolic Garden, Winter*, 2001

1 *The Art Newspaper*, No. 131, London 2002, p. 41

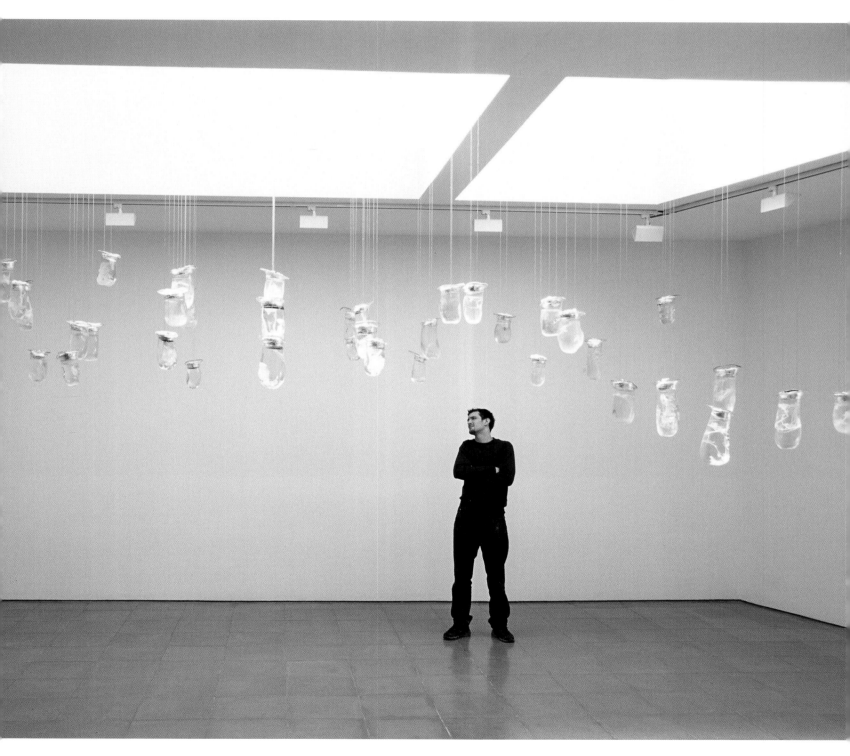

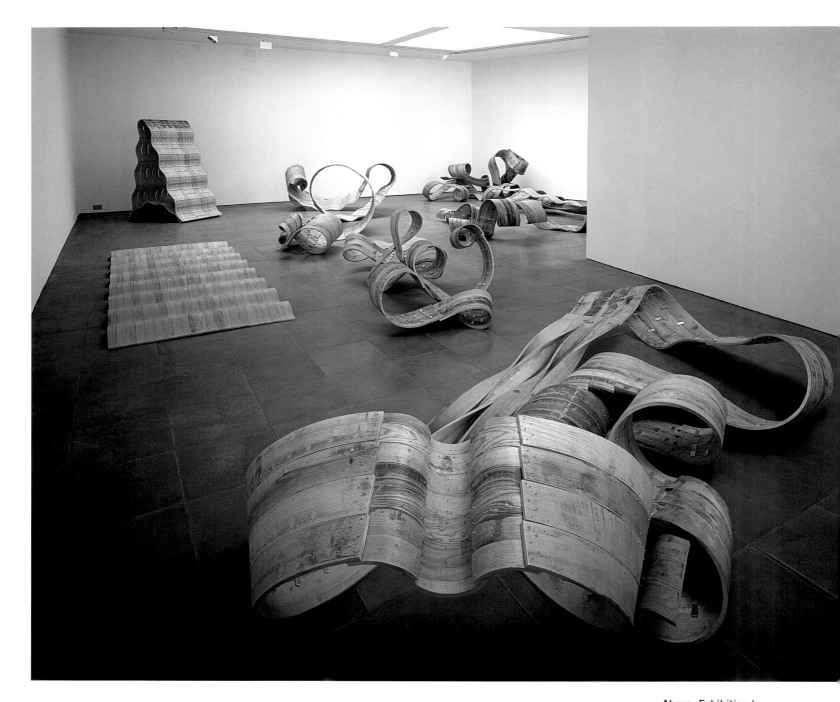

Above: Exhibition by
Richard Deacon, 2002

Opposite: Dan Graham,
Triangular Pavilion with Circular
Cut-Out, Variation C, 1989/2001

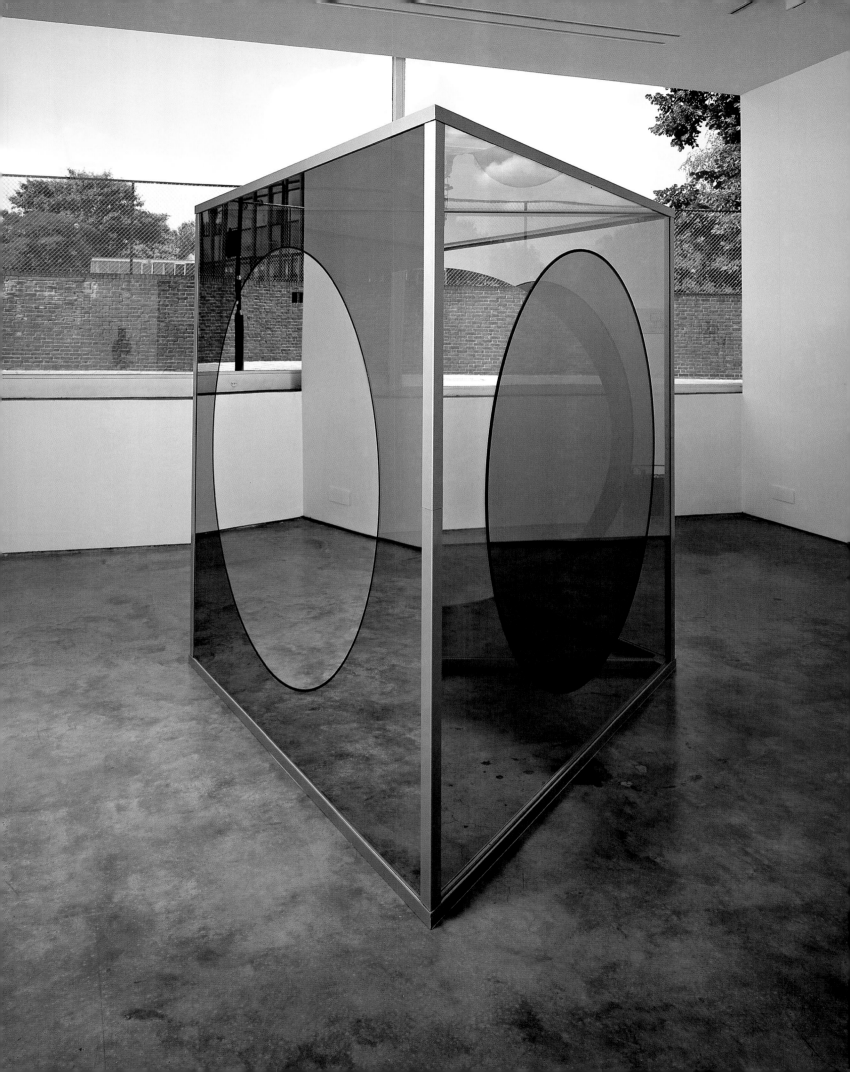

Galerie Paul Maenz

YEAR OF FOUNDATION
1970

FOUNDERS
Paul Maenz and Gerd de Vries

ADDRESS
1970–76 **32 Lindenstraße, Cologne**
1973–74 **195 Avenue Louise, Brussels**
1976–78 **23 Lindenstraße, Cologne**
1978–83 **25 Schaafenstraße, Cologne**
1983–90 **50 Bismarckstraße, Cologne**

ARTISTS REPRESENTED

Giovanni Anselmo, Art & Language, Robert Barry, Alighiero Boetti, Daniel Buren
Sandro Chia, Francesco Clemente, Enzo Cucchi, Walter Dahn, Hanne Darboven
Martin Disler, Jiri Georg Dokoupil, Luciano Fabro, Hans-Peter Feldmann
Rainer Fetting, Keith Haring, On Kawara, Anselm Kiefer
Joseph Kosuth, Nicola De Maria, Albert Oehlen, Mimmo Paladino
Giulio Paolini, Giuseppe Penone, Salvo, Andy Warhol

Paul Maenz and Gerd de Vries, late 1970s

Influencing and changing the world of art. At the start of 1990, at the climax of its success, the Galerie Paul Maenz announced that it was ceasing to exhibit. 'A blow for all those who were accustomed to come here to inform themselves about the best and most up-to-date on German, indeed the European art-scene,' wrote New York magazine *Art & Auction*. On his motives for setting up a gallery, Paul Maenz has said: 'I was not an artist, that much was clear, but I wanted to "be there with the avant-garde". That's how my gallery started.'[1] Explaining his decision to close the gallery after twenty years, he said: 'That has to do with the fact that I now belonged to another generation…. If you know how much we have always made the ideas of young artists our own, if you are aware of the extent of this identification, which was crucial for the credibility, the leverage exerted by the gallery, then you will understand that I cannot see myself in the role of an experienced fatherly friend. But that is precisely what one turns into with experience and with the passage of time.'[2]

A commercial graphic artist by trade, Maenz first met artists such as Yves Klein and Jean Tinguely during his training at the Folkwangschule in Essen in the 1950s. As the young assistant to the art director of an American agency in Frankfurt, he met Carl Andre, Sol LeWitt and Dan Flavin during a two-year stay in New York. In 1967, back in Frankfurt, he organized, together with the artist Peter Roehr, the exhibition 'Dieses alles Herzchen wird einmal Dir gehören' (All this little heart will one day be yours) at the Galerie Dorothea Loehr, with works by Konrad Lueg, Charlotte Posenenske, Thomas Bayrle, Jan Dibbets, Richard Long and Barry Flanagan.

In 1968 Konrad Fischer suggested to Paul Maenz that they open a gallery together. Maenz declined. 'The galleries that I had known till then served a public that we referred to in a derogatory sense as the Establishment,' he explained. 'There was no way I could imagine serving up the new avant-garde to these suspect people as decoration.'[3]

Opposite: Art & Language,
Lexical Items, 1973

1 *Kunstforum*, No. 104, November/December, 1989
2 Paul Maenz, in Gerd de Vries (ed.), *Paul Maenz Köln 1970 – 1980 – 1990. Eine Avantgarde-Galerie und die Kunst unserer Zeit*, Cologne, 1991
3 *Kunstforum*, No. 104, November/December, 1989
4 Ibid.
5 Ibid.

Left: Opening of the 'Arte Cifra' exhibition, 1979. From left to right: Sandro Chia, Nino Longobardi, Mimmo Paladino, Paul Maenz, Francesco Clemente, Wolfgang Max Faust, Alba Clemente, Peter Büscher, Tomás Arana, Gerd de Vries and Lucio Amelio

Opposite: Keith Haring
exhibition, 1984

Below: Keith Haring painting
a model at the exhibition, 1984

But it didn't have to be like that, as Maenz soon realized through Konrad Fischer's work, as well as through Harald Szeemann's staging of the 'When Attitude Becomes Form' exhibition at the Kunsthalle in Bern in 1969. The new forms of exhibition gave rise to new galleries with new artists, and created new circles of collectors.

At the end of 1970 Paul Maenz, in collaboration with Gerd de Vries, opened his gallery in Cologne next door to a 'gallery building' that had only just been established on the city's Lindenstraße. The gallery's motto from the start was Seth Siegelaub's statement, 'Art is to change what you expect from it', and in this spirit, what artist could be more predestined for the inaugural exhibition than the New York-based German-born Hans Haacke? But Paul Maenz sees the real founder of the gallery's identity rather in Joseph Kosuth, whose art, like the Galerie Paul Maenz, was concerned with 'the step from the manifestation to the conception'.[4]

Maenz was able to sell some of the works exhibited in every show, but in order to finance the gallery he was gradually forced to sell the seven Gerhard Richter pictures he had acquired while still in advertising. Alongside the no-nonsense, sometimes austere Minimal and Conceptual Art, which Maenz promoted in the early days of his gallery, in the late 1970s he discovered two groups of artists who represented a totally different trend in art: the 'Neue Wilde' painting.

In Rome, Maenz bought nineteen pieces by one Sandro Chia, whom he had never heard of, and brought them to Cologne. This was the breakthrough for a group of artists who were later to become known under the name 'Arte Cifra', which included Sandro Chia, Francesco Clemente, Enzo Cucchi, Nicola De Maria and Mimmo Paladino.

On Cologne's unfashionable right bank six painters (Hans-Peter Adamski, Peter Bömmels, Walter Dahn, Georg Jiri Dokoupil, Gerard Kever and Gerhard Naschberger) had formed a group called 'Mülheimer Freiheit', after the street on which their shared studio was situated but literally meaning 'freedom of Mülheim', and Paul Maenz provided the forum for their public presence. All of these artists made international names for themselves within just a few years.

While insiders complained that, in the case of the Italian painters, Maenz and de Vries had lost all feeling for quality, the broad public's 'hunger for pictures' (the title of de Vries and Wolfgang Max Faust's 1982 book on the new painting) was more important. In winter 1989–90 the gallery closed with an exhibition trilogy: Hanne Darboven's 'Existenz', Giulio Paolini's 'Artist Theater', and Anselm Kiefer's 'The Angel of History'.

The fact that the Getty Center for the History of Art and the Humanities in Los Angeles has meanwhile purchased the gallery's photographic and written archives bears witness to the charisma radiated by the gallery even after the end of its active work. 'The question of whether the decision was right for art is not one I have ever asked,' says Maenz. 'After all, no one asks whether they should breathe.'[5]

UTA GROSENICK

Giulio Paolini, view of an
installation, 1986

Anthony d'Offay Gallery

YEAR OF FOUNDATION
1965
FOUNDER
Anthony d'Offay
ADDRESS
1965–69 **Vigo Street, Piccadilly, London**
1969–2001 **9, 23, 24 Dering Street, London**

ARTISTS REPRESENTED
Carl Andre, Michael Andrews, Georg Baselitz, Joseph Beuys
Francesco Clemente, Willem de Kooning, Lucian Freud, Gilbert & George
Richard Hamilton, Howard Hodgkin, Jasper Johns, Ellsworth Kelly, Anselm Kiefer
Jeff Koons, Leon Kossoff, Jannis Kounellis, Richard Long, Brice Marden
Agnes Martin, Bruce McLean, Mario Merz, Tatsuo Miyajima, Malcolm Morley
Reinhard Mucha, Bruce Nauman, Barnett Newman, Sigmar Polke
Gerhard Richter, Ed Ruscha, David Salle, Julian Schnabel, Kiki Smith
James Turrell, Cy Twombly, Bill Viola, Andy Warhol, Boyd Webb
Lawrence Weiner, Rachel Whiteread

The staff of the Anthony d'Offay Gallery with Joseph Beuys, 1985, and with Malcolm Morley, 1990

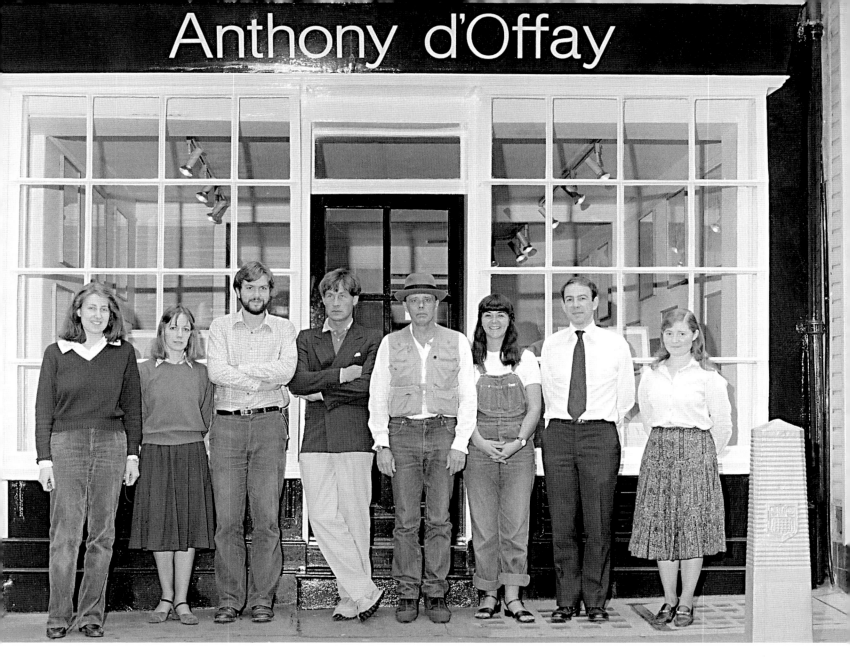

Anthony d'Offay and Joseph Beuys at Beuys's 'Plight' exhibition, 1985

Adhering to the trend. 'A gallery's got a natural life of seven, eight years. And then they've got to change. They've got to change the premises, they've got to change the people, they've got to change the attitude, they've got to change the exhibition programme.' Anthony d'Offay opened his gallery in 1965, aged twenty-five, and it was by following this strict policy of renewal and expansion that he was able to develop it from a small business tucked away in Piccadilly, trading in manuscripts and drawings, to a huge enterprise of international standing, representing a broad swathe of the most important artists of the late 20th century. In 1969 he relocated to a small town house on Dering Street, off London's wealthy Bond Street, and began to focus on early 20th-century British art, resurrecting the reputations of Vorticists, Bloomsburyites and Camden Town artists such as Percy Wyndham Lewis, Duncan Grant, Vanessa Bell and Spencer Gore.

D'Offay gradually came to work with a number of living artists during the 1970s, such as 'School of London' painters Lucian Freud, William Coldstream and Michael Andrews, but the most radical departure came in 1972 with an exhibition by young artists Gilbert & George. Gilbert & George had graduated from London's St Martin's School of Art in 1969 and belonged to the group of artists challenging the nature of sculpture as taught there by veteran British sculptor Anthony Caro. Dressing in identical tailored suits and assuming mannerist poses, they declared themselves to be 'living sculptures' and their whole lives to be art; an 'Art for All', accessible in the form of 'postal sculptures', 'magazine sculptures' and performances. That year, a show curated by Anne Seymour called 'The New Art' took place at the Whitechapel Gallery, which came to be seen as the definitive exhibition of British Conceptual Art of this time. It was through the influence of Anne Seymour, whom d'Offay married in 1977, that his gallery underwent its next metamorphosis,

and by the end of the 1970s he had added key British conceptualists Richard Long and Bruce McLean to his roster.

In 1980 d'Offay expanded into a second generously proportioned gallery in Dering Street, dedicated to exhibitions of the international avant-garde and inaugurated with an exhibition by German Fluxus guru Joseph Beuys. Beuys was to become one of the most inspirational figures for d'Offay and made a number of important exhibitions for him over the next few years. For 'Plight', an installation made just months before his unexpected death in 1986, Beuys transformed the gallery into a muffled grey cavern, lined with huge cylindrical rolls of felt and with a grand piano sitting majestically in the centre of the room.

Throughout the 1980s d'Offay's exhibition programme responded to the prevailing trends in contemporary art. He showed many of the new Expressionist and figu-

rative painters included in the Royal Academy's controversial exhibition 'A New Spirit in Painting', such as British artists Howard Hodgkin and Malcolm Morley, as well as European heavyweights Georg Baselitz, Anselm Kiefer, Gerhard Richter and Francesco Clemente. He exhibited works by American minimalists such as Carl Andre, Italian Arte Povera artists Jannis Kounellis and Mario Merz, late works by Willem de Kooning and early drawings by Jackson Pollock.

'We tried very hard at a high professional level to bring the greatest artists here and to do spectacular shows,' said d'Offay in the late 1990s. 'There was one day…at the end of the 80s when you woke up and the world was different…contemporary culture, contemporary art suddenly seemed to belong to young people…. And I would love to feel that in some way we helped that to happen because we had hundreds and thousands and millions of young people who came to see our shows.' As the economy blossomed throughout the decade, d'Offay's exhibitions brought a glamour back to the art world that had been missing since the 'swinging London' of the 1960s. His 1986 exhibition of Andy Warhol's camouflage self-portraits was the epitome of 1980s art glamour, with suites at the Ritz

Above, left: Gilbert & George's 'For AIDS exhibition', 1989

Above, right: Gilbert & George at the opening of their exhibition, 1989

Mario Merz at the Savile Club
in London, 1982

for Warhol and his entourage, huge press coverage, security guards and throngs of fans.

D'Offay continued to add to his programme in the 1990s, winning US artists Jeff Koons and Bill Viola as well as blue-chip young British artist Rachel Whiteread, whom he wooed away from her founding gallery, Karsten Schubert. But he also lost some long-standing artists along the way, including Michael Andrews, Richard Hamilton, Georg Baselitz and Gilbert & George, who left to join London's flagship gallery of the 1990s, Jay Jopling's White Cube.

By this time, the commercial art scene in London had greatly expanded, and d'Offay's hold on the market was being threatened not only by Jopling but also

by New Yorker Larry Gagosian's recently opened London annex. The gallery continued to enjoy an enormous turnover, however, estimated to be around £30m. In the autumn of 2001 d'Offay astounded everyone by suddenly announcing his retirement. Speculation was rife about his reasons for closing down his Dering Street empire, but his characteristically ambiguous statement that he would continue to provide a 'support service to artists' suggests that this was perhaps not a total abandonment of the art world so much as another stage in the gallery's continuing evolution.

KIRSTY BELL

Fernsehgalerie Gerry Schum
videogalerie schum

YEAR OF FOUNDATION
1968

FOUNDERS
Gerry Schum and Ursula Wevers

ADDRESS
1968–70 **Fernsehgalerie Gerry Schum**
(realized artistic projects in the film medium for television)
1971–73 **videogalerie schum, 37 Ratinger Straße, Düsseldorf**

ARTISTS REPRESENTED
Keith Arnatt, Joseph Beuys, Marinus Boezem, Daniel Buren
Jan Dibbets, Gino de Dominicis, Barry Flanagan, Gilbert & George
Michael Heizer, Richard Long, Walter de Maria, Dennis Oppenheim
Ulrich Rückriem, Richard Serra, Robert Smithson

'I watch the box', or programme as programme. 'The first starting point that I have to explain is the fact that there are no real gallery rooms. The television gallery consists only of a series of television broadcasts, in other words, the television gallery is more or less all in the mind, only becoming a real institution at the moment of being broadcast on television.' Gerry Schum outlined the basic features of a totally novel gallery concept thus in a letter to the American film theoretician Gene Youngblood in June 1969. The first realization of this concept had been broadcast just a few weeks earlier, on 15 April 1969, by the Sender Freies Berlin (SFB) radio and TV station. The title of this first television exhibition, 'Land Art', soon established itself as the everyday name for a new art movement better known in the USA as Earthworks or Earth Art; in 1970 it even got an entry in Brockhaus, Germany's national encyclopedia. The film, of approximately half an hour's duration, comprised contributions by eight artists, all men, who at that time had recently come to public attention through their actions and exhibitions, and to that date had never worked with the film medium: Richard Long, Barry Flanagan, Dennis Oppenheim, Robert Smithson, Marinus Boezem, Jan Dibbets, Walter de Maria and Michael Heizer.

The Land Art film was made between December 1968 and March 1969 as a collaborative effort between Gerry Schum, who had trained as a film director and cameraman in Munich, Ursula Wevers, who frequently also made a photographic record of the shooting, and the respective artist. The declared aim of the television gallery was not to make documentary films about artists, but to create autonomous artworks specifically conceived for the medium of television: thus in Jan Dibbets's contribution, *12 hours tide object with correction of perspective*, a tractor on a sandy

Below, left: Film still, Jan Dibbets, *TV as a Fireplace*, WDR television, Third Programme, 24–31 December 1969

Below, right: Poster for the first television exhibition, 'Land Art', 1969

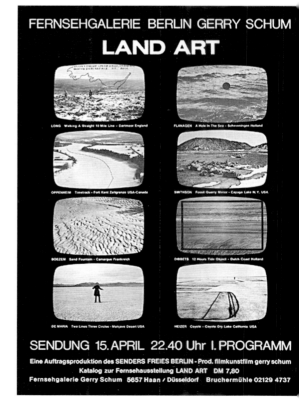

Opening of the first television
exhibition, 'Land Art', in Studio C
of the SFB, 28 March 1969.
Jean Leering is on the left,
and Gerry Schum on the right

beach leaves tracks that mark the edges of the television screen exactly. In fact, the terrain thus marked out on the beach was trapezoidal – but the angle of the camera 'corrected' it into a rectangle, until it was washed away by the rising tide.

The films of the television gallery did not set out, however, just to hone the perception and the media-consciousness of the viewers. They were also designed to undermine the elitist aspects of the art market, and democratize it by the use of reproductive media. 'Instead of private possession of art, which blocks the further dissemination of the artworks, what we have is communication with a broader public through publications or television,' proclaimed Schum in his inaugural address broadcast before 'Land Art', and staged as an exhibition opening in an SFB studio. The first steps in the direction of these theses concerning the production and reception of art can be traced back to documentary films such as *6. Kunstbiennale San Marino* (6th San Marino Art Biennial) (1967) and *Konsumkunst–Kunstkonsum* (Consumer Art – Art Consumption) (1968), which Schum developed for the Westdeutscher Rundfunk (WDR) broadcasting station in collaboration with the artist Bernhard Höke and the art historian Hannah Weitemeier.

What distinguished the *Land Art* film – and also the second (and last) television exhibition 'Identifications', broadcast by the Südwestfunk (SWR) radio and TV station on 30 November 1970 – most strongly from traditional television art programmes was the absence of any commentary. It was above all the resistance of the makers of the television gallery to the editorial conventions of television that sealed the project's fate. 'It had already been hinted to us that the broadcaster [the SFB] wanted the film to be accompanied by a "distancing" voice presentation,' remarked Ursula Wevers in an interview in 2001. 'We had never excluded the idea of making the film accessible to a broader television public, but our attitude was that this could not be the subject of the same broadcast. The broadcast was an exhibition; the view of the beholder was not to be distorted by the "helping hand" of some editor.' This uncompromising position, along with certain contributions that took up a subversive or ironic position towards the medium and the power of the broadcasting institutions, led to irritation on the part of some sections of the public, but also, and in particular, of those who had commissioned the broadcasts: for example, Daniel Buren's contribution to 'Identifications', which took the form of a forty-five-second fade-in of the official SWR 'normal service will be resumed as soon as possible' frame, thus simulating a technical fault during a technically faultless broadcast.

The second television exhibition, 'Identifications', with twenty individual contributions, was not entirely financed by public-service television itself, but predominantly by an arts project sponsored by the city of Hanover. Only the WDR, in its adventurous, but in those days only regionally accessible Third Programme, enabled two television insertions into the Gerry Schum Television Gallery in 1969: Keith Arnatt's *TV Project Selfburial* – a series of nine photographs, faded into the rest of the show unannounced, in which the artist is shown apparently sinking deeper and deeper into the earth day by day, and *TV as a Fireplace* by Jan Dibbets, who ended the pro-

Filming Jan Dibbets's contribution
to 'Land Art', *12 hours tide object
with correction of perspective*,
Dutch coast, February 1969.
On the VW bus: Gerry Schum
and Jan Dibbets

gramme, transmitted between Christmas and New Year's Eve 1969, with a crackling fire in a fireplace. But the plan to turn the television gallery into a national institution, broadcasting television exhibitions of contemporary art nationwide on a regular basis, proved within two years to be a forlorn hope.

The television gallery makers Schum and Wevers tried to make a virtue of this necessity by founding the first European gallery of video art in Düsseldorf. In 1969 they invested in a mobile recording studio. The videogalerie schum, opened in 1971, produced and distributed videotapes by artists such as Joseph Beuys, Gilbert & George, Ulrich Rückriem and Richard Serra. Videos had the advantage over film and television of being more flexible and more independent, but had not yet achieved recognition as an artistic medium. The technology was expensive, and difficult for museum staff and private collectors to handle. The story of the videogalerie schum ended abruptly with Schum's suicide in March 1973. Wevers had meanwhile opened her gallery, Projection, in Cologne in September 1972, which dealt solely in art in reproduction media such as film, video, photography, phonograph records and transparencies, but it was not profitable and closed in 1978.

BARBARA HESS

Gerry Schum in his mobile recording studio, making the video edition *Circles* by Ulrich Rückriem, 1971

Filming Barry Flanagan's
contribution to 'Land Art',
A Hole in the Sea, Scheveningen,
Netherlands, February 1969

Galleria Christian Stein

YEAR OF FOUNDATION
1966

FOUNDER
Christian Stein

ADDRESS

1966–72 **3 Via Teofilo Rossi, Turin**

1972–96 **206 Piazza San Carlo, Turin**

1985–99 **206 Via Lazzaretto, Milan**

1989–92 **Steingladstone Gallery, 99 Wooster Street, New York**

SINCE 1995 **23 Corso Monforte, Milan**

ARTISTS REPRESENTED

Giovanni Anselmo, Georg Baselitz, Domenico Bianchi, Alighiero Boetti
Paolo Canevari, Gino De Dominicis, Luciano Fabro, Lucio Fontana, Gilbert & George
Jannis Kounellis, Francesco Lo Savio, Piero Manzoni, Mario Merz, Marisa Merz
Claes Oldenburg, Mimmo Paladino, Giulio Paolini, Claudio Parmiggiani
Giuseppe Penone, Michelangelo Pistoletto, Bernhard Rüdiger
Remo Salvadori, Antoni Tàpies, Peter Wüthrich, Gilberto Zorio

Mrs Stein between the works of Michelangelo Pistoletto and Luciano Fabro in the gallery in Piazza San Carlo, Turin, 1975

Mrs Stein and Alighiero **Boetti** in the gallery in **Piazza San Carlo**, **Turin, 1970s**

La Signora. In more than one respect, Christian Stein differs from other Italian galleries, which from the mid-1960s committed themselves to the avant-garde, such as Gian Enzo Sperone and Fabio Sargentini. Margherita von Stein, who following the death of her husband Christian Stein ran the business under his name, always remained in a certain sense a collector. As such, she was particularly involved with the artists whom she appreciated and whose work she followed until the end of her life. Margherita Stein died in April 2003 at the age of eighty-two. No art dealer in the traditional sense, and also unlike her dynamic and eccentric fellow gallery owners, she was above all a sensitive and silent companion, who always had a ready ear for the needs of the few artists whom she accompanied her whole life long. The relationships that had matured over thirty-five years were marked by mutual trust and unbounded respect, and extended to Stein's private and domestic milieu, where she surrounded herself with the works of 'her' artists.

Left: Solo exhibition by
Alighiero Boetti, 1967

Below: Summer group exhibition,
with the artists Alighiero Boetti,
Lucio Fontana, Piero Gilardi,
Francesco Lo Savio, Piero Manzoni,
Giulio Paolini, Pino Pascali,
Michelangelo Pistoletto,
Mimmo Rotella and
Giuseppe Uncini, 1970s

Beauty and reliability were the values by which she was brought up, and she referred to these two concepts time and again throughout her life. They led her to found a gallery, at a time when she was not getting any younger, in order to be able to offer better support to the artists whom she valued and collected, and in order to open a dialogue with other artists in her collection, such as Lucio Fontana, Piero Manzoni, Yves Klein and Daniel Buren.

The decision to take over the rooms of a gallery that had recently closed on Turin's Via Teofilo Rossi was a spontaneous one. The exhibition year 1966 began with Aldo Mondino and closed with Robert Indiana. The following year opened on 19 January with Alighiero Boetti's first-ever solo exhibition. He exhibited works that ironically

Solo exhibition, 'Gli animali decapitati', by Pino Pascali, Via Teofilo Rossi, Turin, 1970

recycle everyday and banal materials, such as rolls of corrugated cardboard, from which he constructed a round tower, minimalistically deployed tubes of Eternit and plastic, or camouflage sheets from army surplus stocks, which were exhibited as a large painting. The items in the show, which was extraordinarily important for the gallery's further development, were purchased by Stein herself in their entirety. The end of the year was marked by the group exhibition 'Con temp l'azione', curated by Daniele Palazzoli, in collaboration with two other Turin galleries, Notizie and Sperone. There followed exhibitions by Pistoletto, Uncini and Parmiggiani. In 1971 Stein devoted a whole exhibition to the art of Francesco Lo Savio, with its sensitive use of light and space. The artist, an eccentric personality, took his own life two years later.

Two events characterized 1972. Stein opened a second branch in Turin (which continued until 1986) with a retrospective of the past six creative years of Paolo Fossati, and in Gianfranco Benedetti, who became the manager of the gallery, she acquired support and collaboration that lasted until her death, and (in the sense that he still manages the gallery today) beyond.

The Galleria Christian Stein soon distinguished itself from other commercial galleries by courageous and radical decisions. It worked together with what was after all a strictly limited circle of artists and exhibited few innovations over the years, while the exhibitions themselves were each kept going for a long period. To start with, the exhibits were not even up for sale. In addition, the circle of artists consisted largely of Italians (with just a few exceptions, including Erik Dietman and Robert Watts), for whom Stein sought indefatigably to create a name abroad. To this end she deployed museum exhibitions and donations from her own unusual collection of some 300 works.

As examples of her attitude we might note two episodes: the presentation of the works of Michelangelo Pistoletto, which were exchanged month by month over a whole year (1974–75), and the 'Fideliter' exhibition to mark the gallery's silver jubilee. For this occasion, Stein assembled the artists she had accompanied and would continue to accompany until the end of her life: Anselmo, Boetti, Kounellis, Mario and Marisa Merz, Paolini, Parmiggiani, Penone and Zorio.

During the 1980s the gallery organized exhibitions (on a museum-like scale) of Baselitz, Penck, Kiefer and Dibbets. In 1985 a branch was opened in Milan, which moved twice before settling at its present address at 23 Corso Monforte, and another was opened in 1989 in New York, together with Barbara Gladstone. The inaugural exhibition was devoted to Luciano Fabro, and exploited this new opportunity to disseminate the work of Italian artists abroad. Over the next three years the gallery exhibited works by Merz and Paolini, held an Arte Povera group show, and solo exhibitions devoted to James Turrell, Eva Hesse and Mel Bochner. In the late 1980s and early '90s other Italian and international artists such as Remo Salvadori and Domenico Bianchi were added to the programme, to be joined in recent years by Mimmo Paladino, Bernhard Rüdiger and Paolo Canevari.

LUCA CERIZZA

Galería Luisa Strina

YEAR OF FOUNDATION
1974
FOUNDER
Luisa Strina
ADDRESS
502 Rua Oscar Freire, São Paulo

ARTISTS REPRESENTED
Keila Alaver, Caetano de Almeida, Dora Longo Bahia, Artur Barrio
Cabelo, Alexandre da Cunha, Wim Delvoye, Antonio Dias
Marcius Galan, Fernanda Gomes, Jenny Holzer, Marepe
Cildo Meireles, Tracey Moffatt, Antoni Muntadas
Emmanuel Nassar, Vardirlei Dias Nunes, Adriano Pedrosa
Marina Saleme, Edgard de Souza, Sandra Tucci

Marepe exhibition, 2002

View of installation by
Ivens Machado, 1991

Brazil shows its muscle. At the tender age of sixteen Luisa Strina was already buying and selling objets d'art – and she still is. Since she intended at an early age to become an art dealer, she studied art at the celebrated Escola Brasil. She wanted to take the pioneering step of opening the first professional gallery in Brazil. Today, the Galería Luisa Strina is one of the most important and most respected galleries not only in Brazil but in the whole of Latin America.

In 1974, after four years of activity as a private art dealer, Strina opened her gallery in the former studio of the artist Luiz Paulo Baravelli. She had already organized exhibitions, in museums and galleries, of the work of a group of artists who were later to form the core of her first programme. In the mid 1970s, following an economic boom, Brazil was hit by a severe recession, which also led to a stock-market crash. As the art trade had collapsed in the wake of the general economic problems, this was the worst possible moment to open an art gallery. It was extraordinarily difficult to find interested collectors who could guarantee a regular income for artists and galleries, for at that time there was no Brazilian art scene worth mentioning, and there was very little interest in contemporary art. As a result, Strina sold mostly to close friends and acquaintances of the artists and to sponsors of the gallery. In the early years, during which the gallery had to struggle to keep alive, she presented artists from São Paulo such as Wesley Duke Lee, José Resende, Luiz Paulo Baravelli, Nelson Leirner and Babinski. Only later – but not that much later because they were already exhibiting from 1976 – did Strina include on her agenda artists from Rio de Janeiro, who were more akin to Conceptual Art: people such as Cildo Meireles,

Waltercio Caldas and Tunga. In the following years, they were joined by artists such as Carlos Fajardo and Antonio Dias. Together, these constituted her first 'regulars', and many are still with the gallery today.

During the 1980s the Galería Luisa Strina assumed its unmistakable profile, when artists such as Nelson Felix and, in particular, Leonilson had their first exhibitions there. With the revival of painting in this decade, Leonilson became one of the main protagonists. This development reached its culmination in 1984 with a group exhibition of works by Leonilson, Leda Catunda, Sergio Romagnolo and Ciro Cozzolino, the artists who together became known as 'Generation 80'. Towards the end of the decade, the Galería Luisa Strina had achieved such great recognition that in 1991 it became the first Latin American gallery to take part in the renowned 'Art Basel' art fair.

In the following decade, Strina succeeded in recruiting another group of young artists in the form of Fernanda Gomes, Iran do Espirito Santo, Adriana Varejão and Edgard de Souza. In addition, she began increasingly to work with artists from outside Brazil whose works were little known – if at all – in the country. Even though she had already had some experience of exhibiting the works of artists living abroad, such as Antoni Muntadas from Spain or Julião Sarmento from Portugal, the 1990s represented a new era for her in this field. It started in 1994 with a group exhibition entitled 'Das Americas', which included works by Peter Halley, Roni Horn, Alfredo Jaar, Mike Kelley, Richard Prince and Meyer Vaisman. They were joined over the next few years by further international artists, among them Jenny Holzer, Tracey Moffatt and Wim Delvoye, and another group of very young Brazilians such as Franklin Cassaro, Marepe and Alexandre da Cunha, all of whom have since made international careers for themselves.

When Brazilian art first became internationally famous in the late 1980s (the Stedelijk Museum in Amsterdam and the PS 1 Contemporary Art Center in New York provided overviews with their exhibitions), the Galería Luisa Strina also managed to make its own international breakthrough. Following these exhibitions, Cildo Meireles was represented at the 1992 'Magiciens de la Terre' exhibition at the Centre Georges Pompidou in Paris and at 'documenta IX' in Kassel. Retrospectives were devoted to the works of Hélio Oiticica and Tunga at the Jeu de Paume in Paris.

Just as the art world as a whole had expanded in the previous decades, the Galería Luisa Strina underwent a similar evolution. And, without doubt, the marked increase in international interest in Latin American art in general and Brazilian art in particular owes a great deal to Luisa Strina's own indefatigable commitment to the dissemination and sale of Brazilian art abroad. At the same time, over the last thirty years the gallery has made a significant contribution to the development of a new climate in Brazil – one that is open to artistic developments in other countries and other continents – with the result that the country now occupies a key position within the global art market.

JENS HOFFMANN

The End of the Cold War

The 1980s

Hermann Nitsch exhibition at Galerie Peter Pakesch, Vienna, 1981

During the 1980s the Western world found itself under the rule of durable conservative governments, to an extent previously unknown in the 20th century. In Britain, Margaret Thatcher, known as the 'Iron Lady', won three successive elections, and was in power for the whole decade; in the United States, the Republican president Ronald Reagan, after two terms in office, handed over to his vice-president George Bush, while West Germany also had only one chancellor for most of the decade, the Christian Democrat Helmut Kohl.

In Eastern Europe, by contrast, change was in the air, culminating at the end of the decade with one country after another toppling its communist government: Poland, Hungary, Czechoslovakia and East Germany all removed their regimes peacefully in 1989, while the abolition of the dictatorship in Romania cost 30,000 lives.

The most moving images of these changes are those of the fall of the Berlin Wall on 9 November 1989, when thousands of West and East Berliners danced together on the streets, and of the unceasing streams of East Germans who were able to visit the capitalist West for the first time. The resulting reunification of the two German republics the following year made Germany the most populous state in Europe.

Following some of its worst disasters to date, the Third World became the beneficiary of major relief efforts by the developed countries. Following a famine in Ethiopia, for example, large numbers of lives were saved by food aid. Much of this was made possible by charity events, the best known of which was the rock concert, Live Aid, organized by the Irish singer Bob Geldof.

Even so, political developments did not give grounds for optimism everywhere. The Middle East was still a flashpoint with its wars and civil wars, and the Egyptian president Anwar el-Sadat was assassinated following his peace negotiations with Israel.

Science was forced in this decade to retreat from its belief in unconditional technical progress. The spring of 1986 saw a major accident at the Chernobyl nuclear power station in the Soviet Union: an explosion and a reactor meltdown were followed by the release of large quantities of radioactivity into the environment. A few months later, the American space shuttle Challenger exploded shortly after take-off – for NASA the worst-ever disaster in manned space flight. Medicine was faced by the challenge of a new disease, AIDS, which rapidly spread through much of Africa in particular, and was almost always fatal. It claimed numerous victims in the developed world too. As the virus was chiefly spread by sexual activity, fear of infection put a brake on the sexual revolution that had taken hold in the 1960s and '70s following the invention of the contraceptive pill.

For the visual arts, the 1980s was a turbulent decade, marked by a return to figurative art, while a group of Italian artists – Sandro Chia, Francesco Clemente and Enzo Cucchi – propagated Trans-avantgarde ('Transavanguardia'), or the transcending of the avant-garde. Berlin saw the formation of the 'Junge Wilde', and Cologne the formation of the group of artists known as 'Mülheimer Freiheit'. The leading German artists, Georg Baselitz, Jörg Immendorff, Anselm Kiefer, Markus Lüpertz, Sigmar Polke and Gerhard Richter, embarked on their triumphal march through the inter-

national exhibition rooms. In the United States, Julian Schnabel, Eric Fischl, David Salle and Jeff Koons were discovered, and Britain saw the rediscovery of Francis Bacon, Lucian Freud and Frank Auerbach. Within the space of a year the world registered the deaths of the two most important artists of the post-war period: Joseph Beuys in 1986, and Andy Warhol in 1987. In their totally different ways, both had revolutionized the concept of art.

In New York, the Museum of Modern Art was reopened after a long phase of rebuilding, while Los Angeles saw the inauguration of the Museum of Contemporary Art, which was devoted to precisely that and nothing else. Western Europe too experienced a building boom for museums displaying contemporary art. Within the space of a few years, Germany alone saw not only the opening of a new building for the Ludwig collection in Cologne, but also new premises for the Abteiberg Museum in Mönchengladbach and the Staatsgalerie Stuttgart.

Never was the collecting and purchase of contemporary art, both as an expression of a cultivated lifestyle and as an investment, so much in vogue as in the 1980s. The galleries, above all those in the United States, enjoyed staggering turnovers, and new records were reported by the auction houses too. While in 1983 the unheard-of sum of US$1.2m was bid for the work of a living artist, the American painter Willem de Kooning, five years later the dealer Larry Gagosian was able to rake in no less than US$17m via Sotheby's for the picture *False Start*, painted in 1959 by Jasper Johns.

Opening of an Andy Warhol exhibition at Galerie Paul Maenz, Cologne, 1985

The 1980s seemed to be 'bursting with figuration'; after years in which Conceptual Art had become practically a dogma, you could almost smell the paint again. '…everything was like a big performance, everything was big, not just the canvas and the brushstroke, even the food on the table…,' was how one American collector put it, and Richard Flood, who was director of New York's Barbara Gladstone Gallery during the 1980s, describes the biggest problem of the decade as the constant demand for something new. The galleries provided reinforcements, and the carousel started turning faster and faster. European galleries also experienced the economic miracle of the art trade. In Switzerland, Bruno Bischofberger and Thomas Ammann were not the only ones to prosper; in London, the Lisson Gallery, which had set trends like no other gallery before it, became an established institution, and one former employee, Karsten Schubert, of German descent, discovered for his own gallery (which he had set up in the meantime) the graduates of the Goldsmiths College of Art, with their leading figure Damien Hirst and a few other London artists, in particular Rachel Whiteread. This was the dawn of the Young British Artists, whose success survived the recession, which, setting in at the end of the 1980s, clipped the wings of many gallery owners.

But there were also galleries that did not follow the trend of selling the 'neo-expressive' works that are generally associated with the 1980s. They set their store by those artists who sought to throw some light on the economic, psychological and philosophical conditions in which art evolves. This trend, known as 'institutional criticism', was expounded by the performance artist Andrea Fraser, and also by Mark Dion, who put himself in the role of a natural scientist. In New York, they appeared at Colin de Land's gallery, ironically named 'American Fine Arts' by its owner, who sought to set himself apart from other galleries, not only thematically, but also geographically and visually by setting up shop in a somewhat run-down gallery at the southern end of SoHo. In Cologne, the Galerie Christian Nagel opened on a similar premise with Context Art on the agenda, ushering in the end of opulent works and the fat years.

It could go in the other direction too. The East German gallery owner Harry Lybke is the living proof of this. In order not to be regarded as a capitalist small businessman in communist East Germany, he declared his gallery in Leipzig to be a 'workshop', and exhibited predominantly Action Art. After the collapse of the communist regime, he rented premises in central Berlin, which he used largely for presenting young artists from East Germany to the West. His stars included Olaf and Carsten Nicolai and, in particular, Neo Rauch.

No term was used more frequently in the 1980s than 'postmodern'. It had been used since the 1960s in relation to architecture, where it referred to the reaction to modernist functionalism. In philosophy, it only gained currency in 1979 with the publication of Jean-François Lyotard's essay *La Condition postmoderne*. Here, it refers to the transition from binding value-systems to pluralist forms of thought.

UTA GROSENICK

View of installation by Felix Gonzalez-Torres in Galerie Peter Pakesch, 1992

American Fine Arts, Co.

YEAR OF FOUNDATION
1985
FOUNDER
Colin de Land
ADDRESS
1985–88 **Vox Populi, East 6th Street, New York**
1988–2000 **40 Wooster Street, New York**
2001–4 **American Fine Arts, Co., at Pat Hearn Art Gallery, 530 West 22nd Street, New York**
CLOSED 2004

ARTISTS REPRESENTED
**Art Club 2000, Lutz Bacher, Alex Bag
Dennis Balk, Patterson Beckwith
Bernadette Corporation, Boug & Worth
Clegg & Guttmann, Moyra Davey, Stephan Dillemuth
Mark Dion, Peter Fend/OEDC, Andrea Fraser
Grennan & Sperandio, Gareth James
Silvia Kolbowski, Estate of Mark Morrisroe
Christian Philipp Müller, Nils Norman, Kembra Pfahler
Pieter Schoolwerth, Frank Schroder
Steven Shearer, Ian Wallace, John Waters**

Colin de Land setting up his stand at the 'Art Frankfurt' trade fair, early 1990s

The heroic minority and their spiritus rector. Colin de Land first opened a gallery in 1980 in a small, spare room in a photographer's uptown studio. In subsequent incarnations, the gallery has been located in the Lower East Side, the East Village, SoHo and finally in Chelsea, at Pat Hearn Fine Arts. In the heyday of the East Village, he had a gallery called Vox Populi in what used to be a butcher's on East Sixth Street. Among the artists exhibited at Vox Populi was John Dogg, a fictional artist purportedly invented by the Conceptual artist Richard Prince and Colin de Land, whose work comprised minimalist presentations of automobile and truck tyres. 'Colin's ability to create a dynamic social space was legendary,' as Art Club 2000's Danny McDonald, current director of AFA, said in a recent article in *Artforum*. 'There was always a great mix of artists, animals, art-world veterans and a few brave collectors to be seen there at any hour of the day or night. We all showed up to run into each other, but really everyone was trying to get a hold of Colin, who generously directed the flow by simply never saying no.'[1]

American Fine Arts, Co. became prominent during the market-driven art economy of the 1980s. Colin de Land moved to the space on Wooster Street in 1988, where he remained for twelve years, and which he felt was far enough away from the blue-chip galleries around Prince and West Broadway Streets. The name of the gallery was purposefully misleading. De Land said he chose the name because it connoted something genteel and blue-blooded.

The gallery itself was vintage SoHo, with creaky, wooden floors and ceilings covered in pressed tin, and a line-up of artists more interested in critical than financial success. Unlike most of the work associated with that period, Neo-Expressionism, AFA focused on a generation of artists who were both cynical yet intellectually driven by a desire to understand the economic, psychological and philosophical conditions under which art was produced. Many of Colin de Land's artists came out of

'John Dogg' installation, 1987

the academic/intellectual rubric known as 'institutional critique'. The performance artist Andrea Fraser, best known for her incisive critiques of museum institutions, began exhibiting with American Fine Arts, Co., as did Mark Dion and Tom Burr.

Other artists central to American Fine Arts, Co. included Cady Noland, Jessica Stockholder, Mariko Mori, Alex Bag, Dennis Balk and Peter Fend. De Land also began to show the work of the filmmaker John Waters, who was well known in the alternative film scene as the undisputed king of filth, and who has recently been exhibiting his series of black-and-white film stills. In 2000 de Land decided to move to Chelsea in 22nd Street, in the space formerly occupied by his late wife, Pat Hearn. 'Basically, I got tired,' he said. 'When only three people attend your openings, you feel like a heroic minority, but it's also a bit of a disaster. Chelsea will be the closest I've ever come to Main Street. I'm worried that I'll be just one more voice. But then again, I feel I've always had a very different relationship to artists than most dealers.'

In March 2003 Colin de Land died of cancer, aged forty-seven. His friends and colleagues Christine Tsvetanov and Danny McDonald continued to run the gallery for a short period, but in November 2004 it closed.

GILBERT VICARIO

Artists and staff of American Fine Arts, Co. in front of the gallery in Wooster Street, 2000

1 *Artforum*, summer 2003, p. 29

Art Club 2000, 1998

Galerie Paul Andriesse

YEAR OF FOUNDATION
1984
FOUNDER
Paul Andriesse
ADDRESS
116 Prinsengracht, Amsterdam

ARTISTS REPRESENTED
Jo Baer, Bert Boogaard, Jean-Marc Bustamante
Vincenzo Castella, Marlene Dumas, Keith Edmier, Maria Eichhorn
Christine & Irene Hohenbüchler, Britta Huttenlocher, Henri Jacobs
Johan van der Keuken, Jan Koster, Pieter Laurens Mol, Ann Lislegaard
Sharon Lockhart, Willem Oorebeek, Jan van de Pavert, Antonietta Peeters
Giuseppe Penone, John Riddy, Thomas Struth
Fiona Tan, Lidwien van de Ven, James Welling

Material and metaphor. The Galerie Paul Andriesse was established on Prinsengracht alongside one of Amsterdam's picturesque canals at the beginning of 1984. That was when the young proprietor, who also worked as a photographer, took over the Galerie Helen van der Meij, where he had once worked as an assistant some years before. Mrs van der Meij had been running her gallery since 1970, with German artists such as Sigmar Polke, Markus Lüpertz and Anselm Kiefer forming the focal points of her programme. Paul Andriesse gave this focus more depth by including in his programme the German artists Werner Büttner and Albert Oehlen, who first exhibited in his showrooms in the summer of 1984.

But it goes without saying that the new owner also had an agenda of his own from the outset, in particular the trio Marlene Dumas, René Daniels and Erik Andriesse, his brother. Paul Andriesse described his close relationship with these three as follows: 'I grew up with Erik, in other words with his way of creating art. His painting is very intense and almost obsessive. I noticed this all the more because at the same time I was starting with photography. A quite different, extreme, experience was my friendship with René Daniels, whom I met in 1979. His pictures are set in an imaginary world and, from there, they open up totally new associations for me. Marlene Dumas I met a short time previously via Erik; she represents the female aspect. I am greatly fascinated by the literary and political references in her work, into which poetic levels are often integrated.'

Here Paul Andriesse hints at an aesthetic element typical of most of the artists he represents: they are characterized by a high degree of material awareness, which allows them to develop convincing metaphors. In the late 1980s, with artists such as Richard Wentworth and John Chamberlain, Henk Visch and Keith Edmier, Paul Andriesse switched to the discussion regarding the formal and narrative possibilities

Opposite: Giuseppe Penone, *Propagazione*, 1996

Left: View of furniture and photographs by Le Corbusier, 2002

of contemporary sculpture. In particular the Dutchman Henk Visch, who had his debut in the gallery at the end of 1984, with his figures as crude as they are poetic, is characteristic of the gallery's programmatic attitude on this issue.

In the 1990s the Galerie Paul Andriesse concentrated increasingly on art photography. In the spring of 1990 it was Jean-Marc Bustamante who ushered in a whole series of interesting photographic exhibitions. He was followed by, among others, Thomas Struth, James Welling, Nobuyoshi Araki, Paul Graham and Sharon Lockhart. This thematic context also includes the exhibition with the young photo and video artist Rineke Dijkstra, who was 'introduced' to the international art world there in the autumn of 1996.

Another of the gallery programme's central positions is represented by the Austrian twin sisters Christine and Irene Hohenbüchler and their artistic work, as collaborative as it is sensitive, with fringe groups in our society. The Hohenbüchlers had their first exhibition at the Galerie Paul Andriesse as early as the summer of 1993. To date, they have appeared no fewer than nine times in group and solo (or duo) exhibitions. This too is typical of the Galerie Paul Andriesse: consistency, endurance and loyalty.

RAIMAR STANGE

Above: View of the exhibition 'Miss World' by Marlene Dumas, 1998

Opposite: Fiona Tan, *Cradle*, film installation, 1998

Galerie Daniel Buchholz

YEAR OF FOUNDATION
1987
FOUNDER
Daniel Buchholz
ADDRESS
1985–89 **50 Bismarckstraße, Cologne**
1989–92 **21 Venloer Straße, Cologne**
1990–93 **21 Albertusstraße, Cologne**
1992–93 **36 Breite Straße, Cologne**
SINCE 1993 **17 Neven-DuMont-Straße, Cologne**

ARTISTS REPRESENTED
**Tomma Abts, Kai Althoff, Lukas Duwenhögger, Thomas Eggerer
Morgan Fisher, Isa Genzken, Jack Goldstein, Ludwig Gosewitz
Julian Göthe, Richard Hawkins, Jochen Klein, Jutta Koether
Mark Leckey, Lucy McKenzie, Henrik Olesen, Paulina Olowska
Silke Otto-Knapp, Florian Pumhösl, Jeroen de Rijke/Willem de Rooij
Frances Stark, Stefan Thater, Wolfgang Tillmans, T. J. Wilcox, Katharina Wulff**

Daniel Buchholz and Christopher Müller in their apartment, 2003

Germany's youngest gallery owner. In a sketch outlined by Daniel Buchholz himself (b. 1962), the story of the gallery sounds like this: 'The gallery was founded in 1987 under the name "Daniel Buchholz". The first exhibition room was at 50 Bismarckstraße. It was formerly Rudolf Zwirner's storeroom, where, in 1986, at first under his name and then under mine, I began to organize exhibitions. In 1988: new premises at 21 Venloer Straße. In 1990: the opening of "Buchholz & Schipper" (together with Esther Schipper, a shop for editions and multiples), at 26 Albertusstraße, and in parallel, exhibitions at the gallery on Venloer Straße. In 1992: the opening of "Buchholz & Buchholz" (36 Breite Straße). In the backroom of my father's subsidiary shop I opened a small "White Cube"-like room. From then on, exhibitions took place either at "Buchholz & Buchholz" or in the multiple shop, which was now operated in my name. In 1994: the opening of "Daniel Buchholz" (17 Neven-DuMont-Straße). After the death of my father, I inherited his main shop, a second-hand bookshop that actually specialized in paper antiques. The premises were such that I could convert the rear part of the shop into a gallery. From now on, the activities of the gallery were concentrated in these premises. At the end of 1995, Christopher Müller began to organize film evenings in the gallery. These were events at which artist films (mostly old films by artists dating from the 1960s and '70s) were presented as original 16 mm films. On these occasions the gallery was transformed into a small cinema. Since the series of events "Glockengeschrei nach Deutz", which was organized in 1996 by Cosima von Bonin, Christopher Müller and myself, the gallery has been run by Christopher Müller and me. It was renamed the "Galerie Daniel Buchholz".'

The seventeen years of gallery activity, which are here presented as a series of changes of address (all in Cologne, incidentally), also reflect the visionary mobility with which Daniel Buchholz is constantly exhibiting new positions, discovering new artists, and ultimately never pinning himself down to one particular trend. That is, unless one wants to claim that the overwhelmingly homosexual orientation of the artists who have found a forum at the Galerie Daniel Buchholz in recent years constitutes a common denominator.

Buchholz has in any case always applied very high standards of quality and artistic innovation. As long ago as 1986, at the first two exhibitions in Rudolf Zwirner's storeroom, which he, in elitist fashion, called 'Iterativismus I + II', he displayed the works of international artists working in what was then, in the USA, the very fashionable movement known as Appropriation Art (Philip Taaffe, Sherrie Levine, John M Armleder and Gerwald Rockenschaub, among others), for some of which it was their first show in Germany. In 1988 he exhibited – after having just moved to the gallery building on Venloer Straße designed by Oswald Mathias Ungers – the complete graphic works and multiples of Blinky Palermo, and Isa Genzken also had her first solo exhibition at Galerie Daniel Buchholz. In 1989 the Canadian artist trio General Idea had their first German exhibition in his gallery, although the trio as such was already breaking up, one of their members having died of AIDS the year before.

In 1990, in cooperation with Esther Schipper, Buchholz started a store for multiples and editions. In the immediate neighbourhood of Zwirner's and Reckermann's galleries, as well as the much-frequented art bookshop run by Walther König, graphic works by Sigmar Polke were sold, along with photographs by Candida Höfer and drawings by Tom of Finland. In 1993 the first Wolfgang Tillmans exhibition was held in the multiples shop and behind Hans Buchholz's second-hand bookshop on Breite Straße. Tillmans, who, ten years later, had become one of the world's most celebrated contemporary photographic artists, recalls the start of his collaboration with Buchholz: 'In the autumn of 1992…on the evening before the opening of "Unfair", I was told by Michael Hengsberg, who was then Daniel's assistant, that

they would very much like to do an exhibition with me. This was because they found my work, which they had seen at i-D, so good.'

In 1994 Daniel Buchholz, following the death of his father, took on the latter's main shop on Neven-DuMont-Straße and converted the rear section into a gallery. The inaugural exhibition, 'Sonne München', brought together the young artists Kai Althoff, Cosima von Bonin, Dominique Gonzalez-Foerster, Lothar Hempel, Carsten Höller, Philippe Parreno and Wolfgang Tillmans; it was followed by solo exhibitions with the then largely unknown art stars Ugo Rondinone and Maurizio Cattelan.

The Galerie Daniel Buchholz as we know it today has been around since 1997, when Christopher Müller became co-manager, and the gallery assumed its unmistakable style. This cannot be described – only experienced. There are two ways of doing this. One is to go to an exhibition opening and push one's way through the packed room. The other is to visit the place on a weekday, absorb the relaxed atmosphere, and find oneself engaged in stimulating conversation by the proprietor. You always have to go to an exhibition at the Galerie Daniel Buchholz twice.

UTA GROSENICK

General Idea, *Green (Permanent) Placebo*, view of the installation on Venloer Straße, 1991

More light research, view of the installation by Isa Genzken, 1992

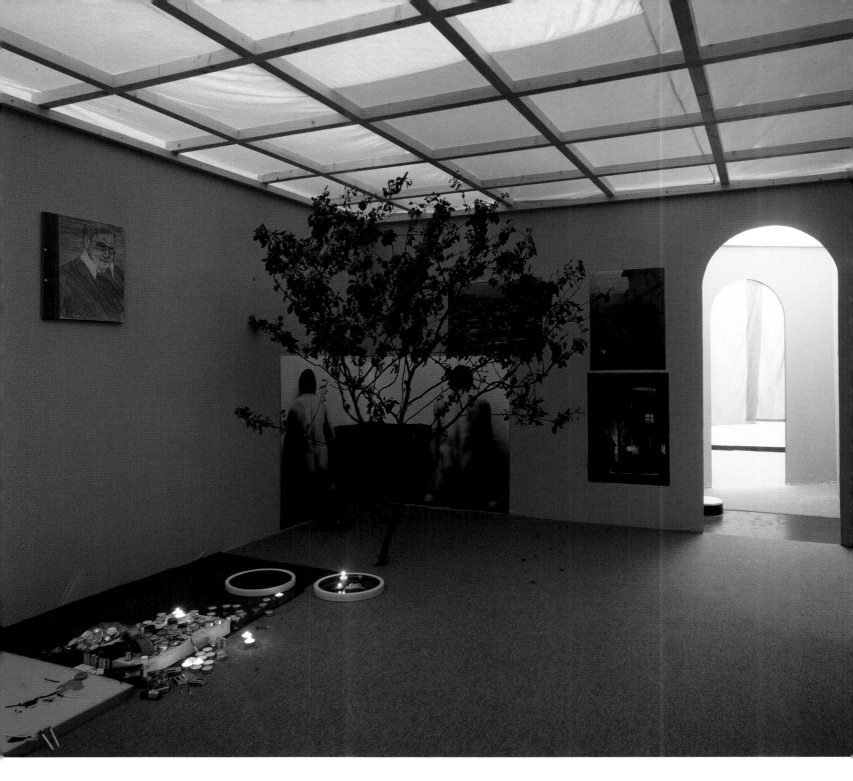

Kai Althoff, *Aus Dir*, 2001

Exhibition by Henrik Olesen, 2002

Galleria Massimo De Carlo

YEAR OF FOUNDATION
1987

FOUNDER
Massimo De Carlo

ADDRESS

1987–94 **Massimo De Carlo Arte Contemporanea, 39 Via Panfilo Castaldi, Milan**

1992–98 **Galleria Massimo De Carlo, 7 Via Bocconi, Milan**

1998–2003 **Galleria Massimo De Carlo, 41 Viale Corsica, Milan**

SINCE 2004 **Galleria Massimo De Carlo, 15 Via Ventura, Milan**

ARTISTS REPRESENTED

Mario Airò, John M Armleder, Massimo Bartolini, Simone Berti, Richard Billingham
Maurizio Cattelan, Roberto Cuoghi, Jeanne Dunning, Elmgreen & Dragset
Rainer Ganahl, Thomas Grünfeld, Carsten Höller, Eva Marisaldi, Aernout Mik
Olivier Mosset, Matt Mullican, Cady Noland, Steven Parrino, Diego Perrone
Paola Pivi, Daniele Puppi, Sam Samore, Julia Scher, Gregor Schneider
Jim Shaw, Ettore Spalletti, Rudolf Stingel, Piotr Uklański
Lawrence Weiner, Franz West, Andrea Zittel

Installation with Massimo De Carlo by Maurizio Cattelan, 1999

New Italian geography. In the mid-1980s the geography of contemporary art in Italy underwent a gradual but palpable transformation. Turin and Rome, previously the centres, lost the leading position, which they had held for more than twenty years, to Milan. There were various factors that led to this change: the emergence of a new generation of critics, as well as the new impulses coming from the Accademia di Belle Arti di Brera and, in particular, the artist professors Luciano Fabro and Alberto Garutti, and from the architect and artist Corrado Levi at the Technical University. We should also mention the presence of new collectors and the information and networking activities of magazines with an international circulation, such as *Flash Art* and *Tema Celeste*, and finally the establishment of new galleries that showed great commitment to the latest currents.

In 1986 Sergio Casoli, Claudio Guenzani and Giò Marconi opened their galleries. In 1987 Massimo De Carlo did the same, followed a few years later by Monica De Cardenas and Emi Fontana. But the most interesting example of the close links between contact with the international art world and the commitment to exhibits from the new domestic scene is perhaps Massimo De Carlo.

At first the young De Carlo's attention was entirely focused on the prevailing Postmodern discourse, the painting of the 'Neo Geo', which was currently evolving (between '*non-pittura*' and '*inespressionismo*', as Germano Celant defined it), and objects of non-functional design. In the Italian context, the extensive exhibition of 'historical' works by the then almost forgotten Alighiero Boetti also points to a detached attitude and a linguistically playful irony, and a contrast with the days of the various manifestations of Trans-avantgarde. The first and second seasons were characterized by exhibitions of the works of Olivier Mosset (for the gallery's inauguration), John M Armleder, Thomas Grünfeld and Rudolf Stingel. At the same time, the gallery started to publicize the new Milan scene, in the form of the works of Amedeo Martegani, for example, one of Corrado Levi's most intelligent pupils.

One of the (until that date) rare solo exhibitions of Cady Noland, in 1987, marked an incipient interest in the American art world, and its links with the Pop and Post Punk subcultures, and the case was similar with Steven Parrino, Raymond Pettibon and Jim Shaw. Here we can also see, in contrast to the first two years, a certain predilection for individual artistic personalities, transcending the logic of groups and movements. Among these individual figures we should at least single out Felix Gonzalez-Torres, who in 1991 had a very successful solo exhibition, in which he showed some of his piles of paper, a trail of candies and jigsaw puzzles.

Two years later we saw the debut of another artist who was to have some influence on the international stage: Maurizio Cattelan. His first solo exhibition at the Galleria Massimo De Carlo, in 1993, was of a teddy bear balancing on a wire, but this could only be seen through the window of the otherwise inaccessible gallery. In the next few years, Cattelan was to stage more of these ironic refractions of the structures and conditions of the art system and the prevailing expectations and role assignments, and to enjoy growing success with them. It was also De Carlo who

Exhibition by
Maurizio Cattelan, 1996

initiated one of the first solo exhibitions by the Brera graduate Vanessa Beecroft, who approached female identity with an intimate eye and created links with the language of film and fashion. One of her performances, involving several young women wearing striking red wigs, took place in 1994. For these two artists, the move from Milan to New York was the springboard to the international art scene and a life as media stars.

The occupation of new premises on the Via Bocconi, which were operated in parallel with the main branch between 1992 and 1994, allowed exhibitions with, in some cases, spectacular effects. These included 'General Idea' (1994) or the solo exhibitions of John M Armleder (1995), Maurizio Cattelan, who hung a stuffed horse from the ceiling (1996), and Vanessa Beecroft, who stood performers of both sexes on a rostrum facing the entrance and thus erected a wall of faces beholding the beholder (1996), as well as the first solo exhibition in Italy by Carsten Höllers, and finally Ettore Spalletti (1997).

The agenda of the Galleria Massimo De Carlo included the presentation of works by young international artists created especially for the exhibition in question and the presentation of a whole variety of positions represented in young Italian art –

Installation by
Elmgreen & Dragset, 2002

also, in some cases, in the context of exhibitions that attracted international attention. Apart from artist personalities who have meanwhile made names for themselves beyond Italy's borders, such as Cattelan and Beecroft (who terminated her collaboration with the gallery in 1996), this programme also featured the young artists of the so-called 'Via Fiuggi' group, who belonged to a new generation of Brera graduates. These included Diego Perrone, Simone Berti, Paola Pivi, Eva Marisaldi and Massimo Bartolini. Pivi's controversial installation of a tableau vivant, consisting of a hundred young Chinese people arranged in a square, inaugurated the new premises on Viale Corsica in 1988: hardly anyone had had time to take a photograph when the group dispersed and left the gallery.

In recent years the gallery's programme has included solo exhibitions by such well-known artists as Lawrence Weiner, a joint project by Ettore Spalletti and Franz West, and exhibitions by Gregor Schneider, Piotr Uklański, Elmgreen & Dragset and Aernout Mik. The gallery has also intensified its work with new-generation Italian artists such as Airò, Bartolini, Berti and Pivi.

LUCA CERIZZA

Galerie Chantal Crousel

YEAR OF FOUNDATION

1980

FOUNDERS

Chantal Crousel

ADDRESS

1980–86 **80 Rue Quincampoix, Paris**

1986–90 **5 Rue des Haudriettes, Paris**

1983–86 **Galerie Crousel-Hussenot, partnership with Ghislaine Hussenot**

1987–92 **Crousel-Robelin/BAMA, partnership with Ninon Robelin of the Galerie Bama**

SINCE 1990 **Galerie Chantal Crousel, 40 Rue Quincampoix, Paris**

ARTISTS REPRESENTED

**Absalon, Bas Jan Ader, Christian Boltanski, Sophie Calle, Tony Cragg
Fischli & Weiss, Gilbert & George, Fabrice Gygi, Mona Hatoum
Thomas Hirschhorn, Joseph Kosuth, Barbara Kruger, Wolfgang Laib
Gordon Matta-Clark, Melik Ohanian, Gabriel Orozco
Anri Sala, José-Maria Sicilia, Jana Sterbak**

Chantal Crousel, 1991

A particular energy. As far as Belgian humour is concerned, Chantal Crousel prefers the merciless self-mockery *à la flamande*, as found in the masks of James Ensor. When the Gulf War of 1991 pitched the art market into such a deep crisis that Paris galleries were forced to close in quick succession, she brought together eight artists, including Rodney Graham, Jana Sterbak and Christopher Williams, for a group exhibition with the sinister but accurate title 'Vanitas'. When, the following year, the crisis had only become worse, and her gallery was on the point of collapse, she lit a new beacon by including the artists Christian Boltanski, Bill Viola, Rémy Zaugg and others in her annual group exhibition entitled 'Mehr Licht' (More Light), the alleged last words of Goethe on his deathbed. More than a mere cry for help, a whole philosophy is concealed behind it.

Chantal Crousel, who as a young woman saw a lithograph by Man Ray in the window of a Brussels store and decided on the spot to become a gallery owner, has

Exterior view of the Galerie Chantal Crousel on Rue Quincampoix, with the Jenny Holzer exhibition, 1981

an inexhaustible reserve of obstinacy. When she went to Paris in 1972, she underwent an artistic training and also an apprenticeship at a commercial college, from which she graduated with a thesis on the subject of the 'COBRA group', which must have come fairly naturally to her. Her attempts to establish a gallery started in 1978, at first in partnership with one of her fellow students, who specialized in naive art: the gallery was pessimistically christened 'La Dérive' (Drifting Away). This hesitant start was quickly doomed to failure and opened the way for the audio cassette *La nouvelle revue d'art moderne* (The New Review of Modern Art), along with the artistic and poetic evenings she organized in her apartment on Avenue de Wagram: those in attendance included François Dufrêne, Bernard Heidsiek, Annette Messager and Sarkis.

With the opening of the Galerie Chantal Svennung (her married name) she returned to a more classical form. This gallery, situated on Rue Quincampoix near

the Centre Georges Pompidou, was soon to be renamed 'Palluel-Svennung', in view of a new liaison, and then, following a number of similar alterations, 'Chantal Crousel'. In 1980 Chantal Crousel's career took shape with the opening exhibition of works by Tony Cragg and the exhibition 'PICTUREALISM' with Robert Longo, Richard Prince and Cindy Sherman, through whom she got to know the whole of the team of the newly established Metro Pictures gallery in New York. The commercial success was not spectacular, but encouraging, since some works were sold to important collectors (four plates by Tony Cragg went to the Conceptual Art collector Herman Daled from Brussels, while a larger work, likewise by Tony Cragg, was sold to the Centre Georges Pompidou, and a picture by Bruce McLean went to the collection of Myriam Salomon, the co-editor of the magazine *Art Press*.

Chantal Crousel now showed renewed energy and considerable commitment, revealing her unyielding character. Many will recall, for example, the film projections by Jack Goldstein, which she staged in the Le Palace discotheque, or the thought-provoking after-midnight performances by Gilbert & George in the art cinema La Pagode.

Abigail Lane, view of the exhibition with the works *Broken Heart* and *Bloody Wallpaper*, 1996

Gabriel Orozco, *La D. S.*, 1993

The list of the subsequent solo exhibitions is impressive and reflects a personality who was very receptive to the international scene. Always on the look-out for the most innovative artists, she was often one of the first to take up the flag on their behalf. Thus in her gallery in Paris, between 1981 and 1983, she staged the first solo exhibitions by Alighiero Boetti, Georg Jiri Dokoupil, Jenny Holzer, Barbara Kruger, Wolfgang Laib, Matt Mullican and Cindy Sherman.

The revival of the market was slow in coming, however, and even though some exhibitions, such as that of Gilbert & George, were sell-outs, many ran up against the ignorance of a badly informed and timid public. Money began to run out, and as a result of two successive gallery partnerships between 1983 and 1992, a slight change of course began to make itself felt. The collaboration with Ghislaine Hussenot brought French artists in particular on to the agenda: these included Bazile-Bustamante, Christian Boltanski, Sophie Calle and Bernard Frize, but non-French artists such as Joseph Kosuth, Richard Long and Thomas Schütte were also brought in. A merger with the Galerie Bama and its manager, Ninon Robelin, enriched the list of artists with important names from the Fluxus movement, such as George

Brecht and Robert Filliou, as well as painters such as Sigmar Polke. At the same time, the young Israeli artist Absalon had his first solo exhibition in the gallery in 1990.

When she was back at the helm alone, in 1992, Chantal Crousel refused to become discouraged, even in those difficult times. During the 1990s the gallery sold just two works to the Centre Georges Pompidou, but fifteen by contrast to the Anthony d'Offay Gallery in London and the Antwerp gallery Zeno X. The death of Absalon and the inclusion of Gabriel Orozco in the programme made 1993 a critical year. Fabrice Gygi, Thomas Hirschhorn, Rirkrit Tiravanija and, recently, Melik Ohanian and Anri Sala have since also joined the gallery.

Although Chantal Crousel indisputably lends the French art scene a particular energy, she remains ironically on the fringe. Her inadequate mastery of the labyrinthine nuances of the French language is not an advantage in a country where there is a veritable cult of rhetoric. In addition, by changing her business partners, she has made many enemies in the French art scene, which is based on personal connections. Her constant financial difficulties have certainly led her on occasion to allow her debts to mount up, in particular with the artists. But she obstinately accepts this in order to be able to go on working. 'In the early 1990s, many artists left the gallery because of payment problems, but most stayed with me,' she says. 'Some, like Tony Cragg, have even spontaneously consented to a drop in the prices for their works.'

STÉPHANE CORRÉARD (WITH LILI LAXENAIRE)

Above, left: Rirkrit Tiravanija cooking for the public on the opening night of 'Dom-ino', 1998

Above, right: Rirkrit Tiravanija, 'Dom-ino', 1998

Left: Exhibition 'Keys for a Building', 1990, with works by Claes Oldenburg, Coosje van Bruggen, Frank Gehry and John Baldessari

Below: Reconstruction of Robert Filliou's studios, 1989

Galerie Eigen + Art

YEAR OF FOUNDATION
1983
FOUNDER
Gerd Harry 'Judy' Lybke
ADDRESS
1983–85 **8 Körnerplatz, Leipzig**
1985–90 **31 Fritz-Austel-Straße, Leipzig**
1990–99 **7–9 Zentralstraße, Leipzig**
SINCE 1998 **14 Ferdinand-Rhode-Straße, Leipzig**
SINCE 1992 **26 Auguststraße, Berlin**

Temporary Galerie EIGEN + ART:
1990 **Tokyo,** 1991 **Paris,** 1992 **Berlin**
1993 **New York,** 1994 **London,** 1995 **Dresden**
1996 **Düsseldorf,** 1996 **Weimar**

ARTISTS REPRESENTED
**Akos Birkas, Birgit Brenner, Martin Eder, Tim Eitel
Nina Fischer / Maroan El Sani, Jörg Herold, Christine Hill
Stephan Jung, Uwe Kowski, Rémy Markowitsch, Maix Mayer
Yana Milev, Carsten Nicolai, Olaf Nicolai, Neo Rauch
Yehudit Sasportas, Annelies Strba**

Gerd Harry Lybke and Mr Penndorf from the Altenburg Museum in Lindenau, purchasing a portfolio, 1987

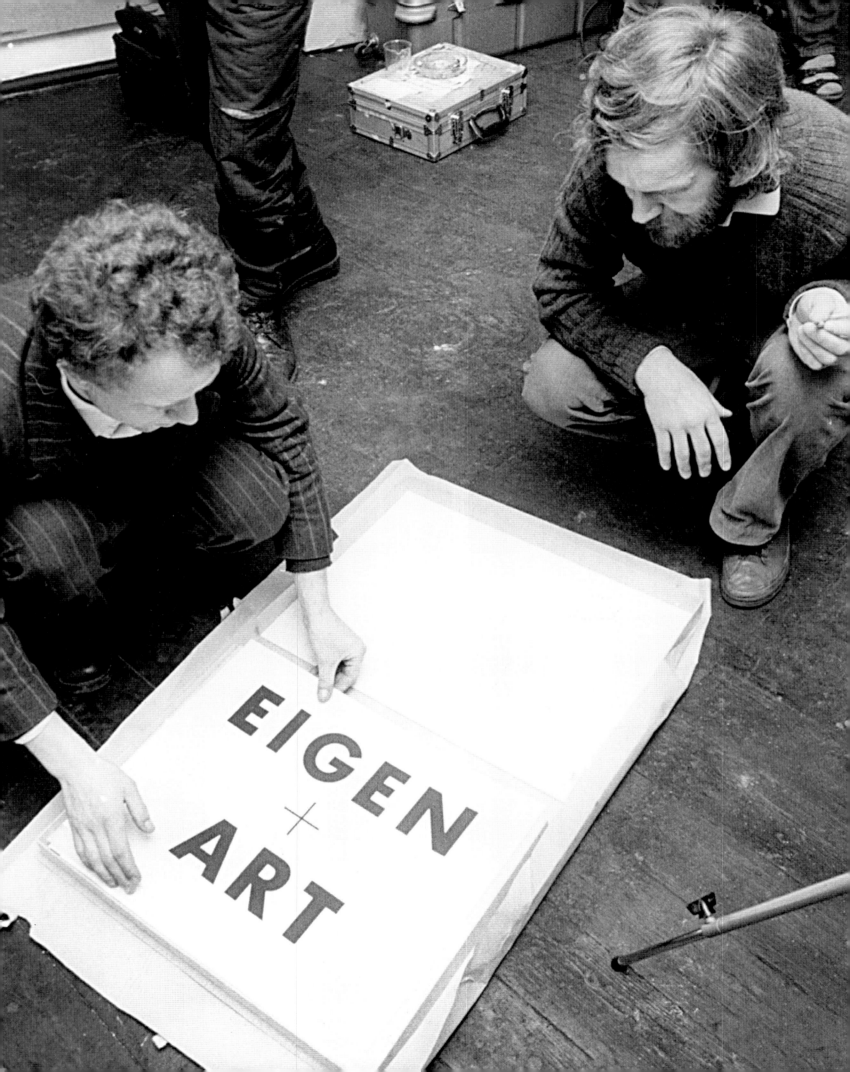

The first exhibition at Eigen + Art
in April 1983, with Gerd Harry Lybke
in bathrobe

The art of changing regimes. The Leipzig gallery Eigen + Art was a legend even during the lifetime of communist East Germany. In addition, it is one of the very few East German galleries to have had any success after the fall of the Berlin Wall in 1989, both in 'united' Germany and abroad.

Eigen + Art – 'eigen' means 'own', and the very word, with its connotations of private ownership, was a provocation for the official ideology – was founded in 1983 in the attic apartment of its guiding spirit, Gerd Harry Lybke, known as 'Judy', at 8 Körnerplatz in Leipzig.

Even the opening is shrouded in legend. Dressed in a bathrobe and trainers, Gerd Harry Lybke, with his untidy beard, received his guests in a ridiculous parody of middle-class bohemianism. On show at this first exhibition, which he curated jointly

Exhibition view, Rosa, Loy, Gerd Harry Lybke and Neo Rauch

on this occasion with his friend Thomas Schilling, was, among other things, a bust of Lenin wearing a 'little boat' hat folded from newspaper.

At first the gallery had neither a telephone nor a fax machine, but in the difficult conditions imposed by real-existing socialism, and under constant surveillance by the Stasi, Lübke soon became more professional. From the outset, he documented his work with the help of a computer and a video camera. And the standard of the art he exhibited also rose quickly. As early as the autumn of 1986, for example, he was exhibiting the later 'documenta' participant Jörg Herold in a group exhibition. But first of all there was a change of venue. In 1985 the gallery moved to a former chemicals factory at 31 Fritz-Austel-Straße, from which, it is said, Pablo Picasso had once ordered his lithography chalk.

In order to avoid prohibition as a capitalist small business, 'Judy' Lybke cleverly registered his gallery as a workshop. This legal nicety also had the significant advantage that all the sales went not to the account of the gallery, but directly to the artist. International collectors and institutions in particular valued the tax advantages that this brought. As a result, Eigen + Art was already on a sound financial footing by the mid-1980s.

By artistic criteria, the exhibition 'Allez! Arrest – Autoperforationsartistik' in the spring of 1988 was one of the absolute high points. For the whole period of the exhibition the artists Micha Brendel, Else Gabriel and Rainer Görss locked themselves in the gallery and produced artworks, which could be acquired by the public in exchange for food at an evening 'surgery'. Some of this food was then eaten by the three art exiles, and some was processed for fatty artefacts. The same year the brothers Carsten and Olaf Nicolai exhibited jointly at Eigen + Art.

'Crossdrawings', Klaus Werner and Gerd Harry Lybke, 1987

In 1989 the Berlin Wall came down, and, in the words of Willy Brandt, 'what belonged together grew together'. What allegedly belonged together, anyway. As we said, in the new Germany 'Judy' Lybke, with his nose for new positions and a goodly portion of publicity-conscious media awareness, continued to attract attention.

The gallery opened further premises at 26 Auguststraße in central Berlin in 1992, and paid short visits to Paris (1991), New York (1993) and London (1994). The busy gallery owner recruited new artists for his expanding programme, such as the painter Neo Rauch, who achieved great success at the end of the decade, the young Stephan Jung from Stuttgart, and Christine Borland from England. He himself described the new situation in Germany with the help of maritime metaphors. 'I always knew that there were two ships,' he said. 'One ship sank, so you swam across to the other. There, all the posts from the helmsman to the captain are already occupied. So you have to look for an opening – and jump into it!' The quality of this search for an opening was revealed at 'documenta X' in 1997: with Jörg Herold, Christine Hill, Yana Milev, Carsten Nicolai and Olaf Nicolai, five artists were represented in Kassel, who were already on board with 'Judy' Lybke, and in some cases still are.

RAIMAR STANGE

Birgit Brenner, view of the exhibition 'Angst vor Gesichtsröte', 1999

Olaf Nicolai, *Hello There / Hell Here*, neon installation, 2002

Gagosian Gallery

YEAR OF FOUNDATION

1980

FOUNDER

Larry Gagosian

ADDRESS

SINCE 1989 **980 Madison Avenue, New York**

1992–2000 **136 Wooster Street, New York**

SINCE 1995 **456 North Camden Drive, Beverly Hills**

SINCE 1999 **555 West 24th Street, New York**

2000–4 **8 Heddon Street, London**

SINCE 2004 **6-24 Britannia Street, London**

ARTISTS REPRESENTED

**Carl Andre, Richard Artschwager, Jennifer Bartlett, Georg Baselitz, Jean-Michel Basquiat
Vanessa Beecroft, Joseph Beuys, Alighiero Boetti, Constantin Brancusi, Cecily Brown
Chris Burden, Alexander Calder, John Chamberlain, Francesco Clemente, Michael Craig-Martin
Gregory Crewdson, John Currin, Willem de Kooning, Walter de Maria, Mark di Suvero
Richard Diebenkorn, Eric Fischl, Dan Flavin, Sam Francis, Alberto Giacometti, Gilbert & George
Nan Goldin, Douglas Gordon, Arshile Gorky, Robert Graham, Peter Halley, Richard Hamilton
Damien Hirst, Hodgkin, Edward Hopper, Howard, Jasper Johns, Anselm Kiefer, Yves Klein
Franz Kline, Jeff Koons, Sol LeWitt, Roy Lichtenstein, René Magritte, Brice Marden, Joan Miró
Henry Moore, Malcolm Morley, Barnett Newman, Pablo Picasso, Jackson Pollock, Jean Prouvé
Robert Rauschenberg, James Rosenquist, Susan Rothenberg, Peter Paul Rubens, Ed Ruscha
David Salle, Egon Schiele, Julian Schnabel, Richard Serra, Cindy Sherman, David Smith
Frank Stella, Philip Taaffe, Cy Twombly, Andy Warhol, John Wesley, Rachel Whiteread**

Exterior view of the Gagosian Gallery on West 24th Street in Chelsea

The power of spectacle. New York's Chelsea. LA's Beverly Hills. London's West End. Top architects. Art superstars. Money. Celebrity. Controversy. Scandal. Welcome to the world of Larry Gagosian, quite possibly America's most notorious contemporary art dealer. With four spacious galleries, featuring painting, sculpture, photography and multimedia installations by leading American and European artists, Gagosian has built an empire. But while he may have written himself into the art history books, he has not escaped the gossip columns or legal entanglements with the government.

Gagosian worked for a short time in the entertainment industry and in the 1970s began his first operation selling prints in Los Angeles. In 1989 his first gallery opened across from New York's Whitney Museum of American Art with an exhibition of American artist Jasper Johns's map paintings of the 1960s. This Madison Avenue space focuses on such modern masters as Max Beckmann, Constantin Brancusi, Alberto Giacometti, Edward Hopper and Yves Klein, mixing in works by renowned contemporary artists. In 1992 he added to the robust scene of New York's SoHo neighbourhood when he opened a gallery on Wooster Street. Designed by Richard Gluckman – an architect responsible for many Chelsea spaces, including the annex of the Dia Center for the Arts and the Paula Cooper, Mary Boone, Charles Cowles, Andrea Rosen and Luhring Augustine galleries – the space was inaugurated

with an exhibition of new sculpture by Richard Serra. In the same year, Gagosian joined forces with legendary dealer Leo Castelli and started a special project space for large and heavy works, located on Thompson Street in SoHo, opening with the work of Walter de Maria, followed by an exhibition of Roy Lichtenstein's bronze sculptures. In 1995 Gagosian opened an expansive Beverly Hills gallery – 8,000 square feet, with 24-foot-high ceilings – designed by Richard Meier. The opening exhibition featured new sculpture by Frank Stella, best known for his abstract paintings. Within six years, this only son of an Armenian stockbroker became one of the art world's leading dealers.

In 1999 the Brooklyn Museum of Art mounted the exhibition 'Sensation: Young British Artists from the Saatchi Collection', which featured several of Gagosian's artists, including the sibling sculpture team Jake and Dinos Chapman, installation artist Damian Hirst, large-scale figurative painter Jenny Saville and conceptualist Marc Quinn. Beset by the controversy that stemmed from Mayor Rudy Giuliani's denunciation of a dung-splattered painting of the Virgin Mary by Chris Ofili, the show was the focus of a media-feeding frenzy. Ultimately, only politics could outperform Gagosian's marketing efforts, boosting the growing popularity of his artists with front-page news.

In November of the same year, Gagosian opened his flagship – a Gluckman-designed Chelsea gallery – with an exhibition of new sculpture by Richard Serra, organized in conjunction with an exhibition of Serra's new works on paper at the Madison Avenue location. Heavy, steel-girded doors made of frosted glass (a Gluckman trademark) open to reveal stylish staff managing what looks like a small museum rather than a gallery. Boasting 25,000 square feet, large white walls and cement floors, it is a powerful, striking space that retains the raw, industrial ambience of its former incarnation. The SoHo location closed in 2000 with a show of paintings by British-born 'abstract figurative' painter Cecily Brown. The opening of the Chelsea space put Gagosian in a league of his own. Few, if any, commercial galleries could accommodate the massive works of such artists as Anselm Kiefer, Mark di Suvero, Hirst and Serra.

Gagosian expanded to London in 2000, inaugurating his fourth gallery with the attention-grabbing spectacle of Italian-born Vanessa Beecroft's first UK exhibition: a tableau vivant of nude women in designer heels. Built by the British architectural team Caruso St John, the generous space – 3,500 square feet, with 14-foot-high ceilings – was once a recording studio (appearing on the cover of David Bowie's 1972 *Ziggy Stardust* album). In 2001 the gallery presented a Richard Hamilton exhibition, praised by critics as the most up-to-date exhibition of the British artist's work in London. Prior to this show, Hamilton was represented by the Anthony d'Offay Gallery and, with the exception of prints, his work had only been seen there and in museums. The acquisition of Hamilton was no small victory: already noted as the leading collector of American Pop Art and one of the primary dealers of Andy Warhol's work, Gagosian finally landed the 'Father of Pop'.

But staying at the top of the art heap has not been easy. On 19 March 2003 the United States government filed a US$26.5m suit against the dealer and three others in an attempt to collect taxes, interest and penalties on a 1990 art purchase allegedly made through a shell corporation. Prior to this lawsuit, Gagosian was implicated, though not charged, in a separate federal case involving Sam Waksal – ImClone's disgraced founder and a Gagosian client – who admitted to owing US$1.2m in New York State sales taxes on US$15m worth of contemporary art bought from the embattled dealer.

Legal matters notwithstanding, Gagosian is still a force to be reckoned with. He maintains a roster that includes some of the world's top-selling artists and deals with such affluent collectors as real estate tycoon Eli Broad, music industry mogul David Geffen, Condé Nast chairman S. I. Newhouse, Clinique Laboratories chairman Ronald S. Lauder and advertising kingpin Charles Saatchi. Boasting four galleries in three cities worldwide, museum-quality exhibitions, catalogues featuring the leading scholars and an uncanny ability to acquire works that are normally out of circulation, Gagosian wields an undeniable influence on the art world. Some criticize his penchant for extravagance, his role in the increasing commodification of art and his dubious business practices. Others admire his prodigious skill as a power broker and his ability to accomplish feats of great magnitude. Considering today's blue-chip gallery world – a highly competitive market in which art (and, possibly more importantly, the business of art) – must rise to the challenge of its time, Gagosian has undoubtedly endeavoured to be a high-stakes player, and has had varying degrees of success. In the case of Gagosian and his milieu, meeting this challenge means considering the cultural currency of celebrity, sensation and controversy as a means to an end. For some, the end is merely a *Page Six*[1] spectacle. For others, it is a testament to the power that art can achieve – no matter what the circumstances are. For Larry Gagosian, it is most certainly both.

RACHEL GUGELBERGER

1 *Page Six* is the *New York Post's* famous gossip column

Interior view of the Gagosian Gallery
in Chelsea, with works by Howard
Hodgkin, New York, 2003

371

Barbara Gladstone Gallery

YEAR OF FOUNDATION
1980

FOUNDER
Barbara Gladstone

ADDRESS
1980–83 **41 West 57th Street, New York**
1983–96 **99 Greene Street, New York**
SINCE 1996 **515 West 24th Street, New York**

ARTISTS REPRESENTED
Vito Acconci, Miroslaw Balka, Stephan Balkenhol, Matthew Barney
Robert Bechtle, Bruce Conner, Jan Dibbets, Luciano Fabro, Gary Hill
Thomas Hirschhorn, Huang Yong Ping, Anish Kapoor, Sharon Lockhart
Sarah Lucas, Mario Merz, Marisa Merz, Jean-Luc Mylayne, Shirin Neshat
Walter Pichler, Lari Pittman, Richard Prince, Gregor Schneider
Rosemarie Trockel, Magnus von Plessen

Exterior view of the Barbara Gladstone Gallery in Chelsea, 2003

Art icon with a good eye. In 1980 Barbara Gladstone moved her gallery from West 57th Street in midtown to the booming art precinct of SoHo. She had decided to become a gallery owner because as a graduate art historian she wanted to move out of academic life and into the living art scene.

During the early years of her career, this 'enthusiast for the somewhat cumbersome positions within contemporary art', as she describes herself, created a programmatic focus in the form of Italian Arte Povera. In spite of an orientation towards an art movement described by her as 'Conceptual Connection', she has since then constantly changed and expanded her gallery's agenda, and today she cannot be assigned unambiguously to any one tendency.[1] Barbara Gladstone was one of the first gallery owners to move from SoHo to Chelsea. Together with Matthew Marks, Helene Winer and Janelle Reiring from Metro Pictures, she bought an empty warehouse on West 24th Street.

Barbara Gladstone must also be credited with a sound eye for new trends where her artists are concerned. For a little while she has represented the Swiss artist Thomas Hirschhorn, who in 2002 with his *Bataille Monument* exhibited one of the most impressive installations at 'documenta 11', and thus enjoyed his international

Installation by Thomas Hirschhorn,
Cavemanman, 2002

breakthrough. His dealer in Germany, Matthias Arndt from Berlin, had to wait ten years for the privilege.

At the start of 2001 the New York-based Iranian artist Shirin Neshat had her first solo show at the Barbara Gladstone Gallery. In large-format black-and-white photographs, which mostly depict the artist herself in a chador, or in oppressively staged video installations, Neshat celebrates the conflicts between Islam and Christianity, Orient and Occident, man and woman. Themes that shortly afterwards – after 11 September 2001 – could no longer be kept out of any newscast.

In 1999 she signed a contract with the young German Gregor Schneider, after she had noticed how he had received plaudits from all sides at the 53rd Carnegie International at the Carnegie Museum of Art in Pittsburgh. In 2001 Schneider won the Golden Lion for his installation in the German Pavilion at the Venice Biennial. However, he did not have a solo exhibition at the Barbara Gladstone Gallery until 2004.

One of the best-known figures among the artists of the younger and middling generations is undoubtedly the media star Matthew Barney. Only two years after graduating from Yale, he was given his first solo show by Barbara Gladstone in 1991:

Left: View of Charles Ray's installation *One-Stop Gallery, Iowa City, Iowa*, 1971/1998

Opposite: View of Matthew Barney exhibition on Greene Street, 1991

a good-looking, muscular young man, dressed in no more than a mountaineer's rope and crampons, he climbed the walls and ceiling of the gallery. Vaseline dripped from his body on to gynaecological instruments, making them look shiny and disgusting, seductive and revolting at the same time.

Gladstone is also Barney's manager, and at considerable expense – the last film alone cost a good US\$4m – produced his five-film *Cremaster* cycle: the first, *Cremaster 4*, was made in 1994, followed by *Cremaster 1* in 1996, *Cremaster 5* in 1997, *Cremaster 2* in 1999, and *Cremaster 3* in 2003. The props for the films, which Barney gets made from artificial-limb plastics, and film stills in huge frames made of the same material, and indeed even the little sketches for the camera positions, are all sold in the gallery.

In 2001–2 all five films could be admired, together with a Matthew Barney retrospective, in museums in Cologne, New York and Paris. Matthew Barney, who is now the escort of Icelandic pop singer Björk, worked as a model while he was a student, and has not lost his flair for creating a media presence.

'Since the 1980s a certain glamour has been associated with the art scene, and today we are accustomed to seeing artists as fashion stars in illustrated magazines,' admits his manager and dealer. 'We are becoming witnesses to a merger of art and fashion. I firmly believe that fashion and art have different speeds: fashion is short-lived, its aim is to be "new". Art by contrast must be timeless.'[2]

Timelessness has made Barbara Gladstone the icon of the New York art scene, in which everything seems to move faster than anywhere else.

UTA GROSENICK

[1] Quoted from Daniel Kletke, in *Neue Zürcher Zeitung*, 17 June 2003
[2] Barbara Gladstone, in *Flash Art*, March/April 2001

The Living Room

YEAR OF FOUNDATION

1981

FOUNDER

Bart van de Ven

ADDRESS

1981–83 **5 Wagenaarstraat, Amsterdam**

1983–93 **70 Laurierstraat, Amsterdam**

CLOSED 1993

ARTISTS REPRESENTED

**Erik Andriesse, Tim Benjamin, Troy Brauntuch
Fortun/O'Brien, Frank van den Broeck, Peter Kantelberg
George Korsmit, Aldert Mantje, Willem Sanders
Rob Scholte, Peer Veneman, Martin van Vreden**

Bart van de Ven and Martin van Vreden, Cologne, 1984

A sworn community. The Living Room's trademark certainly made you sit up. During the openings, music was played. Punk, New Wave, but also schmaltz from Frank Sinatra…in other words, a confusing variety of styles – after all we were in the Postmodern 1980s.

The Living Room was established in previously private rooms – the very name hints at this – on Wagenaarstraat in Amsterdam. At the openings – and this was the gallery's second trademark – you first had to pass the neighbour's washing, which had been hung out to dry. Once in The Living Room, what awaited you was primarily painting and sculpture, mostly by a sworn group of Dutch artists in the typically anti-academic, genuinely 'wild' style of the early 1980s.

'A sluggish, self-satisfied phase was being replaced by a vital, new generation born in the 1950s,' was how gallery creator Bart van de Ven described the mood of upheaval. 'We wanted to seize power. That's why New Wave music was so important. It marked us off from the established order and provided for freshness and optimism.'[1]

This vitality was to be expressed in the paintings of Leo Mennen, Frank van den Broeck and Peter Kantelberg, as well as in the sculptures of Peer Veneman or Fortun/O'Brien. Until the move to Laurierstraat in 1983, the works were shown in an almost family atmosphere – hanging over a bed, for example.

Over the course of time, however, especially after the move to Amsterdam city centre, the exhibition activity became increasingly more staid: the first sales came,

Opposite, top: The rooms
on Laurierstraat, from 1983

Opposite, bottom: The Living Room
on Wagenaarstraat, 1981

Left: Summer exhibition, 1982

various art fairs were visited, in 1986 Art Cologne, for example; indeed the first important international artists were exhibited, such as Rob Scholte in 1984 and Troy Brauntuch in 1986. The production of catalogues underlined The Living Room's professional claim, and secured the gallery an influence well beyond the borders of the Netherlands.

But by the mid-1980s the owners were already beginning to show signs of fatigue. Bart van de Ven fought against these symptoms with unconventional group exhibitions. In 1985, in the 'Unsold Works' presentation, he exhibited, without embarrassment, precisely that. And in 'Youth Works' a year later, it was the unknown youthful sins of his artists that he presented to his public. Finally, in 1993, Bart van de Ven had had enough, and with the exhibition 'Kiss and say goodbye' he, well, said goodbye.

'Everything was going downhill: my energy, my money, my curiosity,' Bart van de Ven explained. 'Besides, I was disappointed, because people with whom I had been working for a long time were producing less interesting works. I had to realize that art is only commercially interesting when the artist is no longer searching. For me, though, the phases when one is still searching are the most interesting.'[2] If only gallery owners were as consistent as Bart van de Ven more often.

RAIMAR STANGE

1 *The Living Room,* Neuenhaus, 1995,
 p. 51
2 Ibid., p. 150

Metro Pictures

YEAR OF FOUNDATION
1980

FOUNDERS
Helene Winer and Janelle Reiring

ADDRESS
1980–83 **169 Mercer Street, New York**
1983–96 **150 Greene Street, New York**
SINCE 1997 **519 West 24th Street, New York**

ARTISTS REPRESENTED
**Olaf Breuning, Carroll Dunham, Ronald Jones, Mike Kelley
Martin Kippenberger, Louise Lawler, Robert Longo, John Miller, Tony Oursler
Jim Shaw, Cindy Sherman, Gary Simmons, Andreas Slominski
Catherine Sullivan, Eric Wesley, T. J. Wilcox, Fred Wilson**

Helene Winer and Janelle Reiring with her son Felix, 1980s

New art for new collectors. Traditionally galleries are known by the names of their proprietors. However, because they thought that their names were somewhat hard to pronounce and spell, the two founders of Metro Pictures, Helene Winer and Janelle Reiring, looked for a name that was more universal.

In the metropolis of New York, numerous businesses were called Metro this or Metro that, and, as for pictures, that could refer to painting, photography or cinema. Therefore, they decided to call their new gallery Metro Pictures, which was opened in 1980.

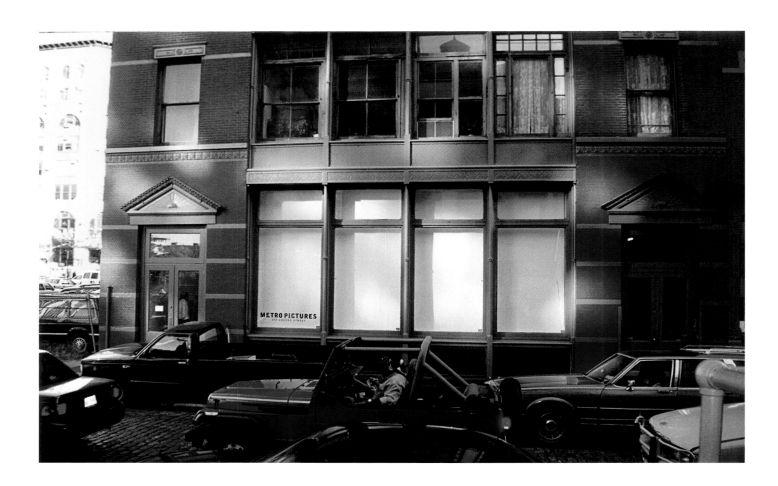

Janelle Reiring had worked for five years at the Leo Castelli Gallery, which had been one of the most important galleries since the 1960s. Helene Winer had been the director of Artists Space, an alternative non-profit exhibition room, for more than five years. The art critic Douglas Crimp had curated the much talked about 'Pictures' exhibition there in 1977, and many of the artists involved, including Troy Brauntuch, Jack Goldstein, Sherrie Levine, Robert Longo and Philip Smith, were soon on the Metro Pictures list.

In the late 1970s young artists were scarcely exhibited in New York's commercial galleries, and the only possibility for them to show their work was in the few 'off spaces'. Helene Winer had therefore had plenty of opportunity to observe the young artist scene and its effect on the public. In the early 1980s the time seemed ripe to open a room of her own, as some of the Artists Space artists, in particular Cindy Sherman, were attracting the attention of dealers and collectors. In addition, the then prevailing art trend, the difficult-to-market Conceptual Art, was gradually being replaced by more acceptable fare appealing to a non-insider public and thus to a new generation of collectors.

Even so, Helene Winer and Janelle Reiring had not predicted the art boom that characterized the 1980s and that brought them such huge success. 'Our expectations and the economic expectations of our customers were very limited. We thought we would show the works to critics and curators – primarily in Europe – and to a few collectors, and organize exhibitions, which maybe would be published in magazines.

Above: Exterior view of the gallery on Greene Street in SoHo

Opposite: Installation by Olaf Breuning, *Apes*, 2001

The artists hoped to sell a work now and then, to exhibit in Europe, and to get a teaching job. That was what you understood by success back then.'[1]

From the outset Metro Pictures has – unlike other galleries (including those run by women) – had a high proportion of women artists in the programme, people such as Louise Lawler, Sherrie Levine, Cindy Sherman and Laurie Simmons: this was deliberate on the part of the owners in order to promote their equal opportunities vis-à-vis their male counterparts.

In the mid-1980s numerous new galleries opened in New York, or, to be precise, in the spacious SoHo lofts with their cast-iron columns. For the first time, artists could select 'their' galleries; indeed, the galleries were competing for artists. Young artists were quickly given solo exhibitions in order to test their market acceptance. But they disappeared equally quickly if their sales did not achieve the expected turnover. Many galleries gave neither themselves nor their artists the time to consummate a joint development. 'I think most of us started out in this field because we had certain romantic notions about art and artists,' says Janelle Reiring. 'But once you're in, it's a practical world that has to work. It's business.' But, she adds, 'Stamina is one of the most important qualities – if you believe in an artist's work, you carry on.'[2]

In 1996 Metro Pictures moved to Chelsea. Matthew Marks had been the first to open a gallery there, in 1994, in a former automobile repair shop on 22nd Street; he was attracted by the Dia Center for the Arts, whose new exhibition rooms had been opened just a block away in 1988. Some other galleries, such as Pat Hearn, Annina Nosei and Paul Morris, rented premises in the immediate vicinity, but the epicentre of the art trade was still in SoHo, and Chelsea was a quiet neighbourhood. It was only when the SoHo pioneer Paula Cooper converted a building on 21st Street that Barbara Gladstone, together with Matthew Marks, who had already outgrown his first room, decided to buy an empty warehouse on West 24th Street.

**View of exhibition by
Mike Kelley, 1985**

View of exhibition by
Cindy Sherman, 1985

As they needed another partner, they asked Metro Pictures to join them. The three didn't need to wait long for a nickname: 'MGM' (Marks, Gladstone, Metro). On 1 February 1996 the new Metro Pictures gallery was opened with an exhibition by Louise Lawler.

Today, Chelsea has become Manhattan's centre for galleries dealing in contemporary art, and every Saturday it becomes a Mecca, attracting caravans of art lovers from all over the world.

UTA GROSENICK

1 From: Barbara Hess, 'Die Profis – Ein Interview mit Janelle Reiring (Metro Pictures)', in *Texte zur Kunst*, Vol. 44, Berlin, 2001
2 From: Laura de Coppet, Alan Jones, *The Art Dealers*, 1984

Galerie Peter Pakesch

YEAR OF FOUNDATION
1981
FOUNDER
Peter Pakesch
ADDRESS
1981–92 **6 Ballgasse, Vienna**
1986–93 **27 Ungargasse, Vienna**
CLOSED 1993

ARTISTS REPRESENTED
John Baldessari, Herbert Brandl, Gilbert Bretterbauer
Gunter Damisch, Joseph Danner, Günther Förg, Markus Geiger
Felix Gonzalez-Torres, Martin Kippenberger, Liz Larner
Hermann Nitsch, Markus Oehlen, Heinrich Pichler
Gerwald Rockenschaub, Mariella Simoni, Jan Vercruysse
Franz West, Otto Zitko, Heimo Zobernig

Peter Pakesch (right), Franz West and exhibition visitors

Ilya Kabakov,
The Targets, 1991

Vienna international. Before Peter Pakesch opened his gallery at 6 Ballgasse in May 1981, he had, after studying architecture for four years, first worked as an artist and freelance curator. Then, together with the Viennese Actionist Hermann Nitsch, he opened his own gallery. Painting was now at the forefront of the programme, painting mostly from Vienna, mostly in the then typical tension field between dilettantism and violent, but also apparently playful, Expressionism. Exhibitions by Herbert Brandl and Otto Zitko, for example, in the early 1980s were representative of this artistic trend. At an early stage, however, Peter Pakesch also exhibited the un-German German artists Martin Kippenberger, Albert and Markus Oehlen, as well as Werner Büttner – in spring 1983, for example, in the group exhibition 'Schwerter zu Zapfhähnen' (Swords into Beer-barrel Faucets).

Just a year later the American artist John Baldessari provided internationalism at a high level at the gallery. And for markedly more conceptual tones, there was Joseph Kosuth's 1985 debut. Sol LeWitt followed a year later. And yet Peter Pakesch was primarily concerned with 'open[ing] up Vienna to the world', in the sense that he should create a firm foothold beyond Austria's borders for current artistic positions in the city. To this end he formed a 'band of men' around him, who promptly did find an

international footing: Franz West, Gerwald Rockenschaub, Heimo Zobernig, Herbert Brandl, Joseph Danner and Gunter Damisch formed this group, successfully promoted by Peter Pakesch, and constantly exhibited in his rooms.

'The gallery owner is a broker and intermediary, he is an inventive interface, and he must not shy away from risk, if he wants to be good,' was Peter Pakesch's eloquent description of his own role. Time and again he sought cooperation with other galleries and institutions from the art network. In spring 1991, in a move that was strategically quite clever, he staged a 'magazine and publisher's presentation' of *Parkett*, probably the most important art magazine internationally. The opening of a second room at 27 Ungargasse in 1986 was, by contrast, one of the risks he took as a gallery owner. The artists whose works were exhibited there included Günther Förg in the winter of 1986, represented by photos and murals, Markus Geiger in the summer of 1987 with austerely geometric works, and Mike Kelley in the autumn of 1989 with a large post-punk installation. Felix Gonzalez-Torres's exhibition of posters piled on the floor and minimalist, yet at the same time highly poetic, strings of lights in late 1992 was doubtless one of the high points of Peter Pakesch's work on Ungargasse.

The gallery on Ballgasse, in which concurrent exhibitions were held, closed in August 1992. At the final show, Franz West exhibited a sofa in front of a television, showing videos by him – the gallery as a living room, as we were to see time and again in other places in the years to come. A year later Pakesch also terminated his work on Ungargasse. Heimo Zobernig was responsible for the final exhibition.

Peter Pakesch has not given up his connection with art. From 1996 to the summer of 2003 he was head of the Kunsthalle Basel, and now he is director of the Landesmuseum Joanneum in Graz, where he heads up the local public art gallery.

RAIMAR STANGE

Exhibition by Hermann Nitsch, 1981

Overleaf: Herbert Brandl /
Franz West, *Die Ernte des*
***Tantalos*, 1988**

Karsten Schubert Ltd.

YEAR OF FOUNDATION
1987

FOUNDERS
Karsten Schubert and Richard Salmon

ADDRESS
1987–93 **85 Charlotte Street, London**
1993–97 **41/42 Foley Street, London**

CLOSED 1997

ARTISTS REPRESENTED
**Glenn Brown, Matt Collishaw, Keith Coventry, Angus Fairhurst
Dan Flavin, Anya Gallaccio, Thomas Grünfeld, Georg Herold
Gary Hume, Michael Landy, Bob Law, Thomas Locher, Stephen Prina
Bridget Riley, Ed Ruscha, Rachel Whiteread, Alison Wilding, Victor Willing**

Martin Kippenberger, *Untitled (Rolling-Pin Curtain)*, 1991

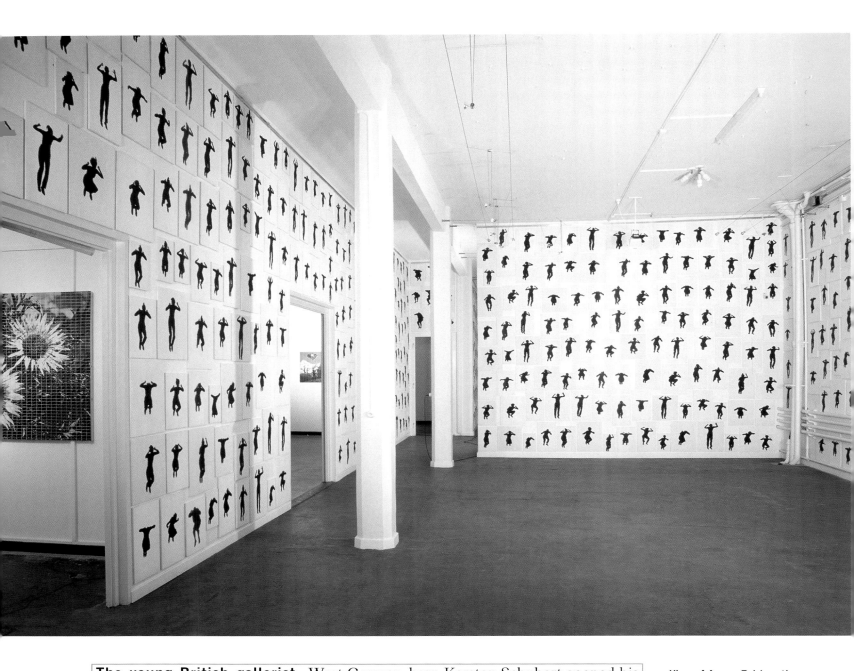

KARSTEN SCHUBERT LTD

The young British gallerist. West German-born Karsten Schubert opened his gallery in Charlotte Street, central London, in 1987 at the height of the 1980s boom. Having spent three years working at the Lisson Gallery – the gallery that defined British art in the 1980s with its stable of sculptors, including Anish Kapoor, Richard Deacon and Richard Wentworth – he wanted to open up debate in a scene overwhelmingly dominated by the Lisson 'school'. At the same time, with a backer in place prepared to bankroll the gallery's running costs, he hoped to take advantage of the opportunities offered by a flourishing and unprecedentedly powerful art market.

Initially, Schubert concentrated on introducing artists from Cologne such as Thomas Locher, Thomas Grunfeld and Georg Herold as well as West Coast artists like Ed Ruscha, John Baldessari and Stephen Prina, with only two British artists on his books: sculptor Alison Wilding and the older painter Bob Law. At this time, however, a new generation of British artists was emerging, nurtured by the progressive and pro-active environment of Goldsmiths College of Art. These artists were

View of Angus Fairhurst's installation *Woman Abandoned by Space*, 1990

ambitious, determined and equipped with an entrepreneurial spirit and a desire to thwart the system, both qualities engendered by Margaret Thatcher's well-entrenched Tory government.

Their figurehead was Damien Hirst, who in 1988 organized 'Freeze', the first in a series of self-run exhibitions held in Docklands in the east of London, featuring work by Hirst and his fellow students including Gary Hume, Michael Landy, Abigail Lane, Sarah Lucas and Angus Fairhurst. Rather than waiting to be invited into the commercial gallery system, they created their own opportunities. As Schubert put it, '[they] were not willing to play the game, they wanted to change the rules and take the initiative…suddenly these artists were forcing the agenda.'

Schubert was quick to respond to this new show of talent and, in November 1988, opened a group exhibition of Ian Davenport, Gary Hume and Michael Landy. Over

the next few years he scooped up the lion's share of the new generation, giving solo shows to both Hume and Landy as well as Angus Fairhurst, Mat Collishaw, Abigail Lane and Anya Gallaccio. Hume's 1989 exhibition of 'door' paintings scaled to the life size of institutional hospital-style doors, and featuring high-gloss surfaces painted with household paint, displayed the interest in minimalist aesthetics and the knowing nod to Duchampian ready-mades that was common to many artists of his generation.

The artist set to become the star of Schubert's stable was not one of the Goldsmiths gang, however, although she did belong to the same generation. Rachel Whiteread graduated from the Slade School of Fine Arts in 1987, and her casts of the negative space around domestic items, which Schubert first exhibited in 1990, shared many of the conceptual and formal concerns of Hirst and his colleagues. In her 1993 master-piece *House*, she created a concrete mould of the inside of a whole three-storey house in London's East End, spurring a nationwide debate. It was eventually demolished but nevertheless helped Whiteread win the prestigious Turner Prize and go on to receive widespread international acclaim.

Above, left: Opening of the group exhibition 'Denkpause', 1987. On the stairs: Karsten Schubert (sitting) and the London gallerist Maureen Paley

Above, right: Opening of the Rodrigo Moynihan exhibition 'Drawings 1934–1985', 1988. In the picture: Lady Helen Taylor, Karsten Schubert and Richard Salmon

The controversy and media attention generated by the Young British Artists had a lasting effect on the general public's previously sceptical approach to contemporary art. 'What we have witnessed in London over the last four years', said Schubert in a 1994 interview, 'is the emergence of a new art scene…it is no longer the old guard only. It is new people [who] have been successful because they have not been encumbered by their own history.' In 1991 Schubert co-published *Technique Anglaise: Current Trends in British Art*, a book that helped to define the movement, featuring works by twenty-six artists and a discussion about their genesis. The one artist Schubert failed to work with, however, was the group's ringleader, Damien Hirst: '…already at that point he was making very, very big demands…. There was just no room for anyone else with Damien. This needed full attention.'

While the reputations of the Young British Artists boomed, the market had peaked and crashed, and the economy in London was struggling. Schubert continued to expand the historical and geographical breadth of his programme, exhibiting work by Piero Manzoni, Hanne Darboven and Martin Kippenberger. In 1992 he had his first exhibition with seminal 1960s Op Art painter Bridget Riley, who was to become increasingly central in Schubert's gallery. Gradually over the next few years, however, his relationships with some of the younger artists he had helped to launch began to founder. Their reputation for hard drinking and partying was well deserved, and late nights in one or another of Soho's after-hours drinking spots were an essential part of their working process. This was not Schubert's style. 'It became intensely social,' he said. 'I think there is something wonderful about it…but…it also becomes incredibly tiring. I just couldn't do it.' Fairhurst branded him 'the wrong man at the right time' and left the gallery, as did Hume. When Whiteread left for Anthony d'Offay in 1997, it proved the final straw for Schubert, who had by now fallen out with his backer and was faced with spiralling debts. He closed down the business on the same day that her defection was announced. His involvement in contemporary art continued but from a back seat, working with Bridget Riley and British sculptor Alison Wilding, but now without a gallery or a public profile, just a small office in Piccadilly.

KIRSTY BELL

Exterior view of the gallery, with
the installation 'Closing Down Sale'
by Michael Landy, 1992

From the Fall of the Berlin Wall to Global Players

The 1990s

Exterior view of The Modern Institute in Glasgow, with Jim Lambie's 'Carnival Strip Club' exhibition, 1998

In 1989 the Berlin Wall finally fell, and with it one of the last bastions of real-existing socialism departed the stage of world history in a manner as surprising as it was pleasantly peaceful. Ten years later the World Economic Summit in Seattle was disrupted by furious, no longer peaceful demonstrations. Between the two events lay a relaxing decade, its beginning marked by a mood of optimistic new beginnings and radical change. Unfortunately, however, this quickly proved to be a delusion. The disappearance of communism, which had been the free-market economy's competition, may have unexpectedly made a process of democratization possible, opened new markets, and provided seemingly boundless production possibilities. Nonetheless, the unaccustomed freedoms soon proved to be less than beneficial for many, and it was primarily international corporations, so-called 'global players', who took advantage of the new situation to optimize their own profits through a policy of operating world-wide. By the end of the decade, 'globalization' was the new buzzword, welcomed by some as a liberal world community, but damned by others as brutal neoliberalism.

But let us start with the optimistic beginning of the new decade: besides the radical political changes outlined, drastic social change was characterized above all by technological change. The most important of these was progress in the automation of industrial production, and the triumph of intelligent (communication) technologies. The keywords were computers, the Internet and mobile phones. In First-World countries at least, these turned 'producing' societies, meaning societies owing their prosperity primarily to the production of goods, into service societies, which instead of production placed their emphasis on the organization and distribution of information, services and planning.[1] This succeeded all the more because those parts of production no longer profitable to automate could be outsourced, thanks to improving globalization, to Second- and Third-World countries. For the powerful industrial nations a degree of prosperity began that had not previously been thought possible, and in Germany and elsewhere people soon began to talk of a culture of luxury and pleasure.

Art anticipated and reflected this development very precisely. On the one hand, it used the new feeling of freedom to dismantle boundaries, particularly between art and 'real life'. The 'crossover' phenomenon – in which art mixed itself with popular culture, science or design, for example – set the tone, although it was a tone that tended to focus on the pleasure-orientated side of life. In this context, artists such as the painter of pop icons Elizabeth Peyton, the trained natural scientist Carsten Höller, or the design and architecture strategist Jorge Pardo must be mentioned. On the other hand, art organized itself in accordance with the service society's structures, often with less classical production of work, and more of a process and event orientation. Thus Rirkrit Tiravanija cooked for visitors to his exhibition, Angela Bulloch asked art lovers to play through different systems of rules, such as those of bungee jumping, and Tobias Rehberger had his works created cooperatively in a complex arrangement of various stages and by several collaborators.

The decade's more advanced galleries also made use of the opportunities in the new global order. Berlin's neugerriemschneider, Galleri Nicolai Wallner in

Installation by Julia Scher in
the group exhibition 'Mapping:
A Response to MoMA' at
American Fine Arts Co., 1995

Copenhagen, and Schipper & Krome, which had relocated from Cologne to Berlin, for example, increasingly stressed the aspect of networking between their artists, and (medial) information about them. They now saw themselves as participating service stations, and sales were only a secondary concern. Artists and gallerists tended to become equal partners who cooperated with one another on all artistic and commercial levels.

The hedonistic qualities of the 1990s were placed centre stage by New York galleries such as Gavin Brown's enterprise and Deitch Projects, and the Cologne gallery Daniel Buchholz, among others. For instance, they tried repeatedly to connect art and popular culture. Gavin Brown's enterprise set up a bar of its own especially for this purpose.

Ultimately, the optimistic openness that particularly characterized the mood in the early 1990s was expressed in the project-orientated aesthetic presented successfully in galleries such as Regen Projects in Los Angeles, the Modern Institute in Glasgow, or Air de Paris in the French capital. Successful because even this art must be and is ultimately sold.

Logically these sales then took place at institutions and collections in the entire (Western) world. In extreme cases, this type of truly globalized sales strategy certainly does take on some neoliberal, corporation-like characteristics. The Zurich gallery Hauser & Wirth stands on the front line here. This gallery has powerful presences, not only in Switzerland, but in New York and London as well. Many of the most lucrative artists are in their programme, which is then also less content-orientated than it is market-focused.

Art dealt with the negative sides of the New World (dis)order in 1997 at Cathérine David's 'documenta X'. In that major exhibition in Kassel, the French curator dealt with subjects such as 'globalization of the market' under the 'supremacy of the USA', the accompanying 'crises of social nation-states' and 'the uncertain future of the former USSR, China and a large portion of the Arab and Muslim countries'.[2] At 'documenta X' it was precisely those themes under aesthetical discussion, among others, that were politically relevant at the end of the 1990s.

RAIMAR STANGE

1 The system theorist Dirk Baecker
 quotes the American economist
 Robert B. Reich in his essay
 collection *Postheroisches Management*
 (Berlin, 1994), 'that the work of the
 most consequence today lies not
 in the production of things, but in
 the manipulations of symbols –
 data, words, oral and visual
 representations',
 pp. 85–86
2 All quotations from: *documenta X
 Kurzführer*, Stuttgart, 1997,
 foreword by Cathérine David, p. 9

Air de Paris

YEAR OF FOUNDATION
1990
FOUNDERS
Florence Bonnefous and Edouard Merino
ADDRESS
1990–94 **18 Rue Barillerie, Nice**
SINCE 1994 **32 Rue Louise Weiss, Paris**

ARTISTS REPRESENTED
**Annlee, Olaf Breuning, François Curlet, Stéphane Dafflon, Plamen Dejanoff
Brice Dellsperger, Trisha Donnelly, Liam Gillick, Joseph Grigely
Swetlana Heger, Carsten Höller, Pierre Joseph, Paul McCarthy
Sarah Morris, Petra Mrzyk & Jean-François Moriceau, Philippe Parreno
Rob Pruitt, Navin Rawanchaikul, Torbjørn Rødland
Bruno Serralongue, Shimabuku, Lily van der Stokker
Inez van Lamsweerde & Vinoodh Matadin
Jean-Luc Verna, Annika von Hausswolff**

'1972', group exhibition with works by Liam Gillick, Philippe Parreno, Carsten Höller and Pierre Joseph, 1972

The paradisiacal studios. In 2000 Olivier Zahm came to the conclusion in the style supplement of *Libération* that the gallery of Edouard Merino and Florence Bonnefous was 'one of the few that couldn't care less about success, and that doesn't barricade itself in a "White Cube" behind the typical behaviour of dealers'. Furthermore, as Florence Bonnefous confesses, 'I didn't actually decide consciously to be a gallerist, it just turned out that way.'

Air de Paris, which opened in June 1990 in a tiny main street in the old part of Nice, shortly after the crisis on the art market had begun, has every appearance of success today. It owes the whole adventure to the bold plan of two students from the art school Le Magasin in Grenoble, who met five art students from the École des Beaux-Arts: Dominique Gonzalez-Foerster, Bernard Joisten, Pierre Joseph, Philippe Parreno and Philippe Perrin. Edouard, the son of Monegasque collectors, loved strong sensory impressions and was always hunting for poetry: naturally in art, but also, for example, in the mysteries of the universe (he collects meteorites). Florence Bonnefous, on the other hand, was an artist who had studied applied art and psychology in Strasbourg, where she had already organized small exhibitions in her studio's display window, which faced the street.

The two major directions in the gallery's programme can be explained by these two strong and starkly contrasting personalities. Their great strength lies in never having conformed to one another.

Tattoo on the back
of Jean-Luc Verna

Edouard organized 'Projects for UFO', an event in which work by Guglielmo Achille Cavellini and Carsten Höller was shown on the roof of a building in Monaco. Since the gallery's opening in Paris in Rue Louise Weiss, 'Silver Space' has also been on show, a true curiosity cabinet of modern times, which has included such things as a Philippine stick from the 18th century, a device for the artificial insemination of turkeys, and a portrait of Rimbaud at seventeen. Other exhibitions have also been shown there, such as the utterly fantastic robots of Yves Amu Klein – the son of Yves Klein – and a 'rehabilitation' of works by the eccentric Italian artist Guglielmo Achille Cavellini.

The 'Tattoo Show', on the other hand, which was organized together with Gilles Dusein from the photo gallery Urbi et Orbi, was Florence's idea. Originally – in 1992 in Paris – it contained about thirty tattoo designs by artists; the project was subsequently enlarged with several dozen suggestions, which were later shown by Daniel Buchholz in Cologne and Andrea Rosen in New York. Of course it was Florence who travelled to Chiapas with Bruno Serralongue for a meeting with Subcommander Marcos, and Florence also planned the Paris exhibition of 'trash painting' in Monica Majoli's uro style.

The preference shared by Edouard Merino and Florence Bonnefous for fiction or, to be more precise, for film scripts induced them to establish a link to cinematic films right at the beginning of their cooperation. The curator and critic Eric Troncy, who, like Nicolas Bourriaud, has assiduously accompanied the gallery right from the time of its establishment, has spoken about this: 'The Air de Paris gallery began life with a brilliant idea. The artists Philippe Parreno, Pierre Joseph and Philippe Perrin conceived *Les Ateliers du Paradise* (Paradisiacal Studio), which consisted of them living in the gallery for one month, and furnishing their living

space with works of contemporary art. The atmosphere was playful, and the thought of integrating artwork into daily life and no longer admiring it as something sacred and untouchable was truly new. For me *Les Ateliers du Paradise* has real historical value.'

The opening exhibition of *Les Ateliers du Paradise*, set up as a 'film in real time', set the tone for the entire run: slaloming between a bodybuilding bench and a video game console, visitors could reach a *Big Nude* by Helmut Newton and an armchair by Ron Arad, while the artists went about their pursuits accompanied by film music from *The Big Blue*, or songs by the Sex Pistols.

This aloof relationship to cinema can also be seen in the films later produced by the gallery: *La Nuit des Héros* by Philippe Parreno and *Pinocchio Pipenose Householddilemma* by Paul McCarthy, or the surprising remakes by Brice Dellsperger. It can also be seen in their definite preference for 'set decor' by Sarah Morris and Lily van der Stokker.

Just as intensively as they participate in the creative processes of the artists with whom they cooperate, Edouard and Florence have also put Robert Filliou's motto into practice for themselves: 'Art is that which makes life more interesting than art.'

Eva & Adele in front of *Fernando, love graffiti* by André (for the birthday of Fernando Mesta, apprentice at Air de Paris)

In accordance with this motto, a group of artists (Olaf Breuning, Liam Gillick, Inez Van Lamsweerde and Jean-Luc Verna must be added to those already mentioned) have laid out the landscape of a very unusual gallery.

While Edouard and Florence have not (yet) realized their dream of a nomadic gallery, they do simultaneously run an Internet site that is a particularly attractive virtual space. With Eric Troncy's comical columns 'The ambassador's chocolates (our friends don't like e-sweets)', and the 'enological' tastings by their former assistant and now wine specialist Linda Grabe, it is far more than a mere gallery website. The two friends don't find this at all astonishing, but insist that they are 'permanently trying everything to fill the little enterprise with joy'.

STEPHANE CORRÉARD (WITH LILI LAXENAIRE)

View of an installation included in the group exhibition 'La Table', 1999

Gavin Brown's enterprise

YEAR OF FOUNDATION
1993
FOUNDER
Gavin Brown
ADDRESS
1994–97 **558 Broome Street, New York**
1997–2004 **436 West 15th Street, New York**
SINCE 2004 **620 Greenwich Street, New York**
SINCE 2004 **Project Space 'Gavin Brown's enterprise at Passerby'**

ARTISTS REPRESENTED
**Franz Ackermann, James Angus, Dirk Bell, Martin Creed
Verne Dawson, Peter Doig, Urs Fischer, Dara Friedman
Mark Handforth, Udomsak Krisanamis, Mark Leckey
Aleksandra Mir, Victoria Morton, Chris Ofili, Laura Owens
Oliver Payne & Nick Relph, Elizabeth Peyton, Steven Pippin
Rob Pruitt, Katja Strunz, Spencer Sweeney
Rirkrit Tiravanija, Piotr Uklański**

Portrait of Gavin Brown, photo by Nick Relph, 2003

Welcome to the club. This former shopfront lay almost hidden in Broome Street. Somewhat out of the way in downtown New York, one certainly doesn't expect a gallery here, not to mention a dance club. Nonetheless, a colourfully blinking, strictly geometric dance floor, which Piotr Uklański installed in both the showroom and the office in the summer of 1996, can be seen through the glass of the display window. The work, *Untitled (Disco Floor)* (1996), by the Polish-born artist seems like a cross between the classic dance film *Saturday Night Fever* and the minimalism of Carl Andre. If you enter the gallery of Gavin Brown's enterprise – for that is what this is – then you will also hear current, very danceable music, by the likes of British group Pulp, for example.

The surprising combination of glamour and banality, of high and low, has been an essential characteristic of Gavin Brown's enterprise all along. Even the name, with its striking 'enterprise', suits this aesthetic, and was intended as an allusion to the well-known American car rental agency Enterprise Car Rental. Gavin Brown, a former

Exterior view of the gallery in Greenwich Street

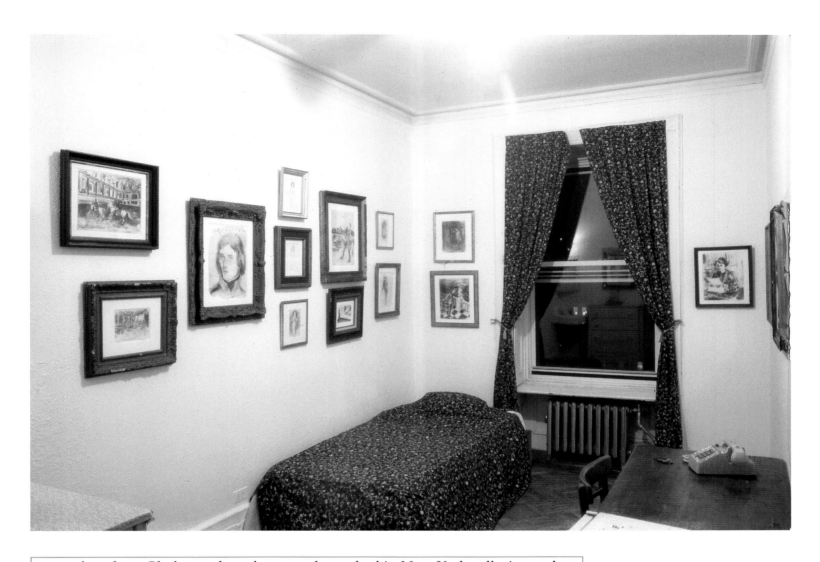

art student from Chelsea, who subsequently worked in New York galleries such as Brooke Alexander, Pat Hearn and 303, sees art as a type of yearning intensification of everyday life, which is always rooted in various modes of operation. Thus Elizabeth Peyton and Mark Leckey, who were first shown here, as well as Piotr Uklański simultaneously play with props from popular culture and art history, Rirkrit Tiravanija experiments with the communicative association of cooking and art, and Steven Pippin brings (antiquated) photography and TV technology into art's current system. Gavin Brown opened his own gallery space with a show by Steven Pippin. In April 1994 the young Brit turned the entire exhibition space into a camera, which was simultaneously a darkroom as well as the picture developed within it.

Gavin Brown had founded his gallery a year earlier, in 1993. At that time he had curated a number of exhibitions for his 'un-gallery' at various locations that were unrelated to art – in a small office in Manhattan, for example, where he arranged the group exhibition 'Insignificant' with artists who were still unknown, such as Daniel Oates, Andrea Zittel and Rirkrit Tiravanija. He also showed works by the Post-Pop painter Elizabeth Peyton in a room in the legendary Chelsea Hotel. Small-format portraits ranging from Princess Diana to Marcel Proust could be admired there. 'Here, art becomes as thrilling as a good TV programme,' the on-the-

go gallerist (who can be charming as well as occasionally abrasive) enthused to the fashion magazine *Vogue*.

Three years later the gallery moved to West 15th Street, following the general gallery migration from SoHo to Chelsea. In 1998 Gavin Brown opened his bar 'Passerby'; his wife, the designer Lucy Barnes, operates a boutique right next door. In many ways 'Passerby' is typical of Gavin Brown's work, which is more than just pure gallery work after all. The bar was designed in the best team spirit by outstanding individuals: Piotr Uklański did the dance floor, the long bench comes from Mark Handforth, and James Angus designed the bar. This bar is a place for creative people of all types to meet and communicate. You are just as likely to see models like Kate Moss there as musicians such as Moby, or the performance group Fischerspooner. But artists who are not represented by Gavin Brown, such as Cecily Brown and John Currin, can also regularly be found in this 'clubhouse', as Elizabeth Peyton calls it.

In 2004 Gavin Brown's enterprise moved to TriBeCa's Greenwich Street. Exhibitions naturally still take place in the gallery, with artists such as Franz Ackermann, Rob Pruitt and Aleksandra Mir. Piotr Uklański, meanwhile, with his gallerist's support, has been working for some years on his first full-length feature film, which he himself declares to be 'the first Polish Western'.

RAIMAR STANGE

Laura Owens
exhibition, 2004

Dance floor by Piotr Uklański
in the 'Passerby' bar in
West 15th Street, New York

Deitch Projects

YEAR OF FOUNDATION
1996
FOUNDER
Jeffrey Deitch
ADDRESS
76 Grand Street, New York

ARTISTS REPRESENTED

Haluk Akakce, Vanessa Beecroft, Philippe Bradshaw
Ingrid Calame, Maggie Cardelus, Nicola Costantino
Fischerspooner, Johan Grimonprez, Keith Haring
Noritoshi Hirakawa, Chris Johanson, Brad Kahlhamer
Kurt Kauper, Martin Kersels, Margaret Kilgallen
Bodys Isek Kingelez, Jeff Koons, Liza Lou, Barry McGee
Mariko Mori, Tim Noble & Sue Webster, Ravinder Reddy
Yehudit Sasportas, Koji Shimizu, Momoyo Torimitsu
Wang Du, Nari Ward, Su-En Wong Chen Zhen

Jeffrey Deitch in his office, 2004

'Every time I drive by an empty space, I want to open a gallery there.'[1] Jeffrey Deitch has been active in the art business since 1972 when, at the age of nineteen and while in the Berkshires, in Massachusetts, where he spent the summer holiday with his parents, he opened an improvised gallery in a hotel lobby because he liked the work of some local artists so much. He sold almost the complete exhibition, and when he returned to college he changed his major from economics to art history.

After finishing school he went straight to New York, marched into the Leo Castelli Gallery and enquired about a job. When he was rejected there, he signed on with the John Weber Gallery. By the time he was thirty-five in 1988, when Deitch established himself as an art dealer and consultant, he already had a number of strings to his bow. He was a performance artist himself and had organized events with Andy Warhol, Laurie Anderson and Vito Acconci in a deserted hall in TriBeCa. He had also completed his degree at the Harvard Business School, curated well-regarded exhibitions such as 'PostHuman' and, last but not least, had co-founded and managed the Art Advisory Department at Citibank.

He proved that this tempo could be increased further by founding his gallery Deitch Projects in 1996, which specialized in producing ambitious projects with contemporary artists. The gallery presented eighty-six individual exhibitions and

Opposite: Exterior view of the gallery, with the exhibition 'I LOVE YOU' by Tim Noble and Sue Webster, 2000

Below: *Piano Americano*, performance by Vanessa Beecroft, 1996

Left and Opposite:
The Garden by Paul McCarthy
(1991–92), installed in the
project room of Deitch Projects,
18 Wooster Street, 2001

projects, eight thematic exhibitions, and numerous public events between January 1996 – when it opened with a performance by Vanessa Beecroft – and mid-2002.

The best-known of these exhibitions include 'Shopping' (1996), with installations by twenty-six artists in twenty-six SoHo shops, *I Bite America and America Bites Me*, the notorious performance in which Russian artist Oleg Kulik lived as a dog in the gallery rooms for two weeks (1997), and *Street Market 2000*, a cooperative piece by Barry McGee, Todd James and Steve Powers, which showed an apocalyptic vision of an urban street.

Jeffrey Deitch has an unerring intuition for time and place. He discovers empty rooms for new activities again and again. When the first alternative galleries opened on the other shore of the East River in Williamsburg/Brooklyn in 2001, Deitch rented

an old warehouse there as a subsidiary office. Subsequently, several dozen galleries opened in Williamsburg, long after Deitch's branch office had closed its doors. One of the first exhibitions about the terrorist attacks on 11 September took place in the warehouse in December 2001. Numerous young artists simply got the chance to express their feelings in a work created on location.

The gallery seeks to examine new points of intersection between art, fashion, music and performance. In September 2002 it supported the production of the New York Fashion Week's *Imitation of Christ*, and showed a fashion–sculpture–perform-ance installation with As FOUR, one of the most influential new design groups. In November 2002 Deitch Projects organized a series of exhibitions and performances on the theme of hip-hop's origins in the Bronx in the late 1970s. In December 2002

Deitch Projects brought the gigantic skateboard bowl 'Free Basin' to New York, and presented skateboarding demonstrations together with a programme of new art and music that has come out of the skater subculture.

According to Jeffrey Deitch, '...if you show innovative and important art, the market will also finds its way to it'.[2] This by no means guarantees that Deitch will always get his money back from his investments. The Electro Pop with song-and-dance act (2002) by Fischerspooner cost him about US$300,000. To cover the costs, photographs and a film were put on sale. A limited edition DVD of Fischerspooner's film *Sweetness*, based on earlier performances, can be bought for US$200,000. Warren Fischer plays the DJ, orchestrating lighting effects with drifts of smoke and silvery streaming cascades, and Casey Spooner heads a group of dancers who relate a kind of *Star Wars* meets Ziggy Stardust story. The intention, by Fischerspooner just as much as by Deitch, is to restore the illusion of glamour and popular culture.

UTA GROSENICK

Opposite: Tim Noble & Sue Webster, *Cheap and Nasty*, 2000

Below: Cindy and Lizzy of Fischerspooner in the performance *Sweetness*, 2002

1 Charlie Finch, 'The Greatest Showman in Art', in *artnet.com – magazine*, undated
2 Alex Needham, Fischerspooner NYC at Deitch Projects, in *NME*, 28 May 2002

Galería Fortes Vilaça

YEAR OF FOUNDATION
1992/2000
FOUNDERS
Màrcia Fortes and Alessandra Vilaça (now Ragazzo D'Aloia)
ADDRESS
1500 Rua Fradique Coutinho, São Paulo

ARTISTS REPRESENTED
Franz Ackermann, Efrain Almeida, John Bock
Tiago Carneiro da Cunha, Leda Catunda, Saint Clair Cemin
José Damasceno, Mauricío Dias & Walter Riedweg
Iran Do Espírito Santo, Chelpa Ferro, Gil Heitor Cortesão
José Antonio Hernández-Diez, Alejandra Icaza, Los Carpinteros
Fabián Marcaccio, Lia Menna Barreto, Beatriz Milhazes, Vik Muniz
Ernesto Neto, Rivane Neuenschwander, Hélio Oiticica, Mauro Piva
Nuno Ramos, Rosângela Rennó, Julie Roberts, Julião Sarmento
Courtney Smith, Valeska Soares, Janaina Tschäpe
Meyer Vaisman, Adriana Varejão, Luiz Zerbini

Màrcia Fortes and Alessandra Ragazzo D'Aloia, 2004

Brazilian art on the rise. In 1992 in the traditional artist's quarter, Vila Madalena in São Paulo, Marcantônio Vilaça and Karla Camargo opened a gallery called Camargo Vilaça, which very quickly became known beyond the borders of Brazil. This was due not only to Marcantônio Vilaça's dedication, charisma and trained eye, but also to his gallery's intense participation in eight to ten international art fairs per year. As a result, more than two thirds of the work was sold abroad.

The gallery was restructured after Vilaça's death in January 2000, and in the summer of 2001 the Galería Fortes Vilaça was opened under the management of Màrcia Fortes and Alessandra Vilaça (now known as Alessandra Ragazzo D'Aloia), the former directors of the original gallery. Instead of over forty artists, only about thirty are now represented, of whom twenty-one are of Brazilian origin in order to demonstrate throughout the world the vitality and quality of contemporary art in Brazil. Such well-known artists as Saint Clair Cemin and Ernesto Neto, or Hélio Oiticica, who died in 1980 and was rediscovered at 'documenta X', are mixed with Brazilian shooting stars such as Rivane Neuenschwander and Vik Muniz, as well as young artists who are not very well known. The programme is complemented by other Latin American and a few European artists (such as Franz Ackermann, John Bock and Julie Roberts) in order to raise awareness of them in Brazil.

The new gallery, explains Màrcia Fortes, intends to remain internationally present, and to strengthen its ambitions on the local market, whereby she hopes for

Rivane Neuenschwander,
view of the installation
I Wish your Wish, 2003

1 Daniel Horch, Brazil Collects,
Art & Auction, November 2001

increasing sales figures in Brazil over the coming years.[1] The gallery has two show-rooms, one on the ground floor and one on the mezzanine level, each of which usually contains a different solo exhibition, with nine different shows in each showroom per season. Once a year an independent curator is invited to organize a group exhibition at the gallery.

UTA GROSENICK

Exterior view of the gallery, with the exhibition 'Momentos – Frames, Cosmococa I' featuring works by Hélio Oiticica and Neville d'Almeida, 2003

Galerie Hauser & Wirth

YEAR OF FOUNDATION

1991

FOUNDERS

Ursula Hauser and Iwan Wirth

ADDRESS

1991–94 **84 Sonneggstraße, Zurich**

1994–96 **1927 Hardturmstraße, Zurich**

SINCE 1996 **270 Limmatstraße, Zurich**

SINCE 2003 **196A Piccadilly, London**

ARTISTS REPRESENTED

Louise Bourgeois, David Claerbout, Dan Graham, Rodney Graham, David Hammons, Mary Heilmann
Eva Hesse (estate), Richard Jackson, On Kawara, Rachel Khedoori, Guillermo Kuitca, Maria Lassnig
Paul McCarthy, John McCracken, Raymond Pettibon, Jason Rhoades, Pipilotti Rist, Anri Sala, Wilhelm Sasnal
Christoph Schlingensief, Roman Signer, Tony Smith, Diana Thater, André Thomkins

1998–2003 **Hauser & Wirth & Presenhuber**
(managed by Eva Presenhuber)
270 Limmatstraße, Zurich

SINCE 1999 **Galerie Zwirner & Wirth**
(founded by David Zwirner and Iwan Wirth)
32 East 69th Street, New York

ARTISTS REPRESENTED

Bernd & Hilla Becher, Dan Flavin, Donald Judd, On Kawara, Martin Kippenberger, Sol LeWitt
Gordon Matta-Clark, John McCracken, Bruce Nauman, Sigmar Polke, Gerhard Richter, Thomas Ruff, Richard Serra

Opening of the Jason Rhoades exhibition 'Flatworks from perfect world', 2000. In the photograph: Iwan Wirth and Bice Curiger

The mogul. Hardly any other gallery has as many big names on its list of artists as the Galerie Hauser & Wirth. That this collection of renowned art-world stars by no means automatically produces an interesting programme, however, can unfortunately be seen very clearly in the work of this gallery, which was founded in Zurich by Iwan Wirth and his wealthy mother-in-law Ursula Hauser. The basic facts about the gallery can be related quickly. It opened in 1991 with work from its own collection. In 1996 the gallery moved to its present space in Zurich's Limmatstraße, where the first exhibition was 'Painting in Germany'. In 1998 the gallery Hauser & Wirth & Presenhuber was founded in collaboration with the Viennese gallerist Eva Presenhuber, who concentrated more on contemporary 'young' art. In 1999 the gallery opened its own museum in St Gallen. In the same year the Galerie Zwirner & Wirth was founded in New York by David Zwirner and Iwan Wirth to specialize in the 'secondary market', and thus as an art dealer for works by financially very lucrative artists such as Bruce Nauman and Gerhard Richter. This simple list alone makes it clear that Hauser & Wirth and its 'boss', Iwan Wirth, are interested in market-penetrating influence. Indeed, the nickname 'Ivan the Powerful'[1] has been circulating in some parts of the art scene.

At the young age of sixteen, Iwan Wirth had already operated a little gallery in Oberuzwil, Switzerland. Today, in his large Galerie Hauser & Wirth, he can afford to exhibit established and expensive artists such as Louise Bourgeois, Diana Thater, Jason Rhoades, Blinky Palermo and Raymond Pettibon in one year. These names, presented in 2000 in exactly this sequence, make the heart of every art lover beat faster – and yet, as stated, from a programmatic point of view this series does not actually make sense. Expressive sculptures and conceptual video work, overwhelming installations and minimal productions, aggressive comics and sensitive drawings: these

View of the building complex in which the gallery is located in Zurich

Louise Bourgeois, exhibition with
marble sculptures, 2002

433

Exterior and interior views
of the gallery building, a former
private bank, in London

Iwan Wirth and Pipilotti Rist

all come together in an almost arbitrary sequence in the building on Limmatstraße – which, by the way, also houses the Kunsthalle Zurich, the Migros museum and a number of other galleries.

The Galerie Hauser & Wirth, with its policy of expansively representing leading artistic positions both worldwide (a further office was opened in London in October 2003) and across artistic generations, is a typical Postmodern gallery, which is making clever use of the laws of neoliberal globalization. Significantly, Iwan Wirth describes artistic work as follows: 'For companies, art can help build image. The artist stands for innovation, creativity and openness. Art is the perfect projection surface there! This cannot hurt art, however. The more people who are interested in art the better! I am an absolute opponent of an elitist notion of art. The middle-class intellectual's elitist view of the world does not please me at all.'[2] Art therefore is asserted honestly and naively to be a hierarchy-free, but nonetheless image-promoting zone, which is open to every projection and can be understood by anybody. Concepts such as 'creativity' and 'innovation', which are also central to the so-called 'New Economy', logically take the place of 'criticism' and 'education' for Iwan Wirth.

RAIMAR STANGE

1 Quoted from: *Bilanz*,
 1 June 2002, Zurich, p. 164
2 *Basler Zeitung*,
 14 September 2002, p. 3

Tomio Koyama Gallery

YEAR OF FOUNDATION
1996

FOUNDER
Tomio Koyama

ADDRESS
1996–2003 **Saga 1-8-13-2F Koto-ku, Tokyo**
SINCE 2003 **1-31-6-1F Chuo-ku, Tokyo**

ARTISTS REPRESENTED
Dan Asher, Gianni Caravaggio, Jeremy Dickinson, Jeanne Dunning
Sam Durant, Tom Friedman, Atsushi Fukui, Rieko Hidaka, Satoshi Hirose
Tamami Hitsuda, Dennis Hollingsworth, Mika Kato, Joachim Koester
Makiko Kudo, Masahiko Kuwahara, Sharon Lockhart, Paul McCarthy
Shintaro Miyake, Mr., Takashi Murakami, Yoshitomo Nara, Tam Ochiai
Jonathan Pylypchuk, Tom Sachs, Yoshie Sakai, Hiroshi Sugito, Atsuko Tanaka
Vibeke Tandberg, Richard Tuttle, John Wesley, Bruce Yonemoto

View of Yoshitomo Nara's *Quiet Quiet* installation, 1999

Emotional Site, performance by Shintaro Miyake, 2002, last exhibition in the former rice market, the Shokuryo Building, before its demolition

Japanese artists for Europe. For approximately three years now, Tokyo's shopping and art quarter, Ginza, has no longer been the magnet for contemporary art enthusiasts that it once was. Outside of Ginza, where the rents are lower and the audience younger and hipper, leading galleries catering for this audience have created little art centres. In this era of restructuring, in which constant rethinking and reorganization is demanded, the Japanese are more mobile than ever before, and the art galleries too.

Over the past months many of the big players in the Tokyo art market have packed up their belongings and abandoned rooms that they have been renting for many years. The pinnacle was reached when four of the most important art dealers settled in the now stylish Shinkawa quarter in January 2003 and threw an opening party together. Shinkawa, on the Sumida river, was a shipping centre between the 17th and 19th centuries, and there are still innumerable wholesalers and warehouses there today. Through painstaking renovations, developers are trying to turn the district into a cool 'Tokyo waterfront' area, and the warehouses have been replaced by

438

office complexes, blocks of flats, cafés and restaurants. The Tomio Koyama Gallery, Shugoarts and the Taka Ishii Gallery have all moved to a fifty-year-old former warehouse. The Koyanagi Gallery also established a showroom there, but still kept its posh space in Ginza. The opening was the best-attended, liveliest and most trend-setting event on Tokyo's art scene for years. Artists, dealers, curators, museum directors, journalists, collectors, art students and fans stood side by side in the freshly renovated rooms with high ceilings.

The dealer Tomio Koyama is known in Europe and the United States for his vigorous efforts on behalf of Japanese Pop artists such as Takashi Murakami, Tatsuo Miyajima, Chiezo Taro and Yoshitomo Nara, and he also shows Western artists in Japan, including Tom Friedman and Dennis Hollingsworth. His gallery is on the ground floor, close to the entrance. Among other things, the opening exhibition displayed a new picture by Takashi Murakami, photographs by Vibeke Tandberg and

Overleaf: Takashi Murakami, *Back Beat – Super Flat*, 1999

oil paintings by Dennis Hollingsworth. Before the move, Koyama's space had been on the second floor of the Shokuryo Building in Saga-cho, a building with a courtyard and European-style architecture, which had been built in 1927 for the rice market and was Tokyo's most popular building for galleries. Tokyo's first alternative space, the Saga-cho Exhibit Space, was there for seventeen years, although it had to close in 2000 due to lack of sponsors. Koyama and a colleague, the young dealer Taro Nasu, had operated their galleries there since 1996 and 1998 respectively, and the Rice Gallery was also located there, a showroom founded cooperatively by the Koyanagi Gallery and Shugoarts in January 2001. All galleries had to vacate the building in November 2002, when it was torn down to make room for residential buildings.[1]

Tomio Koyama now also calls his new gallery 'Project Room', as a sign that his programme has changed and that now only young artists are to be presented.

UTA GROSENICK

Above, left: Vibeke Tandberg and Tomio Koyama at the opening of their exhibition 'Living Together', 1999

Above, right: Takashi Murakami and Yoshitomo Nara at the opening of their exhibition, 2001

1 Kay Itoi, 'Report from Tokyo', in *artnet.com – magazine*

The Modern Institute

YEAR OF FOUNDATION
1998
FOUNDERS
Toby Webster, Will Bradley and Charles Esche
ADDRESS
73 Robertson Street, Glasgow

ARTISTS REPRESENTED
**Martin Boyce, Björn Dahlem, Jeremy Deller, Urs Fischer
Luke Fowler, Henrik Håkansson, Mark Handforth, Richard Hughes
Andrew Kerr, Jim Lambie, Duncan McQuarrie, Victoria Morton
Scott Myles, Toby Paterson, Simon Periton, Mary Redmond
Anselm Reyle, Eva Rothschild, Monika Sosnowska
Simon Starling, Katja Strunz, Tony Swain, Joanne Tathant
Pedraig Timoney, Hayley Tompkins, Sue Tompkins
Cathy Wilkes, Michael Wilkinson, Richard Wright**

Toby Webster (second from left) and the team of The Modern Institute in front of the gallery, 2004

The workshop. 'The Modern Institute is a place for production and research,' wrote the co-founder and present director Toby Webster in a concept paper for the institution in 1998.[1] Together with Will Bradley and Charles Esche he created a lively institution, which has helped primarily Scottish artists to achieve international breakthroughs. To this end, the gallery has organized exhibitions in its rooms and taken part in various events again and again. The spectrum ranges from conventional art fairs – just one year after its foundation, The Modern Institute participated in 'Liste', an art

Jim Lambie exhibition, 2001

fair for young galleries that runs parallel to 'Art Basel' – all the way to experimental dance events. Thus in the same year the Institute was a guest at the legendary techno club WMF in Berlin. In addition, The Modern Institute regularly produces editions by artists such as Christine Borland, Simon Starling and David Shrigley.

Cooperation with other galleries is also a part of the Institute's field of activities. For instance, in 1998 artists such as Richard Wright, Jeremy Deller and Jonathan Monk were shown in the London gallery Sadie Coles HQ. Two years later The Modern Institute introduced Cathy Wilkes, Mary Redmond, Martin Boyce and Jim Lambie in Zurich's Galerie Mark Müller. Through this approach, it is conspicuous that the Institute's interest is less in the auratic presentation of works of art than in

presenting such works in a style that is as natural as it is sometimes rustic, and even almost provisional.

This provisional aspect can also be found in the aesthetics of many artists represented by the gallery – for example, in Cathy Wilkes's lyrical and fragile drawings and objects, or in the poetically crude sculptures of the Swiss artist Urs Fischer. In many of the works to be seen in The Modern Institute adhesive tape becomes virtually a symbol for the openness and transience of Postmodern life.[2]

1 E-mail to the author of 19 August 2003
2 See additionally: Heike Föll/Philipp Ekardt, 'actionbutton', in *Neue Review*, No. 2, Berlin 2003, p. 26

Toby Webster and his team are also not afraid to cooperate with artists who are not strictly part of the gallery's own programme. There have been repeated collaborations with the Danish artist group Superflex (for the exhibition 'Cities on the move' in the Louisiana Museum in 1999, for example), or with Rirkrit Tiravanija. In 1999, in a provisional open-air cinema on the outskirts of Glasgow, the latter showed films chosen by the people living there. Moreover, a Thai barbecue café provided food and drink for the visitors' physical well-being. Such naturalistic, seemingly non-artistic aesthetics as these continue to be typical of the Institute's view of art to this day.

RAIMAR STANGE

Above: Urs Fischer installation, 2002

Overleaf: Rirkrit Tiravanija, *Community Cinema for a Quiet Intersection (against Oldenburg)*, 1999

445

Galerie Christian Nagel

YEAR OF FOUNDATION
1990
FOUNDER
Christian Nagel
ADDRESS
1990–94 **46 Brabanter Straße, Cologne**
1994–99 **22–24 Hohenzollernring, Cologne**
SINCE 1999 **28 Richard-Wagner-Straße, Cologne**
SINCE 2002 **2/4 Weydinger Straße, Berlin**

ARTISTS REPRESENTED
**Kai Althoff, Cosima von Bonin, Merlin Carpenter
Clegg & Guttmann, Stephan Dillemuth, Mark Dion, Andrea Fraser
Ingeborg Gabriel, Renée Green, Kiron Khosla, Michael Krebber
Kalin Lindena, Hans-Jörg Mayer, Christian Philipp Müller
Stefan Müller, Josephine Pryde, Martha Rosler
Markus Selg, Catherine Sullivan, Stephanie Taylor
Luca Vitone, Joseph Zehrer, Heimo Zobernig**

Discourse culture. Christian Nagel prepared himself extremely thoroughly for his job as a gallerist. The topic of his masters thesis in art history was 'Avant-garde Galleries in the 19th Century'. From September 1986 Christian Nagel and Matthias Buck directed the Galerie Christoph Dürr in the Villa Stuck in Munich's Prinzregentenstraße. The first exhibition already set the tone for the programme: the two presented the post-conceptual pair of artists Clegg & Guttmann, and thereby an artistic position in which the discursive moment, reflection, research, information and interaction are more important than the sensual quality of a carefully composed artwork. Similar criteria also apply to the artists later introduced there: Heimo Zobernig, Thomas Locher and Fareed Armaly.

In April 1990 Christian Nagel decided to become independent and opened his own gallery, designed in a consciously restrained manner, in Brabanter Straße in Cologne. Again he relied on an aesthetic that was less concerned with the artwork and with sensuality, instead emphasizing comparatively rational and intellectual aspects. He now tried out institutional criticism and Context Art, but also socio-political topics such as ecology and genetic engineering. In the two years that followed, artists such as Christian Philipp Müller, Andrea Fraser, Mark Dion and Renée Green represented this politically active programme for the gallery.

By then hot competition had sprung up between Berlin and Cologne, and Galerie Christian Nagel was like few other galleries in its self-confident support of the

Exterior view of the Galerie Christian Nagel in Brabanter Straße 46 with *In a Frog's Forehead* by Gabriele Dziuba, 1992–93

Exterior view of the
Galerie Christian Nagel
in Cologne, 2003

cathedral city. 'Cologne is still the best location in Europe,' stated Christian Nagel wholeheartedly. To make this location as interesting as possible, in 1992 he founded an alternative art fair to 'Art Cologne', together with his colleagues Tanja Grunert, Michael Janssen and Achim Kubinski: the 'Unfair'. This art fair was intended to give a younger international generation of gallerists an opportunity to present themselves adequately.

The first time the gallery moved was in August 1994, although naturally not to Berlin. The new space was located above the Ufa-Palast cinema in Hohenzollernring in Cologne. This was the art-business critical space, one might say, for following his artists' 'market-hostile' ideas. No exhibitions took place there initially; after all, exhibitions always serve to present works for the purpose of a later sale. Instead, the gallery understood itself now as an office for the organization and mediation of contemporary art – a kind of 'agency for artist support services'. Not until September 1995 did the gallery return to a posture of business as usual, when the group exhibition 'Aufforderung in schönster Weise', featuring all of the gallery's artists, took place in the new space. Exhibitions followed, featuring the work of artists such as Kai Althoff, Cosima von Bonin and Martha Rosler.

Five years later, in November 1999, the gallery moved again, this time to Cologne's Richard-Wagner-Straße. New, and at that time comparatively unknown, artists such as Jonathan Meese and Jan Timme, but also proven greats such as

Left, top: View of Kai Althoff's installation *Ein noch zu weiches Gewese der Urian-Bündner*, 1999

Left, bottom: View of Cosima von Bonin's installation *Löwe im Bonsaiwald*, 1997

Andrea Fraser and Christian Philipp Müller were to be seen there. In this way, through a confrontation with more current positions, Nagel succeeded in critically revising the artistic operating system of the early 1990s, which he had promoted.

Christian Nagel, who in the meantime also became a founding member of the Berlin art fair 'Art Forum', finally showed even younger art in the subsidiary that he ultimately did open in the new German capital, Berlin, in February 2002. He took over a former shopfront in Weydinger Straße, across from the Volksbühne on Rosa-Luxembourg-Platz, and converted it into a classic white cube. Roger Bundschuh and the artist Cosima von Bonin were the architects responsible. There the focus was initially on young artists such as Stephanie Taylor, Lucy McKenzie and Kalin Lindena. In the summer of 2003, however, Clegg & Guttmann were presented there, with whom Christian Nagel had initially begun his gallery activities.

RAIMAR STANGE

neugerriemschneider

YEAR OF FOUNDATION
1994

FOUNDERS
Tim Neuger and Burkhard Riemschneider

ADDRESS
1994–97 **73 Goethestraße, Berlin**
SINCE 1997 **155 Linienstraße, Berlin**

ARTISTS REPRESENTED
Franz Ackermann, Pawel Althamer, Keith Edmier
Olafur Eliasson, Isa Genzken, Louise Lawler
Sharon Lockhart, Michel Majerus, Antje Majewski
Jorge Pardo, Elizabeth Peyton, Tobias Rehberger
Simon Starling, Thaddeus Strode, Rirkrit Tiravanija, Pae White

Tim Neuger and Burkhard Riemschneider, 2004

Exterior view of the first gallery in Goethestraße, with installation by Jorge Pardo, 1996

Tim Neuger and Burkhard Riemschneider in front of the gallery in Goethestraße, with the group exhibition 'Filmcuts', 1995, in the background

The gallery as company. Tim Neuger and Burkhard Riemschneider founded their gallery neugerriemschneider in May 1994, not in the then hip district of Berlin-Mitte, but in Goethestraße, in the comparatively venerable district of Charlottenburg. It was typical of their programme that the word 'gallery' did not appear in their lower-case name, for neugerriemschneider saw themselves as a kind of 'art laboratory', rather than a mere place for selling or a noble showroom.

In its very first year of existence, the gallery showed the work of five artists who, within this environment that consciously distanced itself from the primarily selling-orientated 1980s, laid the foundations for their future careers in Europe and beyond. They were the design artist Jorge Pardo, the travelling urbanist Franz Ackermann, the conceptual photographer Sharon Lockhart, Rirkrit Tiravanija and finally the Post-Pop painter Michel Majerus. American artist Jorge Pardo was additionally responsible for the enterprise's corporate design. The ceiling lights and conspicuous yellow-green façade, as well as the typography on the invitations and letterhead were all designed by Jorge Pardo. Thus, in a communicative and cooperative manner typical of Postmodernism, the artists were interactively integrated into the gallery activities again and again; for example, Pae White and Tobias Rehberger later did the layout for advertisements for their Berlin gallery. Both sides learned from one another

Rirkrit Tiravanija, *Untitled, 1997*
(a Demonstration by Faust as a Sausage and Franz Biberkopf as a Potato)

there, and an open dialogue between gallerists and artists set the tone at neugerriemschneider. 'We see ourselves as a company with twelve partners,' says Burkhard Riemschneider. 'We are two of these, and the other ten are the artists.'

The gallery quickly had sweeping success with its teamwork, and this can be seen above all in the careers of 'their' artists. Olafur Eliasson, Wolfgang Tillmans, Franz Ackermann, Michel Majerus, Rirkrit Tiravanija and Elizabeth Peyton, for example, very quickly became some of the most influential artists of the 1990s, and Tobias Rehberger and Jorge Pardo also left their mark on the aesthetics of the decade.

The last exhibition in the former butcher's shop took place in November 1997. After three years of successful gallery activity they had decided to move into larger premises. These were located in Berlin-Mitte – in Linienstraße to be precise. The last exhibition in the old space was one of the highlights of neugerriemschneider's work, in

which the gallery convincingly lived up to its claim of offering a 'laboratory situation'.
Rirkrit Tiravanija's *Untitled, 1997 (a Demonstration by Faust as a Sausage and Franz
Biberkopf as a Potato)* took place simultaneously with the opening of the first 'Art
Forum Berlin' art fair, and skilfully played with the 'exhibition opening' genre.
There, Rirkrit Tiravanija turned the gallery into a working theatre stage upon which
two actors recited, in long-winded monologues, various fragments from the novel
Berlin Alexanderplatz by Alfred Döblin, and selected scenes from Johann Wolfgang
von Goethe's drama *Faust*. One of the two male protagonists was dressed up as a
potato, while the other was a sausage. The artist designed a very minimal stage set for
this absurd production: it was made up simply of rectangular wood surfaces lying or
standing around the room. They were painted in monochrome black, red and gold,
which are particularly symbolic colours for the German capital Berlin. Moreover, a
real sausage vendor from Berlin Alexanderplatz sold his inexpensive, deliciously
fragrant meat products in the gallery – a piquant joke for the numerous people
present, including many illustrious and international art collectors, who had the
chance that evening, accompanied by much laughter, to bite into the 'common people's'

The exhibition 'hell', with works
by John M Armleder, Martin Boyce,
Angela Bulloch, Martin Creed,
Björn Dahlem, Olafur Eliasson,
Ceal Floyer, Felix Gonzalez-Torres,
Jeppe Hein, Reinhard Mucha,
Jorge Pardo, Philippe Parreno,
Tobias Rehberger, Anselm Reyle,
Simon Starling, Pae White,
Johannes Wohnseifer, Joseph Zehrer
and Heimo Zobernig, 2002

NEUGERRIEMSCHNEIDER

Pawel Althamer,
Tim und Burkhard, 2004

meal, packaged as art. In this way, the possibilities for interactive art were critically analysed on several levels, and this criticism was simultaneously expanded to include the work of the gallery, during an opening for example. At neugerriemschneider art takes place in the interplay between artist, art lover and gallerist, and is thereby both a criticism of the market and a part of this market at the same time. This is often typical of the gallery's work.

In the spacious new rooms in Berlin-Mitte, neugerriemschneider unwaveringly continued its 'joint venture' between everyone involved in art. Jorge Pardo was again involved in producing the gallery's corporate design, for example, and re-launched the design for the cooperative 'company's' invitations and letterhead. In the gallery's continuing history, not only have theme exhibitions increasingly been presented, such as 'dad's art' in the winter of 1998, but also recent art-historical positions, in order to correlate the currents of the 1990s historically. Thus, in 2000 photographs by Louise Lawler were exhibited, and in 2003 sculptures by Isa Genzken.

RAIMAR STANGE

Regen Projects

YEAR OF FOUNDATION
1989

FOUNDERS
Stuart and Shaun Caley Regen

ADDRESS
1989–93 **Stuart Regen Gallery, 619 North Almont Drive, Los Angeles**
1993–2002 **Regen Projects, 629 North Almont Drive, Los Angeles**
SINCE 2003 **633 North Almont Drive, Los Angeles**

ARTISTS REPRESENTED
**Stephan Balkenhol, Matthew Barney, John Bock, John Currin, de Rijke/de Rooij
Anish Kapoor, Toba Khedoori, Liz Larner, Sol LeWitt, Glen Ligon, Catherine Opie
Jennifer Pastor, Manfred Pernice, Raymond Pettibon, Elizabeth Peyton
Jack Pierson, Lari Pittman, Richard Prince, Charles Ray, Paul Sietsema
Billy Sullivan, Wolfgang Tillmans, Rosemarie Trockel, Gillian Wearing
Lawrence Weiner, James Welling, Sue Williams, Andrea Zittel**

Opposite, above: Shaun Caley Regen, 1996

Opposite, below: Stuart Regen with Richard Prince's 'Skull Bunny' surfboard, in front of a drawing by Christopher Wool, 1992

Though born and raised in New York, the country's undisputed commercial art capital, Stuart Regen chose to open his gallery in Los Angeles in 1989. 'The intelligent thing he did was to go out on his own in another city,' said Babara Gladstone, owner of one of New York's most successful galleries of the 1980s, and Regen's mother remarked, 'he has clear tastes and doesn't need to be under the shadow of anybody'. He saw LA's traditionally dismissive attitude to contemporary art as a challenge and hoped to take advantage of the Hollywood film industry that dominated the city's culture: 'Many of my buyers are younger, in the record and movie industries, and they want to soak up a lot of information. I love the teaching aspect and I have a lot of faith in LA.' Together with partner Shaun Caley, a former editor of *Flash Art* magazine, he founded Stuart Regen Gallery in a 3,500-square-foot space in West Hollywood.

Regen's initial area of interest was Conceptual Art and he began with shows of well-known international artists such as Lawrence Weiner, Anish Kapoor and On Kawara. But the main thrust of his programme came in introducing the younger stars of the New York scene, including Richard Prince, Pruitt-Early and Sue Williams, while showing their young LA counterparts such as recent graduates Larry Johnson and Liz Larner. Regen's coup came in 1992 with an exhibition by a

twenty-four-year-old Yale graduate, Matthew Barney. There was already a great buzz about Barney, with shows planned for the San Francisco Museum of Modern Art and Barbara Gladstone Gallery later that year, but it was his now infamous exhibition at Stuart Regen Gallery that introduced the elaborately constructed and densely referential performance, sculpture and film that went on to establish Barney as the definitive US artist of the 1990s. In a private performance, which took place before the exhibition opened, Barney scaled the walls and traversed the ceiling of the gallery space, naked except for a harness dangling with bunches of climbing equipment, plotting out the gallery's architecture in a performance loaded with sexual tension and athletic prowess. A video of the performance, entitled 'Flight with the Anal Sadistic Warrior', was shown alongside its sculptural props: a wrestling mat, a walk-in cool room and gym equipment cast from his signature medium, petroleum jelly.

By 1992 the art scene was suffering under the post-1980s recession, and Regen was forced to scale down his gallery, moving next door to a space half the size, which he rechristened 'Regen Projects'. The indifference of the LA audience and the city's geographic obstacles had proved a frustration: 'Here you have to go out and find the people. It's not enough to have great art.' But he remained optimistic: 'I still have a lot

Gordo Regen in front of a work
by Lawrence Weiner, 1995

of faith in Los Angeles.' The new gallery was intended to be a base for a number of off-site projects, a 'total reinvention of the traditional gallery format' with a newly flexible set-up to match the 'post-studio' practice being taught in art schools such as the California Institute for the Arts (CalArts). The inaugural exhibition 'First House' was a two-month live-in open studio by Richard Prince in a condemned bungalow in West Hollywood. Prince covered the bare floors with drop cloths, stripped the walls down to plaster and board, and hung them with his new paintings of grimly hilarious tasteless jokes, which took on an added pathos in their depressing domestic setting.

During the course of the 1990s the reputation of Los Angeles' art schools grew, and they produced a crop of ambitious graduates who began to put the city on the map as a vital and cosmopolitan art scene. By this time UCLA had overtaken the hard-core conceptual CalArts as the city's most significant art school, with key figures Chris Burden, Charles Ray and Lari Pittman all teaching there. In 1993 the Museum of Contemporary Art mounted 'Helter Skelter', a show of Los Angeles artists that came to be seen as defining the new LA aesthetic, described by curator Paul Schimmel as 'a sense of…alienation, dispossession, and disorder'. Almost all of the artists in the show had graduated from one of LA's schools, and most of them had also gone on to teach there. Only one, Liz Larner, was represented by Regen Projects at the time, but over the next few years they added three more: Raymond Pettibon, Charles Ray and Lari Pittman. Meanwhile, Regen Projects provided a testing ground for younger

graduates such as Catherine Opie and Toba Khedoori, who had not even graduated when she first exhibited there. By the late 1990s Regen's optimism about LA had proved successful. Many of the LA-based artists he worked with had gone on to international recognition, while wealthy Hollywood's interest in contemporary art had increased exponentially. Tragically, Stuart Regen died in 1998 aged only thirty-nine, finally succumbing to the cancer he had been diagnosed with in 1989, the year he founded the gallery. Since then Shaun Caley, whom he had married in 1992, has continued the gallery's trajectory, adding new artists, both local and international, and expanding into new premises in 2003.

KIRSTY BELL

Raymond Pettibon
exhibition, 1995

465

Schipper & Krome

YEAR OF FOUNDATION

1989

FOUNDERS

Esther Schipper and Michael Krome (since 1994)

ADDRESS

UNTIL 1996 **Esther Schipper, 28 Neusser Straße, Cologne**
1994 **Project room, 116a Friesenwall, Cologne**
SINCE 1995 **Project room, 91 Auguststraße, Berlin**
SINCE 1997 **91 Auguststraße, Berlin**
SINCE 2001 **85 Linienstraße, Berlin**
SINCE 2004 **Esther Schipper, 85 Linienstraße, Berlin**

ARTISTS REPRESENTED

Vanessa Beecroft, Matti Braun, Angela Bulloch
Nathan Carter, Thomas Demand, Liam Gillick
Dominique Gonzalez-Foerster, Grölund/Nisunen, Carsten Höller
Pierre Huyghe, Ann Veronica Janssens, Christoph Keller
Atelier van Lieshout, Philippe Parreno, Ugo Rondinone
Roth/Stauffenberg, Julia Scher, Diana Thater

Esther Schipper and Michael Krome, 1996

A place for communication. Born in Taipei, schooled in Paris, art mediation studies in Grenoble, and initial gallery experience at Monika Sprüth's in Cologne – Esther Schipper's biography is quite impressive. In 1989 she self-confidently opened her own gallery in Neusser Straße in Cologne, and even in her first year showed such interesting artists as the then barely known Brits Angela Bulloch, Gary Hume and Michael Landy. Exhibitions followed over the next few years with new international discoveries such as Dominique Gonzalez-Foerster, Philippe Parreno and Karen Kilimnik. In September 1990 Esther Schipper also founded the bookshop Buchholz + Schipper, together with Daniel Buchholz. Schipper's gallery was to be characterized by cooperation: various cooperative projects with curators and other galleries such as the Parisian gallery Air de Paris, or with culture periodicals like *Purple Prose*, bear witness to the gallery's aspiration to be more than just a showroom preparing art for sale.

For Esther Schipper, discourse and discussion were part of the protocol right from the beginning. The gallery's role, its self-image and its relationship to the artists it represented were central to this, but the relationship between gallery, art and the public was also under permanent critical revision. The gallery increasingly took on the role of producer. Thus Esther Schipper showed the project 'November TV' at the end of 1993. This undertaking was the beginning of her cooperation with Michael Krome, who had previously worked on media projects such as 'November TV' or 'THE THING'.

The pair initially began a six-part series of exhibitions at 116a Friesenwall. Artists such as Diana Thater, Paul Graham and the trained natural scientist and later 'documenta' participant Carsten Höller were introduced there. While 'normal' gallery operations continued in Neusser Straße with exhibitions by Henry Bond and Liam Gillick, among others, Esther Schipper and Michael Krome additionally operated a project room in Auguststraße in Berlin. In October they showed *Pinocchio Pipenose Householddilemma* by Paul McCarthy. Their last exhibition in Cologne took place in 1996, in which Dominique Gonzalez-Foerster showed her work *Sturm*. Following the trend at the time, the gallery then moved to the new federal capital, Berlin.

Bruno Brunnet and Max Hetzler had already made the move to the metropolis on the river Spree. Michael Krome described the difference between Cologne and Berlin as follows: 'We wanted to continue our creeping process of changing into what a gallery in the 1990s should be. Berlin is a more interesting location than Cologne for this, because the environment seems fresher, less worn out, and more willing to experiment. There aren't any niches in Cologne like there are in Berlin.'[1] The Galerie Schipper & Krome used this new context to take new artists into its programme. Now the two gallerists also exhibited the work of Thomas Demand, Ugo Rondinone, Matti Braun and Roth/Stauffenberg. Philippe Parreno, Julia Scher and other 'old acquaintances', however, also continued to win over audiences with thrilling work there.

Diana Thater, *Moluccan Cockatoo Molly numbers 1 through 10*, 1995

In the spring of 2001 the gallery finally moved into its new rooms in Linienstraße in Berlin-Mitte. The Berlin team of designers Vogt + Weizenegger were responsible for the interior design, and placed particular emphasis on 'flexibility of the uses allowed by the space, both for presentation as well as for communication, whereby all work areas should be networked by transparent structures'.[2] The openness they aspired to was consistently reflected in their exhibitions as well. In addition to artworks and project-orientated installations, other presentations were shown, including some by designers like Vogt + Weizenegger. Unfortunately, it seemed that some contact with the positions of younger artists had been lost. In 2004 Krome and Schipper went their separate ways. The gallery is now called 'Esther Schipper'.

RAIMAR STANGE

Above, left: Vanessa Beecroft, *Ein blonder Traum* (A Blonde Dream), 1994

Above, right: Philippe Parreno, *Werktische* (Work Tables), 1995

Opposite: Angela Bulloch, view of the *Macro World: One Hour3 and Canned* installation, 2002

1 In *Kunstforum International*, Vol. 132, Ruppichteroth, 1996, p. 137
2 Gallery press release, April 2001

Galleri Nicolai Wallner

YEAR OF FOUNDATION
1993
FOUNDER
Nicolai Wallner
ADDRESS
1993–95 **101 St Kongensgade, Copenhagen**
1995–98 **34 Bregade, Copenhagen**
SINCE 1999 **21 Njalsgade, Copenhagen**

ARTISTS REPRESENTED
**Stan Douglas, Mari Eastman
Michael Elmgreen & Ingar Dragset, Douglas Gordon
Jens Haaning, Henrik Plenge Jakobsen, Joachim Koester
Jakob Kolding, Peter Land, Jonathan Monk
Christian Schmidt-Rasmussen, David Shrigley
Glenn Sorensen, Gitte Villesen**

Nicolai Wallner after the opening of the David Shrigley exhibition, 1998

The Danish talent shed. Nicolai Wallner had already been curating exhibitions with the Danish artist Jakob Kolding for three years when he opened his gallery in Copenhagen in October 1993. The two showed work by art students of the Danish Royal Academy of Fine Arts in their off-space 'Galerie Campbells Occasionally', located where he lived at the time. Even then, a close cooperation with young Danish artists was characteristic of Nicolai Wallner's work as a gallerist.

For the first six months of its existence Wallner's gallery was financed by a collective of seven artists and himself. When Wallner went into business on his own, he showed practically undiscovered Danish artists in his gallery space again and again.

At first Copenhagen was difficult for the gallery, as there were hardly any collectors of young art there. The local institutions also backed a rather dignified programme, and had a correspondingly defensive purchasing policy when it came to new art. Nicolai Wallner's answer to this situation was logical and successful: only a year after founding his gallery, he began to attend international art fairs, including those in Cologne and Stockholm, where he was able to initiate and intensify lively contact not only with open-minded collectors, but also with curators operating internationally. It was this twofold strategy of cultivating contacts with both collectors and curators that distinguished the young gallerist. In this way he intended, right from the start, not only to sell works of art, but also to place 'his' artists in important exhibitions outside of Denmark.

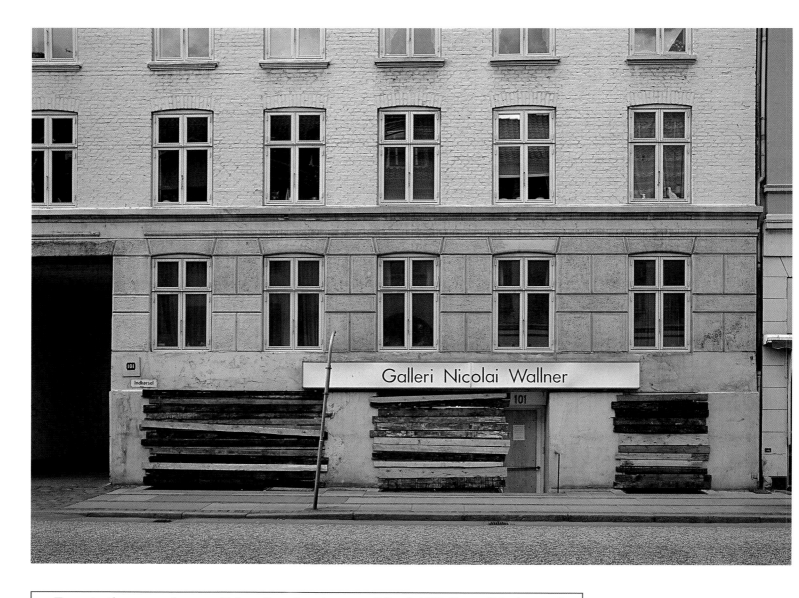

Even in the second year of his gallery's existence, Nicolai Wallner did pioneering work by giving the British post-conceptual artist Jonathan Monk his first gallery exhibition. In the same year he included the artists Stan Douglas and Douglas Gordon, then still virtually unknown, in the group exhibition 'Stain in Reality'. The third in this group was the young Danish artist Joachim Koester. His video piece *Pit Music*, a peek into the orchestra pit at an opera, was shown in a solo exhibition at the gallery in 1996. In the same year this work was the only Danish contribution to 'documenta X', curated by Cathérine David. Wallner knew how to pave the way for young artists to achieve their breakthrough! Wallner was also instrumental in rapidly launching the careers of Henrik Plenge Jakobsen, the gallerist's former curating partner, Jakob Kolding, Peter Land and the artist pair Michael Elmgreen & Ingar Dragset in the international art world.

Despite the variety within the positions represented by Nicolai Wallner, there is also a common denominator: almost all the artists in his gallery experiment with various forms of the fictitious. Jonathan Monk loads the stylistic idiom of Conceptual Art with moments that are narrative and occasionally biographical; Peter Land's

Exterior view of the gallery in St Kongensgade, with the installation *Burn Out* by Jes Brinch and Henrik Plenge Jakobsen, 1994

Jes Brinch and Henrik Plenge
Jakobsen, *Burn Out*, 1994

videos and drawings relate the absurdity of life in a manner that is as succinct as it is tragicomic; and Michael Elmgreen & Ingar Dragset, in their installations, report on the situation of homosexuals in our society. The gallerist himself describes his artists' work as follows: 'Some works are thoughtful, and some political. Others are poetic, while still others examine the relationship between fiction and reality. All of them, however, have more or less of a story.'

It is primarily male artists who are represented. One of the gallerist's latest discoveries, however, is the Danish video artist Gitte Villesen. Naturally she too narrates in her art, which above all is characterized by discreet but precise research, by a restrained tonality, and by a love of detail. In her 1998 exhibition at the Galleri Nicolai Wallner entitled 'Kathrine makes them and Bent collects them', Gitte Villesen tells the story of a lace maker and her collector in a manner at once sensitive and analytical. The crucial points are the dreams of the two, and their intense friendship with one another. Friendship also defines the relationship between the artists and Nicolai Wallner. As he himself says: 'I have a very close relationship with my artists'.

RAIMAR STANGE

Exterior view of the present gallery
in Njalsgade, 2001

476

Michael Elmgreen & Ingar Dragset,
Untitled, 2001

White Cube

YEAR OF FOUNDATION
1993

FOUNDER
Jay Jopling

ADDRESS
1993–2002 **44 Duke Street, St James, London**
SINCE 2000 **48 Hoxton Square, London**

ARTISTS REPRESENTED
**Darren Almond, Koen van den Broek, Jake & Dinos Chapman
Tracey Emin, Gilbert & George, Steven Gontarski, Anthony Gormley
Marcus Harvey, Mona Hatoum, Damien Hirst, Gary Hume, Tom Hunter
Runa Islam, Harland Miller, Sarah Morris, Marc Quinn, Clare Richardson
Neal Tait, Sam Taylor-Wood, Gavin Turk, Cerith Wyn Evans**

The White Cube building on Hoxton Square

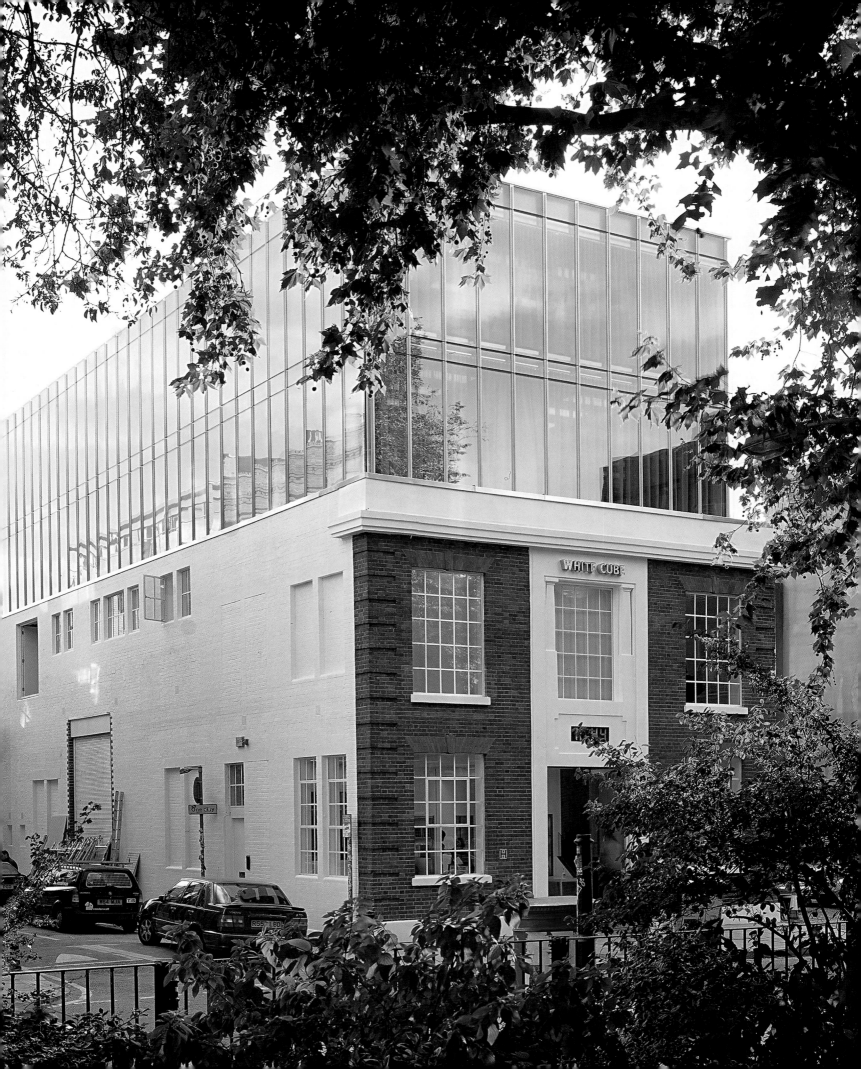

Exterior view of White Cube
in Duke Street

The White Cube as a white cube.... When Jay Jopling and Damien Hirst met in a pub in 1991, they forged a partnership that fuelled the 'Young British Artist' phenomenon of the 1990s. Their initial exchange summed up the expansive ambitions of both dealer and artist:

Hirst: 'Do you know what I like about life?'

Jopling: 'No, what?'

Hirst: 'Everything!'

Two years later Jopling opened 'White Cube' on the first floor of a building tucked away among the Old Master dealers of Duke Street, St James, the heart of London's old art establishment. 'We're not here to challenge the establishment,' he said. 'My interest is in integrating the avant-garde with the establishment.' The twenty-nine-year-old Jopling had convinced Christie's Auction House, who owned the building, to let him have the 40-square-foot room rent free, then engaged renowned minimalist architect Claudio Silvestrin to remodel it into a cerebrally stripped-down bright white square and christened it 'White Cube' after art theorist Brian O'Doherty's famous 1976 essay about the role of the gallery in constructing art's meaning.

With this modest space, tailor-made for the post-recession economic climate of London, Jopling began a programme of one-off exhibitions. Aiming to avoid the usual cycle of biannual exhibitions for gallery artists, he decided that no artist could have more than one show there. The intimate scale of the gallery kept the exhibitions

tightly focused, whether the artist just showed one work, as Damien Hirst did with *Still*, a huge cabinet full of highly polished medical equipment, or the space was transformed into an archive of personal memorabilia, as in Tracey Emin's 1993 exhibition 'My Major Retrospective'. Jopling quickly began to work with the group of Young British Artists that had emerged in the late 1980s, largely graduates from Goldsmiths College of Art, of whom Hirst was the front-runner, but also Gavin Turk, Marc Quinn and Marcus Harvey. As well as their gallery shows, he was to provide the financial backing and logistical assistance for the creation of what became iconic

Left: Jay Jopling, 1998

Right: Opening of the Tracey Emin exhibition in 2001, with visitors in front of the gallery in Hoxton Square

images of the generation: Hirst's shark suspended in a tank of formaldehyde, Quinn's self-portrait bust filled with his own frozen blood, Emin's unmade bed strewn with personal debris. Jopling's relationship with these artists was strengthened by the shared party-hard spirit that fuelled the intensely social London art scene. His openings attracted throngs of people who spilled out of the tight gallery and on to the usually sedate Duke Street – this was usually just the starting point for a long night's hard drinking.

As well as being home to London's domestic newcomers, White Cube introduced international artists, including Nobuyoshi Araki, Luc Tuymans, Nan Goldin and Sarah Morris, while also expanding generationally to include Antony Gormley, Chuck Close, Lucian Freud and Ellsworth Kelly. The small-format gallery allowed Jopling to exhibit work by a myriad of artists – by the time the space closed in 2002, there had been seventy-five shows of different artists' work – while not necessarily committing to an ongoing relationship of representation.

This left him free to concentrate on projects outside the exhibition space, whether additional exhibitions in larger independent spaces, productions of artists' works, or the rigorous promotion that was another defining aspect of Jopling's style as a gallerist. Playing with the tabloids' love of scandal, he arranged for judicious leaks of information and even set up publicity stunts. He invited the *Daily Star* to bring a bag of chips to an exhibition of one of Hirst's high-priced fish-in-formaldehyde pieces, resulting in a photograph published with the headline 'The World's Most

Brian Eno, *Music for White Cube*, 1997

Sam Taylor-Wood,
Travesty and Mockery, 1995

Expensive Fish and Chips'. By the end of the '90s, Hirst, Emin and others had become household names, while Jopling and his artist wife Sam Taylor Wood were 'New Establishment' celebrities, appearing regularly in the society pages.

Jopling's background was blue-chip establishment: his father had served in Thatcher's Tory government, and he had an Eton education to thank for his easy self-confidence. Together with his entrepreneurial flair, he had the right combination of kudos and credibility to convince a sceptical moneyed elite to buy into the Young British Artist phenomenon. While he already enjoyed a close relationship with London's biggest contemporary art collector, advertising giant Charles Saatchi, whose wholesale collecting and exhibiting of 'Young British Artists' was instrumental in their growing success, Jopling also sought to cultivate a generation of young British collectors. A natural salesman, whose career began by selling fire extinguishers, he had a reputation for his persuasive charm and reassuring manner. 'If you believe in something, you can sell it,' he said.

As the British economy thrived during the 1990s, the prices in White Cube escalated to previously unthinkable heights – a sculpture by Hirst selling for £1m in 2000. By this time Jopling had added more major names to his stable, including London's original East End artists Gilbert & George and German photographer Andreas Gursky, while filling in the holes in his collection of young Brits, having taken on Gary Hume in 1995 and Jake and Dinos Chapman in 1999. In May 2000 he opened a second gallery, White Cube in Hoxton, the epicentre of London's hip East

Gavin Turk, *Pop*, 1993

End artist community. With Tate Modern, a new museum dedicated to contemporary art, opening later that month, he was keen to capitalize on London's newly international profile and cultural vibrancy. His timing proved right, as 30,000 people attended the opening show of Young British Artists at White Cube. 'He's an operator,' said Hirst, 'but he operates with enjoyment – he enjoys making deals like I enjoy making art.'

KIRSTY BELL

The New Millennium: Pure Globalization

The 21st Century

Carsten Höller's 'Instrumente aus dem Kiruna Psycho Labor' exhibition at Schipper & Krome, Berlin, 2001

The new millennium was anticipated with mixed feelings; in particular, a collapse of all computer systems had been predicted repeatedly. But things turned out differently. Neither data-destroying nor any other catastrophes dampened the worldwide festivities at the turn of the year.

The supposed harmony at the beginning of the new millennium was deceitful, however. This became all too apparent on 11 September 2001, when Islamic militants flew two hijacked Jumbo Jets into the New York World Trade Center, causing the collapse of its two towers and the death of thousands of civilians. The terrorists simultaneously attempted similar attacks on the Pentagon and the White House in Washington DC.

Despite its obvious fanaticism, the attack also expressed a mood of no longer wanting to accept globalization meekly under the leadership of the sole superpower, the USA. While the assault on the heavily symbolic centres of control in the USA was utterly despicable, it was a clear expression – and one very well suited to the media, as the attacks were followed live on TV – of an extreme aggression against profit-orientated exploitation and an increase in forced ideological conformity by the 'West'. The USA's answer was almost two years in coming. In the spring of 2003, with the support of British troops, the US armed forces attacked Iraq, which they had deemed an 'evil' state and classified as a terrorist threat to the world.

There was no UN mandate for this attack, however, and thus the US and Great Britain fulfilled what Michael Hardt and Antonio Negri had described three years earlier in their (anti-)globalization primer, when they outlined the decline of 'traditional international law' and the simultaneous development of a 'new sovereign, supranational world power' and a corresponding 'imperial notion of right'. As one consequence of this comparatively unchecked new world order, 'war is reduced to the status of a police action'. This ruthless 'police action' resulted, among other things, in feelings of anti-Americanism that still endure in large parts of Europe today.

Art's reaction to this 'imperial' situation is still difficult to make out. Two things can be clearly perceived, however. One is a resigned judgment of the structural feature of worldwide communication and cultural transfer that had been so emphatically celebrated, and was so stylistically influential in the 1990s, the phenomenon of crossover. Instead, a return to more traditional ideas made its appearance, such as that of 'Identity…as a Modus Operandi', as one critic wrote in light of the 50th Biennial of Venice in 2003.

Secondly, in the 21st century the 'art world' finally admitted that it is no longer restricted to existing in the so-called 'First World'. Curated for the first time by a Nigerian-born American, 'documenta 11' can be seen as an example of this. For precisely this reason our selection of galleries for the new century concentrates on galleries from Second- and Third-World countries.

RAIMAR STANGE

Interior view of the New Warehouse,
ShanghART Gallery, 2003

489

China Art Objects Galleries

YEAR OF FOUNDATION
1999
FOUNDERS
Steve Hanson, Mark Heffernan, Giovanni Intra, Peter Kim and Amy Yao
ADDRESS
933 Chung King Road, Los Angeles

ARTISTS REPRESENTED
**Andy Alexander, Julie Becker, Mason Cooley
Dave Deany, Kim Fisher, Morgan Fisher
Jonathan Horowitz, David Korty, Jennifer Lane
J. P. Munro, Jorge Pardo, Jonathan Pylypchuk
Michael Stevenson, Eric Wesley, Pae White, T. J. Wilcox**

Giovanni Intra and Steve Hanson, 2001

More than just talent scouts. Art school dropout Steve Hanson and art critic Giovanni Intra were both working as librarians at the Art Center College of Design in Pasadena when they came up with the idea of opening a gallery. It was the end of the 1990s, and Los Angeles had developed an international reputation as a breeding ground for young artists. The end-of-year shows at its three renowned art schools, Art Center, California Institute of the Arts (CalArts) and UCLA, were routinely swamped by eager collectors looking to invest in the next big thing, not to mention gallerists seeking out new talent. 'The reason the kids here are getting all this early success is because they're not art students, they're young artists,' explained Charles Ray, who has taught at UCLA since 1980.

Being part of the art-school community themselves, Hanson and Intra began their gallery in the spirit of a non-profit artists' space to show work by their contemporaries. They wanted to provide a venue that could respond quickly to the new artists coming out of the art schools and offer them a collaborative exhibition process free of the constraints of commerciality found in many of the more established galleries. A number of successful young LA artists such as Laura Owens, Jorge Pardo and Sharon Lockhart were involved, as well as influential artists such as Stephen Prina and Mike Kelley. The gallery's strength was its clear identity and commitment to an already flourishing local art scene, and it quickly gained recognition and interest from collectors looking for the best of the new.

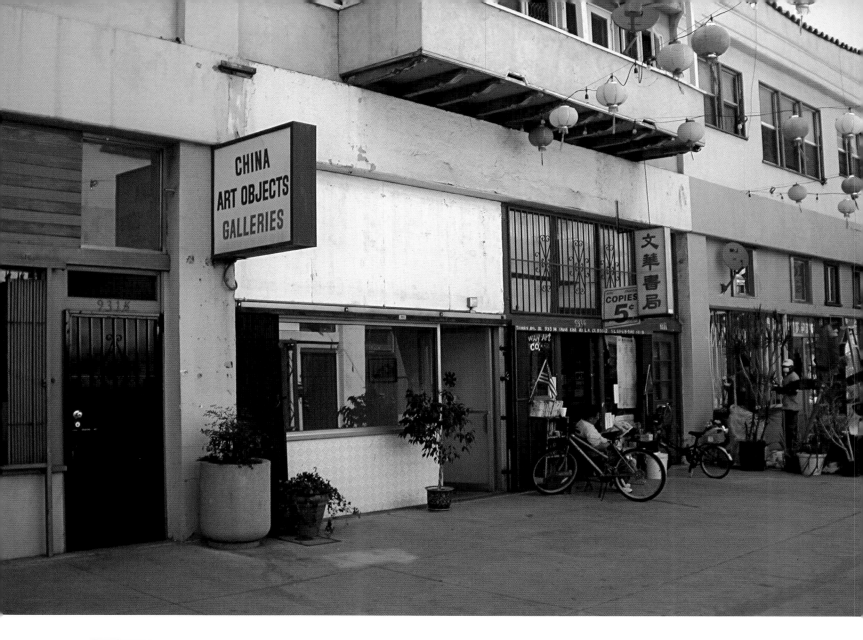

The gallery was opened in an empty shop on a semi-derelict street in 'New Chinatown', a neighbourhood built in the late 1930s as a faux-Chinoise pastiche, complete with pagodas, a lucky wishing fountain and hanging paper lanterns. The jewelry shop that had formerly occupied the premises was called 'China Art Objects', a name too good to change, so they kept it, along with the distinctive sign hanging outside. For the opening show, the gallery exhibited itself, as redesigned by LA artist Pae White, with white globes for lighting, lemon-yellow trim in the backrooms and a forest-green office, as well as a minutely replicated model of the gallery made by Hanson, which he submerged in an aquarium filled with tropical fish.

The shows that followed introduced recent graduates such as Eric Wesley, David Korty and Jonathan Pylypchuk (exhibiting under the alter ego 'Rudy Bust', whose show 'Massive Rudy Bust Liquidation' was crammed with collages, paintings and craftily assembled sculptures at bargain prices); experimental collaborations such as Laura Owens and Scott Reeder's paintings and installations, which transformed the gallery into a pop cosmic version of heaven and hell; and one-off events such as Jorge Pardo's 'Celebrity Roast'.

China Art Objects Galleries in Chinatown, Los Angeles

The gallery acted as a catalyst for the emergence of Chinatown as a new downtown LA art scene, with several new galleries and artist-run spaces springing up along Chung King Road over the next two years. Given the sprawling geography of the city and the fact that the car is the only effective means of transport, galleries have often tended to group together and location is vital.

'It's really all about the openings,' explained Hanson, 'because unlike New York, where you can just walk around a few blocks, getting out here is a big commitment. Once people are here, they like to hang out.'

The openings, which are usually coordinated with the other galleries on Chung King Road, often turn into late-night street parties. Huge crowds of people drink beer on the streets, many of whom are artists from the nearby Eagle Rock and Highland Park neighbourhoods.

In its first three years, China Art Objects earned a reputation as the best place for young local artists. It began to operate more like a commercial gallery than an artist-run space ('more like a conventional space,' quipped Hanson, 'but still without a profit').

Pae White,
'Halloween Show', 2000

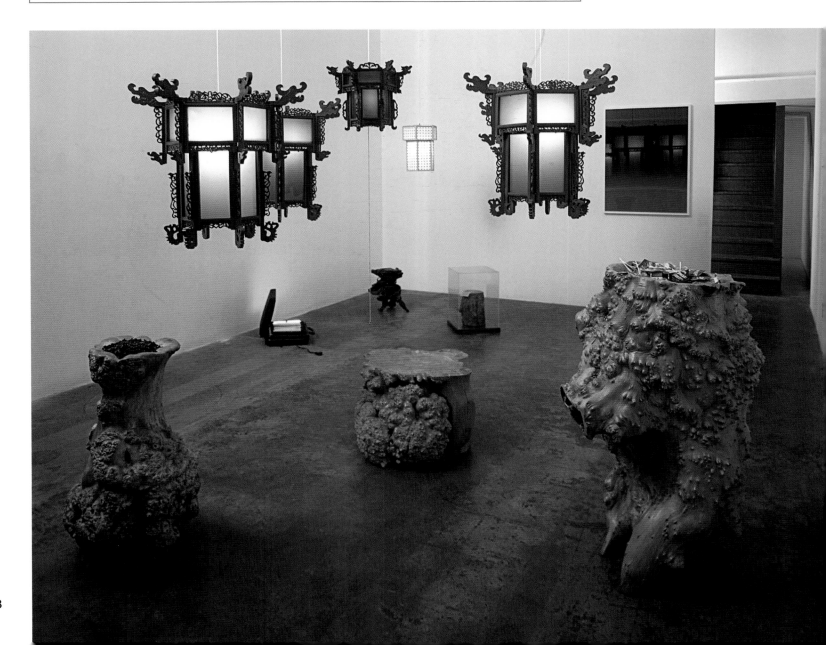

493

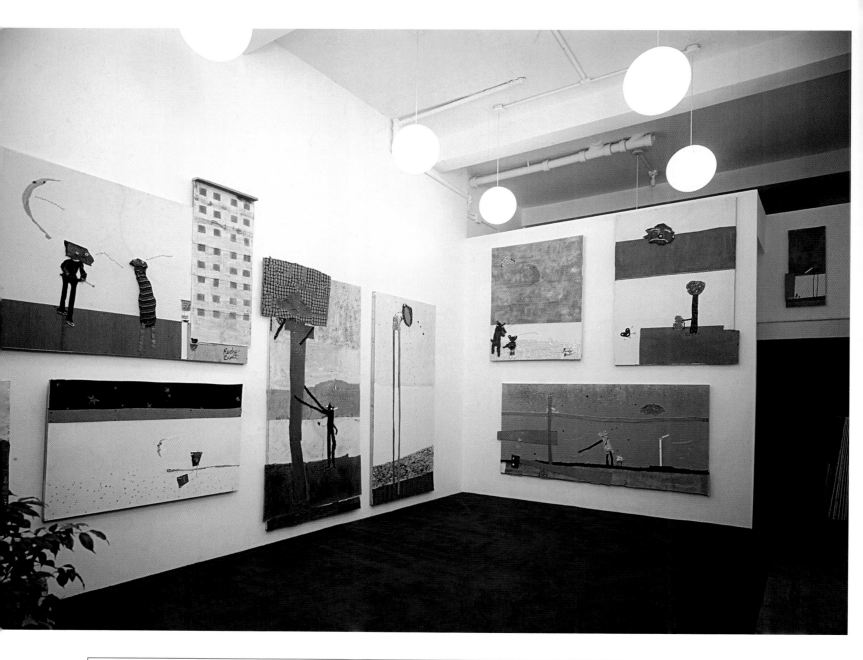

China Art Objects Galleries was dealt a blow in late 2002 when founding partner Giovanni Intra died tragically and unexpectedly at the age of thirty-four. Steve Hanson continues to run the gallery and exhibit its strong core of artists.

KIRSTY BELL

Above: First exhibition by Jonathan Pylypchuk, alias Rudy Bust, 'Massive Rudy Bust Liquidation', 1999

Opposite: Jorge Pardo and Bob Weber show, 1999

Goodman Gallery

YEAR OF FOUNDATION
1966

FOUNDER
Linda Givon

ADDRESS
1966–96 **3b Hyde Square, Hyde Park, Sandton, Johannesburg**
SINCE 1996 **163 Jan Smuts Avenue, Parkwood, Johannesburg**

ARTISTS REPRESENTED
**Deborah Bell, Clive van den Berg, Willie Bester, Norman Chaterine
Dumile Feni, Kendell Geers, David Goldblatt, Robert Hodgins
William Kentridge, Moshekwa Langa, Ezrom Legae
Zwelethu Mthethwa, Sam Nhlengethwa, Tracey Rose
Penny Siopis, Sue Williams**

Exterior view of the gallery

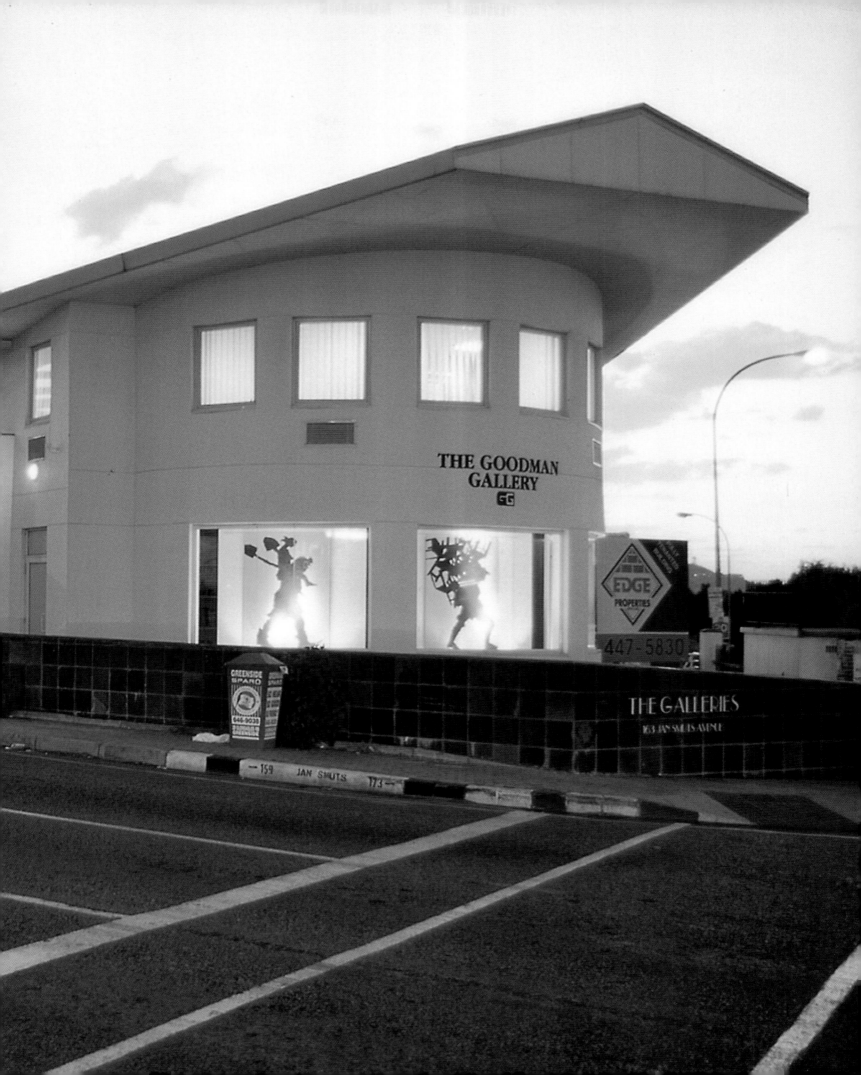

This side, and the other side of South Africa. Before Linda Givon founded the Goodman Gallery in Johannesburg in 1966, she studied dramatic art in London and worked there as an assistant in the Grosvenor Gallery. Amidst Russian avant-garde art and Italian Futurism she learned the gallerist's trade – unfortunately the business then worked completely differently in her native country of South Africa, where she experienced the official policy of strict, inhumane apartheid. Until its abolition and the election of Nelson Mandela as the country's president in 1994, this took dramatic turns again and again. Thus the gallerist not only had to give material assistance to her black artists, but often she also had to protect them from the police and their repressive interference. The manner in which Linda Givon had to 'facilitate' having South African artists such as Dumile Feni, Julian Motau and Ezrom Legae at exhibition openings, as well as having 'white' and 'black' visitors simultaneously present, is little short of grotesque: she kept enough trays handy to be able to disguise her black artists as waiters within seconds, for then their presence was not against the law.

In 1978 the Goodman Gallery showed the now legendary *Chicken* drawings by Ezrom Legae, which deal with the murder of the black man Stephen Biko. When the police wanted to confiscate the pictures, the gallerist mollified them and claimed haughtily and inflexibly that there was nothing to be seen in the drawings except poultry. It therefore seems quite understandable that Linda Givon was vehemently active for the anti-apartheid movement, primarily in the 1980s, and she organized actions and exhibitions in her gallery with groups such as Black Sash.

William Kentridge,
exhibition view, 1999

GOODMAN GALLERY

498

Deborah Bell, exhibition view, 2001

The Goodman Gallery's artistic programme at that time was considerably different from almost all other Johannesburg galleries, since no lyrically naturalistic scenes from the municipal life of the 'whites' were to be found there. Instead, it showed progressive art by South African artists, whom Linda Givon wanted to promote and bring international success despite the despotic conditions of apartheid. 'I made up my mind to seek artists who were controversial and who dealt with socially relevant subjects,' says Givon, describing her own interest in this art.

Not until the end of the 1990s, however, was Linda Givon able to gain acceptance for her internationally orientated gallery policies. In 1997 it was the 2nd Johannesburg Biennial, curated by Okwui Enwezor who would later curate 'documenta 11', which brought art from South Africa into the limelight. The Goodman Gallery was then able to achieve lasting renown for artists in the global art world, such as William Kentridge, who was represented in the same year at 'documenta X', and the photographer David Goldblatt, who created a furore at the following 'documenta'. Younger positions too, such as those of Kendell Geers and Moshekwa Langa, quickly began to appear in important group exhibitions.

In the new millennium, the gallery has thus become an important link connecting South African art to the international market, as well as to important art institutions throughout the world.

RAIMAR STANGE

Jacob Karpio Galería

YEAR OF FOUNDATION
1986
FOUNDER
Jacob Karpio
ADDRESS
1 Avenue #1352 Cuesta de Nuñéz, San José, Costa Rica

ARTISTS REPRESENTED
**Franco Aceves Humana, Guido Anderloni, Lluis Barba
Fernando Canovas, Rolando Cladera, Guillermo Conte
Carlos de Paz, Ana De Vicente, Gabriel Delponte, Lydia Dona
Darío Escobar, Ana Elena Garúz, Federico Herrero
Ivelisse Jiménez, Kika Karadi, Clemencia Labin
Valentina Liernur, Fabián Marcaccio, Priscilla Monge
Carlos Quintana, Leo Rojas, Isabel Rubio, Robert Schaberl
Cinthya Soto, Vargas-Suárez Universal, Guillermo Vargas (Habacuc)**

Opening of Robert Schaberl's 'Central Forms' exhibition, 2004

Exterior view of the gallery
in Costa Rica

The periphery becomes active. Jacob Karpio began working as an art dealer as early as 1982. He opened his first gallery in Quito, Ecuador, and another exhibition space in Panama City shortly thereafter. Both locations proved, however, to be too uncertain for a young gallery without a well-established network of collectors and patrons. Karpio therefore had no choice but to close both spaces, and seek a more suitable location. Two years later he moved to San José, the capital of his native country Costa Rica, where he found a lasting, solid base for his business plans.

In the mid-1980s the political situation was very unstable throughout Central America, and regional economic problems were extreme. Only Costa Rica seemed to be spared from this precarious situation of political, economic and social uncertainty, while armed conflicts and guerrilla warfare were the order of the day for its neighbouring states. Karpio didn't let himself be put off by the region's serious problems and unsafe conditions, and concentrated on his new exhibition space. The gallery opened its doors to the public in 1986 with an exhibition by the Argentinian Guillermo Kuitca, one of the most celebrated Latin American artists of the 1980s.

Since that time, the Jacob Karpio Galería is the only Central American gallery over the past two decades to have worked at an international level, promoting and disseminating Latin American art worldwide with great dedication. Its special location not only made it possible for the gallery to operate throughout Central America, but also allowed it to develop into a hub that connects the contemporary art scenes of North and South America and forms a link with the Caribbean Islands. In fact, the

Jacob Karpio, 2004

Caribbean became one of the gallery's preferred fields of activity, and Puerto Rico in particular increasingly became one of the major markets for contemporary Latin American art in this region.

With its unusual geographical location, the gallery clearly called into question the fixed boundaries between the art world's so-called centre and its periphery. Karpio understood early on that the idea expressed in the dichotomy of 'centre and periphery' had begun to break down and would becoming increasingly irrelevant in a world of expanding migration, growing nomadism, modern information technology, mass media, global economic interests and an internationally orientated cultural industry.

When more and more prosperous Latin Americans searching for a free and politically stable country during the 1980s chose to live in Costa Rica, Karpio took advantage of these circumstances, and his gallery won many new customers. The Internet made it easier for the gallery to work with artists living outside of the country and simplified its contact with collectors and galleries located worldwide. One effect of the economy's globalization was an increasing number of art fairs around the world, and these became a further important instrument for avoiding the danger of being left to struggle in an otherwise only poorly developed local art market. Over the past twenty years the gallery has repeatedly taken part in various art fairs, and thus given its artists a chance to make names for themselves on the international art scene. However, Karpio has also been the driving force in Costa Rica and in Venezuela in the production of ground-breaking exhibitions.

These have included, for example, 'Paradigma 80s–90s' in 1989, 'Mesótica' (in cooperation with Virginia Pérez-Ratton and Carlos Basualdo) in 1995, as well as 'Transatlántica: The America–Europa Non Representativa' (together with Ruth Auerbach) in 1995, which showed works by Vik Muniz, Andres Serrano, Wim Delvoye, Peter Halley, Jonathan Lasker, Lydia Dona, Helmut Dorner and David Reed, among others.

Over the past few years the gallery has promoted and presented works by some of Latin America's most famous artists, including Fabián Marcaccio, Kcho, Guillermo Kuitca, José Antonio Hernández-Diez and Francis Alÿs. But Karpio has also introduced younger Latin American artists to the public, such as Jennifer Allora and Guillermo Calzadilla from Puerto Rico, and Federico Herrero, Cinthya Soto and Priscilla Monge from Costa Rica, all of whom can be counted among the most outstanding young talents from Central America and the Caribbean. Moreover, he has cultivated lasting relationships with museums and public collections in both parts of the Americas and in Europe, and contributed greatly to Latin American art being exhibited in the most important art collections in international museums.

After Karpio had operated his gallery outside the city centre for a while, he moved it back to its original address in the Cuesta de Nuñéz in 2001, in the middle of the old section of San José. In 2004 Jacob Karpio, together with the gallerist Silvana Facchini, opened a new gallery in the Wynwood Art District of Miami under the name Karpio + Facchini Gallery. Installations by Dario Escobar and Guillermo Conte have already been shown there, as well as the exhibition '8WP' at the beginning of 2005, which included works by the painters Lydia Dona, Kika Karadi, Valentina Liernur, Ana Elena Garúz, Isabel Rubio, Ivelisse Jiménez, Clemencia Labin and Heide Trepanier.

JENS HOFFMANN

Fabián Marcaccio, *Derealized paintant (Shopping)*, 2003

504

'Travelling without moving'
exhibition, with works
by Gabriel Delponte, 2004

kurimanzutto

YEAR OF FOUNDATION
1999

FOUNDERS
José Kuri and Mónica Manzutto

ADDRESS
Mexico City, Mexico (no permanent rooms)

ARTISTS REPRESENTED
**Eduardo Aboroa, Abraham Cruzvillegas, Minerva Cuevas
Daniel Guzmán, Jonathan Hernández, Philippe Hernandez
Gabriel Kuri, Dr Lakra, Enrique Metinides
Gabriel Orozco, Damián Ortega, Fernando Ortega
Luis Felipe Ortega, Sofía Táboas, Rirkrit Tiravanija**

Mónica Manzutto and José Kuri

No fixed address. Even though the Mexico City-based kurimanzutto gallery has only been around for a few years, it has still managed to attain a high degree of recognition on the gallery circuit, as well as on the international art scene. The unquestionable quality of the work it exhibits is one reason for this, and the unbelievable enthusiasm of the gallery owners is another. Above all, though, it is due to the gallery's unmistakable method of operating.

Kurimanzutto, which was originally conceived and planned by the artist Gabriel Orozco, has no established location, and no fixed room in which exhibitions are regularly shown. The gallery owes its unusual adaptability and mobility to this circumstance. Kurimanzutto leads a nomadic existence, and organizes its artists' projects and exhibitions in the most varied locations, entirely according to their respective needs: inside or outside, in gallery rooms, in downtown Mexico City, or anywhere at all.

This concept, which had initially been due to financial constraints, quickly became the gallery's trademark. It demands a high level of creativity and innovation, and depends on exceptionally close cooperation between artists and gallery owners,

'La Sala del Artista', 1999

a collaboration that is unequalled in many parts of the art world. Kurimanzutto's unconventional approach to conducting business has created as much interest in the gallery itself as in the young, talented Mexican artists that it represents, many of whom have begun an international career within the last few years.

When the gallery opened in 1999, kurimanzutto was in exactly the right place at the right time. There were absolutely no opportunities for young artists on both the Mexican gallery scene and in the country's institutions, and until then they had usually organized their exhibitions themselves. Kurimanzutto took up this idea and, instead of immediately opening its own space, continued the tradition of self-organized shows that had characterized the situation of emerging artists in Mexico in the 1990s. The gallery's two founders agreed on one thing right from the beginning: the artists were to be the focus of attention, and not a fantastic exhibition space. After months of planning with Gabriel Orozco in New York, where Mónica Manzutto had worked for the Marian Goodman Gallery and José Kuri had just completed his economics course at Columbia University, both were very well prepared for their difficult task.

On 21 August 1999, without large financial resources, they organized their opening show, which lasted only a day: a group exhibition entitled 'Economía de Mercado' (Market Economy). The project, originally conceived by Orozco, was carried out in the well-known and popular Mercado de Medellín, a weekly public market in the centre of Mexico City. The gallery rented a stand during the market's regular opening hours, but instead of fruit and vegetables or some other type of food, they sold works of art there. For the most part the works were made from materials that one could buy at the market, and the prices were in line with those of the goods offered at the other stands. There turned out to be enough buyers as well, even if most of them were not among the usual collectors of contemporary art. It had suddenly become possible to purchase a work of art for the price of an orange or a piece of cheese.

After this opening exhibition, the gallery carried out further projects such as 'La Sala del Artista' (The Living Room of the Artists), from an idea by José Kuri and Damián Ortega. This project was intended as an answer to the 'Le Salon des Artistes' cliché, and took place in a carpet shop in which the living rooms of several of the gallery's artists were shown.

In the same year the project 'Permanencia Voluntaria' (Voluntary Permanence) was also presented. This time the exhibition was set in a cinema, where a compilation of videos made in the early 1990s by four of the gallery's artists (Damián Ortega, Abraham Cruzvillegas, Daniel Guzmán and Luis Felipe Ortega) were shown. Films by other artists represented by the gallery were also shown, however, and there was a selection of film and video works by international artists such as Steve McQueen, Marine Hugonnier, Dan Graham, Bas Jan Ader and Johan Grimonprez.

Shortly afterwards kurimanzutto began to appear at international art fairs, where the two gallerists manned the booths of other galleries – such as that of the gallery Art

& Idea from Mexico City during 'ARCO 2000'. In the same year kurimanzutto also began to occupy other galleries' spaces temporarily, including that of the Galerie Chantal Crousel in Paris, Andrew Kreps in New York, or the Chac-Mool Gallery in Los Angeles. In this way the gallery was able to present a wide selection of work by the artists it represented. The exhibition in Paris was an important step for kurimanzutto and, above all, for its artists, since most of them had never before shown their work outside of Mexico, let alone in Europe, and interest in Mexico's dynamic art scene increased continually following this show.

Altogether, the gallery has carried out more than a dozen different projects in various locations in the last five years. Mexico City's airport was chosen as the location for Jonathan Hernández's exhibition in 2002, 'Travelling Without Moving', which dealt with problems of migration and tourism. Minerva Cuevas presented her show 'Dodgem' in the same year, for which she used bumper cars in an amusement park. Luis Felipe Ortega's show 'KM 96', which followed only a few months later, took place in the back of a large truck that was parked in various locations throughout the city during the course of the exhibition.

The gallery's most ambitious project to date is scheduled for 2005: kurimanzutto plans to open temporary galleries in several cities simultaneously, in order to exchange experiences about creative strategies and other artistic concerns with gallerists and artists in other Latin American metropolises. It won't just be artists from their own galleries that will exhibit works on this occasion – instead, the project sees itself as a meeting place within each respective city, where the works of resident artists are to be presented together with a selection from kurimanzutto's programme.

By temporarily relocating their activities beyond their own national borders, kuri-manzutto is attempting to cast a light upon the artistic environment beyond the well-known centres, in places where artists are working under conditions similar to those of the Mexican art scene.

JENS HOFFMANN

Maccarone Inc.

YEAR OF FOUNDATION
2001
FOUNDER
Michele Maccarone
ADDRESS
45 Canal Street, New York

ARTISTS REPRESENTED
**Matthew Antezzo, Mike Bouchet
Christoph Büchel, Anthony Burdin, Chivas Clem
Phil Collins, Christian Jankowski, Corey McCorkle
Claudia & Julia Müller, Daniel Roth, Olav Westphalen**

Opposite, top: Exterior view of the gallery with George Kunstlinger, the owner of the electrical appliance shop on the ground floor, 2002

Opposite, bottom: Video installation *Point of Sale* by Christian Jankowski, 2002

MACCARONE INC.

A hot art hangout. 'Ever since I first went by this house years ago, I knew I wanted to do something here.'[1] The inconspicuous building attracted Michele Maccarone much less than the blue awning of the small shop for all kinds of electrical appliances, in the middle of which the German word KUNST was printed in large, yellow letters. This had nothing to do with the American word ART, for the owner, a Jewish merchant named George Kunstlinger, had quite simply named his business Kunst Sales Co.

In November 2001, when New York was still reeling from the terrible events of 11 September, Michele Maccarone opened her gallery in the building's upper two storeys, aged just twenty-eight. After studying at Columbia University and working for several years in the renowned Luhring Augustine Gallery, where she had advanced from trainee to gallery director, her bosses predicted a brilliant career for her as a curator.

'But I am far too impatient to work in a museum,' she said. 'If I like an artist and have an idea, then I want to carry it out immediately and not wait for the word "go" from my superiors.'[2]

The first all-over installation by the Swiss artist Christoph Büchel would have been closed by the authorities in any public institution before it had even opened.

**Work by Daniel Roth
on the entrance door**

514

Michele Maccarone, 2004

'That was probably the most illegal exhibition that ever took place in New York,'[3] Michele Maccarone admits.

But whoever saw it won't ever forget it. After crossing all of Chinatown via Canal Street, accompanied by the constant wailing of police-car sirens from the nearby New York Police Department, passing innumerable Chinese vendors in front of little shacks with imitation Gucci bags and forged Rolex watches, and having finally reached number 45 at the street's eastern end, the visitor found absolutely no indication on the entrance that a gallery was located on the upper floor. If he climbed the steep wooden stairs anyway, he immediately had to sign a release declaring that he would enter the premises at his own risk. Thereafter he had to crawl on hands and knees through a hole in a shower cubicle, a small opening cut out with a saw, and then stumble across wobbly ladders leading to a deserted waiting room, a kitchen stuffed full of old newspapers, a smoky cavern containing mattresses and rags, and a cluttered office, thereby completely losing all sense of direction. Before escaping from this nightmare across a tiled roof, on to which rain dripped, the visitor caught sight of a low classroom in which only a child could stand upright, with a sentence from Marcel Broodthaers scrawled upon the blackboard: 'I don't believe in art…I believe in phenomenon.'

So far Maccarone Inc. has twelve artists in its programme, six Europeans who are already somewhat well known, and six newly discovered Americans, all of whom have something in common: none of them are older than forty and they all work in several media simultaneously.

In 2002 Michele Maccarone took over the building's ground floor as well, after Mr Kunstlinger closed his shop and retired. Before this, Christian Jankowski made a video of the two of them entitled 'Point of Sale', which was then presented on three walls in the gallery. In the video, a management consultant sits between them and asks the gallerist and the electrical appliance dealer questions about their respective business philosophies, difficulties and goals. Kunstlinger stands in front of his shop on the right, and Maccarone is seen in front of her doorway on the left. To the consternation of the viewer, each gives the answers, previously learnt off by heart, of the other.

Now that Maccarone can use the whole building, she is one step closer to her plan of creating a 'hot art hangout': 'I wanted it to be more organic, like an art house. It is non-profit, but is nevertheless a place in which art is simply there, together with people.'[4]

When you see her dusty round table with its full ashtray and empty bottles, at which she sits to inform interested parties about the artists as quick as lightning over the computer, you immediately believe her when she says that she wants to set herself apart from the elegant, spacious galleries in Chelsea. But Maccarone Inc. is now no longer the only gallery on the Lower East Side. Around the corner, in Rivington Street, the Rivington Arms and Participant Inc. galleries have just opened.

UTA GROSENICK

1 Michele Maccarone in conversation with the author, March 2003
2 Ibid.
3 Christopher Bollen: 'Lower your sights', in: *Time Out New York*, 21–28 February 2002
4 Leslie Camhi, 'Restored', in: *Village Voice*, 4 September 2002

Opening exhibition of the gallery, with the *Allover* installation by Christoph Büchel, 2001

The Project

YEAR OF FOUNDATION
1998
FOUNDER
Christian Haye
ADDRESS
1998–2003 **126th Street, Harlem, New York**
SINCE 2001 **6086 Comey Avenue, Los Angeles**
SINCE 2003 **37 West 57th Street, New York**

ARTISTS REPRESENTED
José Damasceno, Coco Fusco
Maria Elena González, Nic Hess
Glenn Kaino, Daniel Joseph Martinez, Julie Mehretu
Aernout Mik, Kori Newkirk, Yoshua Okon, Paul Pfeiffer
William Pope L, Jessica Rankin, Tracey Rose
Peter Rostovsky, Jason Salavon, Cristián Silva
Kim Sooja, Stephen Vitiello, Martín Webér

Exterior view of The Project in Los Angeles, 2005

The Project in New York:
left, an exterior view of
the old gallery in Harlem;
right, the entrance to the
new space in West 57th Street

Harlem shuffle. In 1998 Christian Haye, a poet, curator and employee for many years of the British art magazine *Frieze*, opened The Project, New York, on 126th Street in Harlem. Three years later he also opened The Project, Los Angeles. Haye, who had previously worked for the Jack Tilton Gallery, decided to create an exhibition room in which he could also show artists who were less well known, and who came from developing countries, or less predictable environments.

Soon after its opening, The Project made headlines both for its unconventional location and for its roster of young, edgy artists. The location, just one block north of Harlem's central 125th Street thoroughfare, was welcomed as a symbol of the rapid economic and cultural changes occurring in Harlem at the time, and quickly caught on with a fearless contingent of art lovers and artists intrepid enough to venture beyond

the economically sanctioned gallery communities of Chelsea and midtown Manhattan. Regardless of whether this was a conscious decision on Haye's part, the gallery brought much-needed attention to the Harlem community, as well as a sense of solidarity with the Studio Museum of Harlem, itself having just undergone a changing of the guard amongst its staff, and an architectural facelift. The Project, New York, lived a modest and discreet existence on a street that looked truly desolate. Nothing announced the gallery's presence, but that simply added to The Project's mystique. The space itself was quite raw and seemed hardly to trouble itself with the conventional aesthetic standards of international galleries. Instead, visitors could expect to enter into a direct and intimate dialogue with the works on view. Paul Pfeiffer, the Hawaiian-born Filipino artist, exhibited at the gallery from the very beginning, as

did the politically charged, conceptually based Chicano artist Daniel J. Martinez. Pfeiffer's exhibition 'Pure Products Go Crazy', 1998, brought international attention to artists and gallery alike. Christian Haye's selection of artists arose from his desire to make their relatively unappreciated works understandable to a large audience. Haye explained: 'More than half of the artists I show were simply people about whom I would really have liked to write. I decided I couldn't wait forever, until they were far enough along that they could be discussed in periodicals. They had no gallery, and most of them had only been in some group exhibitions in Europe, or I simply knew them. The first exhibition by Paul that I saw hung in a restaurant.'[1] Other artists from The Project are Kim Sooja, Tracey Rose, Julie Mehretu, Nader and Glenn Kaino, all of whom come from completely dissimilar cultural and geographical backgrounds.

In 2001 The Project, Los Angeles, opened in an industrial section of downtown Los Angeles in what one could describe as a garage-like space out of the 1960s, which the architect Peter Zellner had renovated into a gallery. In fact, the space had been used as a storage facility before its conversion into an art gallery. Unlike its Harlem counterpart, The Project, Los Angeles, boasted twenty-foot ceilings and large, unencumbered spaces that were more suitable for showing the kinds of work his artists were producing. 'Right from the beginning I realized that I couldn't rely solely on the support of the New York art scene,' said Christian Haye. While The Project, Los Angeles, does lie close to the Geffen Contemporary of the Museum of Contemporary Art, it is nonetheless in a street primarily populated by panhandlers, prostitutes and drug dealers.[2] In the autumn of 2003 The Project, New York, relocated to West 57th Street in midtown Manhattan. The decision to move away from its humble Harlem location was motivated as much by the lack of passers-by as by the increasing demand for the artists exhibited in the gallery.

GILBERT VICARIO

1 Villareal, Yvonne Force, 'Interview with Christian Haye', 2003
2 Linda Yablonsky, 'Making the Uptown the New Downtown', *ArtNews*, December 2001, p. 115

Installation in the New York gallery by Kori Newkirk, 2003

THE PROJECT

522

View of Paul Pfeiffer installation,
Los Angeles, 2001

ShanghART Gallery

YEAR OF FOUNDATION
1996
FOUNDER
Lorenz Helbling
ADDRESS
GALLERY: **97 Fuxing Park, 2a Gaolan Road, Shanghai, China**
WAREHOUSE: **50 Moganshan Road, Building 18, Shanghai, China**

ARTISTS REPRESENTED

**Zhao Bandi, Lu Chunsheng, Zhou Chunya, Zhang Enli
Shen Fan, Zeng Fanzhi, Yang Fudong, Wei Guangqing
Wang Guangyi, Tang Guo, Zheng Guogu, Liu Jianhua
Geng Jianyi, Pu Jie, Hu Jieming, Xiang Liqing
Feng Mengbo, Yang Mian, Zhao Nengzhi, Li Shan
Xue Song, Song Tao, Zhou Tiehai, Zhan Wang
Jin Weihong, Ji Wenyu, Ding Yi, Wu Yiming
Shi Yong, Yu Youhan, Wang Youshen
Liang Yue, Xu Zhen, Yang Zhenzhong**

Exterior view of the gallery

East meets West. Lorenz Helbling arrived in Shanghai in 1995 where he found a frantic and raving metropolis. The city began its miraculous resurrection in 1992, and the decade that followed was an exhilarating ride of limitless urban and economical expansion. Over night skyscrapers sprang up, highways and entirely new districts were constructed, and the whole city resembled one big construction site in constant development. Coming from Zurich, Helbling encountered a city that was rich in cultural history, alive with an extraordinary entrepreneurial and intellectual energy, and home to more than fifteen million inhabitants. Helbling, who had been in China many times before and in fact studied Chinese history and cinema in Shanghai before graduating in Switzerland in art history and Chinese, quickly recognized that the city was virtually devoid of places to display the huge numbers of ground-breaking artists emerging there.

Fascinated by the artistic intensity and the tremendous amount of creative energy, he knew that he had to change the situation and started to organize smaller exhibitions in apartments and restaurants. After doing this for a year, it became clear that it was essential to find a more permanent site that would offer the artists the possibility to present their works in a more constant and professional environment.

When the gallery opened in 1996, it was one of merely a few commercial spaces in the whole country. Even in the open-minded and adventurous climate of Shanghai during the mid-1990s, the new gallery owner was confronted with strong scepticism. No one believed it would be possible to find collectors and establish a profitable market for contemporary art from China. In addition, most artists seemed interested in showing their works abroad rather than in their home country, as they felt isolated

after years of political pressure and public apathy and in fact mostly wanted to leave China. Many prospective collectors were still interested in the more mundane benefits of the economic upswing, such as big apartments, designer clothes and European cars. At that point, Chinese art had attracted only limited attention in the global art world and was merely looked at as a curiosity.

Helbling did not pay much attention to these reservations and went ahead. Having no doubts that it was possible to set up a professional and economically functioning gallery in Shanghai, he knew that it was an ideal moment to understand the transformation of the country and be an active part of it. It was clear that the 1990s were the beginning of a new era for China, and especially for Shanghai, which once again became its business capital.

What would soon become the first reference in regard to art from China for collectors, curators and artists started in a small and unpretentious space in the Portman Shangri-La Hotel in the centre of the city. Fortunately Helbling did not need to pay any rental fees for his first gallery, as the hotel management, art lovers themselves,

Interior view of the Old Warehouse
by, clockwise from bottom left:
Liu Jianhua, Wang Guangyi,
Xue Song, Zeng Fanzhi,
Wei Guangqing and Li Shan, 2002

offered him the space free of charge. The first shows were very well received, and Helbling began to be recognized for his efforts. Nevertheless, the hotel was only a temporary situation, and only two years after the first opening Helbling began to look for another site. In 1999 the gallery moved to its current address in Fuxing Park – into a renovated garage that was turned into a 1,100-square-foot exhibition space.

Open seven days a week, the gallery is home to an immense archive of documentation on Chinese art, which is available to the public, and quickly established itself as one of the focal points of China's art world. In 2000 the gallery expanded once more, taking over a large, old warehouse space at Suzhou Creek (which was demolished in 2001), and moved, a little later, into loft spaces in an old textile factory on Moganshan Road to host its expanding collection of large-scale sculptural works.

The artists currently showing at ShanghART range in age. Several were born in the 1940s and experienced the dramatic ups and downs of the Mao era, while

Interior view of the New Warehouse, ShanghART Gallery. Works by, clockwise from bottom left: Shi Yong, Liu Jianhua, Wang Guangyi, Pu Jie and Zhao Nengzhi, 2003

Zhou Tiehai, *Movie Stars of the 80s*, 2001

others were born in the 1970s and lived in Deng's fast-developing New China. However, most of the gallery's prominent artists were born in the 1960s and bridge the gap between the older and younger generation. Many of the gallery's artists have become household names in the international art world. Today, ShanghART works with, exhibits, promotes and supports over thirty of China's most active artists. The last three Venice Biennials, as well as 'documenta X', gave a prominent role to Chinese artists, many of whom are showing their work at Helbling's gallery, including Yang Fudong, Xu Zhen, Feng Mengbo and Yang Zhenzhong.

JENS HOFFMANN

Appendices

About the Authors

Kirsty Bell (b. 1971) studied literature and art history at Cambridge University. She has worked in various galleries in London and New York, and currently lives in Berlin, where she is a freelance author and curator. She writes regularly for *frieze*, *Camera Austria* and *Art Review*.

Luca Cerizza (b. 1969) works as a freelance curator and critic in Berlin and Milan. He studied art history at the University of Milan and in 1997–98 attended the Curatorial Training Programme at the De Appel Contemporary Art Center in Amsterdam. He has published various texts about Italian and international artists in magazines, catalogues and monographs, and he writes regularly for *Tema Celeste*.

Stéphane Corréard (b. 1968) initially worked as a journalist and was the proprietor of the Galerie Météo in Paris between 1992 and 1993. Today he is a collector and freelance curator of art and design exhibitions in Paris, and is a regular contributor to the magazine *Beaux-Arts*.

Uta Grosenick (b. 1960) studied art history, German language and literature studies, and theatre sciences. Since 1996 she has been working as a freelance editor and author in Cologne. Works include *Art at the Turn of the Millennium* (Cologne, 1999) and *Art Now* (Cologne, 2002, with B. Riemschneider).

Rachel Gugelberger (b. 1968) studied at the Center for Curatorial Studies at Bard College in Annandale-on-Hudson, New York, and is a freelance curator and Deputy Director of the Visual Arts Gallery at the School of Visual Arts in New York.

Barbara Hess (b. 1964) works in Cologne as an art historian, critic and translator. Since 1994 she has published numerous articles on contemporary art in *Camera Austria*, *Flash Art*, *Kunst-Bulletin* and *Texte zur Kunst*, among others.

Jens Hoffmann (b. 1972) works as a curator and author in London, and is Director of Exhibitions at the Institute of Contemporary Arts in London.

Sylvia Martin (b. 1964) works as a freelance curator in Munich. With a doctorate in art history from the University of Cologne, she completed a traineeship at the Kunstmuseum Düsseldorf and works as a curator and on the academic staff of that art museum, as well as the museum kunst palast in Düsseldorf.

Regina Schultz-Möller (b. 1961) studied art history, classical archaeology and oriental art history in Bonn, and works as a freelance author and curator near Cologne. Since 1986 she has worked on her own exhibition projects and with various publications on contemporary art and the history of the art trade.

Raimar Stange (b. 1960) studied literature sciences and philosophy, and now works as a freelance art journalist and curator. He is also a bassist with the Art Critic Orchester, and co-publisher of the Berlin-based art fanzine *Neue Review*. Publications include *Sur.Faces* (Frankfurt am Main, 2002) and *Zurück in die Kunst* (Hamburg, 2003).

Adam Szymczyk (b. 1970) studied art history at the University of Warsaw. He works as a freelance curator and publicist. In 1997 he co-founded the Foksal Gallery Foundation, and since 2003 has been Director of the Kunsthalle Basel.

Gilbert Vicario (b. 1965) is a curator for Latin American art at the Museum of Fine Arts in Houston, Texas. He organized the first solo exhibition of the Chinese artist Chen Zhen in the United States in 2002, and the exhibition 'Made in Mexico' in 2003. He carried out both of these projects for the Institute of Contemporary Art in Boston.

534

Picture Credits

Berenice Abbott, p. 24
Courtesy Air de Paris, Paris,
 pp. 405, 406, 407, 408; Photo:
 Marc Domage/Tutti, p. 409
Courtesy American Fine Arts, Co.,
 New York, pp. 328, 329, 230–1,
 403; Photo: Susa Templin, p. 327
Courtesy Thomas Ammann Fine
 Art, Zurich, pp. 221, 222, 223,
 224, 225
Rogi André, p. 23
Archiv der Galerie Heiner
 Friedrich/Courtesy ZADIK,
 p. 133; Photo: Anita Kloten,
 pp. 2, 131; Photo: Thordis
 Moeller, p. 132
Archiv der Galerie
 Parnass/Courtesy ZADIK,
 pp. 47, 48, 49, 51
Archiv der Galerie Der
 Spiegel/Courtesy ZADKIK,
 pp. 41, 42, 44–5; Photo:
 Helmut Hahn, p. 43;
 Photo: Moegenburg, p. 430
Archiv der Galerie Otto
 Stangl/Courtesy ZADIK; Photo:
 Barbara Niggl, p. 93; Photo:
 Rosmarie Nohr, pp. 18, 87, 89,
 90–1, 92
Archiv der Galerie Rudolf
 Zwirner/Courtesy ZADIK,
 pp. 211, 212, 214, 215;
 Photo: Adolf Clemens, p. 213
Courtesy Art & Project,
 pp. 228, 229
Courtesy the artist and The
 Modern Institute, Glasgow,
 pp. 400, 443, 444, 445;
 Photo: Andrew Lee, pp. 446–7
Associated Press, pp. 26, 94
Bibliothèque Kandinsky,
 MNAM-CCI, Centre Georges
 Pompidou, Paris, pp. 35, 36, 37,
 38, 39
Courtesy René Block,
 pp. 106, 107, 108–9, 109; Photo:
 Hermann Kiessling, p. 108;
 Photo: Karin Szekessy/Courtesy
 ZADIK, p. 105
Bonhotal, p. 81
Bridgeman Giraudon, p. 128
Courtesy Gavin Brown's
 enterprise, New York, pp. 412,
 413, 414, 415, 488; Photo: Nick
 Relph, p. 411
Rudolph Burckhardt,
 pp. 113, 117, 142
Courtesy China Art Objects
 Galleries, Los Angeles,
 pp. 492, 493, 494, 495;
 Photo: Ann Shelton, p. 491
Courtesy Paula Cooper Gallery,
 New York, pp. 231, 232, 233;
 Photo: eeva-inkeri, pp. 234–5;
 Photo: Lydia Gould, p. 236;
 Photo: Tom Powel, pp. 236–7
Courtesy Chantal Crousel, Paris,
 pp. 354–5, 356, 357, 358 (l),
 359 (b); Photo: Florian
 Kleinefenn, pp. 358 (r), 359 (a);
 Photo: Gernot Schauer, p. 353

Courtesy Anny De Decker,
 pp. 108, 109 (r), 204, 205;
 Photo: R. Van den Bempt,
 pp. 203, 209 (l)
Courtesy Deitch Projects,
 New York, pp. 417, 418, 419,
 420, 421, 422, 423
Courtesy Fortes Vilaça,
 São Paulo, pp. 427, 428, 429;
 Photo: Studio 459, pp. 425, 426
Courtesy Galeria Foksal and
 Foksal Gallery Foundation,
 Warsaw, pp. 248, 249, 250;
 Photo: Albrecht Fuchs, p. 247;
 Photo: E. Kossakowski, p. 253;
 Photo: T. Rolke, pp. 251, 252
Courtesy Jacob Karpio Galería,
 San José, pp. 501, 502, 503,
 504, 504–5
Courtesy Galería Luisa Strina,
 São Paulo, pp. 315, 316–7,
 318–9
Courtesy Galerie Paul Andriesse,
 Amsterdam, pp. 333, 334, 337;
 Photo: Peter Cox, pp. 335, 336
Courtesy Galerie Beyeler, Basel,
 pp. 29, 30, 31; Photo: Peter
 Schibli, pp. 32, 33
Courtesy Galerie Daniel Buchholz,
 Cologne, pp. 340–1;
 Photo: Albrecht Fuchs, p. 339;
 Photo: Lothar Schnepf, pp. 342,
 343 (a), 345
Courtesy Galerie Eigen + Art,
 Leipzig/Berlin; Photo: Ernst
 Goldberg, pp. 361, 363; Photo:
 Birte Kleemann, p. 365; Photo:
 Thomas Steinert, p. 362; Photo:
 Uwe Alter, p. 364
Courtesy Galerie Konrad Fischer,
 Düsseldorf, pp. 240, 241, 242,
 242–3, 243; Photo: Dorothee
 Fischer, pp. 244–5; Photo:
 Candida Höfer, p. 239
Courtesy Galerie Max Hetzler,
 Berlin, pp. 273, 274, 275, 277;
 Photo: James Franklin, p. 276
Courtesy Galerie Georg Kargl,
 Vienna, pp. 255, 256, 256–7,
 258, 259
Courtesy Galerie Yvon Lambert,
 Paris, pp. 145, 146, 147, 148–9,
 150, 151
Courtesy Galerie nächst St.
 Stephan, Vienna, pp. 261, 262,
 263; Photo: Philip Schönborn,
 pp. 264–5
Courtesy Galerie Christian Nagel,
 Cologne; Photo: Andrea
 Stappert, pp. 450, 252 (b),
 452–3; Photo: Simon Vogel,
 pp. 451, 452 (a); Photo: Frank
 Wegner, p. 449
Courtesy Galerie Rolf Ricke,
 Cologne, pp. 168, 169, 170–1;
 Photo: Siegfried Thieler, p. 167
Courtesy Galerie Schmela,
 Düsseldorf, pp. 174, 175;
 Photo: Bernd Becher, p. 176;
 Photo: Laurenz Berges, p. 177;
 Photo: Charles Wilp, p. 173
Courtesy Galerie van de Loo,
 Munich, pp. 154–5, 156, 157;
 Photo: Karin Székessy, p. 152

Courtesy Galerie Michael Werner,
 Cologne, pp. 197, 198, 199,
 200, 201
Courtesy Galleria Massimo De
 Carlo, Milan; Photo: Armin
 Linke, p. 347; Photo: Studio Blu,
 pp. 348, 350, 350–1
Courtesy Galleria Gian Enzo
 Sperone, Turin, pp. 191, 192,
 193, 194 (l), 195; Photo:
 Elisabetta Catalano, p. 194 (r)
Courtesy Galleria Christian Stein,
 Milan, pp. 309, 310, 311, 312
Courtesy Barbara Gladstone
 Gallery, New York, pp. 374,
 375, 376; Photo: Larry Lame,
 p. 377; Photo: © Patrick
 Meagher, p. 373
Courtesy Goodman Gallery,
 Johannesburg, pp. 497,
 498, 499
Courtesy Marian Goodman
 Gallery, New York, pp. 268,
 270; Photo: Michael Goodman,
 p. 267; Photo: Attilio
 Maranzano, p. 271 (b); Photo:
 Tom Powel, p. 271 (a)
Courtesy Hauser & Wirth, Zurich,
 pp. 432, 434; Photo: A. Burger,
 pp. 432–3; Photo: Sebastian
 Derungs, p. 435; Photo: Rita
 Palanikumar, p. 431
Courtesy Tomio Koyama, Tokyo,
 pp. 438, 439; Photo: Sakae
 Oguma, p. 437; Photo:
 Yoshitaka Uchida Nomadic
 Studio, pp. 440–1
Courtesy kurimanzutto, Mexico
 City, pp. 507, 508, 510, 510–1
Courtesy Lisson Gallery,
 London; Photo: Dave Morgan,
 pp. 281, 282–3, 284, 285
Courtesy Maccarone Inc.,
 New York, pp. 513, 514,
 515, 516–7
Courtesy Marlborough Fine Art,
 London, p. 69; Photo: Prudence
 Cuming Associates Ltd,
 pp. 70, 72–3
Courtesy Paul Maenz, Berlin,
 pp. 289, 290–1, 291, 292–3, 323;
 Photo: Benjamin Katz,
 pp. 287, 288
Courtesy Metro Pictures,
 New York, pp. 216, 382, 384,
 385, 386, 386–7
Courtesy neugerriemschneider,
 Berlin, pp. 456, 457, 458, 459;
 Photo: Jens Ziehe, p. 455
Courtesy Anthony d'Offay Gallery,
 London, pp. 295, 296, 297,
 298; Photo: John Wildgoose,
 p. 299
Courtesy the Siegelaub Collection
 & Archives at the Stichting
 Egress Foundation;
 Photo: © Seth Siegelaub,
 pp. 179, 180, 182, 183;
 Photo: © Jacques Caumont,
 p. 181
Courtesy PaceWildenstein,
 pp. 159, 160, 163; Photo:
 Al Mazell, p. 161; Photo: Ellen
 Page Wilson, pp. 162, 164–5

Courtesy Peter Pakesch, Graz,
 pp. 320, 389, 391, 392–3;
 Photo: N. Artner, pp. 324–5;
 Photo: Wolfgang Woessner,
 p. 390
Courtesy The Project,
 New York/Los Angeles,
 pp. 4, 520, 521, 522, 522–3;
 Photo: Benjamin Pursell,
 p. 519
Courtesy Regen Projects,
 Los Angeles, pp. 461, 462, 463,
 464, 465
Courtesy Schipper & Krome,
 Berlin, pp. 467, 468, 470,
 471, 486
Courtesy Karsten Schubert Ltd,
 London, p. 397 (l);
 Photo: Nicola Hollins, p. 397 (r);
 Photo: Sue Ormerod, p. 395;
 Photo: Edward Woodman,
 pp. 396, 398–9
Courtesy Nicolai Wallner,
 Copenhagen, pp. 473, 474, 475,
 476, 476–7
Courtesy ShanghART, Shanghai,
 pp. 489, 525, 526, 527, 528, 529
Courtesy Sprengel Museum,
 Hanover, pp. 53, 54
Courtesy Ursula Wevers;
 Photo: © Ursula Wevers, pp.
 301, 302, 303, 304–5, 306, 307
Courtesy White Cube, London,
 pp. 480, 481 (r); Photo:
 courtesy Jay Jopling, p. 485;
 Photo: Johnnie Shand-Kydd,
 p. 481 (l); Photo: Stephen White,
 pp. 479, 482–3, 484
Gisèle Freund, p. 27
Getty Images © Nina Leen, p. 77
Dennis Hopper, p. 123
© Jeff Koons, p. 189
Ian MacMillan, p. 125
© Patrick Meagher, pp. 367,
 368, 370–1
André Morain, pp. 82, 83 (l), 84
Hans Namuth, p. 75
Bill Ray, pp. 114–5
© Schmitz-Fabri, p. 97
Steve Shapiro, p. 122
Allan Tannenbaum, p. 111
John Webb, p. 127

Every effort has been made to
trace the copyright holders of the
images contained in this book and
we apologize in advance for any
unintentional omissions.